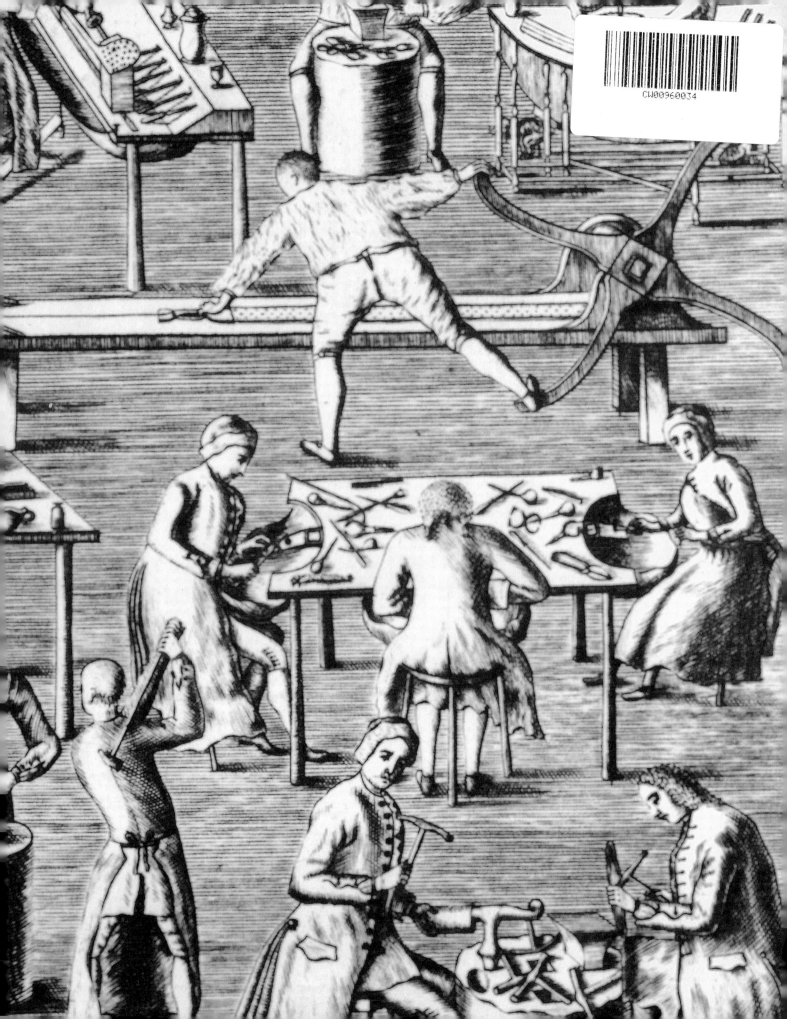

SILVER IN LONDON

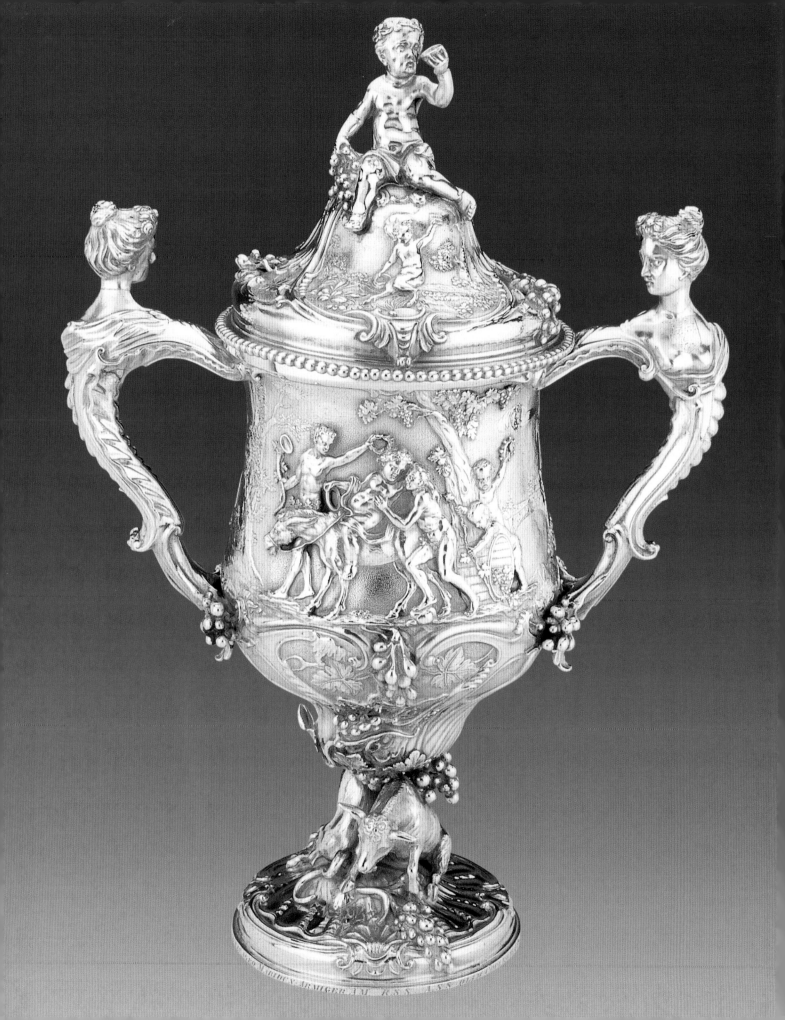

SILVER IN LONDON

The Parker and Wakelin Partnership 1760–1776

HELEN CLIFFORD

Published for The Bard Graduate Center for Studies
in the Decorative Arts, Design and Culture, New York

by Yale University Press
New Haven and London

This book is dedicated to the memory of
Martin Gubbins
and
Arthur Grimwade
two very different men who contributed so much to our
knowledge of the history of silver

This publication has been supported by generous funding from
THE SOUTH SQUARE TRUST

and help with the illustrations from
CHRISTIE'S and SOTHEBY'S

Typeset by Alliance Interactive Techonology, India
Designed by Emily Winter
Index by Indexing Partners, Annandale, VA
Printed in China through World Print

Title page: Cup and Cover, Parker and Wakelin, 1766.
Silver (London). Jesus College, Oxford

Library of Congress Cataloging-in-Publication Data

Clifford, Helen.
Silver in London : the Parker and Wakelin partnership, 1760–76 / Helen M. Clifford.
p. cm.
Includes bibliographical references and index.
ISBN 0–300–10389–1 (cl : alk. paper)
1. Parker and Wakelin (Firm) 2. Silverwork–England–History–18th century.
3. Silverwork–Social aspects–England. 4. Silver industry–England–History–18th century.
I. Title.
NK7198.P36C57 2004
739.2'3'0942109033–DC22

2004009153

Contents

List of Abbreviations

BL	British Library, London
CLRO	Corporation of London Record Office, London
HWRO	Hereford and Worcester Record Office, Worcester
IGI	International Genealogical Index, London
MBP	Matthew Boulton Papers, Birmingham Central Library
PRO	Public Record Office, London
RCA	Royal College of Art, London
RIBA	Royal Institute of British Architects Archives, London
RSA	Royal Society of Arts, London
SRO	Shropshire Record Office, Shrewsbury
V and A	Victoria and Albert Museum, London
VAM	Victoria and Albert Museum Archives, London

Silver is weighed in troy weight: in pounds (lb), ounces (oz), pennyweights (dwt) and grains. One pound troy = 12 oz troy = 240 dwt troy = 5,760 grains troy.

The tower pound of 5,400 grains troy was abolished in 1527 and replaced by the slightly heavier troy pound which had already been in use for more than a century. The troy pound was abolished by the Weights and Measures Act of 1878, except for the weighing of precious metals and stones, and its place taken by the older, avoirdupois pound for ordinary commercial use. One pound avoirdupois = 7,000 grains troy.

Units of money: pounds (£), shillings (s.), pence (d.)
£1 = 20s., £1. 1s. = 1 guinea, 1s. = 12d.

Acknowledgements

Way back in 1986 I was in a state of mild panic. I had joined the new joint Victoria and Albert Museum/Royal College of Art MA in the History of Design, and at the end of the first year I had to choose a subject for my final-year dissertation. I knew that I wanted to do something eighteenth century, as it seemed to me that was when objects and ideas that I thought 'modern' had begun to appear. Philippa Glanville, then Keeper of Metalwork, took me to one side and suggested that I look at the Garrard Ledgers, an unparalleled surviving set of London goldsmiths' account books that dated back to 1735. Armed with Elaine Barr's book on the foundation of the firm I set off for the Archive of Art and Design, where the large leather bound books are kept. I began with the ledgers where Barr's story ended, with the partnership of John Parker and Edward Wakelin.

I was overwhelmed by the detail as I turned the hundreds of pages, neatly kept, bearing customers' names, itemizing what they bought, when and with what; and also a ledger that detailed the makers and suppliers. The problem seemed to be how one could extract patterns of purchase and payment, supply and demand; how one could recreate the business from this detail, without being distracted by the particularities. It was then I had the idea of transcribing the accounts onto a computer database.

After my first efforts of turning eighteenth-century accounts into a twentieth-century spreadsheet I realized this was going to take much longer than the year that the M.A. allowed me. Thanks to a British Academy scholarship my M.A. became a Ph.D. Eight months later, with the guidance of one of my tutors, John Styles, I had a massive database of information. It is difficult to convey the thrill of being able, for the first time since the partners of the business had died, to recreate annual and monthly flows of trade, to grasp its extent and complexities, to make connections. When I got lost in the figures it was Philippa who set the silver back in its social context, providing a constant reservoir of enthusiasm. I am lucky, too, to have had support from Garrard, the firm into which Parker and Wakelin's business developed. Anne Weston and Corinna Pike saw the value of the past for the present and future, and helped me connect the two.

Next came the research into the customers, and here I began to really appreciate the value of the Victoria and Albert's Department of Furniture buildings archive: hundreds of boxes, listed by house, containing inventories, articles and photographs. I am extremely grateful for the support of the Furniture Department staff, and particularly Frances Collard, for allowing me to pore over these papers, discovering just where Parker and Wakelin's customers lived and where their silver was kept and displayed. This led me to countless family archives and county record offices where household accounts,

bills, letters and diaries helped provide me with another layer of context in which to think about the silver in the ledgers. I am deeply indebted to many county archivists, individual families and those generous genealogical researchers who offered me valuable advice and guidance. I should particularly like to mention Lady Rosebery, at Dalmeny, for her generous hospitality and for introducing me to the complexities and worries of maintaining a country estate, as valid now as in the eighteenth century. Lady Willoughby at Grimsthorpe showed exemplary patience in answering so many questions, providing both intellectual and physical sustenance.

As a student at the Royal College of Art I decided to exploit its resources by trying to find out just what was involved in making silver. With a great deal of trepidation, I went to the School of Goldsmithing, Silversmithing and Jewellery and persuaded David Watkins to let me join the first-year class. In those days it was required to execute a series of practical exercises: to raise a bowl, make a box and forge a spoon. The patience, humour and sheer skill of John Bartholomew, our teacher and guide, amazed me then and does still. I am lucky that some of the students I met there have remained friends, and are now established and successful goldsmiths. Through them, and the practice of making, past and present have for me been united. Over the years I have learnt much from other working silversmiths, particularly Gareth Harris and Dennis Smith, whose patience and skill are a constant inspiration. It is from them that I have come close to understanding the tacit knowledge of the maker, and the business of making

The Metalwork Department at the Museum provided me with a second home, for which I am most grateful. Here I learnt about the objects, found where more could be located, was able to handle the silver and became part of the exciting interchange of information that links institutions and individuals, curators and collectors, museums and the trade, part of an international network. I would like to thank Philippa Glanville, Marian Campbell, Ann Eatwell, Richard Edgcumbe, Tony North and Eric Turner for their friendship. Their knowledge and camaraderie were freely shared and generously given. Without the guidance of Susan Hare and David Beasley I would never have appreciated or tapped the rich resources of the Goldsmiths' Company and its archives.

Many of the ideas in this book stem from lengthy discussion with Robert Barker, whose own work on eighteenth-century Jamaican silver will I hope be published. His genius for research has kept me on my metal throughout. Many of the illustrations and thoughts about the interior context of silver derive from my work for Charles Saumarez Smith's book on the eighteenth-century interior. By employing me as a fledging picture researcher he not only gave me much needed employment, but also a whole new world of sources to think about.

I have benefitted greatly from the warm friendship of the Silver Society whose members provide a lively and questioning forum for debate. Here I met Martin Gubbins, whose knowledge and enthusiasm for silver were infectious, whose eagle eye spotted sloppy thinking and grammar, I miss him greatly. Here too I met Tony Dove, whose tremendous expertise and knowledge is hidden by such a modest manner. In the Society it is the objects that matter, to confound one's expectations, and set one thinking.

It has been a long time since I finished my Ph.D., and the gap between its completion and this book has been filled by teaching, first in the Art History Department at Essex University, at Sotheby's Institute, and then for the V and A / RCA M.A. in the History of Design. My colleagues helped me think about

my work, the questions I was asking and the evidence I found. Michael Podro's sense of experimentation made me brave; Carolyn Sargentson's work on *marchands merciers* in Paris provided another context for thinking about luxuries; and John Styles provided intellectual rigour.

Yet it has been my students who have made me think the most, who have kept me on my toes, asked questions that I could not answer. I would particularly like to thank Andrea Wulf who helped me with my research. John Cross and Amanda Girling-Budd both work on eighteenth-and-nineteenth-century furniture, and some of the questions they raised I found relevant to my own work. Alison Fitzgerald who is writing her doctorate on eighteenth-century silver in Dublin has provided me with renewed vigour and another context in which to consider the London model.

I would also like to thank Mrs Marion Roberts, Sir Michael Leighton and Mrs Lavinia Bonner Maurice for their advice and warm hospitality, and Mrs Pat Unwin for her kindness. They made very special links with the past possible.

I am particularly grateful to the South Square Trust for giving me much needed support at a crucial time in the birth of this book. Their generous financial proof of faith in the project, via a grant towards production is greatly appreciated. Sally Salvesen at Yale University Press has been a constant support, waiting in the wings to take this project into production. Without the generous support of the Bard Graduate Center the fruits of this research project might never have been published. I am indebted to Harry Williams-Bulkeley from Christie's and Kevin Tierney from Sotheby's for providing me so generously with so many photographs for the book.

I would like to thank warmly David Beasley, Vanessa Brett and Michael Burden for reading a first draft of this book, and Viccy Coltman for reading a second version. Their sound advice has helped shape this book. Maxine Berg and Matthew Craske made me think about its structure, and David Mitchell's work on the goldsmiths' trade of the seventeenth century provided models of analysis. Days before submission, John Styles came up with his usual pithy points, just in time for me to address some of them, and the book I hope is better for them. Philippa Glanville has read almost as many drafts as I have written, and I owe her much for her wise counsel, good humour and patience. My Mum and Dad read early drafts of this book, and assured me it was intelligible to the layman, encouraging me to continue when encouragement was most needed. Alan Bainbridge has lived with this book as long as I have, and it is his companionship that has helped me keep this project in perspective.

Helen Clifford
May 2004

*the past is alive and stirring with objects, bright or solemn,
and of unfading interest*

William Hazlitt, *On the Past and Future*, 1821

I

Silver and Society in Eighteenth-Century England

Some People call it but Decency to be serv'd in Plate, and reckon a Coach and Six among the necessary Comforts of Life.

Sarah Fielding, *The Adventures of David Simple*, 1744

MESSAGES AND MEANINGS

Objects made from silver, and attitudes to them, were once central to both economy and society. Today silver is very much back stage and it is difficult for us to imagine its dynamic role in the theatre of social and cultural life. The passive museum objects that sit behind glass, and beyond our reach, do not readily connect with past evocations of the elegance of the tea table and the glamour of the dining room, where silver tea urns and tureens were recognized as active symbols of wealth and status, taste and power. As dish, jug and spoon circulated, so too did the shared meanings and values they represented, welding the upper echelons of society and their aspiring imitators together in a self-confirming ritual of use. The aim of this book is to recapture that importance, and to enliven our appreciation and understanding of silver in society. It concentrates on the second half of the eighteenth-century in England, when changes in its manufacture, sale, purchase and use reflect wider social, economic and cultural developments. In this pivotal period old and established ideas about status, and the objects which represented it, were being challenged, and the foundations laid for some of the ideas which we now think of as 'modern'.

The work is based on a pair of ledgers, the business accounts of a partnership of London goldsmiths that cover the 1760s and 1770s, the precise period in which we see so much change and development in the manufacture and consumption of silverwares. As the silver itself lies at the core of this book, it is neither a traditional business history that examines profit and loss, nor a biography of the owners and associates. It is more a means of tracking the story of the objects made and sold, as they passed between networks of makers and retailers, and into the homes of those who bought them. It is a story dependent upon linkages and associations, a biography of things which reveals the influences of particular social, cultural and economic forces that shape the way objects look.

MATERIAL VERSUS WORKMANSHIP

The values placed upon silverware balance between its material, intrinsic and readily convertible worth, and the appreciation of its decorative form. The

former has a set value while the latter does not, it is negotiable. As the celebrated blue-stocking Elizabeth Montagu (1720–1800) phrased it, 'the objects of luxury and pride . . . depend much on the fineness of the materials in which he works, gold, silver, silk and many other things have a standard value – the workman knows the price at which they will be purchased'. In the 1760s and 1770s, a time of relative economic stability, silver cost 5s. 6d. per troy ounce, the price of a pair of wealthy woman's worsted stockings, and just over an ounce of silver would make the handle of a fork.[1] Design and workmanship were more difficult to cost, as the workman 'does not know at what his intention will be estimated . . . the subject the artificer has chosen may displease, then the labour is lost'.[2] While the former carried guarantees of quality, like 'the sterling mark upon plate, and the stamps upon linen and woollen cloth', the latter was more difficult to regulate.[3] The economist Adam Smith (1723–90) in his *Wealth of Nations* (1776) argued for a new relationship between material and labour value, but realized that 'though labour be the real measure of the exchangeable value of all commodities, it is not that by which their value is commonly estimated', because 'it is not easy to find any accurate measure of hardship or engenuity'.[4] For this reason 'the exchangeable value of every commodity is more frequently estimated by the quantity of money, than by the quantity of either of labour or of any other commodity which can be had in exchange for it'.[5]

These debates about value were particularly relevant to commodities made of precious metals, where the cost of materials and labour are more clearly marked, and therefore recognized. Makers, retailers and consumers were all keenly aware of the dual nature of silverware. In its purchase and sale the value of materials and the costs of making had to be clearly presented in bills, receipts and accounts, but this was not the case for furniture, ceramics, glass and other luxury commodities. In the past the weight was often valued over the workmanship, so clearly summed up in the much quoted complaint by Samuel Pepys, that a pair of tankards he had been given cost almost as much to fashion as the weight of the silver. The latter was retrievable, but the former not, when wrought silver was converted to cash. Yet Pepys felt that 'a bag of gold', rather than a piece of worked plate, was 'no honourable present'.[6] Workmanship transformed the material into a gift of greater value. The relationship between the intrinsic and aesthetic value of wrought silver has never been a stable one but has shifted according to changing social, economic and cultural conditions. In the eighteenth century the metal nearly always cost more than the workmanship, but today the reverse is usually true. An exploration of the relative values which a society puts upon silver is, therefore, a particularly fruitful way of understanding a period and a place, its economy, manners and morals.

While the intrinsic worth of precious metal and its use as currency has meant that its production, circulation and control of quality is well documented across time, via guild regulations and business and household accounts, at times the paper-trail becomes particularly rich, usually during periods of change.[7] During the eighteenth century there was much discussion about silver in England, both as currency and as wrought goods.[8] Debate centred on three major aspects: the movement from a coin to a paper-based economy; improvements in manufacture which increased the amount and variety of precious metal wares; and the challenge from other materials to the pre-eminence of silverware as a fashionable and status-bearing commodity.

CREDIT AND CURRENCY

In this period the British economy was liberated from the constraints of its metallic money supply. Gold, silver and copper were replaced by 'symbolical money, which is no more than a species of what is called credit'.[9] Credit evolved from simple deferred payment or cash advances, to the point where bills, notes or letters of credit themselves began to function and circulate as money. As a result the economic and monetary character of the country was transformed. Coin, which had accounted for over eighty percent of England's money in the 1690s, made up less than half in 1800.[10] Goldsmiths, 'the most genteel of any in the mechanick trades', were at the centre of this development. They had the metal reserves upon which credit, then called 'running-cashes', could be drawn and offered what we would now call overdrafts, a financial innovation which was English.[11]

Until the seventeenth century people's thoughts about money were primarily religious and moral in tone. They were inseparable from deep-seated Christian anxieties about excessive wealth and God's judgment on the unjust rich. By the end of the eighteenth century man-made law and the temporal state formed the conceptual frame of reference within which the various aspects of money were discussed. The balance between paper and coin was delicate, and crises frequent when the public, in times of uncertainty, sought to convert their paper into gold, risking a run on the banks. It was within this shifting economic environment that purchasers made decisions about their silverwares.

The development of banking and credit in London in the seventeenth and early eighteenth centuries can be compared with that of the Italian Renaissance.[12] In both periods the fashioning of goods came to be increasingly regarded as a sign of status over the cost of the materials. It was not enough simply to hoard up great masses of silver, the pieces had to demonstrate taste in design and workmanship. Faith in the 'idea' or surface, over the 'substance', in terms of both currency and metalwares, triumphed. As we shall see, the importance of the 'look' of an object over its material value affected the lower end of the market as well as the higher.

The conversion from substance to surface value did not happen overnight, and many believed that paper money could function effectively only if it was convertible on demand into gold or silver coin. The French, and in particular Louis XIV's first great finance minister, Jean-Baptiste Colbert, held on to the more tangible idea 'that the might and greatness of a state are measured by the quantity of silver it possesses'.[13] The French were cautious of the precociousness of credit in England. Le Pottier de la Hestry, an early eighteenth-century French politician, argued that luxury goods without convertible intrinsic value 'could only cater to [the people's] luxury and sensual indulgence and in no way enrich the Kingdom, because in the end these goods will be worn out through use'. Silver on the other hand 'does not wear out with use' and 'would . . . remain in the Kingdom and, increasing more and more every day, would make the state rich and powerful'.[14]

TRADITION AND NOVELTY

In the mid-eighteenth century we can see a tension between old and new ideas about the status conveyed by silverwares. On the one hand the quantity of wrought silver in London, displayed in shop windows, and laid out on aristocratic and royal tables, provided a traditional index of the nation's wealth, one that had a comforting continuity. Both a Venetian visitor of 1500 and the

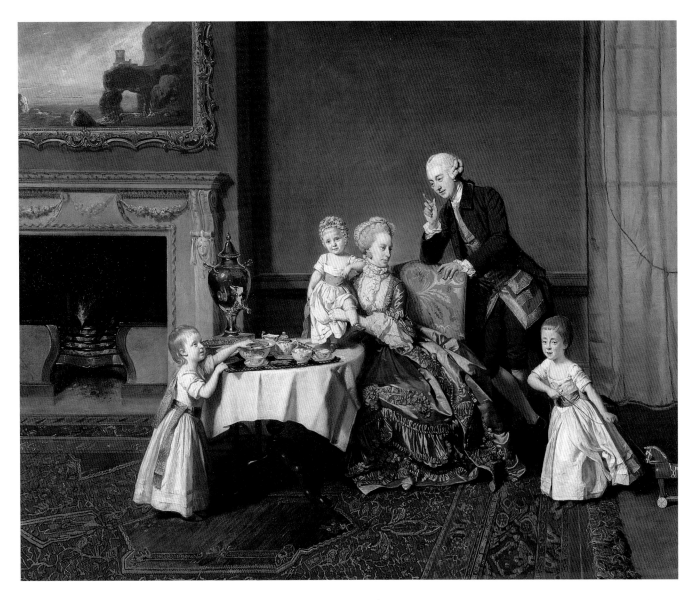

Fig. 1. *John, 14th Lord Willoughby de Broke and his family in the Breakfast Room at Compton Verney*, by Johann Zoffany (1733–1810); 1766. Oil on canvas, 100.3 × 125.7 cm. Getty Museum, Los Angeles

American Envoy, Richard Rush, over three hundred years later, were astonished by the sheer amount of silverware on display in the capital. The Italian marvelled at Cheapside, where 'the goldsmiths shops so rich and full of silver vessels' outmatched all the shops in 'Milan, Rome, Venice and Florence put together'.[15] Rush, the diplomat, was equally awed by the 'profusion of solid and sumptuous plate' that he saw on the tables of his hosts which, he felt, was 'unknown in any other capital' and which struck him 'as among the evidences of a boundless opulence'.[16]

In Zoffany's fashionable portrait of John, 14th Lord Willoughby de Broke and his family, set in their country home at Compton Verney in 1766, the elegant silver tea urn dominates the scene (fig. 1). The rest of the room is reflected in its glory. It would have been the single most expensive item in the room, costing more than the landscape painting in its rococo gilded frame, more than the neo-classical carved marble fireplace, more than the exotic Turkish carpet and more than the rouched, green-silk dress that Lady de Broke shows off.[17] It was the silver that caught the eye and allowed the visitor to calculate the standing of the owner. The difference between the painting

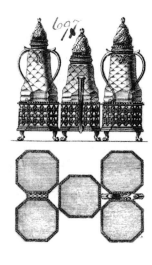

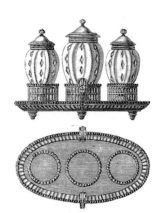

and the silver was that the former was an optional extra, while the latter was deemed essential for the demonstration of 'quality'.

This was not just within the aristocratic interior; in May 1767 the country cleric John Penrose recorded that at Mr Brinsdon's:

> We drank Tea in the Dining-Room . . . the Tea urn plain except a Chinese Border round the Bottom, which stood on the Mahogany Table. The Tea and Coffee cups etc. upon a silver Tea-table or Waiter, of an oblong square, which cost £44 19s. at 7s. 8d. per ounce. The Price of the Tea Urn about 30 guineas. The silver Tea-Table had brackets, instead of Feet.[18]

Penrose was describing the latest fashion in teaware, and a calculating interest in its precise cost with a close observation of form and ornament. He is weighing up the relationship between its material and fashionable worth. The cost of the tea table represented the annual income of a well paid curate or of a journeyman shoemaker in London.[19] Forty pounds in the 1760s would have bought six 'Handsome Carved mahogany chairs' from Vile and Cobb, or a pair of fine blue and gold Sèvres vases, as well as Mr Brinsdon's silver waiter. Yet it is the subtleties of design which also engage the attention of Penrose, the fashionable chinoiserie border and the brackets instead of feet. This is not the family's old tea kettle but a new contraption, an urn.

The importance of a weight of wealth was, in the eighteenth century, being challenged. There was a growing division between the rhetoric of quantity over novelty. Silver was no longer the province of the very wealthy but was to be increasingly seen on the tables of the middle classes, its presence percolated deeper into society. By the 1770s it was no longer enough to have a weight of silver displayed on the sideboard, it had to be of the latest taste, the most recent novelty.

On a visit to Holkham in 1772 Lady Beauchamp Proctor noted 'a most elegant Birmingham vehicle to hold the rusks' and asked the footman to tell her where it was bought, as she was determined to get one for herself.[20] Status was marked by knowing the language of etiquette, of knowing how to use the plethora of new equipment. When Nellie Weeton wrote to tell her friend about her new employment as a governess, she described with awe her first supper when she dined with her employees, 'we had two servants in livery attending, and some display of plate, . . . and some things of which poor ignorant I knew not the use. I felt a little awkward, but as you may suppose, strove not to let it appear'.[21] In a similar way the literal translation of gold and silver lace on clothes as a sign of wealth was replaced with the greater subtlety of cut as an indicator of fashion.

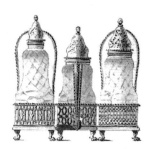

METHODS OF MAKING

While attitudes towards the material status, value and use of silver were being contested in the eighteenth century, the methods of transforming it into goods were changing too. The introduction of flatting mills in the 1720s, and their widespread use by the 1760s, meant that for the first time standard gauge sheet metal could be produced, using a fraction of the time and labour compared with hand hammering from the ingot. Silver objects could be made

Fig. 2. Designs of silver condiment stands with glass bottles, from Matthew Boulton's Pattern Book; c. 1768. Height 31 cm. Birmingham Central Library

from lighter plate, changing the relationship between the weight and the labour involved in its manufacture. In short, workmanship began to assume greater relative weight.

Combined with this ability to make thinner-gauge sheet came a revolution in the scale of production. A stamping machine, patented in London in 1769 and soon improved, enabled simple sections to be shaped and repetitive patterns to be pierced with speed and accuracy.[22] Harder steels and more efficient mills further increased the speed of production and reduced the thickness of silver. In 1779 a machine for making beaded wires was patented, and fly-presses were quickly put into use by leading manufacturers. The amount of silverware passing through the London Assay Office where, by law, it was brought to be hallmarked, shows a dramatic increase between the 1750s and 1770s, representing a whole new scale of manufacture. In 1750, for example, just under 500,000 troy oz were hallmarked in London, compared with over 1,000,000 troy oz in 1760.[23] This leap in scale was associated with the removal of a duty on silver in 1757, but it also reflected an increase in the number and variety of articles submitted.[24]

In 1758 an investigation into the 'Better Prevention of Frauds and Abuses in Gold and Silver Wares' revealed various 'new invented articles of small plate', which were evading assay. As a result a new list of items was published which included objects promoted as essential for polite living. On this list were cruet frames to hold condiments such as oil, soy, mustard, vinegar, ketchup, pepper and cayenne, introduced in the 1720s (fig. 2); and labels, known as 'bottle tickets', which began to appear at the same time, to identify the increasing range of wines, spirits and condiments served at table (fig. 3).[25] The use of gravy warmers, known as 'argyles' (named after the third Duke of Argyll who is credited with first using them), were a later invention of the early 1750s. Made in silver, Sheffield plate, porcelain and earthenware, they became popular in the following decade.

There was an aesthetic dimension to these new methods of production. Steel stamps and dies were suited to 'modular' reproduction; mechanical manufacturing methods required that many of the smaller wares should be of simple structure, with straight lines and lines of ornament that could be easily repeated. Flat sheet was easily made into the cubes, circles and ovals that characterized neo-classical forms as espoused by Robert Adam and other fashionable designers.

THE CHALLENGE OF NEW MATERIALS

As silverware was widening its market profile so it was challenged by other materials such as paktong (an alloy of copper, nickel and zinc imported from China in the later eighteenth century), and most effectively by Sheffield plate. This copper sandwich of silver was invented in the 1740s, made possible by the flatting mills, and commercially produced from the 1750s. The unique property of Sheffield plate, which set it apart from all earlier forms of plated and substitute articles, was that after the laminated sheet was produced it could be worked in the same way as sterling silver, with the one exception that it could not be cast. In terms of design, size, texture, reflective quality and visual impact Sheffield plate came up to the same standards as sterling silver,

Fig. 3. Bottle tickets, various makers; c. 1760s–70s. Silver (London); length 3.5–5 cm. Ashmolean Museum, Oxford

but at between twenty and thirty percent of the cost, depending on the strength of the plating.

Improvements in the hardening of steel meant that the same dies could be used to work both Sheffield plate and silver. The introduction of stamping machines from the 1760s meant they could be produced more quickly and cheaply. Those who could not afford a silver teapot could buy one in Sheffield plate. There is evidence too that, by the 1770s, the titled elite also began to prefer plated wares to silver.

Silver was also challenged by completely different materials, notably ceramics and glass. For the price of four silver comport dishes[26] a whole dining service of 'nankeen china' (Chinese export porcelain) could be bought.[27] The Worcester China Warehouse in London sold home-manufactured ceramic oval tureens for 25s. per dozen, with a fifteen percent discount for prompt payment.[28] Yet the competition was not just about quantity, colour and cheapness. Some ceramics acquired a high value of their own. Dr Johnson famously reported to Mrs Thrale, in 1777, that the finer pieces of Derby porcelain, 'are so dear that perhaps silver vessels of the same capacity may sometimes be bought for the same price'.[29] Ceramics had their own hierarchy of value, Chelsea porcelain and fine India china were for the wealthy, common India china and earthenware were for the less wealthy.[30] Wedgwood's success lay partly in his ability to produce new ceramic materials that responded to the demand for novelty. In the 1760s he produced Queen's Ware, a cream coloured earthenware which was refined in the 1770s as Pearl Ware. By the end of the decade he had developed Black Basalt which he claimed 'was sterling, and will last forever'. As an indicator of fashionable taste silver was being superseded, and sometimes overthrown, by other materials. The Birmingham manufacturer Matthew Boulton was told by one of his agents in 1769 that dessert services *à la grec* were thought only proper in china or glass, 'and that nothing of metal ... would be thought conformable to ye present *whim* of Tast'.[31]

The possession of silverware, mostly for the table was, until the mid-eighteenth century, one of the surest indicators of status and wealth, a means to pass on both intrinsic value and personal sentiment and to convey the owner's taste. As the century progressed it lost out to more sophisticated, reliable and remunerative forms of investment such as East India Company shares and government stocks. Its decline maps a change in attitude towards luxury consumer goods: intrinsic qualities that were redeemable and recyclable gave way to a greater preoccupation with the 'unrecoverable' qualities of novelty and variety. This conforms to a larger pattern of consumer change. 'Patina', Grant McCracken argues, ceased to be valued in the eighteenth century, it was replaced by 'Fashion'.[32] As the attraction of age and tradition dwindled, new and fashionable goods became more desirable than those that suggested longstanding wealth and prestige.

While London goldsmiths continued to service traditional elite markets, drawing upon networks of highly skilled craftsmen, for the supply of commissioned wares made and bought on credit, it was the manufactures in Birmingham and Sheffield which, from the 1760s and 1770s, most effectively exploited the demand for lighter, more standardized goods that were sold by agents and bought over the counter, ready-made, for cash. For the first time London was losing its dominance over the goldsmiths' trade. The London goldsmiths bowed to this new demand and stocked their shops with Sheffield plate candlesticks and 'slight articles of taste' such as milk jugs, spoon trays and bottle stands.

SOCIAL CHANGE AND SILVER SCHOLARSHIP

By the mid-nineteenth century silver had passed from regular use at table to the connoisseur's cabinet. The author of *The Economy for Young Housewives* (1862) explained that formerly,

> Most persons aspired to have as much genuine plate as possible, it always kept its value and remained as a kind of heirloom. Now, from the rise of robbery, and the excessive trouble of keeping plate, not to say the loss of interest of money, it is found preferable to have only a few genuine articles, and others plated or nickel, or electro-typed.[33]

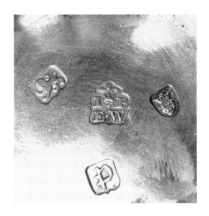

Fig. 4. The 'maker's mark' of Parker and Wakelin on a silver coffee pot hallmarked in London (Leopard's head); 1770–1 (date letter gothic 'p') and sterling (lion passant regardant). Length 4 cm. Private collection

Social change, the expense of servants, changes in the economy and the success of imitative technologies meant that silver was losing its functional status. A whole new set of very different meanings, associations and value systems came into operation.

This attitude to silverware ran alongside an emerging silver scholarship that created new terms of value specific to the collector's market. The markers of quality and worth that this new language of discrimination created are still in common use today. It is important to appreciate this development as it colours our interpretation of the material evidence that survives. In 1853 Octavius Swinnerton Morgan (1803–88) published his researches into what he called the 'makers' marks' on silver. He interpreted the symbols and initials stamped on silverware, together with the hallmarks denoting sterling standard, as signatures of the artists who made it (fig. 4). Herbert Brunner called them 'the artist's monogram'.[34]

These convenient identifiers were seized on by late nineteenth- and early twentieth-century silver scholars who gathered examples of marked (interpreted as signed) work to classify and appreciate the skills of individual makers. It was through the writing of biographies that scholarship progressed. Reitlinger christened this quest for the author as 'the autograph passion', and it applied not only to fine art and silver but also to all the decorative arts.[35] The four hundred-year-old systematic control of the sterling quality of silver, which demanded recognisable guarantees, was envied by scholars of other decorative arts, where standards were not so closely regulated. As a result 'old plate' gained in value more for the marks it bore and its 'fashion' than for its declining bullion worth. In 1883 Lucy Crane wrote:

> There has been lately a taste for old-fashioned plate so that specimens of it we still possess have now a chance of being taken care of, instead, as I can remember, of being sold merely for their value in weight, or exchanged for modish, and worse, only to be melted down into new and hideous shapes.[36]

Edward Watherston, a retail goldsmith, complained in 1893 that: 'We are martyrs to the old plate craze – old Hallmarks. There are people who will give any price for antique plate.'[37] Garrard, the royal goldsmiths, had begun selling 'antique' examples of their own and other firm's silver over eighty years earlier.[38]

COLLABORATIVE CONSTRUCTION AND CONNOISSEURSHIP

It has taken us nearly a hundred and fifty years to question this way of interpreting and reading silverware, and the resulting implications have been enormous.[39] The so-called 'maker's mark' turns out to be no such thing. Objects

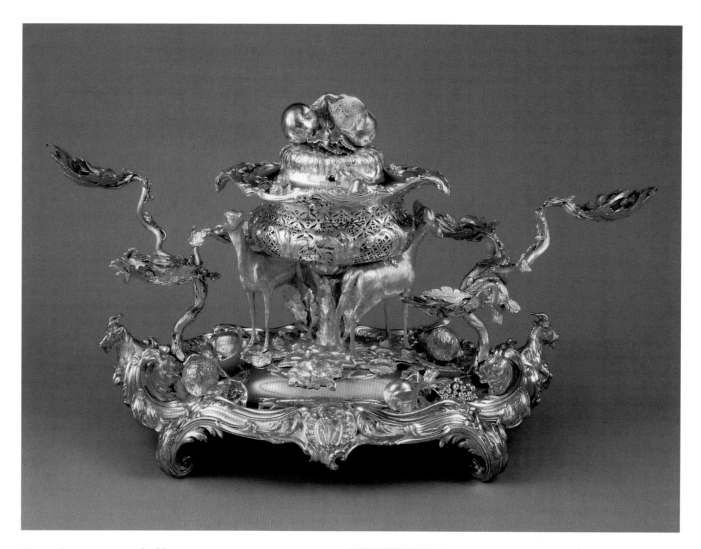

Fig. 5. Centrepiece, marked by
Parker and Wakelin, for 5th Duke
of Bolton; *c.* 1760. Silver (London);
50 × 95.5 cm, 624 troy oz 5 dwt.
Museum of Fine Arts, Boston

Fig. 6. Trade card of Honour
Chassereau, showing range of
account books on sale; *c.* 1773.
6 × 10 cm. British Museum

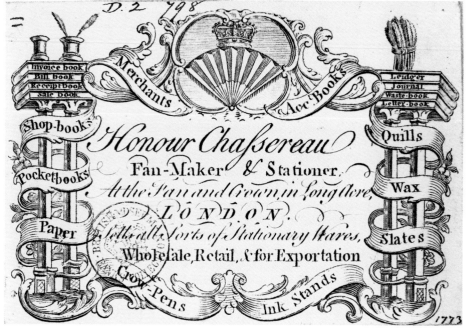

that were thought to be the product of a single pair of hands or workshop, turn out to be the result of collaborative enterprise involving many skilled contributors, often from many different workshops. As John Culme explained as recently as 1987, 'the study of English silver and the understanding of it as largely the product of a vigorous *trade* rather than the talented *individual*, has been hampered by the temptation to overestimate the value of the so-called maker's mark'.[40] As with medieval carved, painted and gilded altarpieces, which were also the products of collaborative endeavour, so individual pieces of silver combined the skills of designers, modellers, casters, chasers and polishers. An elaborate centrepiece, such as one made for the 5th Duke of Bolton in 1760, bearing the marks of the London goldsmiths John Parker and Edward Wakelin (fig. 5), involved a whole team of skilled workers: modellers to form the patterns for the deer, goats' heads and fruit finial; casters to turn the models into solid silver; raisers to transform flat sheet silver into the central bowl; piercers to drill and saw out the lace-like pattern on it; chasers to pick out the detail – the veins of the vine leaf dishes, the fur on the deers' backs; and polishers, using abrasives and burnishers, to bring out the deep and rich gleam of the silver.[41]

It was not just large and complex pieces of silver that required such a large team of specialists; even small components could involve several skilled men. Four cast-silver coats of arms supplied by the Vulliamy brothers for mounting on a pair of Lord Brownlow's tureens were the product of the labour of at least seven skilled men. The brothers' work books record that Cramphorn made the model in wax, which was cast as pattern by Barnet. This was then used to cast the four coats in silver by Cooke, which were filed up by Culmore, chased by Caney and Barker and burnished by Seagrave.[42] How, then, are we to locate and understand authorship?

The making and selling of silver conformed to the same collaborative strategies that we now recognize were adopted by furniture makers, painters, sculptors and other suppliers of luxury goods. Furniture, paintings, sculpture and silver were as much products of commercial activity as of art, and attuned to profit as much as to aesthetics. In the eighteenth century, culture itself was becoming commodified.[43] If we are to examine business strategies then we need to work not on the exceptional examples of silver which survive, representing the particular and the unusual, but on the typical and the usual. The only place where we can see such a full picture is in the records of income and expenditure kept by a business.

ACCOUNTING FOR BUSINESS

Of all the books kept by the tradesman, for stock, invoices, receipts, sales and letters, and advertised for sale by stationers like Honour Chassereau, it was the ledgers which were the most important (fig. 6). They represent the end of the accounting procedure 'wherein all other books meet'.[44] Daniel Defoe called them the register of the tradesman's estate, wherein all he has 'in the world must be found in these . . . articles'.[45] While these records are essential to business, it does not mean that they were neccessarily always kept or maintained, The London goldsmith Joseph Brasbridge confessed in his autobiography of 1824, that his accounts of 'profit and loss' had been 'so elaborately specific, so adroitly balanced' that he 'could never make out a simple bill of parcels by it'. As a result the only entry he made in them was after he had given up his effects to his creditors.[46] If accounts were kept and did survive, then they were often to meet their end at the hand of a librarian or archivist

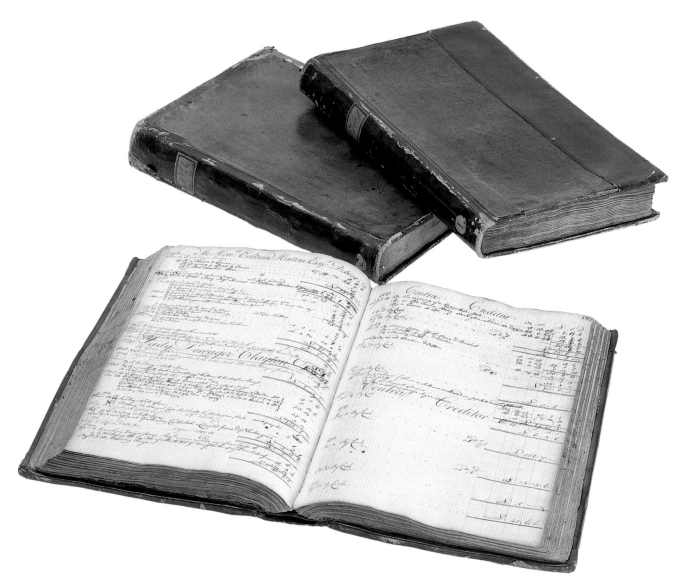

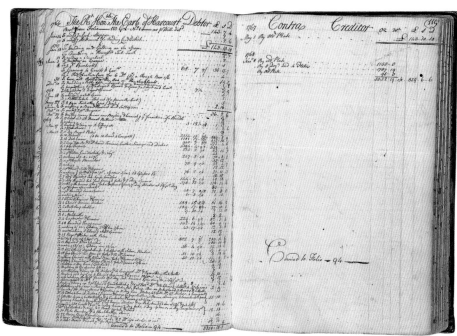

Fig. 7. Three of the Garrard Gentlemen's Ledgers. Victoria & Albert Museum, London

Fig. 8. Page from one of the Gentlemen's Ledgers, or customer accounts, open at the Earl of Harcourt's account, 1766–69: orders bought on the left, payments made on the right. Victoria & Albert Museum, London

who, in accordance with the value systems which prevailed until quite recently, rated politics above business and jettisoned bills and account books in favour of letters of state. The result is that we have few business papers, and those that do survive tend to be fragmentary, relating to an odd couple of years here, a day book there, with a few crumpled sheets of undated calculations tucked inside. From these one can only gain a glimpse, not a complete overview.

THE GARRARD LEDGERS

The unique eighteenth-century exception, in the field of silver, to this dismal history of disdain and destruction, is the Garrard Ledgers, accounts relating to the firm of Garrard the goldsmiths and jewellers. Founded in 1735 by George Wickes, the business developed via a series of partnerships until 1802, when successive Garrards ran the business until 1946, when Sebastian Henry Garrard died, leaving no sons to continue it.[47] The ledgers provide an unparalleled opportunity for investigating the goldsmiths' trade in London through the experience of one firm. The ledgers up to 1818 comprise twenty books of customers' accounts, called 'Gentlemen's Ledgers', which run from the foundation of the business in 1735, and two Workmen's Ledgers covering the periods 1766–70 and 1793–99, as well as a few cash, stock and supply books (fig. 7).[48]

It is fortunate that John Parker and Edward Wakelin, the owners of the business between 1760 and 1776, stuck closely to the wording of their partnership contract in which they promised to

> enter and set down proper Books, an Account of all Buyings, Sales, Receipts and Payments, and of all Cash, Goods, Notes, Debts and other Stock of and Belonging . . . to their joint Trade with all necessary Circumstances of Persons, Names their additions and Places of Residences.[49]

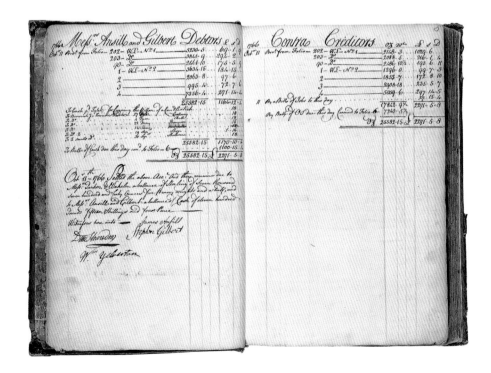

Fig. 9. Page from the Workmen's Ledger, or sub-contractors' accounts, open at p. 71 for Ansill and Gilbert, 1769: orders paid for on the left, orders supplied on the right. This shows the annual making up of books signed by Ansill and Gilbert, and their shop boys Flowerdew and Yelverton. Victoria & Albert Museum, London

For the five years from 1766 to 1770, both Gentlemen's Ledgers, the customer accounts (fig. 8), the Workmen's Ledgers and the accounts of those men and women who supplied the orders (fig. 9), survive. It is in these books 'where every person buying or selling to the tradesman has his account; which is in short, a register . . . [where] all books mentioned before centre, and are as it were, are copied and repeated'.[50] This uniquely complementary set of accounts means that we can recreate all that was bought and sold during this period, providing that much-needed 'overview' to assess glimpses of other businesses.

We are fortunate, too, that the partners clearly took exemplary care in the writing up and keeping of these large, heavy, leather-bound volumes. Their format accords with Malachy Postlethwayte's advice that

> to methodize every distinct act in a peculiar book, two pages are required, opposite each other, that on the left hand serving for the debtor side, the other for that of the creditor, and each article consists of five parts, viz: the date, the person whom we credit, or are credited by, the thing for which we are indebted or credited, the page where such counterpart is found and the sum or amount of the article so posted in the ledger.[51]

PATTERNS OF TRADE: 1760–1776

The picture that emerges from these combined accounts, covering the period 1766 to 1770, and described in detail in chapter 3, is radically different from that which has been created and bequeathed to us by the early historians of silver. The difference is one of emphasis, as we move from the particular and the exceptional, in terms of both objects and individuals, to the general and typical. The past is not a foreign country when we look at Parker and Wakelin's business but one that turns out to be remarkably familiar. The bulk of their business lay less in the supply of magnificently wrought individual pieces of silver, of the kind admired and treasured today in museums, but more in a combination of supplying standardized wrought goods and offering mending and maintenance services. Silver commissioned to new designs by customers, highlighted in public and private collections, accounted for proportionately less and less over time in comparison with stock designs, and silver sold 'ready-made' over the counter.

Sales of silver were complemented by selling jewellery, which because of its delicacy was exempt from assay and is hence unidentifiable in the object record. There is no jewellery in any public collection which can, therefore, be connected with Parker and Wakelin's partnership. Yet the accounts reveal the sale of elaborate diamond, ruby and amethyst rings for gifts, gold bands for marriage and mourning rings to commemorate the dead. A diamond-cluster ring could be bought for £30, comparable to the purchase of a silver bread basket of 47 troy oz, or four silver festoon salts with spoons; £3 6s. would be enough to buy a gold stock buckle or a pair of mocoa agate sleeve buttons and would cover the setting of a picture under crystal for a watch. The sum of £2 2s. would pay for seven paste-stay buttons, or a neat pierced-silver fish trowel. The success of a business lay in its ability to satisfy customer demand for novelty and variety.

THE GOLDSMITHS' NETWORK:
'HANDS THAT EXCEL IN EVERY BRANCH'

Both customers' and workmen's ledgers reveal the importance of networks and the countless interconnections between business and social life. Business was as much about sustaining relationships between people as it was about buying and selling. Success in business was, for the most part, less about the achievements of particular individuals and more about how individuals worked together. The Workmen's Ledger reveals the names of 75 subcontractors. Some supplied particular types of object, such as tureens or spoons, others supplied specialized skills like piercing, gilding or engraving. Many lived and worked close to Parker and Wakelin's retail shop in Panton Street, just off the Haymarket, in the City of Westminster. Others operated from the City of London, in the environs of the Assay Office. Here we see reflected the increasing division between retailing and manufacturing, and the changing economic

Fig. 10. Cup and cover, supplied by Parker and Wakelin. Presented by the East India Company to Richard Earl Howe, Treasurer of the Navy 1765 to 1770; 1766. Silver (London); height 32 cm. Private collection

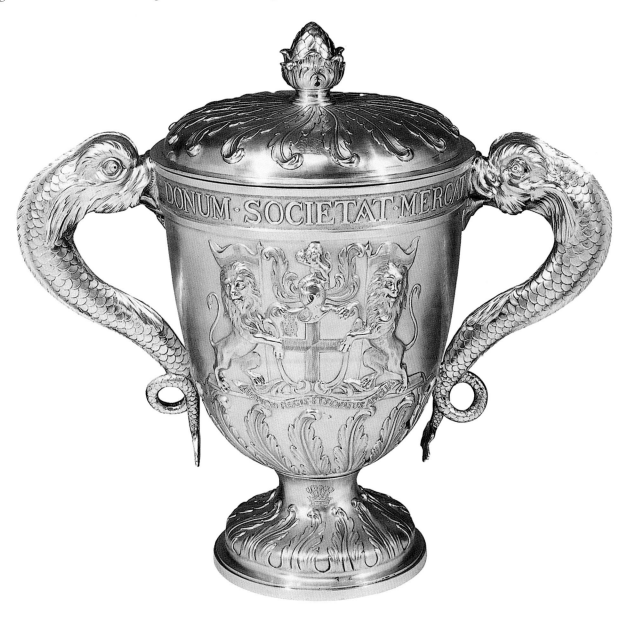

geography of Greater London. The subcontracting network spread beyond London to Birmingham and Sheffield, where the new plated wares could be bought in large orders at attractive trade discounts.

Subcontracting was not restricted to silver but extended to jewellers, watchmakers and enamellers, as well as basketmakers who wickered the handles of

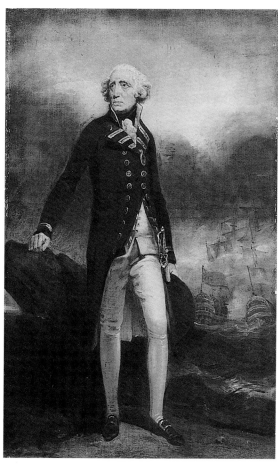

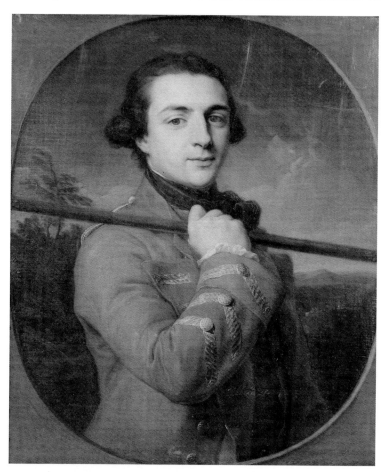

Fig. 11. *Richard Howe, 1st Earl Howe*, by Henry Singleton; before 1799. Oil on canvas; 56.5 × 39.4 cm. National Portrait Gallery, London

Fig. 12. *Augustus Henry Fitzroy, 3rd Duke of Grafton* (1735–1811), by Pompeo Batoni (1708–87); 1762. Oil on canvas; 76.2 × 61 cm. National Portrait Gallery, London

Fig. 13. *Wakefield Lodge, Seat of the Duke of Grafton*. Engraving published 1774. Suffolk County Council, Libraries and Heritage

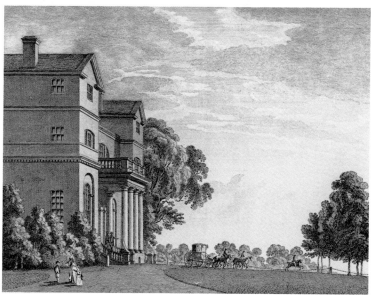

coffee pots, and trunk and chest makers who supplied the finest morocco-leather cases, tortoiseshell inlaid tea chests and rough wooden packing cases. The system of subcontracting was so effective that Parker and Wakelin did not have to make a thing, but they did have to organize, supervise and maintain a complex system of control and coordination which is examined below (chapters 4, 5, 6). In the interdependent world of luxury trades in London even a single object passed through several pairs of hands between the date of its order and its receipt by the customer; networks of supply were linked and several retailers might share suppliers.

PATRONAGE: 'THE GREAT CUSTOMERS FOR PLATE'

The 275 names in Parker and Wakelin's Gentlemen's Ledger are predominantly those of the wealthy elite, and include some of the most prestigious titled families of the time, including six dukes, twenty-four earls, eight viscounts, sixteen lords and nineteen baronets. Royalty was represented by the Duke of Cumberland and by William Henry, Duke of Gloucester, who bought a 'fine soy frame' and a gilded candlestick. The Bishops of Winchester and Exeter appear, as well as Frederick Cornwallis, Archbishop of Canterbury. In 1766 the East India Company went to Parker and Wakelin for a splendid cup to present to Richard, Earl Howe, then Treasurer of the Navy (figs 10, 11). When, in 1768, the urbane and witty Lord Chesterfield ordered a magnificent tea vase from Parker and Wakelin he was seventy-four years old. He had seen political action as British Ambassador to the Hague, as Lord Lieutenant of Ireland and as Secretary of State in Newcastle's ministry. While the Duke of Grafton was buying his bottle tickets from Panton Street, in 1769, he was in the process of a rather public divorce, and was Prime Minister of England (fig. 12). These titled customers were drawn from the top 400 families of society in the mid-eighteenth century. They all possessed great houses which served as centres of social and political influence (fig. 13), and engaged in the ritual of the 'London Season'. Their income averaged about £10,000 per year, and their combined estates totalled some six million acres, one fifth of the cultivated area of England (chapter 7).

These titled customers were joined by the more recently rich. Joseph Gulston, having inherited over £250,000 from his father, a successful loan contractor, was busy spending it on books and prints, and jewellery bought from Parker and Wakelin for his equally spendthrift new wife. The Martin brothers, bankers in the City, bought tea spoons, while the formidable Mrs Elizabeth Montagu, when not patronising Matthew Boulton for her silver, bought from Parker and Wakelin at Panton Street. They formed part of the small group that constituted the fount of norms and values, yet they had their own subdivisions, and their buying patterns cannot be explained adequately by any single simplistic stereotype. Distinctive strategies of purchase and payment emerge from Parker and Wakelin's ledgers. They were not necessarily constant and changed according to time of life, social position and aspiration. Some had their own ideas about how they furnished their town and country homes, and others, as Josiah Wedgwood noted, took the advice of their architects.

Parker and Wakelin's customers were a source of the new design ideas implemented by the firm. Customers supplied designs via existing silver that they wanted copied, both old and new, and especially fashionable imported French silver. They provided a means of access to two-dimensional patterns, via prints and drawings, and connected the Panton Street business with some

of the most celebrated designers of the day, including the architect William Chambers (1723–96), and later John Flaxman (1755–1826). Although the ledgers only hint at this type of communication in an abbreviated business shorthand, letters, diaries and drawings from customers and other goldsmiths, as well as objects, can help us flesh-out the creative process (chapter 8). In a trade characterized by the sharing of workmen and skills, designs passed swiftly between customers, retailers and makers, in a luxury economy that depended more on copying and adaptation than on completely new invention.

While much of what happened between Parker and Wakelin and their customers must have been common throughout the luxury trades, particular patterns emerge which indicate the creation and maintenance of a distinct design profile. One of the most striking characteristics of Parker and Wakelin's trade is how little silver they supplied in the neo-classical 'Adam' style. While Thomas Heming, the royal goldsmith at the King's Arms in Bond Street, can be associated with a great quantity of Adam-designed plate, such as that supplied to Sir Watkin Williams-Wynn, Parker and Wakelin appear to have attracted customers who preferred the heavier, French style of neo-classicism advocated by Chambers. The firm's style was 'in fashion', but 'not above it'.[52] It was 'perfectly in taste, tho' not so much to the glare of taste'.[53] It was not in the avant-garde. The eighteenth-century observer was sensitive to subtle degrees of taste and fashionability which we tend to overlook. Yet to focus solely on these icons of design would be to misrepresent the broader character of a business which included stock designs made for account customers and ready-made for the retail shop. New design elements from expensive commissions were swiftly edited into cheaper versions.

CONSPICUOUS CONSUMPTION: DIPLOMACY, DINING AND THE DOMESTIC INTERIOR

In the growing culture of 'politeness' which characterized the eighteenth century, it was important to be seen to own the right 'goods' and to use the right language – verbal, written and visual. Polite taste was about sociability, it had to be observed at work to be appreciated. The ownership of silverwares helped define one's status, silverwares were on the checklist of essentials for the wealthy. In a poem by Mary Barber, of 1734, the defining goods of the rich include fine clothes and jewels, paintings, furniture, silver, china and a coach and six.[54] In Gay's play *Polly*, a sequel to the *Beggar's Opera*, the frivolous character of Ducat explains that in most of his expenses he is guided by polite taste: he buys books, has a stable of horses, buys plate, jewels and pictures.[55] Of all these consumables silver took centre stage. In the hierachy of goods, silverwares came top. In 1771 Lord Darnley paid Joshua Reynolds £33 for his portrait, but spent twice as much on a new set of table cutlery from Parker and Wakelin, and seven times more on an enamelled repeating-watch.[56] Sir Watkin Williams-Wynn, the wealthiest commoner in England, spent more on plate than paintings for his new house in St James's Square in the 1770s.[57] When the editor of the magazine *Connoisseur* wrote in 1914 that '. . . the time cannot be far distant when silver will rival in price a picture, a piece of Chippendale furniture, or a choice porcelain vase',[58] he was not aware that in the not so distant past, it had cost more.

If politeness needed to be displayed, and it was a distinction that needed to be learnt, then nowhere was this more evident than at the dining table, a prime site that bridged private and public arenas of consumption. The functional necessities of eating could be embellished to give an opportunity to

show off wealth and taste. Elizabeth Montagu argued that 'nothing expresses such affluence as when the richest and most elegant things administer to a Person's ordinary occasions, and where there is no intended ostentation'.[59] The importance of the table was recognized at an international, national, local and family level. Diplomats were issued with perquisite plate to impress host countries with Britain's wealth and taste. It was around the dinner table, after all, where most diplomacy took place.[60] Parker and Wakelin's supply of diplomatic plate, including that made for Sir Andrew Mitchell in Berlin (1766), and Lord Harcourt in Paris (1769), means that we can recapture their now divided and lost glory. At home, royal and political events were punctuated, even defined, by splendid dinners that, to impress, relied as much on the quality and type of the silverware as on the amount and quality of food.

At a national level important events involved the parade of silver, and via the growing power of the press a wider audience than ever before shared in the experience. While old-fashioned weight still impressed, there was a growing sense that it had to be 'in fashion'. For the Lord Mayor's celebration banquet in honour of George III's coronation, staged in 1761, 'the City exchanged' with Thomas Gilpin, a retailing goldsmith in Serle Street, Lincoln's Inn, 'their old plate for his new', for the King's table 'to do honour to this grand occasion'.[61] The whole point of the event was a competitively symbolic display of wealth that operated at several different but interrelated levels. First and foremost, the dining plate represented both the power of the Corporation, which had not always seen eye to eye with the monarchy, and its ability to show the appropriate respect for the new king. When King Christian VII of Denmark, who had married an English princess, visited Britain in 1766, the newspapers were quick to note that a dinner laid on at the Queen's Palace was embellished with 'ten dozen gadrooned plates' and 'ten tureens of various size, twelve candlesticks and the same number of waiters, five dozen dessert knives and forks'.

A silver dinner service was a crucial indicator of a family's fortune. It represented its wealth and standing, and the arms engraved upon it identified it with the present head of the dynasty. The acquisition and maintenance of such services were integral to the duties of a family, and where inventories and accounts do survive we can see the time and effort that went into their care and development.

The anguish which Lady Mary Coke felt when her share of the family dining plate was appropriated by her brother-in-law, Lord Leicester, in 1767, is recorded in her diary. She felt affronted that she had been left,

> such a quantity of broken and useless stuff . . . Of near four dozen of knives, forks, etc., not one dozen that is not broke in pieces . . . I have but one pair of sauceboats, and twelve saltsellers, all the oldest things I ever saw.[62]

As a repository of the family's history, and record of its standing, she decided to keep,

> everything . . . that is possible, that I may obey my Father's will & those things that are entirely broke, I have order'd shou'd be made again with the same silver, & my father's Arms put upon them, this will be expensive, but I think it right, & therefore I will do it.[63]

She was in a sense symbolically re-building the family's lineage, for in use it was more powerful, it actively connected the past with the present, and was also a stake in the future. Yet as Lady Mary's experience suggests,

It is not often that one has the opportunity of seeing anything so complete as an old English silver dinner set, . . . in course of time family divisions take place, and in dividing their treasures one takes a soup tureen, another a pair of entrée dishes, another a pair of sauce tureens. The result is, they become scattered all over the globe.[64]

With the aid of Parker and Wakelin's ledgers, complemented by household accounts and inventories, we can rebuild these symbols of family power and influence (chapter 9).

It is within these household contexts that we can find the decisions behind purchase and use, and restore meaning to silver. At the beginning of the eighteenth century silver had been a relatively stable indicator of wealth; from the 1750s and 1760s it had to compete with a much larger range of luxury goods. In the past silverwares had been continually melted down and re-fashioned into new styles; but from the mid-eighteenth century consumers were more likely to spend the cash retrieved on sets of china, japanned wares and Sheffield plate. Elements of tradition had to cohabit with new patterns of behaviour and use. Depending on their fortunes, standing and aspirations consumers had to negotiate between the sometimes conflicting forces of tradition and modernity.

II

The Parker and Wakelin Partnership

Firm Foundations:
'The King's Arms' 1735–60

Make and Sell all Sorts of Jewells and curious Work in Gold and
Silver, after ye Best and Newest fashion at Reasonable Prices
Extract from George Wickes's first trade card, 1735

In 1760 John Parker (1734–96) and Edward Wakelin (1718–84) took over a
business with which they had both been closely associated. Both knew and
had worked for the founder, George Wickes (1698–1761). At his retirement,
along with that of his partner Samuel Netherton (1723–84), he left them a
successful and prestigious business. Its character had already been established.
Over 250 customers were on their books, including the Dukes of Devonshire
and Chandos, the Duchess of Norfolk, the Marquess of Granby and the Earls
of Egmont, Jersey, Kildare, Scarborough and Winchelsea. The business had
supplied Frederick Louis, Prince of Wales, with silver made to the designs of
William Kent, and Wickes had provided a magnificent dinner service in the
French style to the Duke of Leinster in 1745–47.[1] Their clientele must have
been as large and important as that of Paul de Lamerie (1688–1751), who is
thought to have run one of the largest goldsmith's shops in London at the
time.

GEORGE WICKES: FOUNDER OF THE BUSINESS

George Wickes had been sent to London from Suffolk in 1712 to be appren-
ticed to the established goldsmith Samuel Wastell in Leadenhall Street. Wickes
remained with his master after the completion of his apprenticeship in 1720,
working as his assistant. The mania for speculation triggered by the South Sea
Company's project for more equitable investment in the public debt in 1719,
and the bursting of the 'South Sea Bubble' the following year, created a worry-
ingly unstable economic climate in which to venture into business. All the
more reason to wait for a couple of years while the international financial cri-
sis calmed.

 In 1722 Wickes married Alder Phelps, whose mother was a member of a
wealthy merchant family, and registered his own mark at the Assay Office,
giving his address as Threadneedle Street. The lack of opportunity to set up in
partnership with his master, and access to funds made available via his wife's
dowry may have persuaded him to set up on his own. We know that at this
time Wickes was supplying other London goldsmiths with silver, such as John
Folkingham, a retailer near the Royal Exchange.[2] Wickes, like other business-
men, must have been relieved that the new king, George I who succeeded his
father in 1727, was persuaded by his ministers and wife, Queen Caroline, to

keep Robert Walpole in office, whose cautious policies of peace and economy promoted trade.[3] By *c.* 1730 Wickes had joined John Craig, a jeweller in Norris Street, in a move that took him from the older goldsmithing area of the City to the increasingly fashionable West End.[4]

'THE KING'S ARMS' IN PANTON STREET

1735 was an important year for Wickes, as he registered a new independent mark at Goldsmiths' Hall, signalling his departure from Craig, and leased from Edward Pauncefort a 'corner messuage in St Martin's in the Fields adjoining on the south part . . . the Golden Head' which fronted the Haymarket, and 'on the North side of Panton Street'.[5] The choice of Panton Street was an opportune one for trade. George Wickes must have seen it develop and prosper from his position in Norris Street, and its development typified the expansion of the area. The late Stuart entrepreneur Colonel Thomas Panton, who had accumulated vast wealth from his gambling activities, wisely invested his money in land. One of his earliest purchases, in 1669, was 'a parcel of ground lying at Pikadilly, part of it being two bowling greens facing the Haymarket, the other lying north of the Tennis Court'. The scheme he chose for the street had been recommended by Sir Christopher Wren in 1671, on the grounds that it would divert traffic from the Strand 'by opening a new street from the Haymarket into Leicester fields'.[6] Panton was one of many speculative builders of the time whose object, after acquiring his building lease, was to erect the shell of a building, roofed and floored and usually with the bare internal walls, and sell it on before ground rent became payable.[7] The houses that James Marriott built for Panton conformed to the new post-Great Fire standard, being built of brick, and two rooms deep. The development is clearly visible in Hollar's map of 1676, and described by Strype in 1720 as 'a good open street, inhabited by tradesmen'.[8]

Wickes took over one of these houses, on the north side of Panton Street, 'the second door down from the Haymarket', from a widow, Amy Alexby. The first page of his first account book, dated 24 June 1735, shows that Wickes had laid out just over £353 in turning it into his home and combined retail and workshop.[9] As Adam Smith was to explain later in the century, 'A tradesman in London' was obliged to take 'a whole house in that part of town where his customers live. His shop is upon the ground floor, and he and his family sleep in the garret'.[10] In the *London Evening Post*, 19 June 1735, Wickes advertised that from these premises,

> the King's Arms in Panton-street, the second door from St James's Haymarket, [he would continue] (as the maker) to make and sell all sorts of curious work in gold and silver, jewels and watches after the best and newest fashion, and buys and sells all sorts of second hand plate, jewels and watches.[11]

His trade card proudly announced that he was 'Goldsmith and Jeweller, Silver-Smith to his Royal Highness the Prince of Wales'.[12] This was an impressive achievement for a new business, especially at a time which was considered to be in a period of recession.

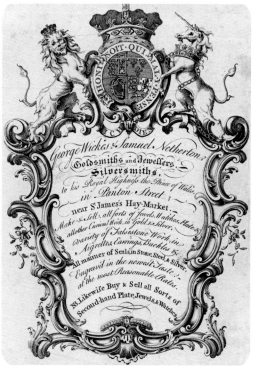

APPRENTICES AND PARTNERSHIP

Two of the seven apprentices Wickes took, Samuel Netherton and John Parker, were to play a crucial role in the future of the business. Samuel Netherton was the son of an undertaker in Fleet Street, who had died before his son's apprenticeship to Wickes in March 1737. The Nethertons originated from Worcestershire, and it is no coincidence that Alder Wickes's family roots, on her father's side, lay in the same county, in the village of Chaceley. After serving his apprenticeship with Wickes, Netherton neither claimed his freedom from the Goldsmiths' Company nor registered his own mark, but became his master's assistant. His handwriting in the business accounts becomes prominent from 1746. Four years later, in 1751, their relationship was formalized with a partnership and the issue of a new trade card (fig. 15). As well as supplying new silver to some of the leading nobility of the day, including that made to the design of William Kent for the Prince of Wales, the partnership also sold the work of other London goldsmiths, like that of their competitor Paul de Lamerie. They probably acquired a tureen from his workshop (fig. 14), at the sale of his stock on his death in 1751, and sold it on second-hand to the Principal of Brasenose College, Oxford, seven years later (fig. 16).

THE NEW PARTNERSHIP

In 1760 both partners retired. Wickes, who was sixty-two, moved back to Suffolk, and Netherton, who was only thirty-seven chose to leave with him, retiring to his native county of Worcester.[13] Their departure from Panton Street made little impact on the running of the business as their successors had long been associated with it – Edward Wakelin as their major supplier from the 1740s (little plate, post 1747, bears Wickes' mark), and John Parker from 1751, the beginning of his apprenticeship to Wickes. Just as Wickes and Netherton had successfully combined the experience of age with the vigour of youth, so did Parker and Wakelin. At the time of signing their partnership contract in 1760, Wakelin was forty-two and Parker twenty-six years old. Their working relationship came close to one of Daniel Defoe's descriptions of the ideal, which he compared with the Roman method of employing two generals to command their armies:

> one of which was to be a young man that, by his vigour and sprightly forwardness, he might keep up the spirits and courage of the soldiers, encourage them to fight, and lead them on by his example: the other an old soldier, that, by his experience in the military affairs, age and counsels, he might a little abate the fire of his colleague, and might not only know how, but when to fight.

In a trade that required at least £500 to set up in business,[14] (and more money than most others for tools, materials, stock and the carrying of customer credit), partnership was a strategy for survival. It was a reasonably successful one, as fewer partnerships appeared as petitioning creditors in bankruptcy cases than individuals in the eighteenth century.[15] It is not surprising that from the 1730s onwards the record of goldsmiths' partnerships grew in number.[16]

If success in business relied on vigour and experience, it also depended on mutual trust and commitment. Defoe drew upon the metaphor of matrimony to convey the importance of these qualities, where business partnership 'is engaged in for better or for worse, till the years expire; there is no breaking it off, at least not easily nor fairly, but all the inconveniences which are to be

Fig. 14. Tureen, by Paul de Lamérie; 1751. Engraved with the arms of Gorges, Lloyd and Sneyd, the donors of the money used to buy it in 1758. Silver (London); height 29.1 cm, width 46 cm. Brasenose College, Oxford

Fig. 15. Trade card of George Wickes and Samuel Netherton; 1751. Etching with engraved lettering; 27.5 × 21.3 cm. British Museum

Fig. 16. Bill for de Lamerie's tureen, sold second hand by Wickes and Netherton to Rev. Dr Yarborough, the Principal of Brasenose; 1758. Brasenose College, Oxford

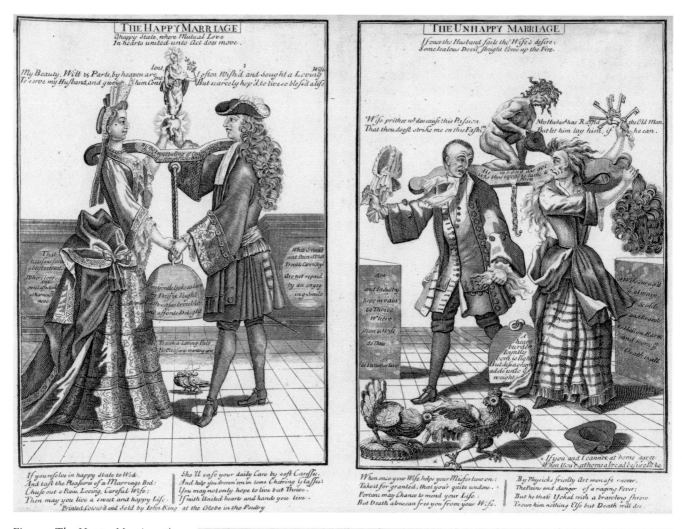

Fig. 17. *The Happy Marriage &
The Unhappy Marriage*, anon.
Printed and sold by John King, at
The Globe in Poultry, London;
c. 1690. British Museum

Fig. 18. Ely Chapel, Holborn;
1772. Engraving; 14.8 × 10.2 cm.
Private collection

feared will follow and stare in your face'. He must surely have been thinking of the popular prints of 'Happy and Unhappy Marriage' when he wrote this (fig. 17). Although Parker and Wakelin came from different social backgrounds, and there was a sixteen year age difference, the success of their business suggests that they were ideally suited for their working 'marriage'; and like the poem in the print, they not only lived but thrived.

EDWARD WAKELIN

Edward Wakelin came from an established Staffordshire family from Abbotts Bromley, which lies some ten miles north of Lichfield. His father, a baker in Uttoxeter, had died in 1729, and this may have prompted Wakelin's apprenticeship to the Huguenot goldsmith, John Hugh Le Sage, at the Golden Cup in Suffolk Street, London, in 1730.[17] Suffolk Street was home to a number of skilled Huguenots, including Megrett, a jeweller; Descharmes, a watchmaker; and Philip Rainaud, a goldsmith.[18] As Le Sage married Judith Descharmes in 1725, personal and business networks were clearly interrelated. Wakelin's master, from the evidence of surviving household accounts, was supplying silverware to wealthy aristocratic families such as the Fitzwalters and the Monsons.[19] As a result the young Wakelin experienced the running of a busy and successful business.

He completed his period of service in June 1737, at the age of nineteen, when his future partner was only three years old.[20] It is likely that Wakelin stayed with Le Sage to gain experience and save money, as Netherton had done with Wickes, and Wickes with Wastell. He would not have been able, according to the Goldsmiths' Company rules, to set up independently until the age of twenty-one. For Wakelin there was no prospect of partnership with his master, whose two sons, Simon and Augustus, followed him in trade.[21] Le Sage turned over his last apprentice, his son Simon, in 1742, although the previous year he had become Subordinate Goldsmith to the King, meaning that he was a plateworker supplying the Royal Goldsmith, Thomas Minors. In 1744–45 John Hugh Le Sage's mark appears on a pair of splendid candelabra, modelled on copies first made by Thomas Germain, the distinguished Parisian goldsmith. It is perhaps not a coincidence that another pair of these candelabra appear in Wickes's ledgers, and were supplied to the Earl of Kildare in 1745 for £154.[22] The unusually high cost of making, at 10s. per ounce, is explained by the complicated casting and skilled chasing. Perhaps Wakelin had made both sets?

WAKELIN AND WICKES

By 1744 all Wickes's former apprentices and those turned over to him had completed their training. It would have been a suitable moment for Wakelin to take over the responsibility for the supply of Wickes's silverware, moving two streets north to Panton Street where Wickes, that same year, had acquired a new workshop, next-door-but-one to the King's Arms, Wickes's home *cum* retail shop.[23] Wakelin lived above this workshop. An account with Wickes, dated November 1747, records '1 months House Rent' of £40 and 'Ballance of Cash Bro^t from a former acct', suggesting that their relationship pre-dated this entry in the ledger.[24]

On 7 May 1748, Wakelin, now thirty years old, married Ann Allen of Holborn, tactfully described in the register as 'aged upwards of twenty-nine years',[25] in the medieval splendour of Ely Chapel, Holborn (fig. 18), and

joined him living in Panton Street.[26] As a 'Mrs Allen' appears in Wickes's ledgers as early as July 1735, only a month after first starting up in business, and was a regular customer thereafter, it is possible that Ann might have been her daughter, and the marriage another example of how business and private life were intimately connected.[27] Their first child, Francis, was born in July 1750, only to die a few days later. John (the future partner of the business) was born a year later, on 29 July 1751.[28] In 1753 a daughter, Elizabeth, arrived, only to die the following year. A second daughter, also christened Elizabeth, was born in 1755, and two years later another son, Edward, was born.[29]

In November 1747 the £400 lease of the workshop, which Wickes had acquired in 1744, was transferred to Wakelin, suggesting a more formalized relationship with the business that involved greater financial security.[30] This may have been made possible by money inherited by his wife from a relative named Edward Allen, named in an executor's account for the same year.[31] In the same month Wakelin registered his first mark at the Assay Office, giving his address as Panton Street. So from this date it is possible to identify work for which he was responsible.

There are many examples to show the high quality of silver marked by Wakelin. One of the earliest surviving pieces bearing his mark is a pair of candlesticks, assayed in 1747, made for John Bourchier whose father owned Beningbrough House in Yorkshire.[32] They appear to have been made to complement an earlier pair, made for his wife's father, Richard Roundell of Hutton Wansley, county York, supplied by Wickes in 1738.[33] Yet Wakelin was also supplying silver for customers other than those of Wickes. Three tea canisters (fig. 19) and a coffee pot of 1747 and marked by Wakelin, bear contemporary armorials of families who do not appear in Wickes's ledgers.[34]

THE WORKING RELATIONSHIP

Two facts help us to understand the nature of the working relationship between Wickes and Wakelin at this time. First, Wakelin entered his own mark in 1747, and not a joint one with Wickes (although their marks are similar, both incorporating gothic initials surmounted by three feathers).[35] Second, a year later, on 7 September 1748, Wakelin claimed his freedom of the Goldsmiths' Company in order to take his first apprentice, James Ansill.[36] By entering his own mark, taking an apprentice in his own name and not becoming a partner, Wakelin had established himself as an independent agent alongside the business in Panton Street. From the evidence of a surviving supply ledger in Wakelin's confident handwriting, covering the period 1747–60, it is possible to build up a picture of what sort of silverware he was supplying to Wickes. The ledger records the delivery of mostly tea and table silver, including waiters, kettles, coffee pots, cream ewers and sugar dishes. For the dining table he provided épergnes, tureens, dishes, sauceboats and candlesticks. One of the most spectacular pieces he supplied to Wickes and Netherton is an épergne and plateau, bearing Wakelin's mark, and assayed in 1755 (fig. 20). It appears in Wickes and Netherton's customer ledger in the 9th Earl of Exeter's account, costing him £338, at an extraordinarily high fashioning charge of 14s. 1d. per troy ounce (well over twice the usual price), accounted for by the complex castings and intricate chasing of the fruits and vines.

Wakelin's supply ledger does not include knives and forks, tea spoons and tongs, buckles, buttons, gem set rings, necklaces and hair ornaments, which we know from the surviving customer accounts were sold. For these and other

Fig. 19. One of set of three tea canisters, by Edward Wakelin; 1747. Silver (London); height 10 cm

Fig. 20. Épergne and plateau, marked by Edward Wakelin, retailed by Wickes and Netherton to the 9th Earl of Exeter (1725–93); 1755. Silver (London); épergne width 53 cm, 246 troy oz; plateau length 64.5 cm, 233 troy oz

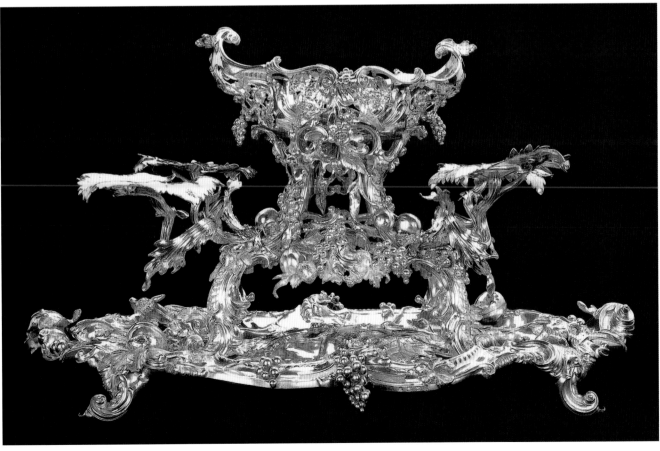

Fig. 21. Invitation to the Goldsmiths' Company, showing specializations within the craft, engraved by A. Kirk and J. Kirk; 1741. 153 × 177 cm. Ashmolean Museum, Oxford

'lighter' goods Wickes must have gone elsewhere, to specialists in flatware, cutlery, smallwares and jewellery. The same ledger also gives details of his employees and the division among them between the unskilled and semi-skilled workshop in Panton Street, and outside subcontractors. It charts the developing relationship between Wickes and Wakelin. But first, it is important to note that as neither a waged journeyman nor a partner, Wakelin continued taking apprentices in his own right whilst supplying Wickes. In 1750 he took his second apprentice, Nathaniel Bray, the son of a diamond cutter in Lothbury, London.[37] On 8 May 1752 he took his third apprentice, Stephen Gilbert.[38] John Arnell was turned over to Wakelin in 1758, having begun his apprenticeship with John Quantock, a candlestick caster, six years before.[39]

As well as these apprentices Wakelin also employed four waged employees who stayed for relatively short periods, from four months to two-and-a-half years. Their terms of payment are recorded in Wakelin's supply ledger to Wickes. Their wages, usually paid on a yearly basis, at a rate of between £5 10s. to £10, suggest they performed unskilled work and were not journeymen. They were probably domestic servants. These employees included, in 1748, Abraham Potts; in 1752, William Farmer; in 1753, William Collipress; and John Griffen who received £12 2s. for '2 Years and 5 Months Wages' in November 1755 when his account was closed. An account for David Edwards was ruled up in the ledger but never filled in. Included in this account of unskilled labour are John Ansill and Stephen Gilbert, who were waged employees between 1746 and 1755 and 1750 and 1752 respectively, before they were apprenticed to Wakelin. The combined workforce reveals that Wakelin was managing a team that grew from three in 1750/51, to six in 1752/53, and then declined in scale over the next six years.

THE SUBCONTRACTORS

The changes in the numbers employed in the Panton Street workshop did not indicate a reduction in the volume of work, as the number of external, skilled subcontractors steadily grew from the period that the supply ledger covers and was maintained as the waged workforce declined. In the same supply ledger are the names of twelve men paid by Wakelin between 1747 and 1760, who by the amount paid, and type of work they executed, appear to have been skilled. It is likely that they were based in their own workshops, and not only worked for Wakelin but also for a number of other manufacturing and retailing goldsmiths. Their accounts reveal that they were not paid by wages but by piece rates. This shift in the character of the workforce suggests a quite deliberate change in manufacturing strategy, which laid the groundwork for the further development of subcontracting after 1760. Wakelin is likely to have moved from manufacturing to management in this process, overseeing making and buying-in ready-made goods.

The different specializations of the subcontractors, which included casting, chasing and polishing, map clearly onto a print of the many skills required by goldsmiths' craft, engraved by A. and J. Kirk in 1741 for an invitation to the Goldsmiths' Company annual feast (fig. 21).[40] The engraving depicts the many interdependent specialisations of the craft. In the centre three men hammer an ingot of silver into flat sheet, prior to raising over a stake to the right, the basic technique for making hollow ware. Above the process of raising are three men at a workbench filing over the wooden pins which act as a support for the silverware while it is worked. Leathers hang below the benches to catch even the smallest scrap of silver (or lemel) which could be recycled. To

An Engraving by 2 Boys

the top-left a man scantily clad, having come from the furnace, knocks out cast buckles and handles from a mould. To his upper-right a turner or spinner works at his foot-powered lathe, while to his right spoon bowls are being punched with a dab. Directly below is a man stretching wire at a drawbench, a device invented in Germany in the mid-sixteenth century and still in use today. Below the wiredrawer is a chaser, using a small-headed hammer and polished-steel punches to compress the surface of the silver to create a decorative finish. He appears to be working on a candlestick and tea kettle, amongst other objects. Below him sits an engraver using a burin to score out the metal, he has a tankard in his hand. At the top-right-hand of the engraving the last phase of production is represented, a footed waiter is being burnished.

From Wakelin's supply ledger it is possible to work out the range of skills that Wakelin was employing that reflect the techniques in the 1741 print. There are only three men mentioned in the ledger whose specialisms are difficult to ascertain, as their entries in the accounts give no clues about the type of work they did. John Woldring was paid for a single 'bill of work' in April 1755. In 1753 Pierce Stirrup was paid for work from July 1753 up to February 1762, and Charles Bichell submitted bills between September 1753 and February 1760.

The first account in Wakelin's supply ledger concerns John Jehner, who received nearly £26 for a bill of work to 2 February 1747. Jehner's bills were paid roughly every three months until the end of December 1752. Like most of the journeymen's accounts, they give little indication of the work he did, but Jehner was paid in silver wire and flatted sheet as well as cash, which suggests that he might have been a box maker by trade.[41] Wire was needed to make hinges, while the flat sheet was cut and soldered together to create the box. It is likely that Jehner would have been responsible for the inkstands that Wakelin supplied to Wickes.

Apart from the working of flat, sheet metal, either by raising or box making, the other most important constructional and decorative technique was

Fig. 22. Candlesticks: one by William Soloman, London 1756; three marked by Parker and Wakelin, London 1763. Silver (London); height 27.3 cm, 126 troy oz 10 dwt

Fig. 23. William Soloman's account with Edward Wakelin 1747–52. Workmen's Ledger. Victoria & Albert Museum, London

casting: the pouring of molten silver into moulds to create handles, spouts, feet and finials, as well as composite forms, like candlesticks. Simple shapes could be made by sand casting, while smaller more elaborate forms could be made via the more complex and skilled lost-wax process. The curvaceous, serpentine and organic modelling that was synonymous with the rococo style, so popular between the 1730s and 1750s, demanded skilled casters, and there is evidence that Wakelin used a number of them. Cornelius Woldring was regularly paid from January 1749 for casting and burnishing. Once the castings had been released from their moulds, their rough surface finish required skilled filing and polishing. His bills were submitted every six months, for sums of around £50 in December and June each year. It is also clear that Wakelin had lent Woldring money, as he was regularly paying £3 a year interest on a 'bond'.

By far the most common cast wares were candlesticks, and the supply of these objects was a specialist trade in its own right. William Soloman, who registered his mark at Goldsmiths' Hall as a plateworker in October 1747, worked for Wakelin from at least February that same year. Soloman specialized in cast work and 'melting'. A candlestick which bears his mark, and was assayed in 1756, reveals a high standard of finish (fig. 22), the casting has been delicately chased-up and polished to exploit the ripple effect. Whether he made it himself or bought it in, his name is associated with quality. Three other candlesticks of the same design were marked by Parker and Wakelin in 1763, and it is likely that Soloman was their supplier.[42] Soloman was paid every six months, with sums varying from £52 in September 1752 to £22 in July 1759, the last payment that was recorded to him (fig. 23). Andrew Killick was paid for supplying candlesticks and for filing and polishing between February 1753 and March 1755.[43] He had been free of the Goldsmiths' Company since 1745, and from 1754 was working from Little Turnstile in Holborn.

According to R. Campbell's advice book of 1747 a skilled journeyman goldsmith could earn 20s. to 30s. a week. This works out at between £24 and £36 for six months work, not far from Soloman's income from Wakelin, although he was probably working for others at the same time. This sum can be compared to the cost a pair of candlesticks to one of the Wickes's clients. George Selwyn paid £29 for a 'fine chased' pair, which graphically illustrates the difference between the income and expenditure of suppliers and purchasers.

We can learn a little more about how casters operated from the evidence given by goldsmiths to the 1773 Parliamentary Enquiry into the running of the assay offices. John Williams, a caster from Wood Street in the City, explained that he cast 'Silver for Silversmiths, from Silver which they deliver to him' but he did 'not cast every person's Silver separately, but mixes them together'.[44] Francis Spilsbury added that 'it is the custom of the Trade to employ casters, who agree to cast the work of such a standard that will pass at Hall', which implies that pre-cast components were bought-in by other goldsmiths, trusting their suppliers to work in sterling standard silver. In this way Wakelin trusted Woldring, Soloman and Killick to provide him with castings that were up to quality.

George Elger was frequently paid in waste from the 'melt of short turnings', which suggests that he worked at a lathe like the one illustrated in the Kirk and Kirk engraving. Turning, Campbell tells us, was 'a very ingenious Business, and brought to great Perfection in this Kingdom'. Turners specialized according to the material they worked in, but those that worked in 'rich materials', earnt more 'than those who work in Wood, and form more necessary Utensils'.

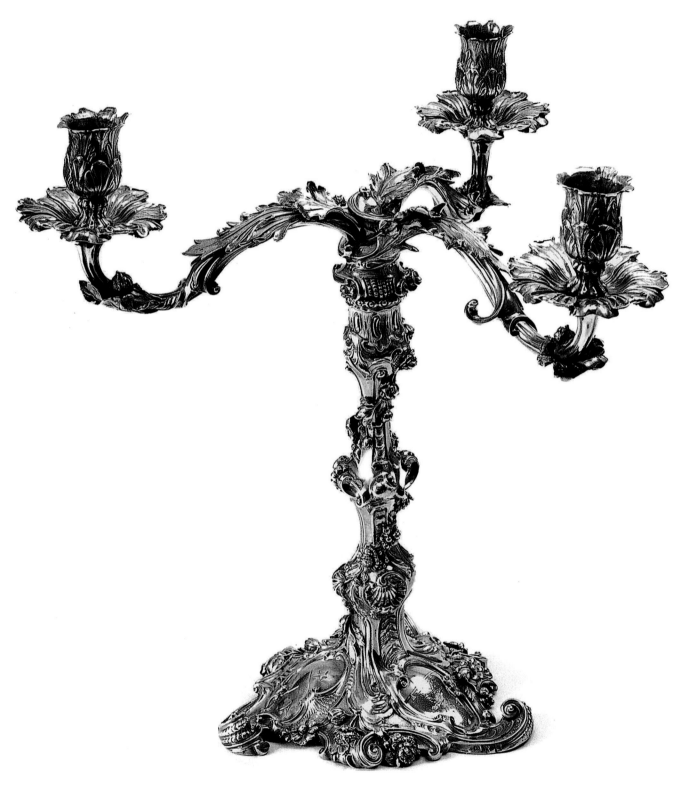

Fig. 24. One of a pair of candelabra, by Edward Wakelin. Part of the Bristol civic plate; 1752. Silver (London); height 40 cm. The Lord Mayor and Corporation of Bristol

Turners produced rod and tube silver, used in the making of hinges, and would have finished off the bases of tankards, bowls and other vessels where the solder that joined base to body had run. They also turned finials and feet. Entries for Elger begin at the same time as the other skilled workmen, in February 1747, and continue until September 1759.

Wakelin, in the 1740s and 1750s, appears to have employed more chasers than any other type of skilled craftsman. This indicates the popularity of the rocaille style, which relied not only, as we have seen, on complex castings and raised forms, but also the rich naturalistic surface effects which could be achieved via chasing. A pair of candelabra of 1752 exemplify the high quality of chasing which he supplied (fig. 24). Work described as 'finely chased' in the ledgers usually translates into high charges for workmanship, reflecting the time and skill required. According to Campbell, chasers needed 'good Eyes . . . a good Genius for Drawing, and ought to be early learned in the principles of that Art'.[45]

The first chaser to appear in Wakelin's supply book was John Fisher, who submitted bills approximately every six to twelve months from February 1747 until 1757. For the year 1755/56 Wickes paid him £31 10s. which suggests that he must have been working for goldsmiths other than Wakelin to make a living. He was paid in cash, silver taken off articles and silver pit tickets, that is, silver season tickets for the theatre.[46] John Christopher Romer had been supplying Wakelin with chased work from at least May 1752 when his account in the ledger begins. We know little about him. He was probably about thirty-seven years old in 1752, and may have been the older brother or cousin of the Norwegian goldsmith Emick Romer, who was to supply Parker and Wakelin with silver in the 1760s.[47] The indentures of two of his apprentices, Edward Norton Storr (1753) and Thomas Storr (1757), the latter the father of the more famous Paul, indicate that Romer's address was in St James's Westminster and that he was a 'Silver Chaser'. This confirms that he was working from his own premises and was not based in Wakelin's workshop.[48]

The final stage of silversmithing is polishing, a skilled occupation in its own right. The highly reflective surface finish, so valued by customers, is the result of a time-consuming process involving the application of abrasives, from coarse trent sand, via pumice and emery to the finest natural soft slate, known as 'water of Ayr stone', and the use of smooth agate-headed polishing tools. There are different polishers for largework and smallwork since the problems involved are different, and an unskilled polisher could ruin a piece of work. From Samuel Paddison's account, which begins in March 1754, it seems that he was a skilled polisher, and his bills were paid quarterly. In December 1756 Elizabeth Paddison began billing Wakelin, presumably on the death of her husband, until 7 October 1760. Given the evidence of the Kirk and Kirk engraving, which shows a woman burnishing, she may not only have run the business but also practised the trade herself.[49] Like button-making, another female-dominated type of work, finishing and burnishing was 'a pretty ingenious business', but 'required no strength'. The earnings of women in the precious-metal trades were lower than those of men in the same occupations.[50]

Although we know that Wickes was selling jewellery, there is no indication of its supply in the Wakelin ledgers, and therefore he is likely to have bought-in from manufacturing jewellers. Netherton, unlike Wickes's first partner, John Craig, was not trained in this separate and equally subdivided craft. Customers expected to have their jewels reset, their seals mounted and miniatures framed. Ladies required rings, necklaces, bracelets, hair ornaments and strands of pearls. Buckles in silver, gold and steel, plain or set with paste or precious stones were needed for stocks, breeches, waistcoats, jackets and shoes. Gentlemen demanded cane heads and sword hilts.

During the 1750s then, Wakelin controlled a sizeable workforce, all of whom were, or were training to be, working goldsmiths or related craftsmen. The development of the relationship between Wakelin and Wickes can be seen

Fig. 25. Second Trade Card of John Parker and Edward Wakelin; 1760. A new design replacing the first one that had been based on Wickes and Netherton's old plate. Etching with engraved lettering; 27.5 × 21.3 cm. Westminster City Archives

in terms of the steadily growing amount of wrought plate that Wakelin supplied each year, as recorded in the front of his supply ledger. In 1748 he supplied 11,271 troy oz of silver, charging £801 for labour to work it up; in 1752 he supplied 17,807 troy oz and charged £1,442; in 1756 he supplied 24,584 troy oz and charged £2,562; and in 1759, on the eve of his partnership with Parker, he supplied 33,141 troy oz and charged £2,717. The large amount of silver and cash owing to each party suggests a high level of trust and interdependence. To give an impression of how much silver these weights represented we should remember that ambassadors were allowed 5,893 troy oz of white and 1,066 troy oz of gilt plate, so the 1759 weight Wakelin made up was roughly equal to five full ambassadorial dinner services.

The retirement of Wickes and Netherton in 1760 offered the opportunity for the forty-two-year-old Wakelin to consolidate his relationship with the Panton Street business. On 29 September 1760 he signed a partnership contract with John Parker, who although sixteen years his junior appears to have taken the lead in the business. A trade card announces 'John Parker and Edward Wakelin Goldsmiths and Jewellers' (fig. 25).

The last entry in Wakelin's supply account with Wickes and Netherton records 'a Moiety of the Stock in trade of Messrs Wickes and Netherton (of £2,700) transfer'd to me this 11th October 1760'.[51] The moiety was purchased with the £1,500 owing to Wakelin for his services and a loan of £1,100 from Wickes and Netherton. The further £100 required by Wakelin for his half share of £2,700 joint capital was loaned to him by Samuel Netherton.[52] The lending of substantial sums of money between partnerships helped tie past and present owners of the business together. Edward Wakelin was paying £5 a year interest on Netherton's loan until 1770, while Wakelin drew £25 a year interest on his loan of £1,400 to Wakelin and Tayler until 1780.

In 1760 Wakelin moved out of the old workshop next door-but-one to the King's Arms and moved into another of Wickes's premises in Panton Street, further down on the corner of Oxendon Street, for which he paid him £20 a year rent.[53] The premises had been built just a couple of years after the King's Arms; from a schedule dated 1695 it is described as being a 'double messuage . . . containing 24 ft to Panton Street and 40ft to Oxendon Street'.[54] A lease for the premises, dated Midsummer 1805, provides a detailed description of the rooms, layout and decoration, beginning at the top of the house.[55] It is unlikely that it would have changed since Wakelin's occupation.

> *Garrets* three Dormer windows three casements nine iron saddle bars inside window shutters the rooms skirted round. *Two pair of Stairs* Five Sash Windows glazed with Crown Glass inside half shutters two portland chimney pieces with Galley Tiles complete The rooms wainscotted chair high with Cornice & Facia round the top a Closet by the *Back Room* Chimney with shelves and Cloak pins *Stair Case* wainscotted Chair high *Bed chamber One pair of Stairs* The Room wainscotted up to the top Two sash Windows with Crown Glass & Portland Chimney with Galley Tiles and Ornamented wood work complete a Closet by the Chimney with shelves and Cloak pins *Dining Room* two sash windows with Crown Glass the Room wainscotted round wth Dado and Cornice a Marble chimney piece with Galley Tiles complete and ornamented woodwork a Sash window and Crown Glass on the *Stair Case and*

Ditto wainscotted with Dado, outside shutters to all the Windows in the one pair of Stairs.

This description suggests a modestly elegant home that got progressively grander as one descended from the garret: the wainscotting growing from chair to full height and the carving of cornice and chimney piece moving from plain to ornamental. Only the ground floor and basement had changed between Wakelin's occupation and the inventory when, in 1779, they were converted to workshops.

JOHN PARKER

If Edward Wakelin brought a practical knowledge of silversmithing and the skills of workshop management to the business, then John Parker brought connections with the gentry, business acumen, financial resources and retailing experience. The second son of Thomas Parker (1686–1751) and his wife Mary Jeffes (1707–38) John was a member of an old Worcestershire gentry family. Their 'ancient residence', the White House at Longdon, had been in the family since at least 1589, and stood in over 150 acres of land (fig. 26).[56] The Hall is approached from the Gloucester to Upton Road by a tree planted drive, clearly visible in a plan of 1775 drawn up by Worcester surveyor, George Young. The White House, painted by John Parker's grand daughter Lady Leighton in the nineteenth century, reveals a substantial country residence that had remained largely unchanged since the early-eighteenth century (fig. 27).[57]

John was baptized on 1 November 1734, two years after his brother Thomas. Other surviving children of Thomas and Mary Parker's marriage were four daughters, Mary (1726), Eleanor (1729), Elizabeth (1731) and Ann (1736). It seems likely that Mary died in 1738 as a result of complications connected with the birth of their third son Benjamin born the previous year. On his father's death, on 13 March 1750, John was left estates in Compton Abdale, Compton, Millington and Overhampton, while his elder brother Thomas inherited the family estate at Longdon.[58] According to the wording on the memorial erected by John Parker in Longdon church, Thomas Parker had been 'a religious observer of the duties incumbent on a good Christian, among which a liberal and unaffected Charity to the distressed was one of the most eminent' (fig. 66). With characteristic economy, which his son John seems to have inherited, he asked that his funeral 'may not exceed twenty pounds'.[59]

The family fortune, however, was not sufficient to provide financial independence for the two sons. It must have been with the consent of their guardian and kinsman, William Parker, that Thomas became a lawyer and John joined George Wickes as his last apprentice in 1751. In England, unlike France, there was little social stigma connected with trade. Voltaire admired England where, 'the younger son of a Peer of the Realm does not not look down on trade'. Lord Chesterfield continually drew upon analogies with trade when advising his son on the arts of being a gentleman: he underwent an apprenticeship, his vices and virtues were cast up like accounts, and good manners were described as 'the settled medium of social [life], as specie is of commercial life'.[60]

John Parker paid a rather high premium of £50 for his apprenticeship, which suggests, if we believe Campbell, that he was to be trained in shopkeeping skills.[61] Apprentices destined for retailing were expected to pay more for their premiums in the goldsmiths' trade, 'often £50 and upwards, because this

Business is esteemed genteel, and, to set him up, his Cash ought to surpass his Stock of Plate'. Working silversmiths usually paid £20. Parker's apprenticeship conformed to a wider pattern of gentleman younger sons going into trade, their ability to underwrite the start-up costs of apprenticeship and subsequent demands for capital were crucial.[62] There were many other goldsmiths in London at this time whose fathers had been gentlemen: Thomas Chawner, whose family came from Derbyshire; Dru Drury, whose grandfather hailed from Bedford, who followed his father into the goldsmiths' trade; and Robert Albion Cox, who became one of London's leading refiners, was the son of a gentleman from Somerset.[63]

John Parker's decision to join Wickes must have been partly motivated by the fact that his second cousin, Samuel Netherton, was already Wickes's partner. Not only was Parker related to Netherton but the land at Longdon adjoined that of Alder, George Wickes's wife, at Chaceley. It is likely that Parker would have been trained in the arts of shopkeeping, that is 'shewing patterns, taking orders and settling accounts'.[64] The instances of his handwriting in the ledgers increase from the mid-1750s, and the surviving ledgers from the 1760s to 1776 are largely in his steady hand. Book keeping was a crucial skill and the key to the good management of any business, but especially that of the goldsmith. By the completion of his apprenticeship in 1758 Parker was amply trained to take over the management of the King's Arms in Panton Street.

In order to raise money for his share of the joint capital Parker did not (unlike Wakelin) need to pursue a loan but sold his 343 acre estate at Compton for £1,500.[65] Parker moved into Wickes's house-*cum*-retail shop. The premises are described in detail in the partnership contract of 1760:

> On the front of the house, the coving covered with lead – The Kings Arms and Feathers – the painted cloth on the said coving – all the sashes in the front of the shop, with the presses, counters, drawers, shew glasses and looking glasses, and all other things as they are now fixed in the shop. In the parlor, behind the shop, the closet with shelves; the marble chimney piece and slab, and outside shutters to the windows – in the kitchen, a double closet, and all the shelves and dressers – in the fore room even with the kitchen, all the sashes, shelves, two closets and a bottle rack – in the dining room a marble chimney piece set with gally tiles, and slab, and marble hearth – in the back marble chimney pieces, a marble slab, the chimney set with gally tiles – two pair of stairs; the rooms wainscotted up to the ceiling, shutters to the fore windows – in the garret, a large sash door, which is usually put up in winter. Outside shutters to the dining room windows.

A policy taken out by John Parker with Hand-in-Hand Insurance in 1781, describes the premises as being constructed of brick with four storeys, each with an area of 619 feet, 32 feet 6 inches by 19 feet, the latter being the street frontage, with a single-storey counting house assessed separately at £25.[66] The inclusion of presses, counters, drawers, shew and looking glasses, and the absence of a workshop confirm that the premises, by this date, were for retail rather than manufacture. The presses were large cupboards, glazed with open sides which might cover a whole wall, as in the shop depicted on Phillips Garden's shop bill (fig. 28).

The drawers for small items, like watches and small toys, could be taken out and laid on the counter, as a detail from an engraving of the interior of a

Fig. 27. The White House, Longdon, by Lady Leighton; *c.* 1860. Watercolour; 11.5 × 25.5 cm. Private collection

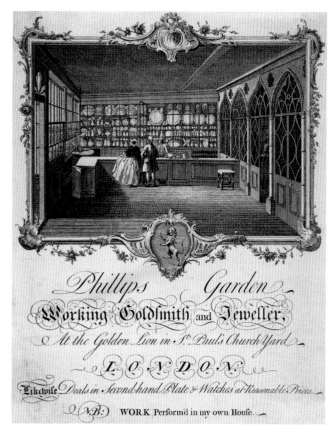

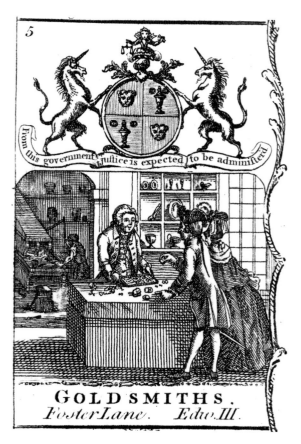

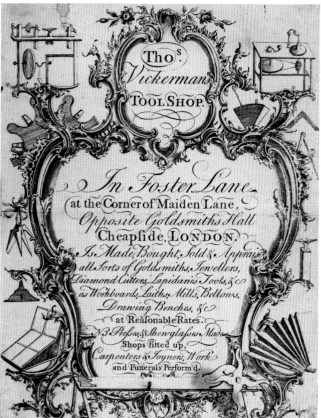

Fig. 28. Trade Card of Phillips Garden, attributed to Francis Garden; *c*. 1750s. Etching and with engraved lettering; 27.5 × 21.3 cm. British Museum

Fig. 29. Interior of a goldsmith's shop, detail from *The Twelve Superior Companies of the City of London*, by Carrington Bowles; 1777. Engraving; height 6 cm. Guildhall Library, Corporation of London

Fig. 30. Trade Card of Thomas Vickerman, by J. Kirk; *c*. 1760, showing a glazed showcase to bottom left, a wire drawing bench to bottom right, and a lathe above. Etching with engraved lettering; 27.5 × 21.3 cm. British Museum

goldsmith's shop of 1777 reveals (fig. 29). The glass display cases were put up in a window or placed upright like a cabinet. The engraved shop bill of Thomas Vickerman, a tool supplier to the goldsmithing and jewellery trades in Foster Lane, shows a small tabletop showcase to the bottom left (fig. 30).[67] Henry Ellis, a goldsmith and jeweller in Exeter, explained that 'a horizontal showcase filled the bottom of the window, which held my gold chains, seals and keys'.[68] Carl Philip Moritz admired the care of London shopkeepers in displaying 'precious objects – all can be seen advantageously displayed behind plate glass windows. There is no lack of onlookers standing stock still in the middle of the street . . . to admire some ingenious novelty'.[69] The arts of display were crucial to the shopkeeper, for the attraction of the window was a way of luring potential customers inside. As the retailing goldsmith Joseph Brasbridge observed: 'Only get people to come to your shop, and when there, you can easily convince them that they cannot go to a better . . . and you will always be sure of customers.'[70]

Parker's accounts of 1766 reveal that he was not only refurbishing his home but also buying new clothing, including a suit for himself from Blittenberg the tailor. These expenses were in preparation for his marriage to thirty-six-year-old Mary Watson, the daughter of a wealthy fishmonger of Thames Street in London, who had left her £2,000 on his death in 1753. They were married at her mother's church in Camberwell (fig. 31) on 17 June 1766. A month after the wedding Parker entered thirty guineas in his account for cash 'pd [paid] Cotes the painter' for a pair of portraits of himself and his wife, by the fashionable London artist Francis Cotes (1726–70) (figs 32, 33), the only serious rival to Gainsborough and Reynolds, who had a studio in Cavendish Square, only ten minutes walk from the Panton Street premises.

THE PARTNERSHIP CONTRACT

John Parker and Edward Wakelin's partnership agreement, 'as joint Dealers in the Art Trade Mystery or Business of a Goldsmith' took effect from 29 September 1760, 'for and in respect of the mutual confidence and good opinion they have of each other . . . and the better (in probability) to augment and improve the fortunes and Estates of each of them'.[71] The document is as long and carefully worded as any noblewoman's marriage settlement, and is unusual for a business contract in its depth of detail and caution. It is likely that John's brother Thomas, trained as a lawyer, had advised on its content. Parker and Wakelin agreed to continue as co-partners and joint dealers for ten years in 'buying selling uttering vending and retailing of all sorts of Wrought Plate, and all such other Things as are usually sold by Men of that Trade or Imployment Or which they the said partners shall think fit to trade and deal in'. It is significant that the word 'making' does not appear at all in the contract. The lease of the retail shop was assigned by Wickes to Parker and Wakelin, who paid him £40 per year, while John Parker paid Wickes £20 rent for the 'dwelling house' above. Wickes and Netherton were paid £200 'for and in consideration of their quitting the . . . shop' and a further £200 for the purchase of the fixtures within the shop, including the shelves and showcases decribed in the inventory. The capital joint stock of £5,400 was agreed to be advanced in ready money, goods and wares. Each party put up 'two Joint and Equal parts or Shares' of £2,700 each. Such ample and fairly divided capital ensured a firm foundation for the business. Both partners were allowed a half share of all the profits that accrued 'for his own separate and Sole use', and £4 a week each from the joint stock for his own 'private

and particular use and expenses'. The scale of the business in terms of the capital can be compared to the smaller concern of Abraham Portal and George Coyte, whose business in Ludgate Hill was valued in 1765 at £2,000.[72]

The more than usually thorough and lengthy wording of the partnership contract reveals an attempt to circumvent some of the more common causes of business failure.[73] We must remember, too, that bankruptcy was common. Information about the trade comes largely from the Chancery records that such disasters generated. Neither partner was liable to honour each other's private debts or become obliged to make payment 'without the consent of the other'. The joint stock was not to be used in any other trade or business, or put out on security other than for the common benefit of both parties. The lending out or delivering on trust of any of 'the moneys, wrought plate or other things belonging' to the joint stock was forbidden without the other partner's written permission.

Stress was put upon the importance of the business accounts, particularly the ledgers in which were recorded 'all Bills of parcells for any manner of Goods bought or Sold or for Plate or other Goods bartered exchanged or delivered upon Trust and all other Securities by Speciality or otherwise And also all Receiptes or other Discharges for any Debt, Duty or Demand relating to the said joint trade', which were set down in 'two Books prepared for that Purpose', to 'be signed and sealed by each' of the partners, 'which each party is to have and keep one to and for his own private and particular use'. The first of these yearly accounts was to be drawn up on or before 1 November 1761. They went on to keep their accounts in immaculate order, like Thorogood in Lillo's *The London Merchant* (1731), who advised 'Method in business is the surest guide. He who neglects it frequently stumbles, and always wanders perplexed, uncertain and in danger'. George Lillo (1693–1739), who was a successful London jeweller as well as a playwright, wrote from experience.[74] These annual accounts, which survive to the present, form the major evidence from which we can reconstruct Parker and Wakelin's business, and the story that follows.

Fig. 31. *View of Camberwell from the Grove*, engraved for Harrison's *History of London*. Bodleian Library, Oxford

Fig. 32. *John Parker*, by Francis Cotes; 1766. Oil on canvas; 66 × 53 cm. Private collection

Fig. 33. *Mary Parker*, by Francis Cotes; 1766. Oil on canvas; 66 × 53 cm. Private collection

3

Patterns of Trade:
'The King's Arms' 1760–76

Joint Dealers in the Art Trade Mystery or Business of a Goldsmith.
Extract from Parker and Wakelin's partnership contract, 1760

THE STATE OF THE COUNTRY

When Parker and Wakelin signed their partnership contract in September
1760, it was not only the new partners who must have been in an optimistic
mood. Britain had been at war since 1756, but successive naval victories in
1759 had secured British control of the Mediterranean, making an invasion of
England impossible. The accession of George III, on 25 October 1760, was
hailed as the dawn of patriotic harmony, even if it was not to last. On a more
personal level Parker and Wakelin must have hoped that the new king would
appoint them royal goldsmiths. Wickes had supplied Frederick Louis, Prince
of Wales, with plate from 1735 until his death in 1751, and had continued to
serve the Dowager Princess Augusta, and from 1759, princes William and
Henry. George III's decision to make Thomas Heming Goldsmith and Jeweller
to the Crown, via the influence of Lord Bute, must have been a disappoint-
ment. The coronation alone required the royal goldsmith to oversee £25,487
13s. worth of plate and jewels, which included £2,213 for new gilding just
over 13,700 troy oz of plate.

In the 1760s the country, like the new business, was settling down to a
period of expansion. Wedgwood had just opened his Burslem pottery, the
Carron Ironworks began production and Matthew Boulton started the Soho
foundry. James Christie opened his auction house in St James's in 1762. The
economy and population were growing. Bankruptcy figures reveal a decade of
stability until the 1770s. The population of England in 1750 had been esti-
mated at 6,140,000,[1] with growth thereafter of some 50 per-cent by the end
of the century.[2]

THE EXPANSION OF LONDON AND THE DEVELOPMENT
OF THE WEST END

It has been estimated that by 1750 about 650,000 people lived in London,
that is over ten percent of the population of England.[3] By the second half of
the eighteenth century it had become a city distinct from its European counter-
parts. After nearly a century of growth after the Great Fire, it had transformed
itself into the largest city in Europe. Its physical look was changing in
response to the increasing numbers and changing pursuits of those it had to
accommodate. In the seventeenth century it was described as a city with two

centres, the 'old', which was the centre of trade and finance in the City, flanked by the port and by the manufacturing suburbs of the Tower, Clerkenwell and Southwark, and the 'new' London which was in Westminster, with the Court, Parliament, and its new residential squares and luxury shops. Daniel Defoe in his *Tour Through England* (1724) described London in terms of the City and the Court, where: 'The City is the centre of its commerce and wealth. The Court of its gallantry and splendour. The out-parts of its numbers and mechanics; and in all these, no city in the world can equal it'.

George Wickes had recently moved out of the City to Norris Street, reflecting a wider pattern of westwards migration.[4] The links between the City and the West End were particularly close in the goldsmiths' trade, which demanded constant interaction between the two. The Assay Office, situated near St Paul's Cathedral, in Foster Lane, was right in the centre of the City, and goldsmiths from all over the metropolis, and beyond, were required by law to send their silver to be tested there (fig. 34). The plateworkers were based here, making silver for others to sell. The retailing goldsmiths were largely based in the West End, along the Strand, in Covent Garden and the Haymarket.

Although there was constant interchange between these two centres, they were growing more socially and culturally distinct. Fanny Burney drew upon the rivalry between the City and the West End in her novel *Cecilia* (1782), creating the character of Mr Briggs who represented the trade interest and who lived in the City, while her Lord Delvile had a house in St James's.[5] Their mutual contempt for each other is expressed in the different languages they speak; they can barely communicate with each other. Both characters fail her heroine Cecilia, Briggs because of his parsimony and Delvile because of his pride.

The rate of new building was prodigious. As the novelist Tobias Smollet's crotchety country squire, Matthew Bramble, complained, 'London is literally new to me; new in its streets, houses, and even in its situation . . . What I left open fields, producing hay and corn, I now find covered with streets, and squares, and palaces and churches'. Although the monstrous growth of London was a common literary trope, it is evident from many other sources that it was based on fact not fiction, as well as on both fear and pride. In 1759 Horace Walpole asked a friend, 'When do you come? if not soon you will find

Fig. 34. *Goldsmiths' Hall, Foster Lane*, by T. White; early eighteenth century. Engraving; 15.5 × 24 cm. The Worshipful Company of Goldsmiths, London

a new town . . . Piccadilly'. In 1764 the demand for bricks outran supply.

One of the areas of the most intense building activity in the West End was, as Defoe wrote:

> the two great parishes of St Giles's and St Martin's in the Fields, the last so increased as to be above thirty years ago, formed into three parishes, and the other about now to be divided also. The increase of the buildings here, is really a kind of prodigy . . . by calculation, more bulk than the cities of Bristol, Exeter and York, if they were all put together; all of which places were, within the time mentioned, mere fields of grass, and employed only to feed cattle as other fields are'.[6]

Parker and Wakelin's shop was situated in the heart of this expanding area.

SHOPPING IN PANTON STREET

What then would it have been like to visit Parker and Wakelin in Panton Street in the 1760s?[7] First, it would have been much cleaner and safer than before, as the streets would have benefitted from a recent 'clean-up' in response to several Acts of Parliament for improvement.[8] In 1760 an Act was obtained for widening and improving the streets of the City, swiftly followed by lighting and paving Acts, introduced in Westminster and the adjacent parishes. 'It is a credit of the present age' wrote Smollet, 'that London and Westminster are much better paved and lighted than they were formerly. The new streets are spacious, regular, and airy; and the houses generally convenient'.[9] The cleanliness extended to the shops themselves, as the Swiss commentator André Rouquet noted, they were 'rubb'd clean and neat; everything enclosed in large glass showcases, whose frames, as well as all the wainscot on the shop are generally fresh painted, which is productive of an air of wealth and elegance which we do not see in any other city'.[10] This impression of cleanliness was enhanced by the amount of light, made possible by large glass windows, which allowed in both natural and, increasingly, artificial light. The competition for space was exacerbated by 'the ambition of Shopkeepers, who [had] encroached upon the foot-ways by bow-windows. When an example was set, the whole fraternity; fired with emulation, thrust each new one beyond his neighbour'. In 1774 the danger from these bows was seen to be so pressing that they were restricted to ten inches or less. This use of light was, according to some observors, a particularly English trait. The shops in Paris by comparison were, according to the antiquary William Cole (1714–82), 'the poorest gloomy Dungeons you can possibly conceive'.[11] The Frenchman Pierre Grosley agreed with Cole that the striking shops of London, enclosed with great glass doors, highly adorned, brilliant and gay, created a 'splendid show, greatly superior to anything of the kind in Paris'.[12] The dazzle of the shops became a symbol of British success, in the face of competition from the French whose luxury goods in terms of design, quality and imagination threatened home produced goods. The German traveller and Anglophile, von Archenholz, noted in 1789 that 'Nothing can be more superb than the silversmiths shops . . . the greatest shops in St Honoré at Paris appear contemptible compared with those in London'.[13] There is no doubt, however, that these comments were part of a rhetoric of competition that was deeply ingrained in the relationship between France and England.

Shopping in the West End was a varied affair, as the specialized areas, monopolized by particular trades that characterized medieval London, were

breaking down. Defoe's comments of 1726 were already old-fashioned when he explained that:

> Many trades have their peculiar street, and proper places for the sale of their goods, where people expect to find such shops, and consequently, when they want such goods, they go hither for them; as the booksellers in St Paul's Churchyard about the Exchange, Temple and the Strand etc; the mercers on both sides of Ludgate, in Round Court, and Gracechurch and Lombard Streets; the shoemakers in St Martin's le Grand and Shoemaker Row; the coachmakers in Long Acre, Queen Street, and Bishopsgate; butchers in Eastcheap.[14]

From the 1760s one would have navigated through the retail and workshops of London less by sign boards, used since the middle ages, and more by numbers. Rouquet noted how these signs were 'very large, well painted, and richly gilt; but the costly iron work they hang by, is so clumsy and heavy, that their weight seems to threaten the thin brick wall to which they are fastened'. In 1762 sign boards were banned after a series of deaths by falling 'King's Heads', 'Black Lions', 'Angels' and 'Beavers'. A London directory issued in 1765 reveals only thirty-five numbered addresses, by 1768 however the system had finally taken hold. Soon it was the contents of the shop windows and not the signs that became 'their chief ornament'. 'Such are the methods adopted by the London tradesmen to attract attention', wrote one commentator, 'commodities are now generally used in place of antique signs'.[15]

Taking Horwood's 1792 map of London, the first to provide house numbers, which replaced shop signs, we can see that Parker and Wakelin's retail shop, the King's Arms (as approached from the Haymarket), stood to the left at no. 31, 'two doors down' (fig. 35). It adjoined the corner site of Panton Street (no. 5) and the Haymarket.

At the time of Parker and Wakelin's partnership this corner site was owned and occupied by Elizabeth Carpenter, a pewterer (fig. 36), who had been running the business since her husband's death in 1738.[16] In the early nineteenth century these premises were taken over by Garrard, when they were described before demolition as having 'a plain brick front four storeys with horizontal bands at the second and floor levels. The lower storey . . . divided by pilasters into a series of bays of shop windows'.[17] The layout is clearly visible in a plan of 1883 (fig. 37). Proceeding down Panton Street, the house adjoining the King's (no. 30) Arms belonged to William Hudson, a chemist. His name appears as 'Hudson the Apothecary' in John Parker's personal account in the business ledgers. Next door, at number 29 Panton Street, was the workshop that Wickes acquired in 1744, and where Wakelin lived until 1760. It is hard to imagine how the sound of silver being hammered mixed with the exotic scents that would have emerged from the perfumerers at number 28, let alone with the clientèle of the Union Arms public house next door (no. 27). At the corner of Panton Street and Oxendon Street stood a bakery (no. 26).

Number 25 Panton Street, which from 1760 was the home of Edward Wakelin, stood at the corner of Oxendon Street. Parker acquired the adjoining premises (no. 24) in 1777, for which he received an annual rent of £35 from a Mr Ward.[18] The celebrated Great Room in Panton Street hosted a range of entertaining diversions, including in 1769, 'rope dancing by the amazing Monkey, just arrived in England' and '900 figures all in motion', which were presumably marionettes which could be seen for a shilling.[19] In 1774 Signor Grimani 'Professor of mathematics' exhibited his model of London and

Fig. 35. Detail from Horwood's Map of Westminster, showing Panton Street and the Haymarket; 1792. Westminster City Archives

Fig. 36. Trade card of Elizabeth Carpenter, pewterer, at the corner of Panton Street; c. 1750. Etching and engraving; 10 × 13 cm. British Museum

Fig. 37. Plan of Garrard's premises on mortgage relating to Panton House, showing absorption of what was once Elizabeth Carpenter's corner site into the Garrard empire, Panton Street frontage to the right. 22 May 1871

Westminster there, while the following year a magic lantern show was staged and an exhibition of caricatures.[20] Mr and Mrs Hickford, who ran the Great Room, appear in Parker and Wakelin's accounts. Other entertainments in the Street included the quack doctor, James Graham, who gave celebrated displays of healthy nude mud-bathing, aided by a bevy of belles.

On the southside of Panton Street, walking back from the Leicester Fields end towards the Haymarket, one would have passed William Shipley, a pawn-broker; John Russell, a cabinet maker; and John Royall, a glover. Opposite the second workshop, and Wakelin's home until 1760, was Robert Clee at the Golden Key (fig. 38). He lived above a chemist's shop, owned by Richard Siddall, for whom he engraved a rather spectacular trade card based on a painting entitled *La Pharmacie* by Jacques de Lajoue in 1735 (fig. 39). Passing a glazier, a brandy merchant and a milliner the circuit of Panton Street ended back at the Haymarket, in front of the shop of Thomas Adams and his wife Amelia (no. 4) who were mercers (fig. 40). The Haymarket, although even then one of the busiest thorough fares in London, was still, until the mid-century, a market for straw and hay. It became a venue for many exotic visit-ors, such as a group of Cherokees in 1762, Mohawks in 1765, Eskimoes in 1772 and the famous Tahitian, Omai, in 1775.[21] The allure of the shops and entertainment drew more than just genteel customers to the environs of Panton Street. Looking back to the 1760s, J.T. Smith, writing the biography of his master, the sculptor Joseph Nollekens, remembered the 'abandoned women and pickpockets' who frequented 'the Haymarket . . . and Leicester-fields, the last of which, from the rough and broken state of its ground, and the shadow of lofty elms, which then stood in the road . . . was rendered a very dangerous part to pass'.[22] In 1761 Theodore Gardelle was publicly hanged at the corner of Panton Street and the Haymarket, the event captured by William Hogarth.[23]

READING THE ACCOUNTS

There is no doubt from the annual profits, calculated in October each year, that the business was in a healthy condition. The partners' combined share in 1766 was £920; in 1767, £760; in 1768, £600; in 1769, £600; and in 1770, £700. A new partnership contract, drawn up in 1770, for another ten years, provided for a more than doubling of the partners' joint capital from £5,400 to £14,100, a clear indication of their success.[24] Turning through the pages of their accounts the reader is both fascinated and bewildered by the sheer range of work provided and it is difficult to identify patterns within the cumulative information rich with so much seductive detail. In 1769 Lord Molyneaux spent over £1,300 on a dinner service, the most expensive com-ponents of which were the five-dozen plates costing £347. Yet Parker and Wakelin also delivered a single toasting fork to John Sawbridge, charging him £1 3s. Parker and Wakelin also sold jewellery, from mourning rings at a guinea each to elaborate gem-set earrings and bracelets costing over £200 each. Old, worn, damaged and unfashionable plate was brought in for repair or re-modelling, and often to set against bills. Lord Delamer paid 7s. 6d. for the 'boiling' of a parcel of filigree toys, and two customers had their épergnes refurbished, with the addition of four branches. In 1767 the partners sup-plied a 'joint to a dog collar' and new lined it 'with velvet', as well as one 'for a squirell'. Customers also drew upon the variety of services that were expected from a goldsmith's shop. Colonel Clarke had two hundred visiting cards printed from an engraved plate, and Parker and Wakelin regularly paid

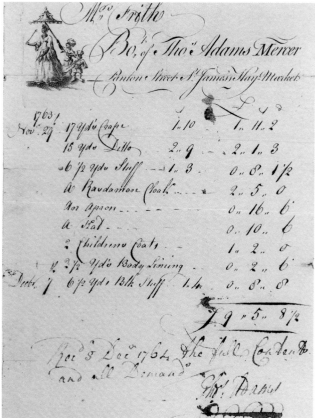

Fig. 38. Trade card of Robert Clee, engraver, at the *Golden Key* in Panton Street; *c.* 1760. Etching and engraved lettering; 20 × 12.5 cm. British Museum

Fig. 39. Trade card of Richard Siddall, chemist, at the *Golden Head* in Panton Street, by Robert Clee; *c.* 1760. Engraving; 24.5 × 18.2 cm. Westminster City Archives

Fig. 40. Bill head of Thomas Adams, mercer, Panton Street; 1763. Westminster City Archives

their customers' annual plate tax, an irritating chore that clients must have been glad to delegate.

Despite the distraction of the detail it is possible to calculate some general figures based on the five years trading covered by the overlapping Gentlemen's Ledger (1765–70) and the Workmen's Ledger (1766–73). The former records all purchases made by customers with accounts, while the latter covers not only their manufacture and supply, but also goods made specifically for the shop. By adding account and shop orders together we can reconstruct how much silver was supplied, in terms of number of orders and their weight. A complete picture of what a single goldsmith's business offered can be recreated.

Between 1766 and 1770 just over 7,000 orders were supplied, which comprised anything from the component parts of a complete dinner service, to a single tea canister. Their amount in weight of silver, at 113,968 troy oz, gives us a much clearer idea of the size of the business. At an average of 5s. 6d. per troy oz, this would have cost Parker and Wakelin just over £31,700, to acquire.[25] This is not an inconsiderable sum of money, the annual salary of the First Lord of the Admiralty came to £4,000. It is not surprising that one of the main problems of setting up and staying in business as a goldsmith was the cost of materials, which had to be paid for before the orders were made, let alone sold. Orders for shop stock accounted annually for anything between a seventh to a quarter of the whole number of orders, while in terms of weight they ranged from a half (in 1768 and 1770) to a quarter (in 1767 and 1769) of the total weight of silver used. These figures suggest that ready-made wares sold over the counter from the King's Arms made a substantial contribution to the business, albeit a rather variable one. At this point it is important to note that these 'shop' figures do not represent sales, but deliveries made to it, which may have remained in stock for weeks, months or even years before being sold.[26]

The ledgers reveal that Parker and Wakelin's business was divided between four major areas of activity:

1. The *supply of services* to customers, such as the payment of plate tax.
2. The *mending* of silver and jewellery, from major refurbishments to minor maintenance.
3. The *supply of jewellery*, from watch chains to topaz rings.
4. The *supply of silverwares*, from single tea spoons to whole dinner services.

THE MEANING OF SERVICE

Without the evidence provided by the ledgers it would be impossible to reconstruct what type of services Parker and Wakelin offered, as they leave no easily identifiable object trace. There were 924 orders between 1766 and 1770 for these services, available largely to account rather than shop customers. They included the payment of plate tax. In 1767 Parker and Wakelin paid Henry Compton's three-years-worth of tax on 100 troy oz of plate; Thomas Grosvenor's four-years-worth of tax on 1,100 troy oz and Earl Shelburne's on 4,000 troy oz. The amounts paid and the survival of the plate tax registers reveal that Parker and Wakelin made nothing on these transactions, which were part and parcel of being a wealthy customer's goldsmith. They did not bring in any money, but they helped keep the customer tied to the business.

Other small services included organising the advertising of lost or stolen goods, like 'advertising a seal' that Colonel Clark had mislaid in 1766. For the banker John Martin they sent a boy to the Heralds' Office to record on a

small vellum sheet his family's coat and crest. For Charles Penruddocke they found two cut-glass flower vases and eighteen plain water glasses. Thomas Walker was supplied with two wicker flower baskets for 16s. 5d. For others they hired out plate. In these jobs we see the meaning of 'service' in the luxury trades, a crucial lubricant to business.

MENDING AND MAINTENANCE

The repair of silverwares and jewellery accounted for 1,761 orders. In terms of income, as for services, they offered little, but as a means of maintaining a connection with customers they were invaluable. The sheer range of repair and refurbishing recorded in the ledgers suggests that it was integral to the business, and a large part of what a customer expected from his goldsmith. The mending of silver falls into three categories: cleaning and re-polishing, repair or replacement of parts and re-fashioning. If the silver was so dirty and damaged that the butler could not restore it, it was taken to the goldsmiths. Parker and Wakelin's accounts are full of orders for 'boyling', treatment reserved for blackened silver. It was suspended in a warm, dilute sulphuric acid pickle to remove the sulphur, and after removal required polishing to restore its gleam. To 'boyl and burn[ish] a pair of fine chaised candlesticks and branches' cost Thomas Brand £1 4s. Lord Holdernesse returned '2 fine cellery tureens and covers' he had bought to be boiled and burnished in 1770, at a cost of £2 10s (fig. 106). In the same year the Archbishop of Canterbury had a 'mace boiled and burnished'. Sir George Strickland paid 1s. 6d. per plate for 'burnishing 2 dozen' of them. It is understable that delicate filigree wares, made of soldered silver wire, were regularly cleaned by the goldsmith, Owen Clutton paid 2s. for 'boiling a filigree quadrille basket'.

The customer accounts reveal that their silver received hard and regular use and was not kept purely for display. The Earl of Westmorland, for example, had his tea tray reinforced to strengthen the edge. This silver tray, which would have stood on a mahogany table, had most likely been dropped. Lord Halifax had the feet of his cruet frame mended, and his tea vase needed a new spigot, the bruises taking out and the body re-soldering.

Doing up silver might also include adding or removing elements, and provided the opportunity for updating. The addition of 'gadroons on 2 tureens and doing up as new' would have transformed the Earl of Shelburne's dinner service, and at £4 11s. 2d. a fraction of the cost of buying two new tureens.[27] Fulke Greville paid £5 10s. for the 'fluting' of 'a tureen and cover and doing up as new', and commissioned another made to match which cost him £42 10s. 3d. and weighed 97 troy oz 11 dwt.[28] William Aislabie of Studley Royal, near Ripon, regularly had his plate refurbished at Parker and Wakelin's. In one month alone they altered four comport dishes, reversed the handles of thirty table spoons, adding engraved crests, and gilded a chased cream ewer. The maintenance of silver might span many family generations. A pair of handsome oval soup tureens marked by Wickes in 1745, has replacement handles marked by Robert Garrard in the early nineteenth century.[29]

Parker and Wakelin were even willing to take on the odd job, like plating a pair of stirrups and a bridle, or silvering a saucepan lining. Lord Exeter had a 'new bottom and hair added' to his beard brush. Whilst the mending and refurbishing must have taken time and trouble to complete, and brought in relatively little money, it was essential in keeping customers happy and maintaining their connection with the business.

JEWELLERY

The partner's ledgers reveal that between 1766 and 1770 they fulfilled 955 orders for jewellery, from the supply of ready-made mourning rings at a standard price of £1 1s. each (one guinea), to elaborate and costly gem-set jewellery like diamond pins, and necklaces costing over £200. Yet most of the jewellery they sold was of the modest sort: garnet strands at £4; gold stay buckles at £2 2s. each; pairs of mocoa [moss] agate buttons costing £2; and silver shoe buckles at £1 a pair. It is clear that customers expected the business to supply jewellery but that it was certainly not its priority. As most jewellery, apart from gold wedding rings, was not subject to assay because of its delicate nature, and most was broken up and re-set as the fashions changed, it is virtually impossible to match surviving pieces with makers and suppliers, let alone customers. The amount of surviving eighteenth-century jewellery is, therefore, small and difficult to interpret, but the accounts provide valuable information about the range, style and cost of jewellery sold. The re-formulation of jewellery can be seen in Parker and Wakelin's accounts: the Earl of Rosebery had new frames and pearls added to a pair of earrings; double-cluster rings were re-set; and Mrs Hubbald had her necklace re-strung with new hooks and a pendant paste drop added.

By far the most common orders were for seals. Of 'All manner of Seals, in Stone, Steel and Silver, Engraved in the Newest Taste' advertised on Parker and Wakelin's trade card, those of red carnelian in gold, costing between £2 2s. and £4 14s. a time were the most popular. However, they kept a wide range to suit all pockets. At the cheaper end of the range were gilt-metal ones costing 8d. each. The most common style of earrings supplied were those made in blue or black enamel, 'set round with marquisats [marcasites]' at £1 6s. to £1 10s. a pair. The majority of the orders for rings concerned those for mourning. The addition of 'Neat Mourning rings of all kinds' to their new

Fig. 41. *Joseph Gulston*, engraved by his wife, reproduced as the frontispiece to *A Catalogue of the Most Remarkable Collection of Prints, belonging to Gulston, and sold by Mr Greenwood, London 16 January 1786; 1772*. Engraving, 21 × 25 cm. Victoria & Albert Museum, London

shop bill of 1760, seems to have been a response to the growing demand for them. A typical purchase was made by a customer called Taylor, who bought 13 standard mourning rings for £13 13s. (that is, a guinea each), then three more for the same price, followed by five more elaborate and slightly more expensive 'hair plait rings set with amethyst paste' for £7, presumably for the close family. It was the 'fashion' rings that cost the most, like the heart brilliant (diamond) ring with rubies that cost £25, although this is modest compared with those sold by specialist jewellers.

The increase in the amount of jewellery supplied by Parker and Wakelin in 1767 is attributable to a single customer. Most of the £2,478 spent on jewellery that year came from the eccentric and reckless Joseph Gulston, the son of a successful loan contractor who died in 1766, leaving him £250,000, in funds, an estate in Hertfordshire worth £1,500, a year, Ealing Grove in Middlesex and a house in Soho Square (fig. 41).[30] It is significant that his orders from Parker and Wakelin coincide with the date of his inheritance. In 1767 alone his more expensive purchases from the partnership included a necklace made of brilliants at £600, a pair of three-drop brilliant earrings at £280, a 'brilliant pompone' at £170 and a blue enamelled watch at £106. His jewellery outshone the silver that he bought. His two pair of 'step pillar candlesticks' cost a mere £35 and his 'nurled coffee pot' only £10 14s. 6d. Gulston's extravagant shopping habits reveal how the fortune of a business could rest with key individuals, whose fate, if they were not careful, could become entangled with that of a business. Gulston dissipated his fortune in collecting books and prints and in building. The inevitable crisis came, and after a succession of expedient sales of properties, consignments of annuities and spasmodic efforts at economy he was forced to sell Ealing Grove to the Duke of Marlborough in 1775, and in June 1784 his collection of books.[31] Fortunately for Parker and Wakelin, he had settled his account with them before his financial disaster had gained momentum. They were not so fortunate with some of their other customers.

'MAKE AND SELL ALL SORTS OF . . . PLATE'

It is, of course, no surprise that the majority of Parker and Wakelin's business rested on the supply of silverware (3,506 orders). The supply of knives, forks and spoons account for the greatest number of orders between 1766 and 1770 (1,184, weighing 22,182 troy oz), but it was tableware in the form of dishes and plates, tureens, baskets, épergnes, sauceboats and salts that accounted for the greatest weight of silver supplied (1,052 orders, weighing 57,695 troy oz). As the flatware and cutlery were for dining and many of the candlesticks were also for the table (376 orders, weighing 11,781 troy oz) the dominance of dining silver is even more apparent. In this general picture at least, the visual evidence, the type of silver that survives, confirms the picture relayed by the accounts. To give an idea of what the weight of silver in these calculations represents, let us turn to a pair of soup tureens with serpentine bodies and cast pomegranate finials, weighing 183 troy oz 15dwt. They were part of an order by Lord Howe for a dinner service, delivered in October 1767, comprising four double-lipped nurled sauceboats (68 troy oz), four dozen nurled plates (789 troy oz 6dwt), eight pincushion comports (162 troy oz) and fifteen oval and two round dishes (574 troy oz 19dwt). The total order weighed just over 1,776 troy oz, nearly a third of the total weight of tableware Parker and Wakelin supplied that year. Yet Howe's soup tureens represent not a usual order, but one of only four orders for tureens within the assay year 1767/68.[32]

To imagine that these splendid tureens are representative of the wider picture of supply would be inaccurate. The business relied more heavily on the supply of smaller, multiple wares that cost less each but cumulatively brought in more profit.

STOCKING THE SHOP

Equally, the range of stock supplied to the shop was far from representative of the whole range of silverwares that Parker and Wakelin sold to their account customers. It did not present a microcosm of the business as a whole. There was none of the dressing plate, no powder boxes, razors, shaving and tooth brushes bought by the account customers. But at the same time, the dominance of dining silver is not so evident in the shop. The shop stock was, in one way, in the van of taste, providing light-weight wares of elegance that were affordable to a wider market in comparison with the heavier silver that appears in some of the customer accounts. The shop silver, from the description in the ledger, had fewer decorative features than their bespoke counterparts. Their weights conform to the stock lists published later in the century by the retail warehouses, like that of Thomas Daniell, where goods are quoted at standard weights: 'tureen shaped pierced bread baskets' at between 20 and 30 troy oz and pierced salts at 3 troy oz. Knives, forks and spoons were the most standardized of all types of silver and were required by a broader section of society. Those who could not afford a silver sauce tureen could buy a set of silver-hafted knives and forks, the minimum requirement for a genteel table. Tea spoons were popular shop stock, Isaac Callard supplying them in two-dozen batches at regular intervals. While account customers bought a wide range of candlesticks, branches, lamps and snuffers, the shop was stocked with candlesticks only, largely of Sheffield plate rather than silver, bought at a trade discount from firms such as John Winter and Company for 15s. a pair, but sold to customers for £5.

The shop stocked only the smaller articles of tableware, such as salts, sauceboats, dish crosses and stands, and soy frames. Waiters and shell skewers were the most popular items on sale. Bread baskets, small (described as 'slight' weighing 14–20 troy oz), medium (20–29 troy oz) and large (30–46 troy oz) also seem to have sold well over the counter. The most popular were those made of drawn wire with glass basins, which weighed only 8–10 troy oz of silver. Using a fraction of the cost of the silver compared with those raised from sheet, they provided a fashionable addition to any dinner table. Only one tureen and two épergnes were made specifically for the shop between 1766 and 1770. The occasional grand piece that did appear in the window usually represented an order, commissioned by an account customer, that was returned and then put in the shop, like Mr Bouverie's 'small epergne with saucers and basket' which cost him £63 14s., plus £3 8s. for 'Graving 5 Coats'. It was returned and a note added in the ledger, 'to taking out the Armes and altering . . . to make it more saleable'. It is a virtue of silver that engraved customization could be removed, unlike that on ceramic which was fired on and irreversible.

The other area in which the shop excelled was in tea wares. Tea canisters and vases were supplied in an unusually wide range of designs, from plain, nurled and chased to the more elaborately festoon and fluted. Sugar baskets came next, weighing between 4 and 6 troy oz each, and silver-tipped glass sugar bowls. Elaborate items in the shop can be traced back to rejects from account customers, including a chased tea table weighing a handsome 182

troy oz and marked in the Workmen's Ledger 'originally sold to Draper', and a 'teapot intended first for Westmorland'. It was these substantial ornamented pieces which attracted customers into the shop.

The same limitation in the type of goods made for the retail shop is also evident in the jewellery. The range was confined to buttons and buckles of the plain or paste variety, hoop rings and chains of a standard pattern, while account customers bought strings of pearls and garnets, jet brooches, and had their seals set with cornelians. What is clear is that over time Parker and Wakelin put relatively more silver and jewellery in the shop, from a third of their stock in 1766 and 1767 to nearly a half in 1768 and 1770. This trend conforms to the greater 'weight' put upon the lighter wares which were becoming popular with customers.

FLUCTUATIONS IN TRADE

One of the skills of trade is the ability to ride the ebb and flow of demand, to sit out the troughs and meet the sudden demands. As Parker and Wakelin's accounts show, business was far from predictably regular, either from year to year or month to month, although certain patterns are recognisable. Fluctuation within a goldsmiths' business is clearly revealed if we look at the weight of silver used each year.

In 1769 Parker and Wakelin supplied 33,998 troy oz of silverware, almost twice the weight of silver used in 1766 (17,853 troy oz). These figures lead us back to the objects, as they reveal the importance of knowing the type of silver ordered. The peak in orders for 1769 is explained when we look at what was being supplied: an exceptionally large number of dinner services. In 1769 ten services were delivered to account customers, from Richard Rigby's modest twenty-four place setting, costing him £343, to the most expensive service Parker and Wakelin supplied, bought by Lord Harcourt for £3,632, which accounted for just over half the total amount of silver used that year. Rigby bought his service over a period of months in 1769: in May, his flatware and cutlery, two dozen forks and spoons and pistol handled knives; in June, his oval serving plates and two dozen dinner plates; and in September his fish plates. Harcourt, in contrast, had his order delivered *en masse* on 13 March; it included eleven dozen plates, six monteiths and a pair of ice pails. In the previous year only five dinner services had been delivered, and in 1767, six. Organising the purchasing of the metal to make them up, let alone its manufacture, demanded both liquidity and a flexible means of production (*see* chapter 5).

Retailing goldsmiths not only had to deal with fluctations in business from year to year but also with the more predictable peaks and troughs throughout a year. The delivery of orders to Parker and Wakelin's customers peaked in the months between March and June, after which they began to decline sharply, reaching their lowest levels in September, October and November. For example, in 1766, 161 orders were delivered in April, but only 49 in September. In 1769, 221 orders were delivered in March, the highest number achieved between 1766 and 1770, but only eighty in November. The lowest level came in September 1770, when only thirty three orders were delivered. These dramatic changes in demand had great implications for Parker and Wakelin's workforce (*see* chapter 3). Fluctations in demand across the year were all part of the effect of 'the Season' on the London trades, and particularly those engaged in the sale of luxuries. As the author of the *Handbook for London* explained, 'the Season may be said to commence in March and terminate in

July. It is in its height in May and beginning of June'.³³ When customers were out of London and on their country estates, during the months of July to October, orders dropped dramatically. As one London jeweller noted in 1772 'in the month of September the town is quite empty'.³⁴ The goldsmith Joseph Brasbridge who had a shop in the Strand explained that 'in the summer months' of July and August, most of his 'customers were out of London'.

During this trough in trade from July many shopkeepers became short of ready money, and this was when letters to customers were written in pursuit of unpaid bills. The London jeweller Arthur Webb wrote in July 1772 to one of his customers, Mrs Butler of Kilkenny Castle, reminding her of an unsettled account. Despite his urgent need for money, he agreed to wait upon her 'conveniency', in his concern not to offend this 'Respectable Family on Any Account'.³⁵ His patience was not rewarded, as the Butlers spent their money, not on settling their debts with him, but on refurbishing the badly run-down Castle they had inherited in 1766.³⁶

Orders made for the shop reflected a far more stable month by month supply. What emerges is an inverse interrelationship between account and shop supply patterns. When customers left London at the end of the Season, suppliers switched from completing commissions to organising the stock of the retail shop. In July, when orders to outworkers for account customers fell, orders for the shop peaked. The rise in the number of deliveries to the shop between August and October was the result of suppliers making good use of the 'dead' time the Season represented. Shopkeepers realized the importance of having a well-stocked shop, as Dru Drury, a goldsmith with a shop in Villiers Street on the Strand, bitterly noted, he saw 'business slip by . . . for want of having proper stock to attract customers and promote its exterior'.³⁷

COMPARATIVE CONTEXT

While the survival of Parker and Wakelin's accounts provides us with an opportunity to recreate their business, their rarity means we have little opportunity of comparing these findings with others. Unfortunately, no directly comparable evidence survives for other eighteenth-century goldsmiths' businesses. How then can we judge how large or small Parker and Wakelin's business really was? If we know the weight of silver Parker and Wakelin used for their orders each year, which we do, then it is possible to compare it with the yearly London Assay Office totals. This helps to place Parker and Wakelin's business in the context of the London trade at large, although of course the London assay figures include provincial silver that was assayed there, and does not account for silver that went untested and evaded the Company's regulations.³⁸

By law all wrought silver had to be taken to an Assay Office, 'for the discovery of false gold and silver from that which is good, . . . to know the true value thereof', except that which was exempt. The Assay year runs from 29 May, so Parker and Wakelin's consumption of silver has been calculated upon the same principle. In 1766/7, for example, 96,460 troy pounds of silver were assayed. In the same year Parker and Wakelin's orders for silver represented 1,707 troy pounds. Most would have gone through the London Assay Office, some pieces bearing their mark, others those of their suppliers, depending on who had agreed to be responsible for the sterling standard of the alloy. According to these figures Parker and Wakelin's share of the yearly assay totals were approximately two percent, making them, without doubt, one of the largest businesses operating in London at the time. Matthew Boulton was producing almost half that (985 troy pounds) at Soho in 1776/7, although he

was running his silver manufactory down over the next few years.[39] In 1779, Birmingham Assay Office handled a peak of 5,083 troy pounds, and Sheffield 4,083 troy pounds in 1776.[40] By the early nineteenth century the scale of some London operations had dramatically increased. Rundells, the royal goldsmiths, were said to supply 'ten thousand ounces of sterling silver monthly' (833 troy pounds) that is 9,996 troy pounds a year, roughly five times that of Parker and Wakelin.[41]

What sort of competition did Parker and Wakelin face? We know from various sources that the number of luxury traders was increasing in the eighteenth century. The growing number of trade cards suggest increasingly sophisticated means of advertising to attract customers. The threat of Birmingham and Sheffield goldmiths to the London trade resulted in an enquiry in 1773, that listed the 'names and places of Abode of all the Goldsmiths, Silversmiths and Plateworkers', that had entered their marks at the London Assay Office. Although this list excludes those who traded without a mark it is the nearest we have to a roll-call of the trade. The report of the enquiry listed 149 goldsmiths and goldworkers (including Parker and Wakelin), and 93 plateworkers in the 'City, Westminster and outer regions'. The addresses of the goldsmiths are divided between those in the City, and those in the West End, the majority residing near Cheapside, with those who moved west clustered around Covent Garden, Soho, Piccadilly and the Strand. Those goldsmiths who gave addresses near Parker and Wakelin included Thomas Heming, William Chawner and John Robinson all in New Bond Street. Only ten of the plateworkers gave addresses outside the City, suggesting an obvious division between manufacturing and retailing. Given the evidence of the weight of silver that Parker and Wakelin supplied, and their location, it can be assumed that they were one of the larger retailing goldsmiths in London at the time.

III

Making and Selling

4

'London Luxuries':
The Skills of Specialization

There is no country where labour is so divided as here.
The French industrial spy Le Turc on English manufactures, 1786[1]

SPECIALIZATION, AN ENGLISH ADVANTAGE

Parker and Wakelin's trade card, in common with those of other tradesmen in luxuries, promised variety, taste and competitive prices. It was a feature of these shops to sell a wide range of goods: in Parker and Wakelin's case, from silver dog collars to whole dinner services, from single meat skewers to diamond rings. How then did they achieve and maintain such diversity, quality and novelty? Their Workmen's Ledger enables us peer beyond their advertising rhetoric and into the complexities of supply; to see who was actually making the goods they sold; and how they were able to satisfy their customers' expectations of quantity, range, quality and cost via a network of seventy-five specialist subcontractors. Their system of supply was mirrored throughout the London luxury trades, creating a complex web of shared skills.

According to Campbell, specialization gave England:

> an Advantage over many Foreign Nations as they are obliged to employ the same hand in every branch of the trade, and it is impossible to expect that a man employed in such an infinite variety can finish his work to any perfection, at least, not so much as he who is constantly employed in one thing'.[2]

Specialization in this context can be seen in two different, but not mutually exclusive ways, by type of object and by particular manufacturing skill. For example, in the silver trade there were makers who were known to supply tureens; their manufacture required a range of tools and techniques, from raising through to the final polishing. There were also those who specialized in a particular technique of making or decorating; for example, raisers, embossers, chasers, gilders and engravers, whose skills could be applied to a whole range of different objects. The division of labour was differently managed in specialization by product and process.

Jean André Rouquet, the critical Swiss commentator on the *State of the Arts in England* (1755), admired the facility of organization demonstrated by the English, characterized by the steel trade, whereby 'different operations may be distributed with economy to different hands, whose age, strength or ability are proportioned to what their task requires'.[3] In a gratifying reversal of the usual state of affairs, the French attempted to imitate the English, sending over spies

to try and work out how the system of of process specialization worked. Yet the system protected itself from replication. Le Turc reported back from England to his masters in Paris that

> No worker can explain to you the chain of operations, being perpetually occupied only with a small part, listen to him on anything outside that and you will be burdened with error. However it is this little understood division which results in the cheapness of labour, the perfection of the work and the greater security of the property of the manufacturer.[4]

Baron Angerstein 'had to use many tricks and much effort' before he could gain admitance to the many factories he had come from Sweden to see. Once inside the buckle factory in Wednesbury he noted 'each worker had his individual and specialized work to do, Some were occuped with filing, others with punching, polishing, grinding, final cleaning and so on'.[5]

Adam Smith's idea of the division of labour, whereby 'the improvement of the dexterity of the workman necessarily increases the quantity of work he can perform – by reducing every man's business to some one simple operation', was more widely recognized in the production of more mundane objects like pins (the manufacture of which took 18 separate operations) and the buckles whose production Angerstein described. Smith stressed that as a result of this division of labour items cost less and could be produced in greater quantity. Specialization reflected a more widely held belief in the virtues of a commercial society, which enjoyed a liberty from dependence on particular masters. In his highly influential work, *The Wealth of Nations* (1776), Adam Smith argued that this independence was achieved through an interlocking social system, so that individuals were truly interdependent. The very interdependency of this world contributed to the maintenance of social order and virtue.[6] This system was, Smith argued, a result of the evolution of a commercial society, of which England was the prime example.

SPECIALIZATION AND THE LUXURY TRADES

One of the most important contributions to our knowledge about manufacturing in the eighteenth century has been the acknowledgement of subcontracting and specialization within the urban luxury trades. Yet, as a form of divided labour, it had been overlooked by historians until quite recently. This has much to do with its negative interpretation by Marxists, as a story of alienation from the unity of the productive process, from social totality and from the self.[7] As a result, the craft labour of a largely imaginary past was set in contrast to the insidious onset of divided factory production. Thorstein Veblen could thus write of the pre-industrial workman as

> a creative agent standing on his own and as an ultimate, irreducible factor in the community's makeup. He draws on the resources of his own person alone . . . with his slight outfit of tools he is ready and competent of his own motion to do the work that lies before him, and he asks nothing but an even chance to do what he is fit to do.[8]

In the same vein Henry Wilson, the Arts and Crafts metalworker, saw the 'clear shining sincerity of the worker and his patient skill' in the objects that he made and imagined how 'the worker's hand travelled lovingly over every part of the work, giving it a kindliness of aspect enduringly attractive'.[9]

It is perhaps the emphasis on cheapness and quantity in the eighteenth-century rhetoric of subdivided labour that encouraged a certain consumer blindness, both by eighteenth century customers and twentieth century histor-ians, to the application of this type of specialized production to more expen-sive luxury goods. While customers were aware of the diverse hands that were responsible for the pins, buttons, clocks and watches they bought, they were unconscious of the many hands responsible for their silver teapots and tureens. The subcontracting system was applied to the manufacture of sci-entific instruments, furniture, coaches and even sculpture, and organized around similarly collaborative networks, where the combination of materials and skills enabled the production of an ever-changing range of goods that responded to changes in consumer expectation and demand.[10] Each trade had its own range of specialists. The production of a coach, for example, relied on the skills of quite separate carcase builders, carvers, gilders, painters, lacemen, chasers, harness makers, mercers, bit makers, milliners, saddlers, woollen drapers and cover makers.[11] *The Book of Trades or Library of Useful Arts* explained that the craft of the coach maker was 'divided into several parts, whose wages are in proportion to the nicety of their work' – the body makers recieved £2 to £3 per week, the carriage makers between £1 and £2, the trim-mers 2 guineas, the painters from 20s. to 30s, the body painters about 40s, the herald painters from £3 to £4 and the smiths 30s. Different trades relied upon different material and skill-based divisions that had their own hierarchies.[12] The accounts of London tradesmen reveal in the lists of their creditors names of countless specialist suppliers. Businesses relied on increasingly large net-works of specialist providers. Adam Smith reckoned that 3,000 people in different trades were dependent on the Adam brothers for their work.[13]

MODELS OF MANUFACTURE

Specialization in the silver trade followed various models of workshop organiza-tion. Matthew Boulton drew his skilled hands together under one roof at his Soho premises in Birmingham, often importing them from London; Parker and Wakelin, in contrast, relied on a complex network of makers who were based in their own workshops, which meant that although they were not bound to pay them regular wages, the partners had to organize the smooth passage of wares between workshops. Thomas Heming, the royal goldsmith, operated both his own workshop and an outside network of suppliers. He was 'contracted with a number of the best hands for a constancy whether there was work or not', and had 'Built large workshops . . . to keep a very Large stock to answer the emer-gencies of the Office'; yet we know from his mark overstamping the work of others that he was buying-in plate from other independent workshops.[14] While we have many accounts of Boulton's system of manufacture, the slow evolution of subcontracting in London and its sheer familiarity, appear to have obscured any interest in its development or any urge to record its existence or operation at the time. The relatively few eighteenth-century depictions of the processes of production in London may be explained by the fact that they were largely hid-den from public view in small workshops, and were thus unlikely to be the sub-ject of a spur-of-the-moment sketch or lengthly written description.[15] The factories at Birmingham, Stoke and Sheffield were, in contrast, open to the pub-lic and on the 'tourist' map for travellers. Visitors were courted and shown round as part of sales and promotion. In the 1790s, for example, Joseph Farington spent nearly as much time visiting factories like those at Etruria, Soho and Pontypool as he did viewing country houses and picturesque ruins.

While different trades adopted different models of specialization and division of labour, there appears to have been a broader divisional structure that applied across the luxury trades in a more general way. In 1726 Defoe described the London trades as being divided between 'those who do not actually manufacture the goods they sell', like Parker and Wakelin; 'those who only make goods for others to sell' and 'those who make the goods they sell though they keep shops'.[16]

We can identify earlier references to these different strategies of organization. William Badcock in his *New Touchstone for Gold and Silver Wares* (1677), refers to private workmen and master shopkeepers. By the eighteenth century the division between the shopkeeper and working silversmith were well established. The author of *A General Description of all Trades* (1747), acknowledged that goldsmiths could be divided between 'the Working-silver-smiths, who make up as well as sell; (though some of them do not sell at all) and the Shopkeepers, many of whom do nothing at the working Part, which hath divers Branches; some of which are heavier work than others'. The growing presence of retailing goldsmiths in London is clearly evident in some undated, but probably mid-eighteenth-century papers which describe how 'working Goldsmiths are discourag'd from keeping of Shops and selling Plate to the Publick, occasion'd by combinations among Retailing Goldsmiths and Shopkeepers, by whch means the price of New Plate is raised upon the Buyers eighteen pence or at least one shilling every ounce, over and above what the working Goldsmiths can afford to sell it'.[17] What was new in the eighteenth century was the *level* of specialization and the increasing separation of the working goldsmith from the customer as the role of the shopkeeper developed and expanded.

MAKING LUXURIES IN LONDON

It was the character of London that helped define some of the features of subcontracting in the luxury trades. It was both a centre of demand and an unparalleled source of highly-skilled labour. As one of the early guide books to London explained:

> The manufacturers of London are often overlooked in the midst of the other and more prominent branches of commerce, but, whether they are considered in their magnitude or value, they are very important. They consist chiefly of fine goods and articles of elegant use, brought to more than the ordinary degrees of perfection such as cutlery, jewellery, articles of gold and silver, japan ware, cut-glass cabinet-work and gentlemens carriages, or of particular articles that require a metropolis, or a port, or a great market for their consumption.[18]

The metropolitan area was by far the largest manufacturing centre in the country, and as Phillip noted it was distinguished by a disproportionately large luxury sector.[19] Pastor Wendeborn was assured that over a quarter of all English manufactories were in London.[20] Manufacturing had to adapt to the advantages and drawbacks: of operating in the nation's capital. There were three large drawbacks: land cost more, so rents were higher than elsewhere; labour cost more; and fuel cost more than it did on or near coalfields. To balance these disadvantages were London's proximity to the largest and most concentrated market in country; low transport costs for finished products; and its prime position for the observation of consumer taste. Labour cost more but there was a great deal of it, and it came in almost any degree of skill required. As William Hazlitt noted, in London 'you are within two or three miles reach of persons, that' outside the

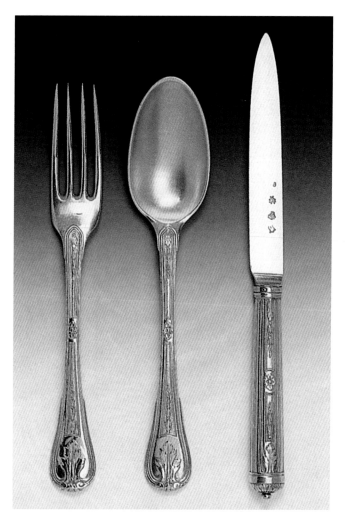

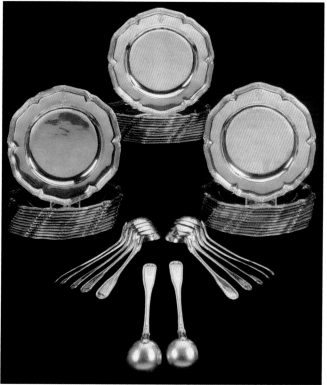

capital, 'would be some hundreds apart'.[21] Manufacturing in the capital adapted to these particular circumstances with systems of production that favoured smaller-scale outfits which were quick to adapt to changing fashions. So, instead of factories, production was shared amongst specialists. As Peter Hall points out, the assembly line ran through the street, where the material in its different stages of completion was carried from one manufacturer to another.[22]

SUBCONTRACTING: COMPOSITE AND INDIVIDUAL ORDERS

This system of manufacture meant that not only large, composite orders could be fulfilled quickly but that individual objects often passed through several pairs of hands in the process of construction and decoration. The extent to which some goldsmiths sold wares made by others can demonstrated by tracing the makers of the constituent parts of one of Parker and Wakelin's dinner services.

Following the first Earl Harcourt's appointment as ambassador to Paris in 1768, he ordered a substantial service of plate from Parker and Wakelin. His account for 13 March that year, which dealt with the order, amounted to £3,862 11s. 2d. (fig. 42). From this order it appears that Parker and Wakelin were responsible for the whole service. However, the order can be traced back into the Workmen's Ledger to reveal who actually supplied the constituent parts and how much they charged Parker and Wakelin for their labour. Taking the silver-gilt dessert service first, the '42 Baggatt Plates', weighing 790 troy oz 18dwt, for which Harcourt was charged £260 16s. 6d, were made by Ansill and Gilbert for £39 11s. (fig. 43).[23] The gilding cost a further £180 10s. 6d, which was included in Thomas Caler's regular, but non-itemized bills. The accompanying silver-gilt plates were also made by Ansill and Gilbert. Without the Workmen's accounts the identity of these suppliers would have remained anonymous, as the surviving service reveals that the plates were marked by Parker and Wakelin and not by their subcontractors (fig. 44).[24] The flatware specialists, however, seem to have preferred to mark the wares they supplied: the '12 Chais'd Dezert four Prong's forks and 12 Do Spoons', weighing 50 troy oz, bear the punch of William and Thomas Chawner, the maker's account being credited with £10 6s. on 11 February 1769,[25] while Harcourt was charged £14 6s. 2d. for the silver in addition to 11s. each for making, that is £13 4s, almost as much for their fashion as for the material, showing just how much fine chasing could cost. They were made to match existing flatware in Harcourt's possession, made by the Parisian goldsmith François-Thomas Germain in 1767. On top of this came 5s. 6d. each for gilding.[26] The handles of the dessert knives were supplied by Phillip Norman, not a flatware specialist but a general retailer, who is likely to have subcontracted this order out himself (fig. 45). Norman's account was credited with £6 6s. on 23 February 1769 for '12 fine Dezert knife handles' (fig. 46). They reappear in Earl Harcourt's order of 13 March 1769 as '12 fine Chais'd Desert knife handles', together 'with silver blades', 31 oz 10 dwt, for which he was charged £6 18s. 6d, in addition to 17s. each 'To making the knives with Blades' and 5s. 6d. each 'To Gilding'. The provision of this service, which bears a variety of goldsmiths' marks, should be contrasted with the dinner service supplied to Charles Pelham in 1770, the majority of which bears the retailer's, Parker and Wakelin's mark, but was supplied via exactly the same process of subcontracting.[27]

The subcontracting network operated not only at the level of composite, large-scale orders, but also on the smaller scale of individual objects.[28] The supply of a particular type of tea caddy, referred to in the Ledgers as a 'tea tub', demonstrates how the system worked (fig. 47).

Fig. 42. Detail from Earl Harcourt's account with Parker and Wakelin, showing order of his ambassadorial service, delivered 13 March 1769. Gentle-men's Ledger. Victoria & Albert Museum, London

Fig. 43. Detail from Ansill and Gilbert's account with Parker and Wakelin showing supply of part of Earl Harcourt's ambassadorial service, 9 March 1769. Workmen's Ledger. Victoria & Albert Museum, London

Fig. 44. Dessert Service: thirty-six silver-gilt plates, by Parker and Wakelin, 1768; and twelve silver-gilt ladles (olio spoons), by Phillip Norman, 1768. Silver-gilt (London); plates diameter 26 cm, ladle length 26 cm

Fig. 45. Dessert knives, forks and spoons, by François-Thomas Germain, Paris, part of a twenty-four-place setting; 1767. Silver (Paris)

Fig. 46. Detail of contra side of Phillip Norman's account with Parker and Wakelin, showing order of dessert-knife handles on 23 February, and twelve threaded olio spoons, 13 March 1769. Workmen's Ledger. Victoria & Albert Museum, London

Fig. 47. Tea tub, marked by Aaron Lestourgeon; 1768. Silver (London); diameter 9 cm. Ashmolean Museum, Oxford

Fig. 48. Trade card of Chandler and Newsom, tea dealers and grocers, by W. Newman; c. 1790. Engraving; 6.5 × 9 cm. Bodleian Library, Oxford

Fig. 49. *A Tea Warehouse, Canton,* by an anonymous Chinese artist; *c.* 1800. Gouache; 37.5 × 47.5 cm. Martyn Gregory Gallery, London

Aldridge and Woodnorth, or more usually Ansill and Gilbert, made the body of the tea tub using small-working techniques of scoring, folding and soldering flat sheet silver, at a standard charge to Parker and Wakelin of £1 8s. each. The advent of the flatting mill made the supply of flat-rolled sheet to an even gauge cheap (as there was less weight of silver required than for raising or casting) and easy (compared to hand hammering from the ingot). The cube form, called 'square' in the ledgers, was quick and involved less labour to make compared with the more time-consuming raising required for earlier designs of canister.[29] The design and ornament were based on the chests in which tea was imported from China (fig. 49), which appear in the trade cards of eighteenth-century grocers (fig. 48), like that of Chandler and Newsom, tea dealers and grocers. The design could also be adapted to circular, oval (which were cheaper to make at £1 5s. each) and octagonal forms (fig. 50). Ansill and Gilbert also supplied the cast finials, in a choice of three sizes of 'sprig' – small, medium and large – which were attached to the lid by means of a silver nut. The tubs were then passed to Aaron and William Lestourgeon, for locks to be fitted and the interior lined with lead, or sometimes pewter, to keep the contents fresh, at a standard charge of 5s. per tub. After lining, the 'Chinese' or 'India' characters and borders, either scroll or key pattern, were engraved by Robert Clee, although his orders are rarely itemized. The simplicity of the design, relying on the engraving for ornament, meant that it was easy and cheap to 'customise' the design, incorporating the purchaser's coat of arms or more elaborate scenes taken from published sources. The last part of the order concerned the case (if one was required), from Edward Smith, which usually took the form of a mahogany box costing between 10s. and 18s., and an outer case of deal for protection whilst in transit from the retail shop to the customer.

The £18 9s. 2d. which Richard Cox, a wealthy army agent, paid for '2 square tea tubs' in February 1768, can thus be divided between £7 7s. 2d. for the 26 troy oz 7dwt of silver, £4 4s. for the making (for which Parker and Wakelin paid Ansill and Gilbert £3 6s.), £6 6s. for locks and linings to be fitted by the Lestourgeons, which included the 10s. for 'graving of Characters' and '2 Coats'. The 'Plain mahogany case' from Smith cost 12s.[30] The supply of Cox's tea tubs thus involved five different parties. The retailers Parker and Wakelin took the order and organized its circuit around the specialists; the plateworkers Ansill and Gilbert made the form; the Lestourgeons applied the locks and linings; the engraver Robert Clee decorated the surface; and the case supplier Edward Smith provided the lockable box. The whole process of manufacture took under three weeks to complete.

THE IMPORTANCE OF SHARED INFORMATION

The success of this system of supply relied upon the efficient circulation of information, the availability of skilled labour and the operation of credit networks. Access to information was the key to the smooth running of subcontracting. Retailers and makers needed to know who was free to work for them, where they were located, what their specialization was and how much they charged. A sudden, large order might mean the retailer had to look beyond his usual network. George Coyte, who called himself a 'silversmith and toyman', working in Bridges Street, Covent Garden,[31] used the back of his day book to note down potential suppliers: Mrs Pollard sold 'jewels of all kinds, Hoop rings of all colours, lives at the Corner of Portigal Row, the corner of Lincoln's Inn Fields – sells very good garnett earrings at 5s. a pr sett in gold and garnett hoop rings at 6s. a piece and I think very neat small seals at 7s. a piece'.[32] Coyte

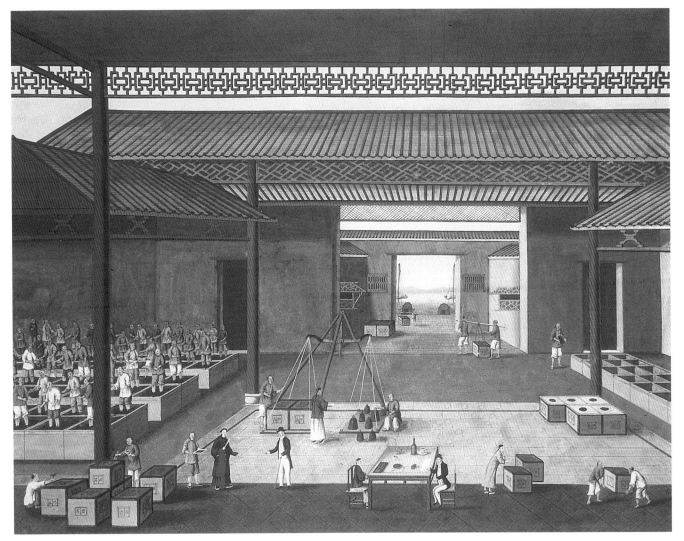

Fig. 50. Tea tub, marked by Willliam and Aaron Lestourgeon, with medium size cast sprig finial and chinoiserie engraving; 1768. Silver (London); height 12.5 cm

added that 'the Jewler that setts marquisats, bars of earrings, pins, rings – works for Shelly and King, Lodges at Mrs Smiths a Chandlers Shop, near the Sun in Clements Lane'.[33] Coyte also noted how much Betsy Aitkin of Ely, who lived in Bowling Alley Street, Westminster, charged for her painting on ivory, vellum and satin: 8s. for 'midle landscape upon ivory', and 7s. for work 'upon velem or white sattin'. From one customer, Mrs Jarman, he discovered a 'ring maker, John Fry number 6 Bull and Mouth Street, Aldersgate, rings 3s. 6d.'.

Arthur Webb, a jeweller in Throgmorton Street, created his own network of subcontractors whose names he noted in his account books, including Mrs Small and Dennet of Frith Street who did his enamelling, Mrs Hyde who threaded beads, Mr Hogg a stone setter, Mr Nicholls a diamond cutter and Mr Triquett a lapidary in Leicester Fields. A retailer's reputation rested on the quality and efficiency of his subcontractors. If things went wrong it was the retailer who had to face the customer. Arthur Webb had to write to one of his most important customers, Major Butler, in 1772 explaining that:

> I have been much concerned at the delay there has been with your Commission in truth it was not owing to any neglect in me, but to a principal false stone worker in the City whose business consists in such sort of things, tho these were a novelty to him, I went in many times and wrote to hasten him but to no purport.

It was not only information about suppliers that was required, but also the smooth transmission of design details. The form, decoration and weight of an order had to be accurately conveyed if the end product was to meet with the customer's satisfaction. Failure meant loss of time and put the relationship between the retailer and client at risk. One of Parker and Wakelin's suppliers, Thomas Whipham, mistook 'the mark on each candlestick for the weight of the pair' when he was asked by the goldsmith Joseph Brasbridge to make a pair 'exactly similar indeed on point of pattern', but ended up 'as thin as paper'.[34] Brasbridge was then obliged to go to Robert Makepeace, the original retailer of the candlestick and ask for a matching pair.[35]

Eighteenth-century London luxury retailers depended on their ability to grant credit to their important customers. The large capital sums involved in these firms were not just used in setting up the premises and in providing shop stock. Vast amounts were also necessary to provide many customers with credit, some of whom took many months, if not years, to pay their debts. In the goldsmiths' trade, the retailers settled their accounts with their suppliers at frequent intervals, by arranging for the working silversmiths to be supplied with silver bullion and by paying for the costs of manufacturing the wares. Thus it was the retailers who were the first in line, bearing the risk of any customer being unable to settle his debts and, as a result, it was more normal for such credit-supplying retailers to go bankrupt, not the specialist manufacturers. However, those who subcontracted out were freed from supporting a permanent workforce that required regular payment whatever the state of the market. From their perspective, whilst the specialist suppliers would have been diversifying their risks and delivering their lines to a number of different retailers, disasters could still occur.[36] If one business failed it had the potential to effect many others.

One of the most dramatic bankruptcies in the 1770s concerned James Cox (c. 1723–1800), the celebrated and much self-publicized jeweller, watch, clock and automata maker, who claimed at the height of his success that he employed over eight hundred hands.[37] The Prussian officer von Archenholtz, who visited London in 1771, noted in his diary that 'The most notable mechanics of England and France, jewellers, watchmakers, goldsmiths etc. were invited to

furnish . . . [Cox] with their masterpieces in the various arts'.[38] Many depended on Cox to keep afloat, and when he began to experience financial difficulties the complex credit networks that tied them all together collapsed. The extent of this interconnectivity is revealed in a letter sent by Arthur Webb to one his customers, in which he described the impact of Cox's financial collapse: 'it is certainly the worst season of the year for our Business independent of w^{ch} Mr Cox having dismissed such a vast number of hands when he stopt paym^{t} that very many in the various Branches and their Families are destitute and some gone or going to our settlements abroad'.[39] As a result, the ripples of the London subcontracting system washed the shores of other countries. Cox was perhaps the nearest equivalent to the Parisian *marchands merciers* who no longer made things, but had them made for them. Their actual work was carried on between purchase and manufacture, between supply and sale.[40]

BUSINESS AND PLEASURE

London tradesmen were not only interconnected by business but also by pleasure, although it would be misleading to separate the two. For example, the jeweller Arthur Webb appears to have been a keen amateur scientist, natural history collector, musician and fisherman. The inventory of his household furniture taken at his death in 1792 reveals that he possessed a telescope, barometer, thermometer, hygrometer, hydrostatic balance and a microscope. He also had four boxes of wood samples and shells, a box containing sundry crabs, a basket of fossils and a box of pebbles. He owned a bird organ, a German flute, a fife, violin and piano. His casting net, fishing rods and tackle were in the front garret.[41] Each of these pursuits would have connected him with other specialist groups of people who widened the complex network of contacts. He was clearly a refined gentleman. One can imagine him in the silk stockings and figured waistcoats listed in the inventory, reading his copy of Hogarth's *Analysis of Beauty*, consulting his collection of prints, which included the works of Titian, Veronese and Rubens. Like the characters in Joseph Wright of Derby's painted 'scientific' scenes, he was engaged with an Enlightened understanding of the physical and cultural world which he inhabited. A glimpse at the contents of his library testifies to the range of his interests and included Brooke's *Art of Angling*, Milton's *Paradise Lost*, Baker on *The Microscope* and Plutarch's *Lives*.

Dru Drury was not only a goldsmith with a shop in Villiers Street, but was also a keen entomologist. His day book, now in the Natural History Museum, reveals that on the same day he was taking orders for silver knives, forks and spoons, he was sending solander boxes out to Papua New Guinea. It was his importance as a collector and cataloguer of insects, rather than his reputation as a goldsmith, which rescued him from bankruptcy. His scientific friends and admirers bailed him out and gave him large orders to restore his position.

The goldsmith Abraham Portal (1726–1809) was more interested in writing plays and poetry than attending to his goldsmith's shop; while John Tuite, according to the patents he registered in the 1730s to 1750s, was as much an ingenious mechanic, inventing water pumps, as a working goldsmith.[42] Tuite's patents were underwritten by Lewis Pantin I, a fellow goldsmith working in Leicester Fields. Networking connected trades and families, work and home, competitor and collaborator, art with science.

5

The Goldsmiths' Network:
'Hands that excel in every Branch'

> The Goldsmith employs several distinct workmen, almost as many as
> there are different Articles in his Shop; for in this great City there are
> Hands that excel in every Branch, and are constantly employed but in
> that one of which they are Masters. He employs besides those in his
> Shop, many Hands without.
>
> R. Campbell, *The London Tradesman*, 1747

We know from Campbell that London goldsmiths relied on 'several distinct workmen', but how were they divided between those based within the 'shop', and those without, between dependent and independent suppliers? What exactly did these relationships involve? Parker and Wakelin's Workmen's Ledger, listing the names of their suppliers, what they provided and how much they charged, means that, for the first time, we can answer some of these questions. We can unravel the interconnections between work and retail shops which, by their nature, cast light upon not just one business but upon a large proportion of the London goldsmiths' and associated trades.

Parker and Wakelin had no need of their own manufacturing facilities; they relied on organising others to provide what they needed, from the smallest salt spoon to the grandest centrepiece for the table, from the most standard wares to the execution of architect-designed tureens. Their dependence on skilled workmen from 'without' has important implications for how we view the relationship between leading goldsmiths: as rivals with their own team of makers, or as part of a much more complex network of shared skills, where individual authorship, the circulation of patterns and the dissemination of design was far more complicated than we had previously thought. Parker and Wakelin's shared network offers a picture of the London goldsmiths' trade in the second-half of the eighteenth century, that revolves around separate and independent workshops competing for, and also co-operating on commissions. It was a mode of operation that dated back to at least the late sixteenth century, if not before.

SHOPS FOR MAKING AND SELLING

Although Parker and Wakelin's partnership contract made provision for the taking on of apprentices 'to be employed in and about the Business', the partners took only four between them over the whole period of their partnership (1760–76), and all appear by their training, backgrounds and evidence of what they did, to have been employed in a shopkeeping and not a manufacturing capacity. Parker's only recorded apprentice was Daniel

Fig. 51. John Christopher Romer's account with Edward Wakelin, Wakelin's Supply Ledger; 1757–60. Victoria & Albert Museum, London

Fig. 52. Pair of dish rings, by John Christopher Romer. Each is engraved with the crest of the 3rd Duke of Buccleuch and 6th Duke of Queensberry (1746–1812), with a ducal coronet above; 1765. Silver (London); diameter 23.5 cm

Flowerdew, taken in June 1762,[1] although it is evident from the accounts that a young lad named William Yelverton was also employed to help with the business.[2] Flowerdew's name appears on a shop bill of 1765, which suggests that he was helping with the accounts. This is confirmed by the appearance of his signature, and that of Yelverton's, at the bottom of the end of year accounts for the subcontractors Ansill and Gilbert (*see* fig. 9).[3] Wakelin, who was free of apprentices by the time of his partnership with Parker, took three new ones, Thomas Boswood in 1761,[4] Thomas Kinnaird in March 1766[5] and, on the same date, his own son John.[6] It is likely that they assisted in the shop and were taught the arts of bookkeeping, salesmanship and management.

All these men were certainly not sufficient in either training or numbers, at any one time, to manufacture in any great quantity of silver, and there is no evidence for the employment of journeymen under the partners' direct supervision. If we look at the precise wording of Parker and Wakelin's partnership contract it is clear that no mention is made of making but only of 'buying selling uttering vending and retailing of all sorts of Wrought Plate'. Running a network of seventy-five subcontractors was a time-consuming and skilled business in its own right.

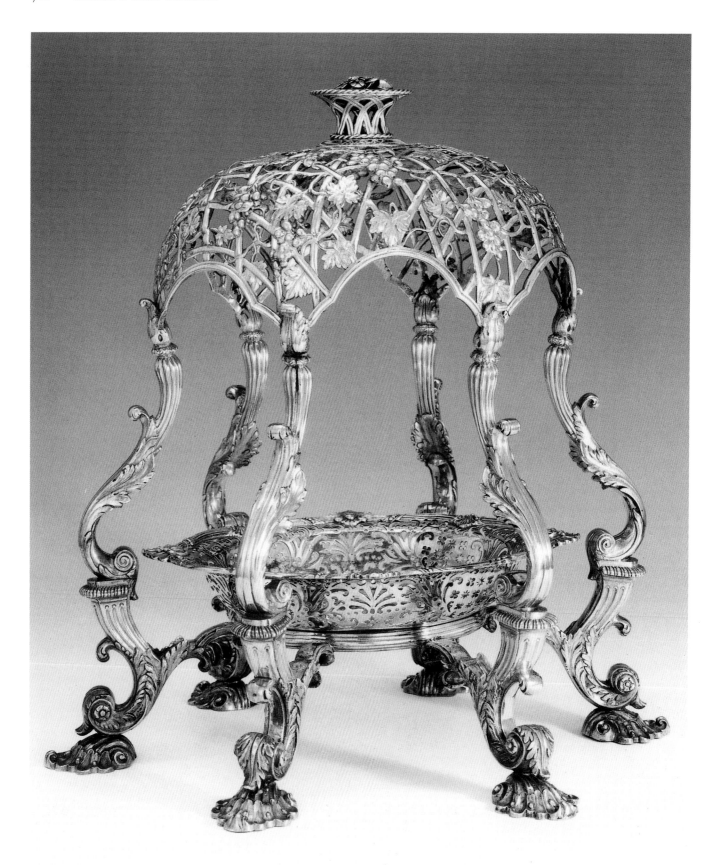

JOHN CHRISTOPHER ROMER

The absence of evidence for the employment of servants or journeymen, and the number and character of Wakelin's new apprentices after his partnership with Parker, suggests that Wakelin gave up running the workshop next-door-but-one to the King's Arms when he entered the partnership. This is supported by the transference of the workshop, including 'patterns fixtures and the lease of the house' along with an extra £7 7s. for '2 beds 2 bolsters, 4 blankets 2 coverlids a grate fire shovell and tongs 6 chairs a large candle box and a safe', to John Christopher Romer for £400 on the day the new partnership began. His last entry in Wakelin's supply ledger is made on the same date (fig. 51). In 1760 Romer would have been an experienced silversmith of forty-five years old, who had been supplying the firm with cast work from his St James's workshop since at least May 1752. Work bearing his mark can be related to clients who do not appear in Parker and Wakelin's accounts, suggesting that Romer also supplied other retailing goldsmiths. This evidence is important in showing that he was an independent supplier and not a dedicated subsidiary of the Panton Street firm. A pair of dish rings with cast palm and acanthus borders, of 1765, bear the contemporary arms of the third Duke of Buccleuch, who was not at the time a customer of the Panton Street business (fig. 52), nor are there dish rings of this weight in the firm's Gentlemen's or Workmen's accounts.[7] There are many other examples to prove this order was not exceptional.

It is impossible to be precise about how long Romer worked from the Panton Street workshop. His name does not appear in the 1766–70 Workmen's Ledger, and we know that by 1773 he was working from Compton Street in Soho.[8] A cup and cover of 1772 bears his mark and is engraved 'Portal and Gearing Fecit Ludgate Hill' which shows that he continued to make work sold by retailing goldsmiths.[9] It may be no accident that work bearing his mark starts appearing from 1764/65, like that on a 'pagoda' centrepiece made for Thomas Conolly, based on a design after William Kent, and used first in 1745 by Wickes (fig. 53).[10]

JAMES ANSILL AND STEPHEN GILBERT

Romer's role as Parker and Wakelin's key supplier appears to have been only a temporary one, as James Ansill and Stephen Gilbert appear to have gradually taken his place. It is clear that from the first Ansill and Gilbert had been groomed for a special place within the business. Ansill was apprenticed to Wakelin in September 1748 and Gilbert followed him in 1752. Both were from Wakelin's home county of Staffordshire: Ansill from Stow and Gilbert from Hixton.[11] Before and during his apprenticeship Ansill was paid £8 per annum from 1746 to 1755, and Gilbert received £5 annually between 1749 and 1751. Wakelin, as workshop manager, would have had the opportunity of training them, not only supervising their making but also introducing them to the management of a workforce. Perhaps, in 1760, they had been too inexperienced to be responsible for the supply of such a large amount of silverware. Gilbert would have just finished his apprenticeship, while Ansill had completed his term five years before. Neither would have had enough money to set up in business independently. By 1764, however, they appear to have been ready. In order to run a workshop and take apprentices they needed to be free of the Goldsmiths' Company. Ansill claimed his freedom on 1 January 1764, and Gilbert just a month later.

Fig. 53. Pagoda centrepiece, by John Christopher Romer, based on a design by William Kent, published by Vardy in 1744. Engraved with the arms of Conolly impaling Lennox, for the Rt. Hon. Thomas Connolly of Castletown, Co. Kildare; 1765. Silver (London); height 42 cm

Fig. 54. Dinner Service, for the 6th Baron Craven (1738–1806), including forty-eight shaped circular plates and eighteen shaped entrée dishes, marked by Sebastian and James Crespel; and fifteen meat dishes marked by Francis Butty and Nicholas Dumée; 1766–7. Silver (London)

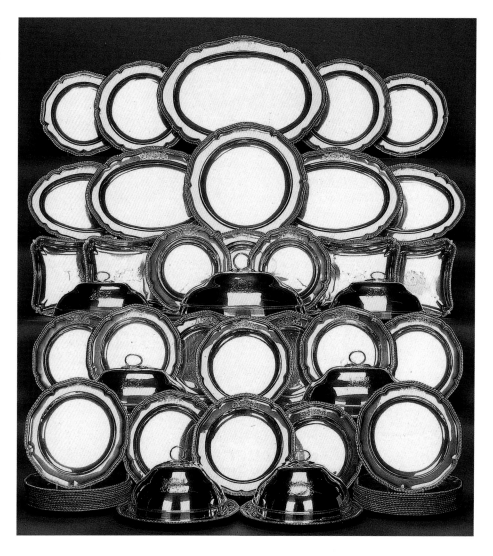

We cannot be sure of the exact date at which Ansill and Gilbert took over from Romer. Their signatures appear in the surviving Workmen's Ledger for the end of the accounting year October 1766. The earliest reference to their paying rent for a workshop is 17 October 1767, when their account includes 'a Years Rent and taxes to Michaelmas' of £40 0s. 10d. for the workshop used first by Wakelin, then by Romer. Ansill and Gilbert took on a new apprentice almost every year between 1764 and 1772.[12] It is significant that many of these apprentices were turnovers who had served two-to-four years with other masters before joining Ansill and Gilbert, suggesting a demand for semi-skilled workers rather than for raw new recruits. They also maintained the Staffordshire connection their master had initiated, taking Randolph Jones, of Church Stretton, in 1767 and John Hulme, of Uttoxeter, in 1768.

Ansill and Gilbert, along with their workforce, supplied the lion's share of wrought plate to Parker and Wakelin's business from 1764, just as Wakelin had for Wickes and Netherton in the 1740s and 1750s. In the year 1766/67 they supplied 17,842 troy oz of plate, representing three quarters of that year's total weight of silver (23,934 troy oz). They charged Parker and Wakelin £2,271 for working it up into a wide range of silverware. In July 1769 alone, they delivered twenty-three orders including six bottle tickets, a

tumbler, two 'fine chaised Terrines and Covers', five 'double shell skewers for beef and veal' and the fourth Duke of Marlborough's communion plate, comprising a chased flagon, chalice, paten and bread plate. The diversity of silverwares made by Ansill and Gilbert and their workforce, requiring raising, casting and forging, as well as high quality chasing and engraving, suggests that they had access to a whole range of making and decorative techniques.

Ansill and Gilbert continued supplying the firm with silver until 1779, when James Ansill died. His two apprentices, Thomas Orton and John Devereux, were turned over to John Wakelin who, with William Tayler, had taken over the Panton Street business three years earlier. Gilbert did not retire but took Joseph Taconet as an apprentice in November 1779, giving Church Street, Soho, as his address.[13] A year later Gilbert registered a joint mark with the Swedish goldsmith Andrew Fogelberg, who had been apprenticed in Gothenburg and had arrived in England sometime in the early 1770s.[14]

THE CRESPELS

In 1779 Ansill and Gilbert were replaced as Parker and Wakelin's major suppliers by James and Sebastian Crespel who had been making silver for them from at least 1769, when their names appear in the first surviving Workmen's Ledger.[15] In six months alone they turned 2,279 troy oz of silver into dishes, plates, sauceboats and gravy pots, charging £89 1s. 2d. for their labour, working from their Whitcomb Street premises just round the corner from Panton Street.[16 17] It is clear from work bearing their mark prior to this date that they supplied other retailers with high-quality largework. When William, sixth Baron Craven (1738–1806), married in 1767 he purchased a large dinner service made up mainly of silver marked by the Crespels, including 48 dinner plates and seventeen oval meat dishes (fig. 54).[18] The bill for the service reveals that it was retailed by Thomas Heming the Royal goldsmith, a significant competitor of the Parker and Wakelin partnership.

The Crespels continued to supply Heming as well as Parker and Wakelin after 1770. Six serving dishes of that date bear the Crespel's mark, overstruck by that of Thomas Heming, and were sold to William Tatton Egerton (1749–1806).[19] This demonstrates their independence and proves that they were subcontractors rather than merely 'tied' suppliers or a wholly-owned subsidiary of Parker and Wakelin. The ascendance of the Crespels as Parker and Wakelin's major suppliers can be seen in the steady increase in silverware they provided. In 1778/79 the Crespels worked 20,201 troy oz of plate, two years later it had risen to 22,700 troy oz.

The success of a leading London retail goldsmith's business relied upon two complementary sets of skills: the manufacture and supply of silverware on the one hand and retailing, involving sales and management, on the other. The two activities were often divided between individuals or partnerships. Wickes and Netherton relinquished the responsibility of manufacture and supply to Edward Wakelin in the late 1740s and 1750s, while they concentrated on administration. The pattern was repeated in the 1760s and 1770s when Ansill and Gilbert took over Wakelin's workshop while Parker and Wakelin controlled the sales and credit control; and again in the 1770s and 1780s when the Crespels supplied first Parker and Wakelin and then Wakelin and Tayler. The relationship between the Panton Street business and their major suppliers was thus a crucial element of a strategic division of labour that ensured a regular and reliable supply and rested on the interconnected bonds of business, family and friendship.

THE WIDER NETWORK

Although Ansill and Gilbert and the Crespels supplied a great deal of plate to Parker and Wakelin, there were many others who helped maintain the diversity of plate and services expected by customers. They were part of a much larger group of subcontractors, who between 1766 and 1770 numbered seventy-five, whose various skills and specialisms, places of work and relationship with the partners, created different levels of association and interdependency (*see* appendix 1). Of these seventy-five, there were fifty-three silversmiths or related tradesmen and twenty-two were connected with jewellery and gold work. Silverwares supplied to customers bore either Parker and Wakelin's mark or that of a subcontractor, making the reliance on so-called 'maker's marks' a misleading means of identifying a representative range of work for a single business. Some manufacturers, like the specialist salt suppliers, the Hennells, seem to have been keen to have their mark stamped on their wares, while others were not. Some registered their own marks at Goldsmiths' Hall, while the work of others remained anonymous.

There are various ways in which these specialists can be categorized, but it is by their skills and goods they offered that they can most clearly be identified. On this basis we can distinguish between suppliers of raw materials: first and most crucially, the refiners; second, those who supplied specialist types of silverware, like Thomas Pitts, who seems to have made largely épergnes and tureens; third, there were those who offered particular skills, such as engravers and gilders. What drew all three groups together was the fact that under the generic title of 'goldsmith' they were the elite of London's workforce, the 'genteelest in the mechanick way' and, according to Adam Smith, their wages were 'everywhere superior to those of many other workmen, not only of equal but of superior ingenuity, on account of the precious material with which they are entrusted'.[20] These subcontractors were paid by the piece and submitted bills for their labour and materials used. The following description of Parker and Wakelin's subcontracted workforce is organized around the particular materials, types of silver and jewellery and skills they offered. These descriptions reveal the broader picture common to the London trade.

THE REFINERS

Although the goldsmith was able to refine his own silver 'he has more Advantage in employing those who make it their Sole Business', a good example of the advantages of specialization.[21] By the mid-eighteenth century refining was 'a distinct Branch belonging to the Goldsmiths' Trade'. Campbell explained that the process of 'separating Silver from Gold and other Metals, and reducing them to their proper Standard', required 'great Judgment in Alchemy, and much practice to become expert in the several Processes in which they are engaged'. He warned that although journeymen could earn between half-a-crown (2s. 6d.) and 3s. 6d. a day, refiners were 'Subject to Paralytic Disorders, from the Effluvia of the great Quantity of mercury they use'.[22] The *Gentleman's Magazine* of 1753 recommended the swallowing of gold leaf, which would attract the mercury as it passed through the body, and commented 'gilders know where to find the gold again'.[23] Gilders tended to earn more, but died young.

Mortimer, in his *Universal Director* (1763), explained that refiners 'not only refine Gold and Silver in substance, but likewise purify the smallest filings that

fall from the tools of the Gold and Silver workers'.[24] They also burnt old gold and silver lace, and bought foreign currency, such as Spanish dollars, for its melt value. Mortimer listed only eight refiners in London 'because a large capital is requisite, in order to arrive at any degree of eminence'. Yet there were many more in London, but presumably they did not think it worthwhile paying for inclusion in the *Director*.

Spindler and Palmer were Parker and Wakelin's main source of refined silver until 1769. Samuel 'Spendler' is listed by Mortimer as being in Gutter Lane, and must have subsequently entered into a partnership with Palmer. Their accounts with Parker and Wakelin were brought from the first Workmen's Ledger, and list between five and ten monthly weights of 'old silver' supplied: 9,837 troy oz between January and October 1767, costing £2,787; 5,293 troy oz between October 1767 and February 1768; and 3,010 troy oz between March 1768 and January 1769, some of which appears to have been sent direct to Parker and Wakelin's suppliers. For example, in October 1767, 700 troy oz of silver was sent to Ansill and Gilbert, 200 troy oz to Whipham and Wright and 100 troy oz to George Padmore. It is easier to understand what these weights represent if we translate them into their equivalent in wrought goods, Lord Molyneaux's five dozen round dinner plates weighed nearly 1,000 troy oz.

In 1769 Parker and Wakelin switched to William Binns as their main source of refined silver. Between March and April 1769 he supplied 3,999 troy oz, between June and July 2,000 troy oz, July to August 1,000 troy oz and September to October 3,000 troy oz. Binns accepted dollars and gave cash for 'articles marked off', which refers to the silverwares Parker and Wakelin's customers traded in, as part payment of their bills. The Earl of Coventry, for example, paid for £90 worth of silver by trading in '2 Fire dogs, 4 Tops and a Pap boat, a Large Dish, and silver taken off 4 sallad dishes'. Sir Roger Newdigate part financed the purchase of a fine tea urn by sending in 'an old challice'. Yelverton's signature at the bottom of Binns' accounts suggest that the management of raw silver was one of his shop duties.

From May 1769 Parker and Wakelin also began using Robert Albion Cox, a refiner in Little Britain, although their account with Binns continues in the ledger until 1773.[25] Cox's name appears in many goldsmiths' accounts; he appears to have cut a large figure in the London trade as the founder of the most important London refinery of the time. That he was keen for business is evident from a surviving letter of his to Matthew Boulton, soliciting trade, which was ultimately successful.[26] Cox had registered a mark at Goldsmiths' Hall on the attainment of his freedom in 1752, and a few objects survive that bear his mark. His priorities, however, appear to have lain with refining, suggested by the fact that in March 1768 he spent £300 registering a patent for 'a new method of refining gold, silver, copper, lead its ores, waste and sweepings'.[27] The testimony of one of his apprentices to the 1773 Parliamentary Committee reveals that his master, Cox, 'sold Five thousand Ounces of Silver Weekly to Working Silversmiths', and that 'he believed he had more than Two hundred Customers in Town and Country'.[28]

The networks of business spread far beyond Britain. Refiners were connected with international precious-metal brokers who traded with the Iberian peninsula, with the Spanish and Portuguese colonies in America, and Amsterdam, as well as with the Levant, the Baltic area and even India.[29]

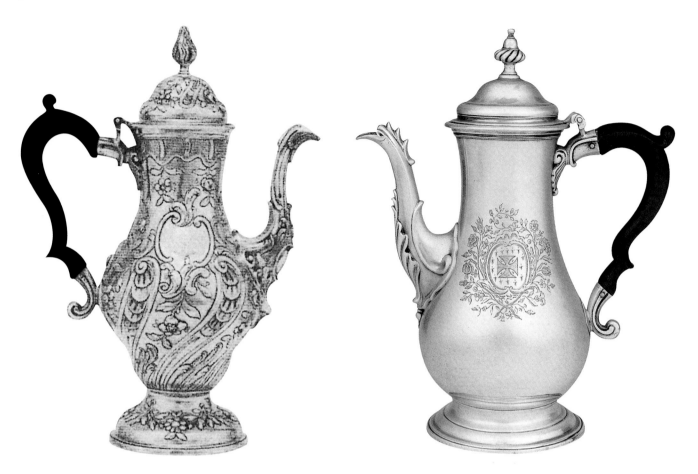

Fig. 55. Coffee pot, by Thomas Whipham and Charles Wright; 1766. Silver (London); height 32 cm

Fig. 56. Coffee pot, by Thomas Whipham and Charles Wright; 1767. Silver (London); height 28 cm

PLATEWORKERS

A distinctive group of Parker and Wakelin's suppliers were trained as working goldsmiths and provided a wide range of silverware: from large tureens to small bottle stands, tea canisters and cruets. Their production involved all the techniques of construction, from raising, box-making and casting as well as decoration, including embossing, chasing, piercing and engraving. Their addresses were largely in the City and not in the retailing district of the West End. Whilst John Romer, Ansill and Gilbert and the Crespels provided most of this type of silverware, they did not supply it all. Three partnerships of goldsmiths, Aldridge and Woodnorth, Whipham and Wright, and Herne and Butty supplemented Parker and Wakelin's stock. The amount of silver they supplied suggests that their work for the business provided only a small proportion of their livelihood. The success and continuity of Parker and Wakelin's business should be set against the experiences of these three supply partnerships and that of the other subcontractors whose fortunes appear to have been far from uniformly buoyant.

Aldridge and Woodnorth's account with Parker and Wakelin was brought forward from the first, and now lost, Workmen's Ledger, so it is not clear exactly when they began supplying the Panton Street business, but it was certainly before 1765. They appear throughout the second, surviving, Ledger until June 1771. Edward Aldridge had been in partnership with his father, a specialist silver basketmaker, in Foster Lane until he moved to George Street, St Martin's Le Grand in 1762.[30] William Woodnorth was working as a goldsmith from the same street in 1771, and it seems likely that they had become partners. The absence of any surviving trade card for the partnership suggests

Fig. 57. *Prince William, later Duke of Clarence, as a child*, showing a gilt tea urn, by Allan Ramsay (1713–84); *c.* 1764. Oil on canvas; height 66 cm. The Royal Collection. Right, detail.

that it was acting as supplier rather than as a retailer. In 1766 they supplied Parker and Wakelin with 3,438 troy oz of silverware, charging £1,950 for their labour; in 1767 they supplied 2,024 troy oz, charging £1,003; and in 1768 they supplied 2,220 troy oz, charging £1,670.

By looking at the orders they supplied over a single month it is possible to get an impression of the range of wares they made. In April 1766, for example, they delivered a small, nurled inkstand, a large dolphin trowel, a set of vases, a set of chased canisters, three escallop shells and three dish crosses.[31] These objects would have required raising, piercing, box-making and casting techniques, as well as chasing and polishing. Glancing down the far right hand column of their account it is easy to identify a range of standard charges for their workmanship: £5 15s. 6d. for making chased bread baskets, £5 5s. for gadrooned ones, the former clearly requiring more labour than the latter. Nurled dish crosses came at £2 15s. each. An 'upright orange strainer', '2 large cream pails and ladles' and a 'black peartree inkstand' each cost £1 1s. to make. Woodnorth appears either to have died or left Aldridge in June 1771, as the latter stays in Parker and Wakelin's accounts and gave evidence to the 1773 Committee, while the former disappears.

Thomas Whipham (senior) and Charles Wright, who advertised themselves as 'plateworkers', and from 1769 Wright alone,[32] supplied a wide range of silver goods, including coffeepots and tea urns, cruets and labels, inkstands and tea canisters. They charged Parker and Wakelin between £8 16s. 6d. and £9 13s. 7d. for their tea vases, the more expensive ones having 'a fine foot'.[33] For the average bottle ticket they were paid 1s. labour and 1s. 3d. for the silver, making a net cost of 2s. 3d. per ticket.[34] However, the average retail price was

5s. 6d., a substantial mark-up. Small novelties were profitable to sell and popular with customers. Their account with Parker and Wakelin was settled yearly in September or December. Between December 1767 and September 1768 they supplied 1,256 troy ozs of wrought silver, charging £127 for their labour. These figures indicate that although they worked a greater weight of silver than Aldridge and Woodnorth, the workmanship was simpler and less decorative and, therefore, less time-consuming and expensive. Surviving silver with their mark suggests that, although much of their work was plain, they either bought-in or made themselves, more highly fashioned silver, although Parker and Wakelin chose not to order it from them. Two coffee pots, of 1766 and 1767 (figs 55, 56), show how extra workmanship in the form of embossing and more elaborate cast components could transform the look of an object from 'standard stock' to a 'one-off'.

Thomas Whipham senior had entered his first mark at Goldsmiths' Hall in 1737. In 1757, from premises in Ave Maria Lane in the City, he took his former apprentice, Charles Wright, as his partner,[35] and opened a shop in Fleet Street, leaving Wright at Ave Maria Lane; their partnership was to continue until 1769. That there was a close working relationship between the partnership and the Fleet Street business is verified by the survival of pages of an account book for the period 1762 to 1770. The accounts establish that Thomas Whipham, father and son, traded in the shop independently and at the same time worked closely with the partnership, and later with Charles Wright on his own.

It is evident that makers and retailers worked together for their mutual benefit in a variety of ways, and the Whipham–Wright relationship forms another successful business strategy.[36] What the pages from the Fleet Street account book also suggest is that as a retailer Whipham operated his own subcontracting network, one that overlapped with that of Parker and Wakelin, and no doubt with that of other London retailers and manufacturers. Payments were made to 'Romer', possibly John Christopher or Emick; Thomas Pitts, a working silversmith and chaser in Piccadilly; Thomas Nash, a silver piercer; and Herne and Butty, all of whom appear in Parker and Wakelin's accounts.

Lewis Herne had been in partnership with Francis Butty as a large worker in Clerkenwell Close from 1757.[37] We know from the 1762 bankruptcy papers of the goldsmith Phillips Garden, that Herne and Butty were his chief creditors and were likely to have been supplying him with silver, as they did Parker and Wakelin.[38] Herne absconded from that address in 1765, although Herne and Butty's account in Parker and Wakelin's surviving ledger, which include payment for plates, waiters, jugs and sauceboats, gives no indication of this.[39] Their account shows 357 troy oz in silver and £42 in cash brought over from an earlier account. In October 1767 Butty was paid £95 for working up 1,257 troy oz of plate and in February 1768, £59 for 227 troy oz plate, when the account was closed. An account in the name of 'Messrs Butty and Company', for Francis Butty and Nicholas Dumée, was opened with Parker and Wakelin in 1768, but comprises no more than half a dozen orders. This was fortunate for Parker and Wakelin as the bankruptcy of the new partnership was announced in the Gentlemen's Magazine only five years later, in

Fig. 58. Tea vase, by Francis Butty and Nicholas Dumée; 1763. Silver (London); height 55.9 cm, 112 troy oz. J.H. Bourdon Smith

Fig. 59. Tea vase, by Thomas Whipham and Charles Wright; 1764. Silver (London); height 35.6 cm

Fig. 60. Tea vase, by Francis Butty and Nicholas Dumée; 1767. Silver (London); height 49 cm

March 1773.[40] Butty was reported to have gone 'to France or into other foreign parts beyond the Seas', and was still missing three years later when Dumée joined William Holmes.[41]

From the 1760s the tea urn became increasingly fashionable. A portrait of the young Prince William, later Duke of Clarence, by Ramsay includes just such an urn. It is probably part of a new tea and coffee equipage ordered by George III from Thomas Heming in December 1761 which included 'a Gilt vase Boiler and Stand' (fig. 57).[42] They are referred to in Parker and Wakelin's ledgers as 'tea vases', and were supplied by both Butty and Dumée, and Whipham and Wright. Weighing between 63 and 85 troy oz they were substantial pieces of silver, and are not to be confused with the smaller versions of between 10 and 15 troy oz, that often came in pairs or sets of three for tea for condiments such as sugar, pepper and salt.[43] By looking at surviving examples of these urns (figs 58 to 60), we can gain a clearer picture of stock and shared forms circulating amongst the trade; the sharing of cast components, such as handles and finials; and how decorative details could provide variations to common shapes, a strategy for producing endless novelty.

Butty and Dumée's models of 1763 (fig. 58) and 1767 (fig. 60) share the identical cast, beaded handles, floreate spigot and flame finial, and similar cast and pierced bases, although cut with different designs. The 1767 example, with its embossed swags of leaves and flowers, would have cost extra to make. In the ledgers such urns are described as 'fluted' and cost the customer about £35 each. Whipham and Wright used the same formula for their 1764 urn (fig. 58), although all the cast components are subtly different. It looks remarkably similar to the urn depicted in Ramsay's portrait, the original of which does not survive in the Royal Collection.

There were other silversmiths who supplied a more limited range of tea and table wares, in small quantities, to the partnership. Thomas Jones' account with Parker and Wakelin is headed, 'Rupert Street', indicating that he was conveniently close to Parker and Wakelin's shop, at the northern end of Oxendon Street. He supplied coffee pots, cream boats, chafing dishes and saucepans. He made a fluted coffee pot for which he charged £2 6s. for making,[44] while Parker and Wakelin billed Cailleud £8 16s. 6d. for the pot, including £3 for fashioning. Between 1767 and 1772 Jones submitted small but regular bills for work, like the £36 requested in December 1767 for working-up 286 troy oz of silver.

Robert Piercy, Francis Chanel, and John Daniel and Son specialized in the supply of cruets, soy frames and bottle stands and tickets. These were new, light goods invented to satisfy demands for new equipment for the dining table. The heavier cinquefoil cruet frames, known since 1710, were being replaced by lighter, oval examples, increasingly with glass rather than silver bottles. An undated frame design of this type is labelled 'Oil, Soy, Mustard, Lemon, Vinegar, Ketchup, Pepper and Cayan'.[45] Soy frames weighed around 3 to 4 troy oz if made from wire, and 5 to 6 troy oz if pierced. Although bottle tickets are known from 1723, they started to appear in great numbers from 1760, showing an increased tendency to offer as much choice of condiments as possible at table.

Piercy's account includes nurled, pierced, gadrooned and fluted cruet stands, for which he provided the glass, pepper boxes and castors.[46] He had been apprenticed to Samuel Wood, a specialist castor maker. Piercy's work was supplemented by that of Francis Chanel, a native of Gollion, Switzerland, who was an active member of the French-speaking Protestant church founded in London in 1762.[47] His 'Sun insurance policy describes him as a working silversmith 'next to the White House, Castle Street, in Longacre'.[48] His

Fig. 61. Pair of tea caddies, by Emick Romer; 1762. Silver (London), embossed and chased with chinoserie figures; height 14.1 cm

Fig. 62. Épergne, by Emick Romer. Arms of Newton with Jacomb in pretence; 1769. Silver (London); height 45 cm, 216 troy ozs

account ends in March 1768, around the time of his death. His will, proved that year, mentions his 'shopwares wrought and unwrought plate', and his tools.[49] Although most of his small account with Parker and Wakelin was for wire soy frames, cruets, bottle stands and tickets, and a few items of flatware, he was also capable of providing much larger work, as surviving soup plates and sauceboats show.

It was not until 1773 that John Daniel and Son began supplying Parker and Wakelin with similar types of silverware, but again only in small quantities. Their first bill amounted to only £10 13s. 6d. for a year's supply.

Thomas Nash specialized in piercing and sold Parker and Wakelin fretted bottle stands costing £1 16s. a pair; pierced soy frames at £1 11s. 6d. each; and pierced trowels for 12s. each.[50] As well as providing standardized goods there is evidence that he was occasionally asked to design new forms. Parker and Wakelin paid him 12s. for making a 'pattern for a sugar pot' for one of their customers, Mrs Mordaunt. It must have found favour as a further £2 4s. was paid to him for making it up.[51] Between 1768 and 1773 the Workmen's Ledger records the regular payment of his bills, at two- and three-monthly intervals, increasing steadily as the years progressed, from £11 to £72. His account was carried forward into the next, now missing, ledger.

'Messrs Vincent and Lawford' specialized in the manufacture of cream pails, sugar bowls and bread baskets. William Vincent and John Lawford, had both been apprenticed to Isaac Duke, Lawford, in 1750 and Vincent in 1751.[52] From their ledger descriptions the items appear to have been quite elaborately fashioned. They charged Parker and Wakelin £5 5s. for making a 'chas'd bread basket with Chais'd Ornaments and Wheat ear foot', and 26s. for making a 'chas'd wire sugar bowl'.

In December 1770, Emick Romer, presumably a relation of John Christopher Romer, who had briefly taken over the workshop in Panton Street, began supplying the firm with sugar baskets, milk pails and the occasional épergne, although the latter were usually bought from Thomas Pitts.[53] Emick's name is consistently spelt 'Emuch', so this may give us an idea of how Parker and Wakelin pronounced it. His skills are evident in a pair of tea caddies, elaborately embossed and chased with Chinoiserie figures (fig. 61), hallmarked in 1762.[54] There is evidence from his account that he was asked to provide quite complex designs: for example, he was paid 3s. for the plaster moulds he had made for a 'chas'd wire epergne', with five branches, four saucers and four baskets costing £16 10s. in labour and weighing 120 troy oz 12 dwt, complete with 'blue glass basins'. An épergne which bears his mark, nearly twice the weight and triple-tiered, reveals what he could achieve on a grander scale (fig. 62). The cast, openwork frame stands on four shell-and-scroll feet and is hung with floral swags and a detachable Cupid finial. Like John Christopher Romer, his skills lay in casting and chasing. Yet orders from Parker and Wakelin never amounted to more than just a few pieces of plate. We know, from surviving silver that bears his mark, that Emick Romer supplied a far wider range of silver than the orders from Parker and Wakelin suggest. He was also making silver for other goldsmiths such as Thomas Heming.[55]

William and Aaron Lestourgeon entered into partnership in 1767, registering their joint mark in that year from Clement's Inn Passage, near Clare Market in Holborn.[56] William, who had been born in Amsterdam in 1709, would have been fifty-eight years old and his son twenty-five.[57] Their account with Parker and Wakelin is headed 'William Lestourgeon and Son', and details the supply of a whole range of smallwares: mustard pots, wine funnels, punch ladles and tea tubs, which although small in size and light in weight accounted

Fig. 63. Knife and fork, steel blade and prongs with blue and white porcelain handles; *c.* 1760. Bill Brown Collection, Worshipful Company of Goldsmiths, London

for nearly £200 in labour per year. They seemed to have specialized in making a particular design of tea canister for Parker and Wakelin, called in the ledgers 'tea tubs', based on the wooden slatted chests in which tea was imported from China. It was a simple but effective design that exploited the use of flatted silver, which could be scored and soldered rather than raised or cast, the latter method requiring a greater weight of metal and more time to make. Engraved with rocaille scroll, or neo-classical key-pattern borders, and Chinese letters (also called 'India' in the ledgers), they satisfied the growing market for the exotic.

In 1771 the account changes to Aaron Lestourgeon's name alone, reflecting the departure of his father to set up on his own in Mouldmaker Row, St Martin's Le Grand, close to the Goldsmiths' Hall.[58] Two years later Aaron moved to High Holborn 'at Mr Douxsaints', a toyseller. Aaron's mark continues to be found on tea tubs well into the 1770s. Parker and Wakelin's accounts reveal an increasing demand for these smallwares, and business must have been brisk and lucrative for those silversmiths specialising in their manufacture.

Some working goldsmiths exploited the advantages of specialization to an even greater degree than the general plateworkers by supplying specific types of objects such as flatware and salts. Retailers like Parker and Wakelin chose what they wanted from what was on offer: from David Whyte they bought cups and covers; from Walter Brind pap boats and panakins for feeding babies.[59] There was a supplier for every type of silverware, from spurs (which they bought from John Cowper) to stately centrepieces to grace the dining table.

FLATWARE AND CUTLERY

Perhaps the largest group of specialist manufacturers within the goldsmiths' trade were the flatware makers (spoons and forks) and cutlers (knives). Few of the smiths who were not specialists in flatware supplied knives, forks and spoons. There were five businesses that specialized in flatware that appear in Parker and Wakelin's ledgers. Four were regular suppliers: Isaac Callard, William Portal, William and Thomas Chawner, and Woods and Filkin, whose account began in December 1770. Those who supplied only occasional orders for flatware were James Tookey[60] and Thomas Squire, whose accounts were carried from the first ledger, and Philip Rainaud who did not appear in the books until 1772,[61] and whose annual bill rarely came to more than £12. Flatware production, as a separate craft, was further subdivided: haft makers (William Portal); specialists in spoon making, either on their own (William and Thomas Chawner), or with forks (Philip Rainaud, Woods and Filkin, and James Tookey); and cutlers who made knives and blades (Thomas Squire). Most of the flatware supplied to Parker and Wakelin was silver and steel, and it is only in the mending of items that we see more exotic materials such as agate, mother-of-pearl and china used for handles.[62]

Such was the demand for knives, forks and spoons, that flatware makers also specialized in specific types of decorative detail. William Portal supplied a whole hierarchy of silver haft designs, which show variations in quality when reduced to their making price per dozen. The cheapest were called 'common', costing 18s, then came 'plain' at 20s, followed by 'square threaded' and 'octagon threaded' at 21s. a dozen. Cast handles cost more, at 22s, and would have required chasing-up. They weighed almost twice the weight in silver as their stamped counterparts, and therefore cost a great deal more in terms of both

weight and workmanship.[63] As the decorative detail increased the making charge went up, so that nurled hafts cost 26s. a dozen, while the most expensive, the single- and double-shell variety, both cost 30s. a dozen. Portal also fitted '12 chinea handles' (which cost 18s, comparable with the cheapest type of silver handle), which may have looked like the handles on a knife and fork of c. 1760, with imported blue and white porcelain hafts (fig. 63).[64] Portal was paid twice a year by Parker and Wakelin, receiving £353 in 1769 for his labour, for working up 1,500 troy oz of silver.[65]

Green-stained ivory hafts were supplied by Thomas Squire, this sort of ivory had a tendency to 'undergo a sea-change, from a gay pea-green tint, to the yellow tone visible in an overgrown cucumber' (fig. 64).[66] Squire charged Parker and Wakelin £1 12s. a dozen for green hafts, while the twelve 'table prongs' cost £5 4s. 7d. His accounts are full of 'setting work' and general 'bills of cutlery', for which he was paid £197 in 1771, £148 in 1772 and £208 in 1773. One of his more unusual orders was for a cucumber slice. The accounts show that his work sometimes went to the Chawners for modifying, such as the addition of rims on ferrules.

Thomas Chawner had been apprenticed to Ebenezer Coker (who was supplying Parker and Wakelin with waiters) and had registered a mark at Goldsmiths' Hall in 1759. In 1767 he was working as a spoon maker from 60 Paternoster Row, in partnership with his brother William, until 1774, when he moved to 9 Ave Maria Lane, the previous address of Thomas Whipham and Charles Wright.[67] Their account with Parker and Wakelin is in their joint names until July 1771, then in Thomas Chawner's name alone, which suggests a lapse in the partnership before they both moved addresses. The Chawners supplied largely plain and polished tablespoons, sauce and kitchen spoons, as well as gadroon and twisted handle salt spoons. They supplied fewer tablespoons and dessert spoons than Isaac Callard, at the same cost for labour and more for teaspoons and salt spoons, which seem to have been their speciality. These smaller spoons were usually elaborately decorated with fluted handles and shell bowls and were, therefore, as expensive or even dearer than their larger counterparts for table and dessert. For example, a dozen 'fluted handle and shell bowl' teaspoons cost 24s. to make, as against the same number of common tablespoons which cost only 10s. to make. The dozen common tablespoons sold to the Earl of Cornwallis retailed at £10 3s. 2d. which included £1 13s. for making, 12s. for engraving and the weight of the silver.

In May 1769 the term 'laureld' first appears in the accounts, relating at first to teaspoons. The Chawners made '12 laureld teaspoons' with a pair of matching tongs, for which Sir Edward Hulse was charged £3 19s, which included 6s. 6d. for their fashioning. (They must have looked very similar to the set of six in fig. 65.[68]) The term 'laureld' is not used today but it almost certainly translates into the modern trade term 'feather edge', and indicates an early form of neo-classical-style decoration, and called at the time 'antique'. The pattern grew in popularity, as evidence by the increasing number of orders that are described as 'laureld'. It is interesting that this new style was introduced via small and popular silverwares first, before being applied to larger orders, a common strategy for testing 'novelty'. By 1769 some customers, like Mrs Bourchier, had accumulated large, matched sets: four laureld gravy spoons first, then a dozen tablespoons, followed a month later by two dozen more.

The amount of wrought silver the Chawners supplied to the partnership gradually increased, in June 1769 they were paid £263 for making-up 3,524 troy oz of plate and in September the same year £296 for 4,126 troy oz.

Fig. 64. Knife and fork, steel blade and prongs with green ivory handles; c. 1790. Bill Brown Collection, Worshipful Company of Goldsmiths, London

Fig. 65. A laureld teaspoon, probably by Thomas and William Chawner, *c.* 1770. Silver (London); length 12.5 cm. Private collection

Isaac Callard's account reveals that he generally supplied sets of forks and spoons, at a standard cost for his labour, usually charged per dozen. Tablespoons were 21*s*, four-pronged table forks 20*s*. and dessert forks and dessertspoons 15*s*. These prices can be compared with those of John Fossey, who published a list of prices of 'the best Sorts of NEW PLATE made in the newest Taste' *c.* 1747, which included 'Large Table Spoons polish'd at 18*s*. per Dozen Fashion'.[69] More elaborate spoons included those described as having 'scrole' handles, probably those known today by the twentieth-century trade term as 'Onslow pattern'. More difficult to interpret are the teaspoons and sauce ladles described as being 'with flesh'. Callard's bills to Parker and Wakelin in 1767 reveal quite a substantial account: in February he was paid £138 for working-up 1,124 troy oz of silver; in July 1767, £230 for 2,690 troy oz; and in October, £274 for 3,796 troy oz.

Callard was almost certainly connected with another of Parker and Wakelin's flatware suppliers, the partnership of Woods and Filkin. Christopher Fly Woods had been apprenticed to a Paul Callard in 1762, who was the son of Isaac, who at this date would have been in his early seventies.[70] Woods and Filkin gave their address as Battersea to the *Parliamentary Committee investigating the Assay offices* in 1773, suggesting that they were working in connection with Isaac Callard, whose final mark was registered from 'Battersea Division, Near Ye Black Raven'.[71]

James Tookey registered himself first as a large worker in 1750, then as a small worker in 1762, an indication of a change in direction from large, raised work such as plates and dishes, to smaller wares such as sauceboats, tea canisters and cream jugs. His son Thomas was apprenticed to him 'to learn the art of a spoonmaker' in 1766.[72] Tookey supplied 'common' teaspoons and salt spoons to Parker and Wakelin from his address in Silver Street. Tookey's spoons seem to have been largely destined for the retail shop, which he supplied on a regular basis. In March 1766 he supplied '54 com[n] tea spoons' and charged 18*s*. for their making, that is only 4*s*. a dozen, his standard charge. These may have been part of his last orders; his wife Elizabeth's mark has been identified on a pair of marrow scoops for 1767, suggesting that he died sometime that year, although his name continues in the Parker and Wakelin account as if nothing had happened.[73] It was common for goldsmiths' wives to manage the accounts, and Elizabeth simply continued managing the business. Their work for Parker and Wakelin only represented a small income: £19 in July 1767, £39 in May 1768 and £1 8*s*. in March 1769.

The second appendix to the 1773 Parliamentary Report lists the names of those who had silverware broken at the Assay Office for being substandard. Most were makers of flatware, and included William and Thomas Chawner, Elizabeth Tookey and Judith Callard. The prominence of flatware makers in the list of offenders suggests that they had rather tight profit margins. As the range of flatware designs was limited, competition was strong, with little to choose between makers except for the price of their goods. This may also explain why there were so many attempts at inventing new, speedier methods of production, revealed in the large number of patents registered in connection with their manufacture.[74] In the 1760s lighter, two-part stamped knife hafts, made of thin sheet silver, superceded the heavier cast models.[75]

The letter books of the goldsmith Dru Drury tell us more about the process of communication between flatware and cutlery suppliers and retailers. Drury began in trade as a specialist haft maker, in Wood Street in the City in the 1760s, and from these premises he sold flatware and cutlery to other London goldsmiths such as Lewis Pantin and Charles Kandler. Yet Drury also bought-

in wares from others, such as Mr Woolhouse of Sheffield and John Trickett, who was probably of Madin and Trickett, whose name appears on Sheffield flatware of the 1770s.[76] In 1768 Drury wrote to Trickett ordering, amongst other items, a gross of three-prong forks 'with oval shoulders like ye Pattern fork I sent'.[77] Drury explained 'I have sent you this Order by way of a Trial to see what work it will be, if they are made to my mind I will directly send you another Order and if you make your forks according to my directions I shall apply only to you for all the forks I have occasion for'. Trickett must have been a large enough manufacturer to employ assistants, as Drury adds 'please tell your Forger to let the Oval shoulders of the forks stand exactly even wth the sides of the prongs'.[78] Parker and Wakelin probably communicated in a similar way with their flatware suppliers.

CANDLESTICK MAKERS

While flatware and cutlery manufacture was highly specialized, other areas of the goldsmiths' trade were similarly if not so extensively subdivided, and candlestick making was one of them. There were dynasties of candlestick makers and their apprentices. The universal need for lighting, before gas and electricity, meant there was a large demand for candlesticks, candelabra and related equipment, like snuffer pans, for every conceivable site in the house; for the table, library, bedroom and servants' quarters. Yet these objects are rarely described by location in the house, although there is one 'nursery candlestick' listed in Parker and Wakelin's accounts. Instead they are differentiated by their design; figure, step gadroon, festoon and, most commonly, pillar.

Most of the Panton Street retailer's candlesticks were supplied by John Arnell at standard rates, '2 pair plain pillar' at £8 8s. to make, '2 pair fine pillar wth chaised feet' at £12 12s. He also supplied 'water leaf candle snuffers', 'plain hand candlesticks', nozzles for wax candlesticks and china branches, and 'nurled trencher candlesticks'. John Arnell had been turned over to Wakelin in 1758, having begun his apprenticeship with John Quantock, a candlestick caster, six years before. This means that he would have been highly skilled by the time he moved to Panton Street.[79] He was made free in 1763 on the same day as Edmund Vincent, who joined him in partnership. This business relationship was not to last however, as four years later it had been dissolved.[80] Arnell's account with Parker and Wakelin is carried forward from the earlier, missing, ledger, suggesting that he may have been supplying them since gaining his freedom, which would be logical if he had made a smooth transition from apprentice to subcontractor. John Parker noted in Arnell's account that he still had '2 pr fine candlesticks (very ill made)' supplied by him in 1767, and still on his hands three years later. Arnell's accounts were settled in March and September every year: in 1768 amounting to £254, accounting for 2,430 troy oz of silver and the following year, £316, accounting for 3,216 troy oz of silver.

Another source of Parker and Wakelin's candlesticks was Ebenezer Coker, who supplied the nurled step pillar, beaded and stamped varieties. The use of steel dies, from the 1760s, meant that different combination patterns could be made, which although requiring finishing could be made in less time and of lighter-weight silver than their cast counterparts. They were sold in increasing quantities from the 1770s. Coker also sold Parker and Wakelin waiters of various designs: dupee, nurled, shell and carved.[81] The problems of working out who did what in the trade is exemplified by a waiter, marked by Coker, of

Fig. 66. Waiter, by Ebenezer Coker;
1763. Silver (London); diameter
39.8 cm, 225 troy oz

1763, with an elaborate cast pagoda and open diamond-pattern border (fig. 66) which appears in a slightly modified form on waiters marked by Richard Rugg, David Whyte, and William Holmes of the same date.[82]

The range of wares Coker could have supplied was, in fact, much larger than the quite limited selection chosen by Parker and Wakelin. We know, for example, that he also made spoons but none appear in his Panton Street account.[83] Coker was in partnership with a Thomas Hammond in 1759/60, working from an address in Wood Street, although he had moved to Clerkenwell Close by the time he was listed on his own in Mortimer's *Universal Directory* of 1763. Between September 1769 and June 1770 Coker was paid £86 for making up 603 troy oz of silver.[84] Although Parker and Wakelin con-

tinued patronising Coker, they also went to his erstwhile partner, now calling himself 'Hammond and Company' for their waiters. These they bought in quantity and in great variety: nurled, gadrooned, with chased edges and pierced borders, plain, shell, beaded and 'hob-a-nob'. They also came in a range of sizes, from eight to eighteen inches in diameter.

The business fortunes of the individuals involved in this company seem to have been rocky, as by April 1767 the account in Parker and Wakelin's ledgers is marked 'Now John Carter'.[85] The *London Directory* of 1768, and *Baldwin's Complete Guide* of 1770, list Carter as being a 'working goldsmith' at Westmoreland Buildings in Aldersgate Street. Three years later he gave his address as Bartholomew Close to the 1773 Parliamentary Committee, and described himself as a 'manufacturer of large plate'. His mark appears mostly on candlesticks, and is found overstruck on Sheffield silver that he supplied to London goldsmiths.

It is clear that Parker and Wakelin were always looking out for new sources of supply. The quantity and quality of stamped silver emerging from Birmingham and Sheffield from the 1760s must have attracted their attention, as the names of manufacturers from these provincial sources appear in their accounts. Although only one entry in the Workmen's Ledger relates to Matthew Boulton, it is evident, from Boulton's letter books, that there was a protracted correspondence between them in 1771. In many ways it typifies the relationship between London and Birmingham that was tinged with competitive mistrust. Parker and Wakelin had written to Boulton in November enquiring about two pairs of candlesticks 'like Mr Udny's'.[86] From the content of Boulton's reply, it appears that they had been enquiring about buying unfinished silver from him. He assured them that he had

> never sold anything in silver unfinish'd', [but] perhaps if we were in some regular business with you your plan might be as convenient to both parties but that is a subject for future consideration ... Mr Boulton purposes being in London at the end of January when he will do himself the pleasure of calling upon you and confer upon the matter ... we have always used silver worth 6s. for light stamped candlesticks as it is better to stamp [so] silver candlesticks amount to a larger sum of money than plated ones although there is no more work in making them and there being some trouble and expence in marking.

For these reasons Boulton always charged 'the fashion exactly the same without discount as we charge the plated ones of the same pattern viz £7 17s. 6d. and at that price there is less profit per cent than upon plated ones'. Parker and Wakelin appear to have inspected a pair of Boulton's 'lyon faced' candlesticks (fig. 68) that he had sent them, presumably on request, but were not satisfied with the price, as Boulton wrote:

> we don't doubt in the least but you may get cand^s, from Sheffield upon the terms you mention but then they certainly must be very different in size and pattern from those we forwarded to you ... In order to facilitate and increase your dealings with us we have examined minutely the Calculation we made of these Lyon faced candles. and find that if ever you ordered so many of 'em it is out of our power to make 'em under six guineas nett money a pr if we are to find the silver, polish 'em, and get them Hall mark'd, and £5 pr if you find the silver &c for ready money.[87]

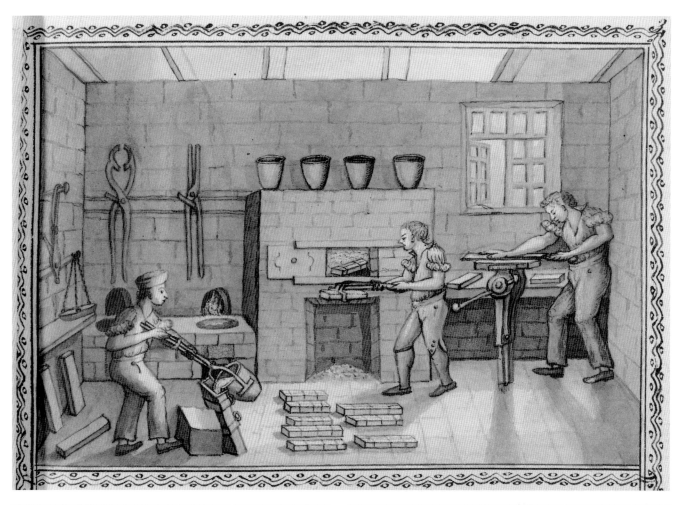

It is significant that the dispute centres on the comparative language of description between Sheffield and Birmingham products, and a challenge to Boulton's claim that he could produce cheaper goods. Boulton also refers to payment in 'ready money', which most customers were not used to paying, preferring to buy on credit. Boulton's account in the Workmen's ledger contains only one entry, for the pair of 'lyon faced candlesticks' paid for in January 1772. It was not until 1778 that the business, under Wakelin and Tayler, resumed trade.

Fig. 67. *The Process of Plating*, from R.M. Hirst, 'Short Account of the Founders of the Silver and Plated Establishment in Sheffield'; 1830–32. Bradbury Collection, Sheffield City Archives

SOURCES OF SHEFFIELD PLATE

Parker and Wakelin's relationship with other firms outside London was more successful. They stocked the shop with Sheffield plate candlesticks bought from three Sheffield firms, supplied with a trade discount for bulk purchase and prompt payment. Sheffield plate had been invented in 1742 by a cutler called Thomas Boulsover, who had discovered that copper bonded to silver under heat and pressure. However it was not commercially exploited until the 1750s, when Joseph Hancock, Boulsover's son-in-law, began producing candlesticks and other vessels in the material.[88] An illustration from a manuscript history of the trade shows ingots of copper being made, onto which sheet silver is being bonded, then rolled (fig. 67). One of Parker and Wakelin's customers, Thomas Phillip, third Lord Grantham, visited the plating company of Goodman's in Sheffield in 1799. In his diary he recorded the whole manufacturing process. Ingots of copper were fastened to those of silver then heated, then rolled under a mill, formed 'according to the shape wanted . . . If for round candlesticks, the bottom is stamped whole, and the neck in three pieces which when united makes it compleat. If oval, generally one half (cut perpendicularly) is stamped at once. Tea Pots and Urns are beat out by much time and trouble. The dies are made of steel and cut out by hand'.[89] The next stage involved cutting off superfluous parts and, finally, the sections were soldered together. He further noted that 'for the purpose of engraving they have a method of making the Silver plating thicker in one part then another'. At between one third and one fifth of the cost of silver, and made with the same dies, Sheffield plate was a popular novelty, which any 'fashionable' goldsmith was required to supply.

Fig. 68. 'Lyon-faced' candlestick, by Matthew Boulton and John Fothergill; 1769. Silver (Chester); height 30 cm. Private collection

Fig. 69. Pair of Sheffield plate candlesticks; c. 1775. Height 29.5 cm. Leeds City Art Galleries (Temple Newsam House)

Parker and Wakelin made only occasional purchases from 'Messrs Hancocks', amounting to no more than £10 to £20 per year, beginning with '4 pr plated Pillar Candlesticks' at 50s, '2 pr Scrole footed Do' at £5 and '2 pr hollow footed Do leaves at corners' also for £5 in August 1768, at 15 percent discount, all bound for the shop. It is likely that they would have looked similar to a pair of pillar candlesticks of c. 1775 now at Temple Newsam (fig. 69). Only one of these pairs turns up in a customer's account, that of Joseph Cocks, who bought a 'pr of plated candlesticks' in 1768 for £5 9s.

There are, however, a growing number of references to Sheffield plate in Parker and Wakelin's accounts, largely via requests for its repair and embellishment. Horatio Mann, for example, had a snuffer mended in 1766, and a new capital made to a fluted candlestick, while Mrs Penton had her candlesticks engraved with 'a lozinge and crest'. We know from Mann's correspondence with Horace Walpole that he was also buying direct from source. He went to great trouble over the purchase of his double-plated covers for dishes which he was assured 'for such a use they would be as lasting as solid silver'. He went on to explain 'Nevertheless I had my doubts, and for that reason I took the freedom to send my letter to Mr Munro at Birmingham open with

the designs, and begged that he would consult with somebody . . . as to the propriety and the duration of them'.[90] He appears to have been satisfied as he went on to order them.

The Sheffield firms of Tudor and Leader, and John Winter and Company supplied Parker and Wakelin with silver and Sheffield plate, although only candlesticks and never in great quantities. We know from surviving trade catalogues and accounts that both manufacturing firms sold a much wider range of wares, including sauceboats, cruets, tureens, cups and covers, and many more items. Tudor and Leader had been established since 1760 and, like Winter, produced silver as well as Sheffield-plated wares.[91] Parker and Wakelin were buying from John Winter only a year after he had started up in business in 1768. He produced mainly candlesticks and buckles, although he was a partner in several other firms making all kinds of domestic silverware.

A fourth Sheffield-plate supplier, Hoyland, also based in Sheffield, appears in the Workmen's Ledger in December 1772, but only for one £30 order for candlesticks and their carriage down to London. We know from one of their later surviving trade catalogues c. 1790, that they supplied 68 different designs of candlestick, along with cruet frames, sugar baskets, cream pails, tea urns, pots and caddies. A 'Table candlestick, flowered foot, Corinthian pillar and capital', of 11¼ inches, cost £2 5s. a pair for plated and £6 to £8 a pair in silver. They would have looked identical as the same dies were used for both silver and Sheffield plate.[92] The catalogue reveals a wide range of goods, and the standard pricing allows further comparison with the cost of similar types of object in silver. Pint coffee pots, single plated, sold at £1 6s, while Parker and Wakelin sold a 'plain coffee pot' in silver to the Earl of Coventry in 1769 for £6 6s. 6d, which included the cost of 14 troy oz 4dwt of silver and £1 16s. for making.[93] The Sheffield platers dealt with a wide range of London firms. For example, Fenton and Creswick's letter book includes the names of Joseph Brasbridge, Whipham and North, as well as many of Parker and Wakelin's customers with whom they dealt direct.[94]

The trade in Sheffield plate did not end Parker and Wakelin's purchase of French plate, an earlier form of substitute silver, introduced from France in the early 1700s. The process involved the covering or 'charging' of copper or brass with four to six layers of silver foil but, unlike Sheffield plate, the

Fig. 70. Trade card of John Legrix, French plate worker in Long Acre; c. 1766–70. Etched and engraved lettering; 9.75 × 15 cm. British Museum

Fig. 71. Trade card of Thomas Pitts, working silversmith and chaser in Piccadilly; c. 1760. Etched and engraved lettering; 15.5 cm × 13 cm. British Museum

process took place after the article itself was fashioned, and had a tendency to peel off.[95] John Legrix's account with the Panton Street business, although very small, ranging from £6 to £18 per year, nevertheless ran from 1766 until 1773.[96] A wider range of his stock, sold from his premises in Long Acre is advertised on his trade card (fig. 70). Unfortunately his account with Parker and Wakelin is unitemized, so from this source it is impossible to tell what sort of French-plate objects the firm was buying from him. However, if we turn to the customers' accounts we find a range of French-plate articles being supplied, although their number and range declined substantially between 1766 and 1770.

In 1766 Fulke Greville bought several pairs of 'chaised French plated candlesticks' some with two-and three-light branches, as well as waiters. Only five months after this order had been delivered Greville returned a pair of candlesticks to be re-silvered, which confirms the difficulties manufacturers had with bonding the silver foil to the base metal. Greville's four French-plate waiters cost him £4 12s. Although it is difficult to make a comparison with their silver equivalents as we do not know their size, a pair of pierced handwaiters in silver, bought in the same year, cost £11 9s. 10d. In 1769 Lord Rosebery bought a pair of silver candlesticks for £9 and a pair in 'Tootenaugh mettall', which cost him £3 3s, which must have been even cheaper than French plate.[97] Tutenag is what today we call paktong, a non-tarnishing alloy of copper, nickel and tin or zinc imported from China.[98] Dish crosses and tops to glass inkstands were also made of French-plate. Silver tea canisters and sets of table and dessert flatware were fitted in mahogany and fish-skin cases with French-plate mounts. By 1770 it is only the French-plate furniture that appears in the customers' accounts, as it had been superceded by Sheffield plate.

Both French-plate and Sheffield plate, along with other silver substitutes, had two great advantages: they made 'just as good a show as silver', as Sheridan remarks in *The School for Scandal* (1777), and both paid 'no tax'.[99]

The tax referred to had been introduced in 1756, and was paid by owners of 100 troy oz or more of silver. Largely due to the difficulties in collection, plate tax was abandoned in the year the play was first performed. Since the removal of duty on silver in 1757, silversmiths had not been obliged to pay 6d. per ounce of silver and the trade had flourished as a result. In 1784 William Pitt the Younger (Prime Minister) reintroduced this form of taxation as part of his programme of fiscal reform, and for the customer this added to the benefits of buying Sheffield plate over silver.[100]

SILVER FOR THE DINING TABLE: ÉPERGNES AND TUREENS

Silver for the table, as the largest category of silverware catered for by Parker and Wakelin, offered plenty of opportunity for specialization; from small individual salts, which now stood at every fashionable place setting, to large individual centrepieces. Épergnes and tureens were the most spectacular individual elements of the dining table, being large and often highly decorated, even sculptural in form when they incorporated complex decorative cast finials, feet and handles. The épergne, deriving from the French *épargne*, meaning 'saving' (the necessity of handing round separarate serving dishes), had been introduced in the early eighteenth century and soon became a very fashionable item.

Parker and Wakelin went to Thomas Pitts for most of their épergnes, and little else. His wildly rococo shop bill indicates that he worked from the Golden Cup in Air Street, Piccadilly, and that he was a 'working silver-smith

Fig. 72. Épergne, by Thomas Pitts; 1762. Silver (London); height 60 cm, 149 troy oz

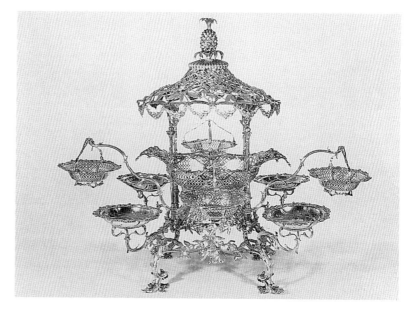

Fig. 73. Épergne, by Thomas Pitts; 1771. Silver (London); height 37.5 cm, 90 troy oz

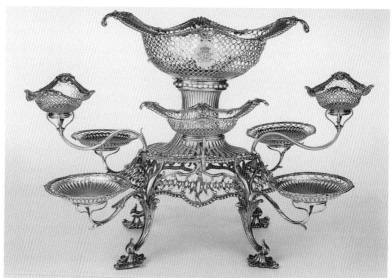

Fig. 74. Épergne, by Thomas Pitts; 1772. Silver (London); height 32.5 cm, 90 troy oz

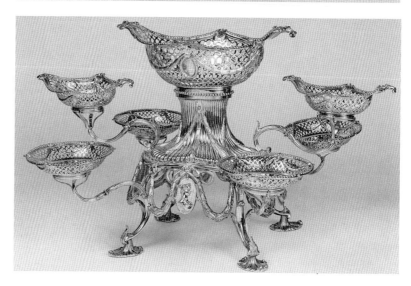

and chaser' and he made and sold 'all Sorts of large and small Plate in the newest Taste' (fig. 71).[101] His three sons, Thomas, William and Joseph, were apprenticed to him in 1767, 1769 and 1772 respectively. His mark most frequently appears on two-handled cups and covers (like the one on his trade card), which by their number suggest that he made them himself, although he may have been supplied by other goldsmiths.[102] They often incorporate complex figures at the handles' base and finial and show a flair for asymmetrical naturalistic modelling. An insurance policy of 1777 described him as a 'silversmith, jeweller and cutler' and includes not only unspecified 'plate in trade', but also, 'paste and garnet work' with jewels which, as a retailer, he must have bought-in.[103]

It is more difficult to assign standard charges for his workmanship than for other Parker and Wakelin subcontractors because of the variations in scale, form and decorative detail that an épergne could take. However, the basic units tended to be rather formulaic and were reused again and again, as a surviving épergne, of 1762, bearing Pitts' mark reveals (fig. 72). It has a standard cast trellis and festoon 'pagoda' top with pineapple finial, floreate scroll feet and rose supports which can be seen on many other examples of this period. The scroll arms and four supporting colums, appear on others, providing different combinations of pierced and unpierced dishes and baskets. By the early 1770s this design had been replaced by one which relied on a central raised- and-fluted column, which accommodated the taste for less fussy and exotic ornament, and incorporated a new set of cast units (figs 73, 74).

The orders Pitts fulfilled in the Workmen's Ledger included chased, polished and pierced épergnes with baskets, basins and saucers, in combinations of two, four, six and eight. In 1768 Parker and Wakelin sold four complete épergnes to account customers, three of which were supplied by Pitts. A 'chaised epergne wth 6 branches, 4 saucers and 2 baskets' cost Thomas Budgen £68 which included the weight of 148 troy oz 8dwt of silver and Thomas Pitts' making charge of £20 7s. Most of Pitts' work for Parker and Wakelin involved not the provision of complete épergnes but their maintenance, supplying glass liners, which presumably got broken, and extra 'pipes' and branches, replacing those which became bent. The frequency of these orders suggest hard use. It was only when the pressure was on that Parker and Wakelin called upon Pitts for help with other dining ware. For example, when Lord Harcourt's large order for his ambassadorial service came in they pressed Pitts into action, buying from him two ice pails (weight 225 troy oz 2dwt) for which he charged them £33 15s. to make, and '4 fine Terrines, Dishes and Ladles' (weight 1,290 troy oz 10dwt, costing £193 10s. to make).[104]

TABLEWARES: SALTS

While the style of épergnes and tureens changed gradually, salts were subject to more rapid response to fashion. As Josiah Wedgwood commented, it was in the small items of taste that fashion mattered. One of the most specialized and successful of Parker and Wakelin's suppliers were the Hennells, who were able to meet the demand for such rapid change. David Hennell (1712–85) and his son Robert (1741–1811) were the largest suppliers of salts to the London trade. David Hennell's shop bill advertised him as a 'working goldsmith . . . in Gutter Lane'.[105] They registered their joint mark at Goldsmiths' Hall in 1763, and supplied not only Parker and Wakelin, but also a large number of goldsmiths in London; their name appears in many surviving goldsmiths' accounts.[106] In return Parker and Wakelin selected what and when they

Fig. 75. Gadrooned salt, by David Hennell; 1747. Silver (London); length 9.5 cm

Fig. 76. Pierced salt, by Robert Hennell; 1770. Silver (London); 9.25 cm. Schredds of Portobello, London

Fig. 77. Festoon salt, by Robert Hennell; 1772. Silver (London); 9.25 cm

bought from the Hennells, with no commitment to place regular orders. Very few salts survive that bear Parker and Wakelin's mark, yet they supplied a great many to their customers. The ledgers reveal that the Hennells provided them with eighty to a hundred salts a year, between 1766 and 1770, ready assayed and punched with their own mark, establishing their identity in the market and as a result securing their place in the history of goldsmithing.[107]

Parker and Wakelin appear to have ordered salts only from the Hennells, although their trade card advertises 'all sorts of . . . punch ladles, cream boats, sauce boats etc.', and surviving silver indicates that they also supplied bottle stands, teapots and épergnes. The Hennells supplied a range of salts to Parker and Wakelin that differed in shape but were mostly oval, although some were round and a few are described as 'basket' or 'boat' shaped. The language with which these salts are described gives us an indication of the changes in style over time. Between 1766 and 1768 many were chased, but most were gadrooned and a few were fluted; only occasionally do we see more revealing descriptive terms, like the set of 'stamped shell' salts ordered in 1768, or the

'fine' set with 'water leaves' bought in 1770, indicating the influence of classical motifs on design. Parker and Wakelin chose largely the ribbed and gadrooned variety (fig. 75), but by 1769 the circular gadrooned pattern of salt was no longer the height of fashion and the prevailing taste had moved on to pierced work (figs 76, 77).

Parker and Wakelin went elsewhere for the majority of their pierced salts. The only ones supplied by the Hennells appear in the accounts in July 1769 and are described as '4 Large oval pierced salts with Double blue glass', weighing 11 troy oz 11dwts, costing £2 8s. for the making.[108] In the same month Thomas Nash supplied the firm with '4 large pierced salts with double blue glasses' at £2 16s. for the making, although his usual orders were for pierced frames for cruets, bottle stands and trowels.[109] Whether it was on account of their high price or their workmanship, Parker and Wakelin chose not to return to Nash for these type of salts. It seems clear that Parker and Wakelin were shopping around to find a supplier that provided both quality and value. They found what they wanted with John Langford and John Sebille in St Martin's Le Grand, who specialized in pierced work. This source of supply was not to last long, as in 1770 Langford and Sebille were declared bankrupt.[110] By the 1770s fashion had moved on and the Hennells were selling the festoon design with applied swags and masks (fig. 77).

From the orders in the accounts it is clear that the Hennells also supplied with their salts the glass liners that protected the silver from oxidising. Liners came in various qualities and were priced accordingly. The glasses were blown into the salt cellar, or a model of it, as the vestigial impression of the piercing frequently indicates. The cheapest quality were then ground and polished on the top edges, the next best had the sides and bottom ground and polished as well, and the finest had in addition to the grinding, a five pointed star cut into the base.[111]

TRUNK, CASE AND BASKET MAKERS

Subcontracting networks went beyond the limits of the metalworking trades and connected very diverse businesses. The example of the box-making and case-making trades illustrates this well. They employed various materials, from rough deal to the most expensive mahogany, as well as shagreen, lacquer and tortoiseshell, and used trimmings of gold and silver lace. Their manufacture combined the skills of cabinetmaker, carver, locksmith and upholsterer. The more expensive cases were often integral to the presentation of plate at table or on the buffet: the fine designs Chippendale included in his *Director*; the sets of knife boxes included by Robert Adam in his design for the eating room at Kedleston in 1769 (*see* fig. 147); the Earl of Shelburne's '2 large neat mahog cases wth high lacquered ornament and gold lace' which were expensive, costing him £5 14s, while a customer named Richardson paid less per case, at £5 18s. for '3 ogee mahog cases wth french plate furniture'. The same money would have bought a complete silver soy frame.

Parker and Wakelin's orders were often delivered in custom-made boxes of the most basic 'iron bound', deal chest variety in which the plate was packed for carriage, sometimes with the addition of padlocks. John Jones' tea tub was packed in a deal box and wainscot case for its journey to Chester, from where it was shipped to Dublin. 'Wainscot' referred to the superior quality foreign oak that was imported for interior panelling, and denotes a finer case than deal but not so elaborate as mahogany. Richard Rigby paid £1 6s. for his 'wainscot case' to '2 pr candlesticks and branches'.

More elaborate cases were required for presentation purposes, or when a piece of silver was obviously meant for special use or display. Nearly all tea urns were sent in a case, presumably because the spigot was vulnerable to damage and they were the centrepiece of any fashionable tea table. Robert Hildyard had a 'red leather case to shape' for his tea urn which cost him a £1. Sets of six teaspoons and a pair of tongs were often boxed in red leather and mounted with gilt furniture. The Earl of Holdernesse had '2 small leather cases for basins, lined wth chammy ['shammy', chamois] leather', and his two new tureens fitted in '2 black leather cases with locks and lined wth chammy'. Large orders, like that of Harcourt, for his ambassadorial dinner service, involved the provision of the whole range of chests, boxes, cases and bags. The cutlery was housed in fine fish-skin cases trimmed with gold lace; tureens and plates went into seventy-seven baize bags, these were packed in plate chests, secured in deal boxes filled with paper shavings and the whole matted, corded and padlocked, ready for their journey by ship to Paris in 1769.

Parker and Wakelin went to several specialists for such wares, choosing particular suppliers for different types of case, within a hierarchy of materials, quality and cost. Edward Smith made plate chests and appears in the accounts from 1770 until he went out of business in 1773. Smith's bill for a year's work, from 1769 to 1770, came to £137 18s. We know from a surviving bill that Smith also supplied private customers. A Mr Monckton was invoiced by him in April 1770 for '2 Strong Iron Bound Trunks made to Order at £2 10s. each, £5, 2 Wainscot cases at 13s. each £1 6s.'.[112]

Michael Collins supplied Parker and Wakelin with knife cases. Between 1771 and 1773 he was paid between £120 and £160 per year. Both Smith and Collins were always paid in ready money, and their accounts run from September each year. Edward Darvis provided most of Parker and Wakelin's tea chests, while John Westry supplied their locks, handles and escutcheons.[113]

Goldsmiths also required the skills of the basket maker to wicker the handles of teapots and coffee pots, to insulate them from heat. Parker and Wakelin used the firm of Scotts to wicker the handles of their coffee pots and kettles.[114] Scotts had moved from the City to Old Compton Street in the early eighteenth century. They supplied a range of trades, including china and glass sellers as well as goldsmiths, although there was a price scale that favoured the former. Chinamen and potters, such as Wedgwood, were charged 3d. per handle, while goldsmiths paid 6d. and private customers 8d. to 9d.[115] Parker and Wakelin charged their own customers between 1s. and 1s. 6d. per handle. The goldsmiths who appear in Scotts' accounts in the 1770s included some of the more well-known tradesmen: William Pitts, Richard Gardner and Andrew Fogelberg. Their most frequent customer was John Wakelin.

SPECIALIST PROCESSES: GILDING AND ENGRAVING

Although most of Parker and Wakelin's suppliers specialized in specific forms of silverware, from cups and covers to salts, there were some craftsmen who specialized in particular processes, one of which was gilding. Campbell, in 1747, described it as 'a very profitable business, but dangerous to the Constitution', few of them, he explained, lived long because 'the Fumes of the Quicksilver affect their Nerves, and render their Lives a Burthen to them. The Trade is but in few Hands; some of them Workmen. A quick Hand may earn from Fifteen Shillings to a Guinea a Week'.[116] Gilders had short but prosperous lives.

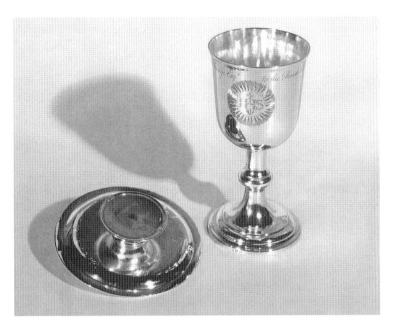

Parker and Wakelin paid all their gilders in ready money. Thomas Caler's account began in September 1769, and John Crockett's a year later. Chappel was the only gilder who did not have an account in the preceding (missing) Workmen's Ledger. Although the gilders appear to have been paid relatively large sums of money, often well over £100 per year, the cost was mostly taken up in the gold used, rather than the labour involved. Parker and Wakelin required very little gilding, and what was commissioned usually related to the inside of tumblers and salts, sets of teaspoons and tongs and the occasional dessert service. Lord Harcourt, for example, spent £6 12s. on the gilding of '12 fine chased four prong forks and 12 spoons' for his ambassadorial dessert service. One of the more exceptional orders came from Lord Holland who, in 1766, ordered a small coffee pot that was gilded on the outside, costing him an extra £1 18s. It must have been special as it was delivered in a red leather case costing 10s. 5d. More substantial orders concerned the regilding of dressing plate. For example, Peniston Lamb had a dressing service gilded in 1770, for £89 6s. 8d, this must have been for his new wife, Elizabeth, whom he had married the previous March. He paid a further £8 10s. for a 'red morocco case lined with plush'. Lamb also had two pair of candlesticks and branches gilded in '2 colours' for £19 12s. 10d, revealing a taste for the current French fashion of coloured gold.

Another skill which Parker and Wakelin had to buy-in was that of the engraver. Only one engraver, Robert Clee, appears in their Workmen's Ledger, and his account was brought forward from the first (missing) ledger of the partnership.[117] This suggests that he had been working for them before 1765/66. His account with Parker and Wakelin was paid every September: in 1770, he billed them for £250; in 1771, for £345; in 1772, for £285; and in 1773, for £385. As engravers did not have to provide the precious metalwork on which they worked all of this income would have been for labour. Mortimer included Clee in his 1763 *Directory*, giving his address as Panton Street, Leicester Fields. We know from his trade card (*see* fig. 38) and the local rate books that he lived opposite Parker and Wakelin's retail shop. Mortimer's list of engravers indicates the various branches of the trade, which included engravers of 'Heraldry and Ornaments', of landscape, writing and anatomy.

Fig. 78. Communion cup and paten, by Parker and Wakelin; 1769. Silver (London): cup: height 21.5 cm, 14 troy oz 2 dwt; paten: diameter 15 cm, 7 troy oz 7 dwt. Engraved 'The Gift of Thomas Byrche Savage Esq. To The Parish of Elmley Castle, 1770' by Robert Clee. Elmley Castle Church

Fig. 79. Pull from a piece of church silver by George Coyte; *c.* 1760–70. Victoria & Albert Museum, London

J. Cattarello Inv. et delin.t Price 4.s.
 Chatelin fecit, aqua fortis
A Book of Eighteen Leaves
Containing Divers Subjects, Calculated for the use of Goldsmiths, Chasers, Carvers, &c.
From Mess.rs Germain Messonier Sig. Cattarello &c.
To be had of the Proprietor Rob.t Clee, at the Golden Head in Panton Street, St. James's Hay Market, & at the Printsellers in London. 1757.

The only other silver engraver like Clee listed in the *Directory* was John Woodfield, of Maiden Lane, Covent Garden. We know, however, that there were many active in the area from the occupational listings recorded in the 1776 Westminster poll book. Although Clee's account at Panton Street rarely itemizes exactly what he did for the partnership the customers' accounts reveal a whole range of work that involved engraving, from 'graving a crest on a tin reflector' to 'graving borders all round and chinese characters' on a tea tub. Engraving ornaments all over Lord Exeter's teapot added £2 2s. to the £7 15s. 6d. bill for materials and making. The only work on silver that it is possible to connect directly with Clee is the 'graving glories and inscription on flaggon chalice, patten and bread plate' for Thomas Byrche Savage, which cost him £1 15s. The communion set is still in the possession of the Church to which it was presented (fig. 78).[118] It is of high quality, although of a standard design that can be seen on a range of eighteenth-century church silver. A 'pull' from George Coyte's record book shows the standard sunray 'IHS', cross and three nails (fig. 79). It seems likely that Clee was also responsible for the book plates and visiting cards which were ordered by some of Parker and Wakelin's customers.

Clee did not work as an engraver solely for Parker and Wakelin. We know from his signature which appears on shop bills that he engraved for Thomas Heming, the royal goldsmith, and Richard Siddall, the chemist in Panton Street above whose shop he lived. His work for them is but a small indication of a variety of jobs he executed for a range of clients.[119] By virtue of the survival of some small scraps of evidence that go beyond business accounts it is possible to explore the relationships between Parker and Wakelin, Clee and the royal goldsmith, Thomas Heming. On Clee's death in 1773 at the age of 62, he left a handsome £3,500 in bequests and a request that Parker and Wakelin should each have 'A Diamond Ring of the Value of ten pounds to be made by themselves', implying a degree of affection that surpassed mere business ties.[120] He also left money for a ring to be made for Thomas Heming. Clee gave 'Mr Parker my two Drawings by Schatlain of Views in Wales and also my two views of Water to Mr Wakelin by the same Master'.[121]

Jean-Baptiste Claude Chatelain was a prolific engraver who seems to have specialized in reproducing the work of some of the most famous French ornament designers, such as Watteau, Lajoue and Pierre Germain. We know from an anecdote left by Francis Grose that Clee used to invite Chatelain to dinner, 'and whilst it was getting ready, had chalk and other drawing material put before him, always taking care that dinner should not be produced until the drawing was finished. Clee used likewise to lend Chatelain money on his drawings'.[122] Clee published a later edition of Chatelain's *Book of Ornaments, Containing Divers elegant Designs for the use of Goldsmiths, Chasers, Carvers etc.*[123] in 1757, entitled a *Book of Eighteen Leaves* of designs, the majority after Pierre Germain (fig. 80). Some of these designs appear to have been the starting point for some of Parker and Wakelin's more expensive silverware. For example, two pair of large silver wine coolers supplied by Parker and Wakelin in 1763 appear to be a free adaptation of a design by Germain and were included in Clee's *Eighteen Leaves*.[124]

The number of designs Clee owned at his death suggests that he was also a dealer in prints, and his engraving activities may have only been a supplement to this trade. In a similar way, Panton Betew, 'a silversmith of the old school', was 'also a dealer in pictures, drawings and other works of art'.[125] J.T. Smith, in his biography of the sculptor Joseph Nollekens, for whom he worked, recalled how Betew asked Nollekens 'what became of that poor fellow

Fig. 80. Robert Clee, *Book of eighteen leaves, containing diverse subjects for the use of goldsmiths, chasers, carvers, etc. from Messrs Germain, Messonier, Sig. Cattarello etc.*; 1737. Yale Center for British Art, New Haven

Chatelain, who used to work for Vivares', and reported how Chatelain had died 'at the White bear in Piccadilly' and because of his poverty had been given a parish burial in the 'Pest-fields of Carnaby-market'. Francis Vivares published many books of designs that were influential in circulating French patterns in England. George Wickes, Francis Vivares and Robert Clee were all members of the Society for the encouragement of Arts, Manufactures and Commerce, founded in 1753 to promote the development of the arts of design. Here, too, they would have met some of the most influential members of the nobility, merchant class, artists and designers, expanding their networks of patrons and suppliers.

Clee was at the centre of a close community and those who might have seemed rivals were, in fact, tied together by bonds of commerce. Within the small community of London goldsmiths, who shared suppliers and relied on credit, businesses are best understood not as independent rivals but as players in an inter-dependent network. Beyond the goldsmiths' trade the bonds of business spread wide, and the opportunities for creative interchange were immense. At the same time that Josiah Wedgwood bought a tureen, made to the design of Flaxman, from Parker and Wakelin, he purchased swaged gold, silver and brass wire to mount his jasperware placques.[126] While Francis Cotes painted John and Mary Parker's portrait his younger brother, Samuel, sent his miniatures to Parker and Wakelin to be mounted in bracelets and jewelled frames.[127] The cabinetmakers Ince and Mayhew also appear in the Panton Street accounts; they bought silver ornaments for some of their deluxe beds.[128] Businesses like that of Parker and Wakelin were the go-betweens, who connected makers and buyers, offering the opportunity and stimulating the demand for invention and creation.

6

Gems, Jewellery, Buttons, Buckles and Boxes

a new Fashion takes as much with the Ladies in Jewels as anything else: He that can furnish them oftenest with the newest Whim has the best Chance for Custom.

R. Campbell, *The London Tradesman*, 1747

Visitors to London in the eighteenth century were particularly struck by the glitter of the goldsmiths' shops. At Thomas Jeffery's, near Charing Cross, in 1786, Sophie von la Roche was dazzled by the 'sparkling gold and silver moulds and vessels'which were reflected in the large mirrors that lined the walls, and 'the shelves round the window and the tables [that] contained a number of indefinable but delicately wrought trifles, as, for instance, rings, needles, watches and bracelets'.[1] Twenty years later a London guide book described how: 'The Goldmiths and Jewellers and some Pawnbrokers indulge the public with view of diamonds, pearls, emeralds, gold and silver, in most facsinating quantities.' In these descriptions the glamour of the goldsmith is heightened by the jewellery on display. The provision of gems, jewellery, buckles and buttons was an essential element of being a fashionable goldsmith.

In Mortimer's *Universal Director* of 1763, Parker and Wakelin are listed not as goldsmiths but as jewellers, along with fifty-two other London businesses, including those of Peter Webb of Throgmorton Street, John Deards of Piccadilly and Charles Belliard, 'Jeweller to his Royal Highness the Duke of York'. Mortimer explains that the artists listed 'hold first rank among the Mechanics, for the elegance of their designs, and the magnificence, splendour, and richness of their work', they are 'the capital Masters, who are either actual workmen, or employ others under their direction, and who have been brought up in the art'. It is not clear how Mortimer selected those who appeared in his *Director*, but no doubt it was a commercial enterprise, and those included probably paid to be advertised. It was not of course, 'the complete guide' it claimed to be, and many of the 'most considerable makers in London' were, contrary to Mortimer's claims, not included. Parker and Wakelin's customer accounts show that between 1766 and 1770 they sold £6,344 worth of jewellery compared to £40,274 worth of silverware. Yet the fact that Parker and Wakelin wished to be recognized as jewellers suggests that although jewellery did not form a major part of their trade, in terms of numbers of orders or income, they deemed it an important facet of their business image.

The provision of jewellery was expected from a respectable goldsmith, as their engraved shop bills suggests. Thomas Heming, the royal goldsmith,

offered 'all sorts of Jewellers work', as well as watches, seals and mourning rings. Benjamin Cartwright, advertises himself as a working goldsmith in West Smithfield, yet has watches, jewelled earrings and buckles hanging from the rocaille cartouche of his trade card, as well as tureens, kettles and tankards. George Wickes had sold watches, gold hoops, buttons and buckles to his customers, as his ledgers show, and the business continued to supply jewellery into the late eighteenth century as the only surviving stock book, dated 1797, proves.[2] It begins with diamond bracelets, earrings, feathers for the hair and lockets.

Parker and Wakelin's customers bought a large range of jewellery from them; from simple and standard enamelled mourning rings, sold at a guinea each, to more elaborate and expensive pieces, such as a 'pair of fine single drop brilliant earrings' which cost Lord Burghersh £205. In between there was a whole range of more modest jewellery that made up the bulk of the orders: gold chains, Scotch-pebble earrings, fancy flower and cluster rings, garnet necklaces, gold and enamel buttons, and paste and foilstone buckles. In comparison with other London jewellers these orders seem moderate. For example, Arthur Webb, a jeweller in Throgmorton Street (close to the Bank of England and the Royal Exchange), sold Henry Drummond the banker, in 1777, a pair of oriental pearl bracelets for £180, a 'superfine pair brilliant diamond earrings' for £580 and 37 oriental pearls for £180, part of an order that totalled £941, which was not exceptional in terms of cost or range of work he regularly undertook.

All Parker and Wakelin's orders for jewellery, like their silver, were supplied by subcontractors. This is ironic, as one of the reasons for Mortimer undertaking the *Directory* was to provide 'Patrons of merit' with an 'opportunity of visiting the artists of this metropolis, and employing them in their several departments, instead of applying to those general undertakers', that is 'the retailer, instead of the maker'[3] But Mortimer's comment is testimony to the importance of shopkeeping jewellers and their high profile in the market place. Their dominance may be explained by problems associated with setting up a business specific to the jewellery trade.

Campbell warned that the jeweller required a large stock 'especially to furnish a shop', estimating that it cost between £1,000 and £5,000 to set up as a master, one of the higher upper limits in his compedium of trade, comparable with book sellers and timber merchants and surpassed only by coal factors and brewers. Peter Webb complained to a customer in 1771 that 'the misfortune of jewellery is that with a large stock the things wanted are often what one has not got'.[4] This was the penalty of serving fashion and novelty. Campbell added, however, that 'he that intends to work only for Shopkeepers, and employ Apprentices and Journeymen, may begin with very little, and must be contented with less Profit than if he sold to the Wearer. These kind of Piece-Masters are paid according to the Work'.[5] The jewellery trade was, and still is as, specialized as that of the goldsmith, with different skills and tools required to cut and set stones, make and mend watches, string beads or paint enamel. Campbell noted that what was really important in the trade for a working jeweller was the ability to 'have a quick Invention for new Patterns, not only to range the Stones in such manner as to give Lustre to one another, but to create Trade; for a new Fashion takes as much with the Ladies in Jewels as anything else: He that can furnish them oftenest with the newest Whim has the best Chance for Custom'. It is significant that when Peter Webb's son Arthur, who had taken over the family jewellery business in 1775, died in 1792, he left a large number of designs, including 'a parcel of drawings', 'a

book of drawings of jewellery' and 'four books of jewellers patterns and Ornaments for jewellery', which were acquired by other London jewellers at the sale of his goods.[6] Arthur also possessed drawings by Choffard, Delaune and Pillement, well known French designers of ornament. These drawings were crucial in the invention and manufacture of new designs, many of which came from France, for example, J.H. Pouget's *Traité des Pierres Précieuses*, published in Paris in 1762.

Jewellery in all its forms was crucial as a signifier of status and wealth. The wearing of fine diamond earrings and the sporting of gold waistcoat buttons and chased-silver shoe buckles defined the wearer in society. As the political economist Bernard de Mandeville had made clear in his *Fable of the Bees* (1714) 'fine Feathers make fine Birds, and People where they are not known, are generally honour'd according to their Cloaths and other Accoutrements they have about them; from the Richness of them we judge their Wealth, and by their ordering of them we guess at their Understanding'.[7] As Lady Mary Wortley Montagu explained to Lady Bute, mother to her son-in-law, she wore her jewels because if she did not it would be reported that she had pawned them, and this would have questioned her position in society.[8] As it was, their value was contested. General Graeme calculated that they were worth £2,000, while consul Smith put the figure at only £1,500. If jewellery was at the gold-smiths being mended or refashioned, replacement jewels were lent, for you could not afford to be seen without them. To keep up appearances Arthur Webb 'lent Lady Cornwall of Stanhope Street, Mayfair a pr of brill. mirza earrings wth crystal value £400 until the lady's own earrings are new set'.[9] They were symbols of both material wealth and taste, the dual index to status in society.

While Campbell stressed the importance of the 'Ladies' in the matter of Jewels, it was largely men who bought for them and themselves. As Margot Finn has observed, the consumer market 'included highly acquisitive men as well as compulsively possessive women'.[10] Lord Chesterfield warned his son, 'a fool cannot withstand the charms of a toy-shop; snuff boxes, watches, heads of canes, etc., are his destruction'.[11] Yet he also advised him to 'Take care to have your stockings well gathered up, and your shoes well buckled; for nothing gives a more slovenly air to a man than ill-dressed legs'.[12] He sent his own diamond buckles to his son in Venice, with the comment 'they are fitter for your young feet – they would only expose me'.[13] It was in these matters that the ladies held sway. Chesterfield knew that 'Women stamp the character, fashionable or unfashionable, of all young men at their first appearance in the world', which added 'a lustre to the truest sterling'.[14] Women of fashion were 'a numerous and loquacious body, and their hatred would be more prejudicial than their friendship can be advatageous to you'.[15] Eighteenth-century por-traits show them sporting seals, snuff boxes, buckles and buttons. Gains-borough's portrait of the Rt. Hon. Charles Cornwall, depicts him as a man of taste, holding a snuff box, seals hang from his waistband and smart silver buckles adorn his shoes (fig. 81).[16]

London jewellers had their own networks and 'commonly met at Chad-well's Coffee-house to do Business among themselves'.[17] Chadwell's was in Threadneedle Street, a place where rewards could be claimed for finding 'lost' goods, and where catalogues for forthcoming auctions could be bought. Of Parker and Wakelin's seventy-five suppliers listed in the Workmen's Ledger, twenty-two were jewellers, goldworkers or related craftsmen and women. Of these, two were seal mounters and engravers (Richard Frewin and Samuel Rush); two suppliers of stones and pearls (Francis and John Creuze and John

Fig. 81. *Rt. Hon. Charles Wolfran Cornwall*, by Thomas Gainsborough (1727–88); 1785–6. Oil on canvas; 228 × 148.5 cm. National Gallery of Victoria, Melbourne, Australia

Wood); two button and buckle suppliers (George Padmore and Isaac Rivière); four goldworkers (John Barbot, Elias Russel, John Derussat and James Morley Evans, who made chains); a watchmaker (Joseph Lucas); a motto ring supplier (Edmund Price); a filigree worker (Henry Hayens); a partnership of enamellers (Toussaint and Morisset); two bead stringers (Richard and, later, Margaret Binley and Thomas Howell); a pocket book maker (John Pepper); and five jewellers who billed the firm for unspecified work (Gideon Ernest Charpentier, Thomas Forrest, Edward Holmes, Daniel Payan and Michael Shucknell). It is significant that in *Mortimer's Directory* none of the above are named in the list of fifty-two 'capital Masters'.[18]

These twenty-two subcontractors were part of a much large reservoir of skilled labour in London. According to the poll book of 1774, 44 men gave their occupation as jeweller in Westminster alone, which would have included makers as wells as retailers, and excluded those who made and sold jewellery but chose to register as goldsmiths and silversmiths. The jewellers and associated tradesmen and women who supplied Parker and Wakelin reflect the established divisions within the trade. In the Workmen's Ledger the speciality of each jeweller is usually clear from the accounts. However, there are a few whose work was unitemized and who were paid according to bills of 'jewellers work', which give little indication of what they were supplying. Michael Shucknell and Edward Holmes were supplying the business with such work from 1767, the date that their accounts begin in the Workmen's Ledger, since there is no indication that they were brought from the earlier (missing) supply ledger.

Michael Shucknell submitted an account with Parker and Wakelin which was settled annually: in 1768 he received £804, in 1769 he received £609 and his account continues up to 1773. However, it is unclear what proportion of this sum represented labour and what proportion materials. He was paid in a combination of cash, new silver, gold, pearls and diamonds. Shucknell also appears to have been a retailer, as his name appears on a bill for a diamond parure costing £5,000. He was dealing directly with Sir Watkin Williams-Wynn, fourth baronet (1749–89), one of the wealthiest commoners in Britain.[19] The £2,408 the latter spent on a great silver dinner service supplied to him by Joseph Creswell seems by comparison modest.

Edward Holmes was a working goldsmith who, in 1777, advertised in a trade directory that he operated from 138 Aldersgate Street.[20] It is impossible to tell from his account with Parker and Wakelin just what sort of work he did for them. However, from the day books of Arthur Webb we can glimpse the type of work Holmes specialized in, as he appears in Webb's accounts as a supplier in the 1770s. He sold Webb cameo rings, stones and pearls, and appears also to have lent Webb money, as he was paid £700 interest in 1771. Although Shucknell and Holmes continued supplying Parker and Wakelin into the 1770s, three other jewellers appear in the accounts in this period. Thomas Forrest's account begins in 1770 and he, like Shucknell, was paid each September: in 1771, £129; in 1772, £83; and in 1773, £24. Forrest was the half brother of William Paris Tayler, who had joined Parker and Wakelin in 1769 and would eventually take over the business with John Wakelin in 1776.[21]

New employees brought new networks of suppliers. Daniel Payan, was paid from October 1770 to September 1773. In the 1790s he advertised from 44 St Martin's Lane as a jeweller, which may mean that he had saved enough money by that date to set himself up in business.[22] Gideon Ernest Charpentier's name appears in the Workmen's account in January 1771, again for 'jewellers

work'. He was paid annually until 1774: £71 in 1771, £57 in 1772, £50 in 1773 and £142 in 1774. He was born in Emden, Germany, in 1733 and was in London by 1758, as his name appears in the marriage register of St James's, Westminster, at that date. He gave his address as 4 Great St Andrew's Street and called himself a silversmith, not a jeweller.[23]

'CURIOUS WORK IN GOLD'

The specialist jewellers and associated craftsmen that Parker and Wakelin relied upon to stock their shop and serve their account customers reflects the major types of jewellery and accessories advertised on their trade card, which were common to a goldsmiths' business.

Craftsmen skilled in working gold formed a distinctive group of specialists. They are listed in a document dealing with duties on gold of 1738, and included 'gold snuff box makers and joint hinge makers, gold plain ring and earring makers, gold chain makers, gold watch case and dial plate makers, gold equipage and trinket makers, gold coral and knife haft makers, gold water gilders, jewellers, gold cane head makers, gold sword hilt makers'.[24] The author commented that 'it is modestly computed by the persons who are best judges that the gold wrought up yearly . . . must far exceed eighty Thousand ounces'. The cost of gold compared with silver meant that it was unusual, because of its expense, to make large objects from it such as dishes, cups and covers. In 1770 the price of silver was 5s. 6d. per troy oz, while gold was £3 18s. per troy oz. In Parker and Wakelin's accounts between 1766 and 1770, the only order in gold that was not for jewellery was for a gold punch ladle with a whalebone handle, for Anthony Keck, costing £11 10s. In the same year the Earl of Radnor bought an oval punch ladle in silver which cost him only 11s. 6d. An exceptional piece of wrought gold was supplied by Parker and Wakelin in 1772, for John Smith Barry who commissioned a 'fine Chais'd Gold Cup and Cover'. At £157 15s. for the gold alone (and £50 for the making), it cost fourteen times the amount for one made in silver.[25]

Elias Russel[26] must have been working for Parker and Wakelin from at least 1761, as a hallmarked gold box survives bearing Russel's mark and the inscription 'Parker and Wakelin Londini Fect' (fig. 82) on the bezel.[27] It is made in the most fashionable French coloured gold. Yet the identification of this object with Russel is misleading in that it suggests that most of his work for them was of an elaborate and expensive character. Between 1766 and 1770 the only work on boxes he carried out for Parker and Wakelin was for repair work, like the 'sundrys to a fine bloodstone box' for which he was paid £1 1s; repairing 'a snuff box for Portuguese ambassador' for 2s; and adding a 'new tortoiseshell top' and 'fixing the flowers on Richard Temple's'.[28]

Between 1766 and 1770 Parker and Wakelin supplied only two gold snuff boxes, a 'fine oval chaised snuff box' costing John Williams £39, and another for Edward Stratford costing £23. This does not mean there was little demand for these objects, but rather that Parker and Wakelin's customers went elsewhere for them. There is plenty of evidence in diaries, letters and literature to show that the snuff box was one of the most common personal accessories in the eighteenth century, for both men and women, whether made from the cheapest Bilston enamel or the most precious stones and metals. The Norfolk parson James Woodforde 'Gave away' his snuff box to a 'Particular Friend',[29] while Thomas Gray, in 1772, left his fellow antiquary

Fig. 82. Snuff box, by Elias Russel, retailed by Parker and Wakelin; 1761. Gold (London); 7.7 × 3.7 × 3.5 cm. The Worshipful Company of Goldsmiths, London

Fig. 83. *Peter Perez Burdett and his first wife Hannah*, by Joseph Wright of Derby (1734–97); 1765. Oil on canvas; 145 cm × 205 cm. National Gallery, Prague

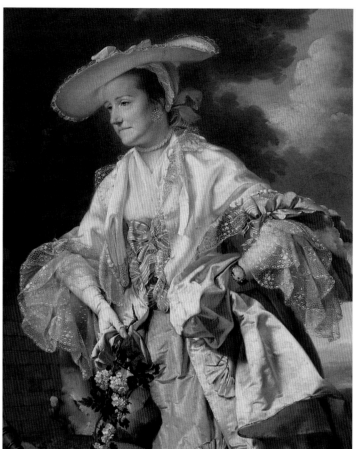

William Cole 'a large embossed silver snuff box'.[30] Horace Walpole alerted his cousin Thomas to the sale of the Duchess of Portland's collection of 'hundred's of old-fashioned snuff boxes that were her mothers who wore three different ones a week'.[31]

As a goldworker, Russel supplied gold hoop wires for earrings, and small gold buckles, but most of his work involved mounting 'pictures' on boxes and for bracelets. For a customer named Lethieullier he mounted 'a picture in a gold frame and cristal in a Box', for which he charged Parker and Wakelin £1 16s. It is likely that it was Russel who mounted the miniatures that Samuel Cotes brought into the workshop to be turned into the then highly fashionable 'picture bracelets' and pendants. They appear in society portraits of the 1760s and 1770s, like that of Lady Elizabeth Foster, painted by Angelica Kauffman, and Joseph Wright of Derby's portrait of Hannah Burdett wearing a mounted picture bracelet on her left wrist (fig. 83).[32] Charles Tryon bought just such a bracelet for his wife in 1768, and paid £18 10s. for the setting with brilliants (diamonds) and rubies. Some bracelets were further set with hair plaits at the back, as an even more intimate reminder of the person portrayed.

The small amount Russel was paid each year, between £70 and £90, suggests that he was working for other London goldsmiths. Between 1751 and 1785 the Westminster rate books record Russel at 42 Suffolk Street, which is an extension of Oxendon Street, so at the time of his account with Parker and Wakelin he was only a few hundred yards away from the King's Arms in Panton Street.[33] An inventory taken in 1746, in which he valued his

wrought and manufactured plate at £100, suggests that he was not a shop-keeper. Such low-value stock implies a craftsman working with or on materials supplied by his clients.[34] By 1786 the value of his stock had fallen to £50.[35]

John Barbot's account with Parker and Wakelin opened in January 1767 and continued until October 1775. This is puzzling, as we know from his will that he died in 1766.[36] It is likely that Parker and Wakelin kept the name of the account the same, despite the fact that John had taken his son Paul into partnership in 1765. Paul's name does not replace his father's in the rate books until 1771, in which year he also entered his first mark. A delicate gilt-mounted nécessaire survives of c. 1765–70, which bears the signature of Paul Barbot in pencil inside, giving an indication of the high quality of his work (fig. 84).[37] One of Barbot's larger jobs for Parker and Wakelin was the making of an Order of the Bath for a customer named Blaguire, in 1774, for which he charged Parker and Wakelin £6 7s. 6d. for the gold and £5 5s. for the fashioning. Most of his work for the partnership was, however, much more mundane: repairing watch cases and mending trinkets; and supplying toothpick cases, 'bird topped scissors', needles, gold-capped smelling bottles for étuis, and cane heads. In August 1768 he was paid £36 of which just over a third, £9 19s, went on a gold toothpick case, that is £7 1s. for the gold and £2 18s. for the making. Parker and Wakelin sold this trinket to Lord Onslow for £11 0s. 6d.

Barbot's willingness to execute such mundane work for Parker and Wakelin may be explained by the changes in fashion which were occurring in the 1760s and 1770s. There is no doubt that he, like his father, was one of the 'best hands' at chasing in London.[38] However, fancy cane heads and elaborate rocaille chasing were going out of fashion, so chasers had to look elsewhere for trade. Only three chased-gold cane heads were sold by Parker and Wakelin between 1766 and 1770; the most elaborate was described as 'chaised wth goats heads, festoons and cypher', for Lord Nuneham in 1770. He paid £5 4s. for the gold and £3 6s. for the chasing. J.T. Smith, noted how George Michael Moser, 'originally a chaser', had to apply himself to enamelling when 'that mode of adorning plate, cane-heads, and watch-cases became unfashionable'. Paul Barbot was a close friend of John Andrew Derussat, whose will, written in 1776, acknowledged a loan of £250 and named his as executor.[39]

Derussat took out a Sun Insurance policy in 1766 for the Black Moors Head, Little Earl Street, in Seven Dials.[40] In that year he would have been an established London tradesman of thirty-four. He was from a family of Huguenot jewellers, called himself a 'smallworker in gold' and we know that he was a snuff box maker.[41] A fine unmarked silver-gilt snuff-box, now in the possession of the Goldsmiths' Company, is engraved with the story of the good Samaritan and the words '*Jno Derussat London Fecit 1756*' (fig. 85).[42] This was given to the Company in his memory by his friend Paul Barbot in 1807.[43] The ties of business and family were complex, and objects such as this box are rare material evidence of these interconnections. As in the cases of Russel and Barbot, despite the survival of elaborate and expensive objects of virtu bearing Derussat's mark, we know from the ledgers that he supplied only the small and mundane to Parker and Wakelin, including scissors, needles and bodkins, stay hooks, tweezers and ear and toothpicks.

Another gold working specialism was the making of chains. James Morley Evans supplied women's and men's jack, round and square-link chains to

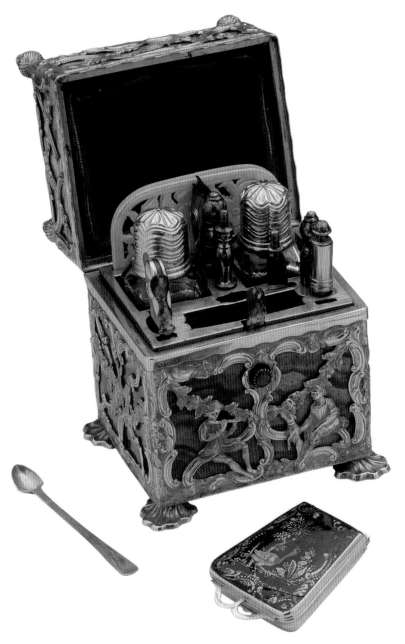

Fig. 84. Nécessaire, signed by Paul Barbot; *c.* 1765–70. Gold, with ivory and blue glass (London). Ashmolean Museum, Oxford

Fig. 85. Snuff box, engraved *Jno Derussat, London, Fecit, 1756*, open and closed; 1756. Gold (London); 8.5 × 2.3 × 5.6 cm. The Worshipful Company of Goldsmiths, London

Fig. 86. James Morley Evans's account with Parker and Wakelin; 1767–8. Workmen's ledger. Victoria & Albert Museum, London

Parker and Wakelin (fig. 86). His entry in the Workmen's ledger for 1767–68 shows that he made for both account customers and the shop, and that a years' labour cost Parker and Wakelin £212 17s. Chain making before the advent of mechanization in the mid-nineteenth century was a time-consuming business. It took one day to link eighty-five links producing seventeen inches of chain.[44] Morley charged between £5 and £7 for each chain, and Parker and Wakelin made a profit of 15s. per chain they sold. Evans also supplied and engraved gold buttons, buckles and watch keys.[45]

'MAKE AND SELL ALL SORTS OF . . . WATCHES'

As Campell noted, watchmaking was one of the most subdivided of the trades. 'The Watch-Maker puts his Name upon the Plate, and is esteemed the Maker, though he has not made in his Shop the smallest Wheel belonging to it'. His skills lay in judging 'the Goodness of Work at first sight' and he puts his 'Name to nothing but that will stand the severest Trial, for the Price of a Watch depends upon the Reputation of the maker only'. There was no lack of watch-making skill in London, and the author of *The Book of Trades* (1811) explained that 'This business has not been known in England for more than a century and a half, but now the best watches in the world are made in London'.

Although Parker and Wakelin's customers regularly brought their watches in to be cleaned, to have chains attached, keys replaced and cases renewed or engraved, very few new ones were sold. The only watch sold in 1768 was bought by John Palmer for £28, and described in the ledger as a 'blue enamelled horizontal watch, capped and jewelled'. Joseph Lucas appears to have been the only watchmaker on Parker and Wakelin's books, and most of his work concerned mending and cleaning: 'colouring and repairing a chais'd watch', 'repairing the motion of an enamelled Repeater', 'repair watch by Grignon', 'repairs to a Pendulum Clock' and 'repairs to a Gold Watch very much broke'. Lucas supplied Palmer's watch for which he charged Parker and Wakelin £24. He charged £1 6s. for 'engraving a gold watch case all over' for which the Portuguese ambassador, the Marquise de Pombal, was billed £2 2s. Lucas' annual bills, which came to between £70 and £90, were usually settled in a combination of ready money and old gold watches.

Looking at other jewellers' accounts it is clear that the watches Parker and Wakelin supplied were of quite modest price and design. The Webb's day book includes 'an enamelled watch and chain by Moser with diamonds' which he sold to the Earl of Strathmore in 1768 for £351. The account tells us that the gold and jewelling cost £51 and Mr Moser was paid £75 for enamelling and chasing. Moser, as a chaser, designer, modeller, initiator of a drawing school in London and a director, in 1765, of the Society of Artists, was a leading figure who connected the world of fine and decorative arts. Webb's watch by Moser was an exceptional piece of jewellery. A more usual order was for 'a blew enamelled repeating watch and chain' bought by Webb at a cost price of £60, and presumably a much finer version in materials and quality than that bought by Palmer from Parker and Wakelin.

There was no shortage of watchmakers in London. The 1774 Westminster poll book includes thirty-two of them, including Alex Cumming not far from Parker and Wakelin in Bond Street, John Gervis in Golden Sqaure and Conyers Dunlop in Spring Gardens.

BUCKLES AND BUTTONS

Buckles and buttons were an important component of a person's identity. In descriptions of runaways in newspapers; in depositions recalling suspects and witnesses; in diary accounts of friends and strangers; and in fictional creation of characters, buckles and buttons play an integral role. The novelist Tobias Smollet relates how his character Mr Cringer, Member of Parliament, was dressed in 'a blue frock with a gold button, a green silk waistcoat, trimmed with gold, black velvet breeches, white silk stockings, silver buckles, a gold-laced hat, a Spencer wig, and a silver-hilted-hanger, with a fine clouded cane in his hand'.[46] In this description the number of accessories outweighs the clothes in creating the character.

When the country parson James Woodforde dined out in June 1784, he noted: 'The Ladies and Gentlemen very genteely dressed.' He also calculated the relative standing of two of the guests via the cost of their shoe buckles: 'Mr Micklethwaite had in his Shoes a Pair of Silver Buckles which cost between 7 and 8 Pounds', while 'Miles Branthwaite had a pair that cost 5 guineas'.[47] Two years before, Carl Philip Moritz had been irritated by a young fop sitting behind him in the pit at the Haymarket Theatre, who 'continually put his foot on my bench in order to show off the flashy stone buckles on his shoes; if I didn't make way for his precious buckles he put his foot on my coat tails' (fig. 87).[48] The very point, of course, was that they were worn to be *seen*, and their value (both in weight and workmanship) calculated; it was part and parcel of weighing up one's peers. Buckles were even thought valuable enough to be worth stealing. Thomas Noel wrote to his sister in 1771: 'I suppose you have heard that widow Rowney was robbed at night, and that the man came into her room and stole her buckles out of her shoes she never waked.'[49]

Although worn by women as well as men, the shoe buckle formed a particularly visible form of male jewellery. While women could wear necklaces, earrings, bracelets and aigrettes, the male was restricted to a relatively limited repertoire of ornament: a ring, stock, shirt, waistcoat, breech and shoe buckles, a watch, a cane and sometimes a sword.[50] Parker and Wakelin sold every conceivable shape, size and function of buckles: for belts, knees, shirts, stays and stocks, but most of all buckles for shoes, from fine topaz ones at £27 6s. a pair to the cheapest plated ones costing between 4s. and 6s. a pair. Shoe buckles in particular were immensely fashionable in the 1760s and 1770s, and the increase in their size, and therefore their visibility, is commented on by Sheridan in his popular play, *A Trip to Scarborough*, first performed on the London stage in 1777. Lord Foppington complains of the small size of the shoe buckles offered by his jeweller, who has come to help dress him:

> My good sir, you forget that these matters are not as they used to be; formerly, indeed, the buckle was a sort of machine, intended to keep on the shoe; but the case is now quite reversed, and the shoe is of no earthly use, but to keep on the buckle. [in the past] The buckle then its modest limits knew, Now, like the ocean, dreadful to the view, Hath broke its bounds, and swallowed up the shoe.[51]

George Padmore of Frith Street in Soho supplied most of Parker and Wakelin's silver buckles.[52] He made buckles for stocks, for boots and shoes, garters and knees, that could be 'neat', 'best', 'plain' or 'common' depending on the amount of workmanship involved. He supplied common silver buckles

Fig. 87. Buckles; 1760s–80s. Silver and paste with steel. Kenwood House, London

at 2s. a pair, which Parker and Wakelin sold to their customers for 6s. Campbell, in 1747, commented that 'the best Branch of the Buckle making is making Silver Buckles, either plain, carved . . . It is a branch of the Silver-Smith's Business and a genteel Livelihood is made of it, by working for the Shops', and estimated that a journeyman could earn from a guinea to 30s. a week. Although a lucrative business, that had emerged in the 1660s, by 1800 it had rapidly declined as laces replaced buckles.

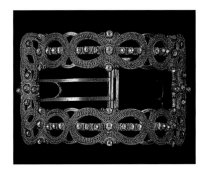

James Morley Evans, the goldworker, supplied gold buckles. He made a standard charge of £2 2s. for fashioning them and, depending on the amount of gold employed, charged Parker and Wakelin between £10 and £12 a pair, which gives a good illustration of the difference between the cost of materials and of workmanship.

A reflection of the importance of buttons, was that button makers registered regular patents for faster and cheaper manufacturing methods and for diversity in materials and design. Sheffield plate was first made by a button maker, Thomas Boulsover, in 1742, and was for the first ten years after its invention confined to button production. The *Tradesman's True Guide and Directory*, of 1770 explained:

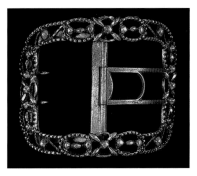

> This Branch is very Extensive, and is distinguished under the following Heads: viz. Gilt, Plated, Silvered, Lacquered and Pinchbeck, the beautiful new Manufacture Platina, Inlaid, Glass, Horn, Ivory and Pearl Metal Buttons such as Bath, Hard and Soft White etc., as well as Paste, Stones etc. in short the vast variety of sorts . . . is really amazing, and we may with Truth aver that this is the cheapest market in the World.

Despite this diversity, which is dominated by cheaper materials, Parker and Wakelin sold mostly gold, diamond, garnet and enamelled buttons. However there were also orders for cut marcasite, pebble and agate buttons which although cheaper were fashionable in their own right.

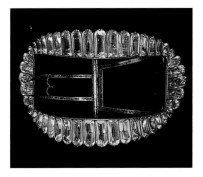

Isaac Rivière (1734–86) appears to have specialized in buttons, providing patterns for coat, waistcoat and breast buttons, and also shoe clasps and corals (fig. 88). His account with Parker and Wakelin includes a gold thimble, and more unusually '4 ferrit bells', presumably for the collar of a much-loved pet. An insurance policy he took out in 1771 gives his address as Tottenham Court Road.[53] He came from a family of watchmakers, goldsmiths and jewellers.[54] Rivière's buttons were mostly made of silver, but he was able to furnish them in a whole variety of materials: gold, enamel and paste, some with foiled backs, called 'foilstones' and set with semi-precious stones like agate and mocoa, a special type of agate that had attractive moss-like inclusions. Some must have been 'made to match'. We can recreate what the process of purchasing must have been like via a detail from one Edward Purefoy's many letters about shopping. Writing from Sussex to his friend in London he asked that he 'send 20s. Silver Buttons for my son's Breetches, the same sort and size you sent last, wch if the man that sells 'em has forgot I must send up a Button for a pattern'.[55] The exchange of patterns between retailer and customer was the most reliable method of reproduction. Johnes of Hafod sent Matthew Boulton,

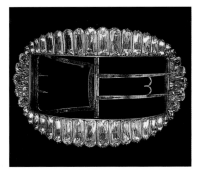

> two of the Buttons of the Carmarthenshire Militia, and as I am not a little proud of so very Fine a Body of Men I wish to set them off by every means and shall beg of you to exert yourself in making us a handsom Button, and as reasonable as you can . . . I wish that the shanks may be particular strong, I wish you would send me some patterns and the prices to me as soon as you can.[56]

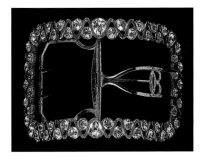

Boulton kept button dies in stock, which were reserved for his clients as an aid and encouragement to reordering.

Zoffany's portrait of Sir Lawrence Dundas (1733–1810) with his grandson, painted in 1769, gives some idea of how prominent these button and buckles were on male dress (fig. 89). It is a painting that very consciously picks out the detail of material possessions: the rich coloured pile of the carpet, the polished gloss of the mahogany tables and the gilded carving of the picture frames. His waistcoat, edged with gold braid, is fastened with nine gold buttons and his coat is sewn with matching buttons that also decorate the broad sleeves. His breeches are buttoned up the side and are secured at the knee with silver garter buckles, while his black shoes sport plain silver buckles. We cannot see the stock buckle that holds his white neckerchief in place. His waistcoat buttons alone, if gold, would have cost about £15, while Zoffany was paid £105 for the painting.[57] Joseph Wright of Derby's portrait of Sir Robert Burdett, of 1760–62 provides a more detailed view of male costume at the time, and the profusion of gold buttons integral to the design. Burdett has at least twenty-four gold buttons on his coat and fifteen more on his waistcoat, which in Parker and Wakelin's

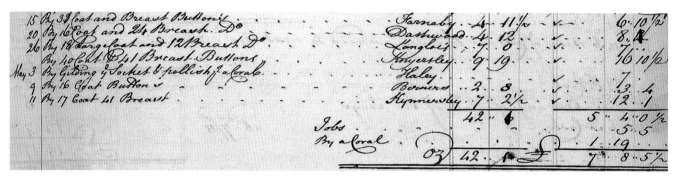

Fig. 88. Isaac Rivière's account with Parker and Wakelin; 1769. Workmen's ledger. Victoria & Albert Museum, London

Fig. 89. *Sir Lawrence Dundas and his Grandson, afterwards first Earl of Zetland in the Library at 19 Arlington Street, London*, by Johann Zoffany (1733–1810); 1769. The Marquess of Zetland

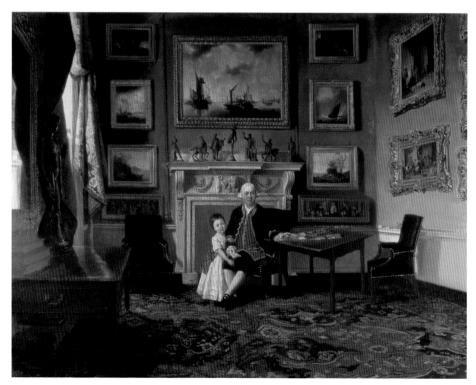

accounts would be called 'coat' and 'breast' buttons. In 1766 William St Quintin paid £2 10s. 10d. for fourteen coat and fourteen silver breast buttons, each of which were engraved with 'ornaments', in gold they would have cost over £70.

SUPPLIERS OF STONES AND PEARLS

The author of A General Description of all Trades (1747), made a distinction between jewellers and dealers; the former 'cut and polish Diamonds, and all other precious Stones, a very curious Business' and others who could also be jewellers who were 'great Dealers in them'. It is unclear whether either Parker or Wakelin were able to 'Judge of all manner of precious Stones, their Beauties, common Blemishes, and their intrinsic Value', an integral part of a jeweller's skills. They relied on Francis and John Creuze for most of their precious stones and pearls, like the '4 penny weight of seed pearls' which cost £2 3s, the '62 Brilliants for Rings' costing £16 3s. 6d., and the '46 roses for Urn Rings' at £8 1s. These refer to rose cut diamonds, which were going out of fashion in the eighteenth century as the more fiery brilliant, introduced at the end of the seventeenth century, was gaining in popularity.[58] The Creuze brothers' bank account at Drummonds reveals they were dealing with an extensive network of diamond dealers, including Salomons, Lejeune, Tregent, Desfevbres and Vandermeulen, and were supplying other retailing jewellers including Charles Belliard.[59]

In 1771 John Wood, jeweller, began supplying brilliants, emeralds, oriental pearls and mocoas, onyx urns and other stones to Parker and Wakelin. He was paid in cash and in kind, receiving in part payment for one bill a gold snuff box that 'had been Lord Nuneham's', parcels of stones and silverware including two oval dishes and covers. Wood appears in the New Complete Guide to London of 1777 as being in Noble Street, Foster Lane. His account with Parker and Wakelin shows that he frequently deducted money for prompt settlement of bills, a 'Large Brilliant ring', for which he charged £195, was sold for £5 less 'for prompt payment'. Jewellery incorporating other precious stones was made up for customers: 'a yellow B[rillian]t Ring set round with rubies' for which they charged £14 and 'a sapphire ring with Bt and rubies', for £8 8s.

By far the largest orders were for diamonds, which appears to confirm Rouquet's belief that 'The use of diamonds is more received in England than that of other jewels; they are richer, less variagated, and less liable to imitation'.[60] Queen Charlotte's love of them enhanced their popularity at Court and in fashionable circles, and, as a result, 'at this time the Jewellery Business was in a flourishing state'.[61] Allan Ramsay's portrait of Queen Charlotte shows a diamond aigrette (feather), a 'rivière' necklace of 26 diamonds, and a stomacher sewn with diamonds, which the Duchess of Northumberland reported was valued at £60,000 (fig. 90). The jewellery had been sent round to the artist's Harley Street studio for him to copy.[62] The painting survives, the jewels have not. The diamond aigrette was the latest French fashion. Lady Susan Lennox wrote to her friend, Lady Susan Fox Strangways, in 1766 that 'the french dress is coming into fashion', which included little flowers in the hair 'dab'd on the left side' and a black and white feather, with a diamond feather-jewel.[63] Mary Little, later Lady Carr, was painted by Gainsborough c. 1763 wearing an aigrette in diamonds in her hair, diamond cluster earrings and strings of pearls at her wrist (fig. 91).

Fig. 90. *Queen Charlotte*, by Allan Ramsay (1713–84); 1761–2. Oil on canvas; 196.9 × 135 cm. Schloss Wilhelmshohe, Kassel

Fig. 91. *Mary Little, later Lady Carr*, by Thomas Gainsborough (1727–88); c. 1763. Oil on canvas; 127 × 101.6 cm. Yale Center for British Art, New Haven

Mrs Delaney's description of Mrs Spencer's first appearance at Court, in 1756, gives an impression of the most expensive type of diamond jewellery then fashionable. The size, cost and elaborate settings outstrip anything sold by Parker and Wakelin.

> The diamonds worth twelve thousand pounds, her earrings three drops all diamonds, no paltry scrolls of silver. Her necklace most perfect brilliants, the middle stone worth a thousand pounds, set at the edge with small brilliants . . . Her cap, all brilliants (made in the fashion of a small butterfly) had a very good effect with a pompon, and behind . . . a knot of diamonds, with two little puffs of diamonds . . . and two shaking sprigs of brilliants for her hair, six roses for her stays.[64]

Reynolds' portrait of Lady Elizabeth Keppel painted in 1761 suggests what Mrs Spencer might have looked like. She wears an elaborate diamond headress, with large girandole earrings swaying from frames, at the throat a short festoon of diamonds and a long diamond chain ending in fashionable knot, on her white-satin shoes are diamond-set buckles (fig. 92).[65] Isabella, Countess of Hertford's diamonds look similarly spectacular in her portrait of 1765, painted by the Swedish artist Alexander Roslin (fig. 93).

The author of the *General Description of all Trades* noted that a 'Dealer in Diamonds' needed more to set up in trade than 'a master, who only works for others'. The dealer 'must have Cash in Proportion to his Stock, and

some only trade in them but never work on them'. From Parker and Wakelin's accounts it appears that the Creuze brothers also made-up jewellery as they supplied a pair of 'three drop Brilliant earrings' made for Joseph Gulston, which cost him £240, and a 'Brilliant Pompone' [a diamond encrusted sphere with a long pin for the hair], for Dashwood costing £160. This was none other than Sir Francis Dashwood, founder of the infamous Hellfire Club.

We have no information in the ledgers to shed light upon the design process, so we must look elsewhere for evidence. In a letter from Matthew Boulton to the London jeweller John Duval, of 1770, we learn a little of the exchange of information which was required in the making up of such expensive jewellery:

> We send you enclosed drawings which we have made for the diamonds you left us, if the Lady chuses to have rose diamonds to be taken in payment or exchange or brilliant to be furnished we can make a pair of single drop earrings like the further drawing, if the Lady would chuse to keep Rose diamonds we can use a pair of tops like the Drawing no. 2 and besides an Aigrette and for pins.[66]

Diamonds were suited to both young and old. One of the most popular forms in jewellery Parker and Wakelin took in the later 1760s were cluster rings and earrings. Gainsborough's portrait of Mary Duchess of Montagu (1711–75), painted in 1768, shows the sitter wearing fashionable cluster ear-

Fig. 92. *Mrs Elizabeth Keppel as a bridesmaid*, by Sir Joshua Reynolds (1732–92); 1761. Oil on canvas; 236.2 × 146 cm. Woburn Abbey, Bedfordshire

Fig. 93. *Isabella, Countess of Hertford*, by Alexander Roslin (1719–93); 1765. Oil on canvas; 85.7 × 73 cm. Hunterian Art Gallery, University of Glasgow

Fig. 94. *Mary Duchess of Montagu,* by Thomas Gainsborough (1727–88); *c.* 1768. Oil on canvas; 125.7 × 100.3 cm. The Duke of Buccleuch and Queensbury, Bowhill

Fig. 95. *Miss Ann Ford, later Mrs Thicknesse,* by Thomas Gainsborough (1727–88); 1760. Oil on canvas; 196.9 × 134.6 cm. Cincinnati Art Museum

rings which would have been made from setting up to two hundred individual brilliant cut diamonds (fig. 94). A diamond ring along with a gold band appears frequently in Parker and Wakelin's accounts and usually heralded a marriage. For example, their client, 29-year-old Thomas Bagge of Stradsett Hall and Islington Hall in Norfolk, married a near neighbour, Pleasance Case, on 20 July 1768. A 'brill hoop ring and gold Do'. had been delivered to him on 28 June, and he paid £13 17s. 6d. two months later.

The transformation of the raw diamond via the skills of cutting and polishing into an object of desire and display, was a popular metaphor for the virtues of refinement and culture, and the relationship between material and man-made values. As Lord Chesterfield observed: 'A diamond while rough, has indeed its intrinsic value; but, till polished, is of no use, and would neither be sought for nor worn. Its great lustre, it is true, proceeds from its solidity and strong cohesion of parts; but, without the last polish, it would remain for ever a dirty rough mineral.'[67]

Yet other stones were popular, including semi-precious garnets. They appear in Parker and Wakelin's accounts as 'bunches', bracelets and crosses; customers paid shillings rather than pounds for them. Thomas Gainsborough painted Anne Ford, later Mrs Philip Thicknesse, in 1760, wearing such fashionable garnet jewellery (fig. 95). She wears strings of garnets at both wrists and around her neck in a choker, clusters of garnets are at her ears and strings of garnets are wound into her hair. They catch the light and twinkle, setting off the sitter's creamy skin, but are not ostentatious. However, by the mid 1770s the gold-

smith Dru Drury advised one of his customers that: 'Garnet [bracelets] of all sorts are now much out of fashion. The present taste is to have them composed of small pictures . . . and fixed to black velvet or else Hair of some particular form worked into a cypher or Landskip and set in Gold or metal double gilt' (*see* fig. 83).[68] Her subsequent order followed Drury's advice. Sir William Young made just such an order from Parker and Wakelin in 1770. His 'pair of garnet bracelets in gold with cristals and hair plaits' cost him £9 10s.

Imitation stones were not necessarily cheap if they were in fashion. Thomas Egerton paid £5 5s. for his pair of 'fine paste shoe buckles' and Admiral Osbern paid 6s. more for his 'fine oval foilstone buckles'. None of Parker and Wakelin's customers bought diamond buckles, suggesting they were simply not the 'mode'. Paste and foilstones made up an important element of their jewellery sales, and as such were advertised on their trade card as 'variety of False Stone work'.

Pearls were also popular, and much cheaper than diamonds. Contemporary portraits show the fashion for long strands of pearls wound round the collar and bodice, for several rows of pearls to be strung as a necklace, for drop pearl earrings and pearl shells, known as coques, turned into more informal earrings and pins. Gainsborough's portrait of Mary Countess of Howe (1763–64) includes pearls round the neck and clusters of pearls at her ears (fig. 96). Thomas Hudson's earlier portrait of a lady in a blue gown shows the sitter with pearls wound into her hair, draped around her breast and set in bows at her elbow (fig. 97). Such ensembles are common in Parker and

Fig. 96. *Mary, Countess of Howe (1732–1800)*, by Thomas Gainsborough (1727–88); *c.* 1763–4. Oil on canvas; 243.2 × 154.3 cm. Iveagh Bequest, Kenwood

Fig. 97. *Lady in a Blue Gown*, by Thomas Hudson (1701–79); *c.* 1750. Oil on canvas; 127 × 101.6 cm. Mallett & Son Ltd, London

Wakelin's accounts. Thomas Egerton bought his wife, in 1769, 'a pair pearl single drop earrings, bows, knots, necklace and pompone' for £148; the pompon, or tassell being the latest in French fashion. Joseph Gulston paid £59 for a bracelet 'with 12 rows fine oriental pearls'. Lady Byrche Savage's 'pr coque night clothes earrings' cost, by comparison, a modest £1 11s., being made from shell and not 'real' pearl.

'NEAT MOURNING RINGS OF ALL KINDS'

In comparison with the elaborate stone-set jewellery the Creuze brothers and John Wood supplied, Edmund Price dealt in a much more modest and common form of jewellery, motto and mourning rings. We know little about Price, except what he mentions on a Sun Insurance policy which he took out in 1771 for 17 Maiden Lane in Wood Street, covering his dwelling house for £70 and his wash house for £30.[69] He called himself, on the policy, a 'goldsmith'. He supplied Parker and Wakelin between forty and fifty motto rings a year, charging 4s. to make each ring (whether turned, threaded, nurled or waved [referring to the pattern of the upper and lower edges]), which Parker and Wakelin sold for a standard £1 1s. each. Short 'mottoes' were engraved on the inside of the ring, an intimate and very personal form of jewellery, which, from their number in the accounts, seem to have been very popular. If Smollet's reference to this type of ring in his novel *Humphry Clinker* relates to reality, then customers had a choice between 'ready-made' mottoes and those engraved to the customer's choice, which were more expensive. More elaborate stone-set motto rings were also supplied, like the 'amethist motto ring' which cost 10s. to make and 6s. for the stone.

Mourning rings were supplied in quantity. The presentation of them to favoured relatives and individuals was often stated in the deceased's will, which the executors were bound to honour. Dame Cecilia Garrard, in her will proved in 1753, bequeathed an 'esteemed old acquaintence [a] mourning ring as a token of my kind remembrance and regard for her', as well as bequeathing them to her close neighbours, and 'all my kind obliging friends who have been so good to enquire after me in my late sickness'.[70] These are likely to have been the standardized rings that Price supplied, like the thirteen mourning rings for a customer named Lynes in 1768, charging £2 12s. for their making and £2 for the gold. Lady Delamer bought twenty mourning rings in 1770 for £21. These were batch-produced rings, conventional symbols of grief, made as goldsmiths' shop bills advertised 'at the greatest expedition'. They were usually enamelled in black or white, with the name, age and date of death of person to be commemorated, revealed in gold, and sold for a guinea each (figs 98, 99).

Fig. 98. Waved mourning ring, gold and black enamel for William Cole (died 12 August 1759, aged seventy-five). No hall marks, mark RH. Private collection

Fig. 99. Turned mourning ring, gold and black enamel, for Dr T. Herring, Archbishop of Canterbury (died 13 March 1757, aged sixty-four). No hall marks, mark MC. Private collection

Single crystal rings with hair plaits were a more personal form of commemorative jewellery and cost a little more, at 15s. each, than the standardized gold and enamel bands. By the later eighteenth century they had become larger and set in a fashionable marquise shape (fig. 100). On the death of Sir Roger Newdigate's mother in September 1765, he sought to preserve memory of her by purchasing 'a brilt motto ring with hair underneath', for £1 5s., and a new crystal set into an old ring set with her hair. While Price supplied both the enamel and crystal-set rings to Parker and Wakelin, it was the Creuze brothers who provided the more elaborate gem-set mourning rings. The provision of such jewellery was not without its problems as the diary of Lady Mary Coke, a difficult customer at the best of times, reveals. When her mother died in 1767 she ordered a special ring from her jeweller, whose name is not mentioned, who 'brought me the diamond ring I had order'd to be set with my Mother's hair. It did not satisfy me. I did not think it look'd good enough, and was set ill'.[71] As Marcia Pointon has suggested, the cheaper enamelled bands were 'institutionalised, collective and disposable', while those incorporating symbolic motifs, or hair, were understood as individual and private.[72]

Fig. 100. Mourning ring, gold, with hair set under crystal, pearl border; late eighteenth century. Ashmolean Museum, Oxford

'ALL MANNER OF SEALS IN STONE, STEEL AND SILVER'

The popularity of seals in the later eighteenth century, particularly those carved in intaglio in semi-precious stones, can be partly explained by the fashion for collecting examples from the Renaissance and classical antiquity. The seal engraver Edward Burch exhibited his 'antique style' works at the Society of Artists, where they were celebrated as 'sculptures in miniature'. From the prices at which Parker and Wakelin sold their seals it is clear that they did not have any pretensions to high art. Their customers bought many new seals of all types in silver, gold, steel and a variety of stones from red and white cornelian, brown and white crystal and even topaz, but paid from shillings up to a maximum of £7. They were an essential piece of equipment for the landed letter writer and a key accessory. As portraits show, a seal was an important element of male dress that hung from a fob or watch chain suspended from the small pocket in the waistband of a gentlemen's trousers.[73] Seals were key elements in the goldsmiths' shop window, displayed on pads and hung in the window to attract attention and draw in potential customers, as the shop bill of Hawley's *Fashionable Repository of Jewellery* in the Strand shows (fig. 101).

In a letter of 1765 to Horace Walpole, Nathaniel Hillier mentions that a toyman, 'Kentish by name, the west corner of Pope's Head Alley, in Cornhill' has 'exposed an impression of an intaglio in the possession of Sir Robert Walpole, in the centre of divers others, against the left hand doorpost of his shop, so that it may be inquired after en passant by anybody'.[74] Some goldsmiths, like Joseph Brasbridge, went to great lengths to keep up with fashion and introduce new-patterned seals. Brasbridge recalled how, on acquiring 'an engraving from a bust of Turnerelli' he had 'impressions taken from it by Tassie', from which he sold so many 'that were I to enumerate the names of those who bought them it would make a volume itself'. There were many ways of engaging the customer. John Byng remarks in his travel journal 'that Mr T [a seal engraver] urges me, by flattery to pick up fine pebbles [for him to cut]', perhaps another method of keeping a customer coming back.[75]

The cutting and engraving of seals appears to have long been the subject of subcontracting. Dorothy Osborne, in the 1650s, commented how her jeweller, named Walker, employed a Frenchman to cut his seals, which came as a

Fig. 101. Trade card of John
and Thomas Hawley, *Repository
of Fashionable Jewellery*, Strand;
c. 1780–90. Etched and engraved;
13 × 9.5 cm. British Museum

Fig. 101. Trade card of John
and Thomas Hawley, *Repository
of Fashionable Jewellery*, Strand;
c. 1780–90. Etched and engraved;
13 × 9.5 cm. British Museum

surprise to her as she thought he executed all his own work: 'It seems hee do's not use to do his worke himself (I speake seriously) hee keeps a french man that setts all his Seal's and Ring's'.[76] Thomas Bewick, recalling his days as an apprentice engraver in the 1760s, relates how Isaac Hymen

> had got gathered together a great collection of impressions of well cut seals, and being a Man of good address and a good singer, he introduced himself into Coffee Rooms frequented by Gentlemen and respectable tradesmen and there he exhibited his Impressions as the work of his own hands, and by his own good management (for he knows nothing whatever of engraving of any kind) he got his orders–and somehow or other it was well propagated through the Town that his Seals surpassed by far any thing we ever did or could do, and though we had done the whole of his orders.[77]

Bewick blamed this state of affairs on his customers, for 'this must continue to be the case so long as Gentlemen will not be at the pains to encourage merit and go themselves to the fountain head for their nice jobs'.[78] Here was a complaint against the growing numbers of retailers, and their power over the public.

Most of the seals that Parker and Wakelin sold where of red or white cornelian, which cost the customer, along with engraving the crest, coronet or cypher, between £2 and £4 each. The most expensive seal they sold between 1766 and 1770 was a topaz one which cost £6, although much cheaper versions could be bought in silver for 8s. or in brown or white crystal. Parker and Wakelin's prices for seals are comparable with those of W. Addis, a bill of whose records 'cutting a fine Scotch pebble and engraving items and crest on one side cypher and crest, on second "Friendship" elegantly set in gold £6 6s.'[79] Campbell noted that there were two types of lapidaries: those who worked by hand, which was 'a very profitable Employ to a master and a Journeyman may earn a Guinea and if a noted Hand Thirty Shillings a Week', and the others who used 'mechancial Engines, contrived for cutting Devices in Cornelians and other Stones, which render those kind of toys cheap [and] are sold to the first Hand for four to five Shillings a Dozen; which, if done by Hand would cost two Guineas a Piece'.[80] From the charges listed in Parker and Wakelin's accounts it appears they employed those who worked by hand. Samuel Rush charged £4 19s. for engraving 'a white cornelian seal with a Hercules', and £1 2s. 6d. for engraving 'a Crest and a Bloody hand on a Triangle Seal'.

Samuel Rush and Richard Frewin executed all Parker and Wakelin's orders for seal cutting and their maintenance. There are many references to 'sundry repairs' on seals, their new setting, and repolishing. Rush advertised himself as a jeweller and clock maker, working in Porter Street, on his shop bill.[81] Rush, through his marriage to Susanna Passavant in 1759, was part of an extensive network of jewellers and toymen. Passavant had been apprenticed to the toyman Thomas Willdey,[82] for whom she later worked as resident shop manager until his death in 1748. She kept up the Ludgate Hill shop until 1762, where she is referred to as a jeweller. She operated her own network of suppliers who included the engravers John Brumley and John Fossey, the fanmaker Lambert Duvivier, the gold chain maker John Raynes, and the goldsmiths William Bird, John Jacob, Peze Pilleau, Edward Wood and Dru Drury. John Cruikshank supplied silver snuff boxes, John Barbot and Margaret Mean her étuis, and John Le Boux her watches.[83]

Compared with the orders for seals for other goldsmiths and jewellers, Parker and Wakelin's orders appear somewhat humdrum. For example, Dru Drury, who had a retail shop in the Strand in the 1770s, pursued an Italian cameo cutter and seal engraver in Rome, whose address had been given to him by a customer. He asked for examples of his work, 'which ought to be pleasing' and 'at a moderate price', expecting him to 'find the stones'.[84]

ENAMELLERS

Parker and Wakelin sold a small range of enamelled wares, from watch cases and keys, chains, matching necklaces and earrings of 'stock' design to more personalized items, like John Martin's pair of 'fine enamel buttons brown ground with bird and blue border' which cost him £2 10s. Watches had enamelled picture plates, like Admiral Osborn's which also had a 'brilliant border' and Joseph Gulston's '2 fine enamel bracelets' set with diamonds which cost £102. All the enamelled components were supplied by Louis Toussaint in partnership with his brother-in-law, James Morisset.[85] Morisset only entered his

own mark, as a smallworker, at Goldsmiths' Hall in 1770.[86] From this date gold and enamel boxes, and presentation swords have been identified as his, which testify to the high quality of his craftsmanship.[87] Morisset, who gave his address as Denmark Street in Soho in the 1773 Parliamentary Committee Report, worked there alone until 1778 when he entered into a short-lived partnership with Gabriel Wirgman, which was dissolved the following year. They both appear as creditors of Dru Drury that year, suggesting that they were supplying him in a similar way as Parker and Wakelin. James Morisset must have been successful in business as he could afford to apprentice his son Augustin to learn the art of enamelling and painting from George Michael Moser, for the high premium of £210.[88]

When Lord Rosebery (1729–1814) was made a Knight of the Order of St Andrew in 1771, he ordered the setting of a 'large brillt Order of St Andrew and Thistle finely enamelled' from Parker and Wakelin. He was painted wearing his breast star c. 1778 (fig. 103) with his family on his estate at Barnbougle, just ouside Edinburgh. He is portrayed with his second wife, Mary Vincent.

Rosebery's first wife, Susan Ward, who had died in 1771, had begun buying jewellery from Parker and Wakelin soon after their marriage in 1764, and two years later had spent £800.[89] This sum puts the £100 spent on three dozen silver plates, and £15 15s. paid to Gainsborough for a painting, in the shade. It is perhaps fitting that Parker and Wakelin should have provided the twenty-three motto rings and a diamond urn motto ring on her death. This association with the business must have prompted Lord Rosebery to go to them for his decoration, a sumptuous affair with an enamelled figure of St Andrew surrounded by brilliants. The partners went to Toussaint and Morisset who charged them £40 for 'Gold, Making and Enamelling an Order of St Andrew' that year (fig. 102). When Rosebery finally settled his account in January 1773, he paid Parker and Wakelin £80 for the same decoration, twice the price he paid in the same year for a horse. The Order was particularly splendid as the painted figure of St Andrew holding his white cross is surrounded by diamonds. The Order of the Knights of the Thistle was 'revived' in 1687 by James VII of Scotland and II of England, who made provision for twelve Knights and four Officers. They were the most sumptuously dressed Knights in Britain: they wore a green velvet mantle trimmed with gold and embroidered with 250 gold thistles, and collars of thirty-two links of gold of alternating thistles and sprigs of rue, upon which the Order hung.

STRINGING

The stringing of pearls and precious and semi-precious stone beads was a separate specialization. From Richard and Margaret Binley's account with Parker and Wakelin it seems beads were frequently strung on horsehair.[90] For John Budgen they threaded a 'pearl bow on horsehair' which cost him £1 5s., while for Anthony Keck pearl tops were threaded onto hair for 10s. 6d. Sometimes stones were sewn onto fabric, such as Mrs Hubbald's 'garnet necklace' which was sewn 'in a pattern on ribbon' for 4s. Designs could be quite elaborate, like the pearl necklace 'strung in puffs' for Richard Gwillym for £15 15s.

It appeared that Margaret Binley, who took over her husband's business after his death, sometime in 1764, ceased to supply Parker and Wakelin after 1767. Margaret and Richard Binley supplied Parker and Wakelin with buttons, buckles and bottle tickets; stringing was supplementary skill they offered.[91] We know that Margaret was still in business in 1778, when she

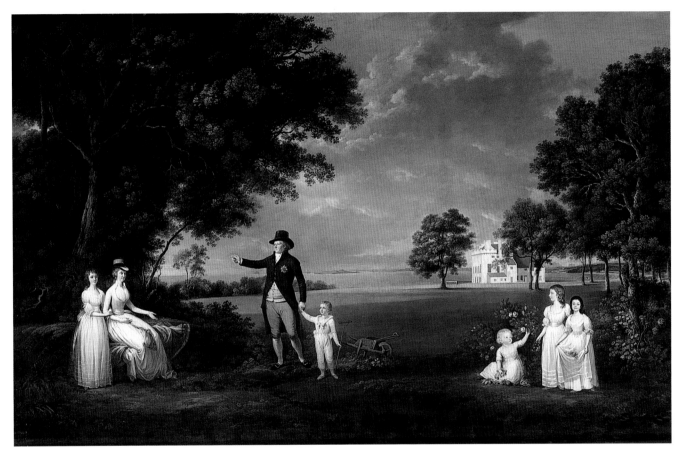

gave her address as Gutter Lane on Dru Drury's list of creditors. Her place as a supplier to the Panton Street retailers seems to have been taken by Thomas Howell. His first bill for 'pearls and stringing' was paid in August 1768, and from then on he was paid in cash for quite substantial amounts every September: in 1768 for £674.[92] This figure includes the cost of the pearls as well as labour.

INTERCONNECTED NETWORKS

Parker and Wakelin's network of jewellery suppliers was only one of many that operated in London. We have already seen how Susanna Passavant kept her toy shop stocked in the 1740s and 1750s. The accounts of other retailers and makers reveal the same specialists, and others, at work for a variety of retailers. Between the 1750s and 1770s Mary Chown sold the Webbs' motto rings, Miss Cabanis threaded their beads, and the name of Toussaint and Morisset reappear as their enamellers. The operation of such networks posed problems regarding the risk of others copying special commissions.

Fig. 102. Detail from Toussaint and Morisset's account with Parker and Wakelin, showing supply of Rosebery's Order of St Andrew for £40, 6 September 1771. Workmen's ledger. Victoria & Albert Museum, London

Fig. 103. *The 3rd Earl of Rosebery and his Family in the grounds at Barnbougle Castle*, by Alexander Naysmyth (1758–1840); *c.* 1778. Oil on canvas; 165 × 241 cm. The Earl is wearing his Garter Star on his breast. Private collection

James Cox's fear that the designs of his jewelled novelties would be stolen led him to draw up a contract in 1769 between himself and one of his suppliers, the jeweller Louis de Forceville. The contract gave Cox the 'Liberty at all times and upon all occasions to enter [Forceville's] Dwelling House and Workshops . . . [and] examine whatever Work or Business is carried on there to make objections and put a stop to the same . . . and insist on every satisfaction that he can in reason and justice require'. Breach of the agreement incurred a £1,000 fine.[93] Networks rely on the easy flow of information and the circulation of materials, part-finished goods and credit; however, they are also the perfect medium for the dissemination of new and fashionable ideas and objects, which was not always in the retailers' favour in areas where 'the newest Whim has the best Chance for Custom'.

IV
Buying and Using

Patronage:
'the great customers for plate'

The great customers for plate are not to be caught by show as they walk along the street.

Matthew Boulton to Robert Adam, 1770[1]

Eighteenth-century goldsmiths like Matthew Boulton seem to have had a clear idea about who the 'great customers for plate' were, what they expected and how they should be treated. Josiah Wedgwood, too, made clear distinctions between the 'numerous class of People' who 'purchace *shewy and cheap things*'[2] who responded to the distribution of hand bills by common shop-keepers and the 'Great People', the 'Ladies of superior spirit who set the ton [fashion]',[3] who needed more subtle handling. 'You know well', he wrote to his business partner Bentley, 'they will not mix with the rest of the World any farther than their amusements, or conveniencys make it necessary to to so.'[4] It is significant that few goldsmiths and jewellers advertised their wares in the newspapers, something that Wedgwood also shunned. Stafford Briscoe, the first London goldsmith to try this sales strategy, gave up after he had advertised thrice weekly in the *General Advertiser* between January and April 1751.[5]

Contemporary commentators on the English social, cultural and artistic scene recognized the difference between those buying ready-made goods over the counter and those commissioning. They acknowledged that the power of the patron was important not only for ensuring but also for stimulating the quality of art, design and manufacture, and that patronage was under pressure from a growing demand for luxuries that could be bought ready-made. Quality needed to be maintained, as well as quantity increased. Robert Dossie, in his *Handmaid to the Arts* (1758), considered that as a result of the

> several circumstances both of our economical and political condition [which] enhanced to a very high degree the price of common necessaries [and] . . . more expensive modes of life . . . it particularly behoves us to exert in cultivating those of a more refined nature, where skill and taste (in which we are by no means wanting) are required to give a higher value to the work.

Dossie was defending the importance of quality over quantity production, an expensive commodity that the rich alone could afford to promote.

Jean André Rouquet, the Swiss author of *The State of the Arts in England*, published three years before Dossie's *Handmaid*, saw this contrast between quantity and quality production in terms of the differing demands and

expectations of the retailer versus the private patron, ready-made versus commissioned goods. Rouquet explained that the shopkeeper

> who employs an artist with a view of profit . . . requires only a certain degree of perfection, so much as he knows is necessary to the success and reputation of his trade. As soon as the man he employs has finished his work for common sale, every step beyond that is so much out of pocket, and consequently becomes a superfluity that hurts him: then he stops the artist's hand, and at the same time the progress of the art. But he is right to do so, since his motive is not to enjoy the productions of his ingenuity, but render them subservient to his gain. [The private customer] acts upon a different footing. [He] consults only his own taste which inclines him to have the work perfectly executed; hence he is afraid to beat the artist down in his price, lest he should be disappointed: as he has but few occasions to employ him, it would be an ill judged economy to require only indifferent work, on the account of its being cheap.

As Lord Chesterfield advised his son, the gentleman 'employs, even in the meanest Trifle, none but the ablest and most ingenious Workmen, that his Judgment and Fancy may as evidently appear in the least things that belong to him, as his Wealth and Quality are manifested in those of greater Value'.[6]

As the great entrepreneurs Boulton and Wedgwood acknowledged, although there were great risks involved in dealing with these wealthy customers, whose demands were great and often fickle and who expected long periods of credit, it was worth the worry, as their custom provided the opportunity to make high-profile objects, which signalled taste and attracted other customers. Yet the growing interest of historians in the commercialization of the market in the eighteenth century has, by emphasising a contrast with an older client economy, perpetuated a crude stereotype of the aristocratic patron. In staking out the power of the growing middle classes, the character of the aristocratic patron has been simplified to the point of caricature.[7] The purchasing behaviour of wealthy individuals should be set within the context of broader patterns of consumption and payment, to present a much more rounded picture of how they operated. Their behaviour as purchasers was more flexible, complex and variable than the aristocratic stereotype implies.

THE MARKET FOR SILVER

We know that the ownership of silver, from a silver spoon to substantial holdings, was widespread. Lorna Weatherill's analysis of probate inventories between 1675 and 1725 has shown that it was only poor labourers who could not afford any silver at all; that ownership increased over time; and that it was common to both rural and urban environments.[8] Yet it was the great customers, who could pay bills that amounted to more than a butler's annual wage of between £30 and £60, that made the bulk of clientele of the larger London goldsmiths' shops like that of Parker and Wakelin. We can estimate the number of customers who owned these larger collections of silver via the various registers of taxes on luxury goods, such as those for carriages and for silverwares that were introduced in the eighteenth century. Although the owners of coaches and silverware might not necessarily be purchasing at the time the returns were made, they do help establish a sense of the community that was expected to possess them. A tax on those who 'own, use, have or keep any Quantity of Silver Plate', in excess of one hundred troy

ounces, was introduced in 1756 and modelled on that instigated for four-wheeled carriages – another costly attribute of status.[9] The proposal of the tax in Parliament revealed a great deal of confusion about how silver was weighed and taxed, the difference between troy and avoirdupois weight, the various duties, and their drawback if exported.[10] Horace Walpole declared 'I think I never heard so complete a scene of ignorance as yesterday on the new duties! . . . you would not have thought there was a man in the House had learned troy weight . . . poor Sir George never knew prices from duties, nor drawbacks from premiums!'.[11]

The lower level of tax began at 100 troy oz of silver, with a charge of 5s. This modest weight of silver can be compared to the Duke of Bolton's cup and cover which was supplied by Parker and Wakelin c. 1765, and weighs exactly 100 troy oz (fig. 104).[12] The tax bandings ascended by 100 troy oz units to a maximum of £10 for ownership of 4,000 troy oz of silver or more. This would have been equivalent to two, very generous, full silver dinner services.

The collections were gathered between July 1756 and July 1762 by county, with a separate collection for London. Over this period 1,000 households in London were taxed annually for silver, of which 135 returned for the maximum amount of 4,000 troy oz or over. The 1,000 taxed households represented a fifth to a quarter of high-income families estimated by the historian Rudé to be in the metropolis at some time of the year in the eighteenth century.[13] These families stood at the apex of London society. Malachy Postlethwayte had suggested in 1766, that the total population of London was 1.2 million, although informed opinion now puts the figure at about 650,000.[14]

Outside London, forty-nine provincial collections were made, accounting for 20,110 households who possessed over 100 troy oz of silver. London commanded the greatest number of maximum tax payers. Bristol returned 1,508 tax-paying families, but only eighteen paid for over 1,000 troy oz. Oxfordshire returned for 301 households but recorded the highest provincial return for those possessing over 1,000 troy oz, with twenty-six accounted for by the holdings of the university colleges.

Receipts for the payment of plate tax survive in many institutional and household accounts. Notes made by the collectors reveal increasing difficulties in securing payment of the tax.[15] At least three of Parker and Wakelin's customers proved difficult to pin down. Against Sir John Hussey Delaval's entry in the tax register the collector wrote, 'will not give an answer'; the Earl of Harrington agreed to speak to his steward about the matter; and Robert Cotton Trefusis promised to 'weigh his plate'.[16] As the tax was so 'very vexatious and troublesome in the levying and collecting', it was repealed in 1777.

PARKER AND WAKELIN'S CUSTOMERS

The Plate Tax Registers reveal a core of wealthy customers. Their names appear in the letterbooks of Josiah Wedgwood, the ormolu sales ledger of Matthew Boulton, the drawing books of Robert Adam and in the accounts of the Parisian *marchand-mercier* Lazare Duvaux. Of Parker and Wakelin's 321 customers who appear in their ledgers between 1766 and 1770 (*see* appendix 2), 19 were amongst the 135 payers of the maximum amount of plate tax, that is about one seventh of the whole. This suggests that Parker and Wakelin did business with a substantial sector of this upper end of the market. Their clientele included some of the most prestigious titled families, including six dukes, twenty-four earls, eight viscounts, sixteen lords and nineteen baronets, members of the 400 pinnacle landed families, whose annual incomes came to

£10,000 or more.[17] Many, of course, had a much greater income, like Lord Folkestone, who in 1759 estimated that his estate was worth £52,000 a year.[18]

It is difficult to judge how large or small this customer base was compared with other luxury businesses as there is little evidence to draw upon. During his first five years in trade, between 1735 and 1740, George Wickes had 305 customers on his books, only thirty-three of whom were titled. The London jeweller Peter Webb had 458 customers in his ledger, covering the twenty-two year period from 1735 to 1757.[19] The goldsmith Joseph Brasbridge claimed in his autobiography that he served between seven and eight hundred 'principal' customers by 1790 from his premises in the Strand. Presumably he was referring to those who bought more than one article, who can be compared with Parker and Wakelin's account customers. Businesses went to great lengths to secure their customers and keep them coming back for more.

A letter written in 1775 by the London retailing goldsmith Dru Drury, reveals how sensitive tradesmen were about their customers and what a precarious line they walked between securing and loosing them.[20] Drury had been surprised and hurt that a gentleman had called at his shop to 'see the Dressing Plate I was making for Sir George Smith'. Drury explained to his visitor that although he had the 'honour of executing' some of Smith's commands he had received no order for the silver which, it appears, Smith had given to 'Jefferys in Cockspur Street'. A draft letter to Smith in Drury's letter book is underscored 'Did not send', as presumably Drury thought it better to keep some of Smith's business rather than risk losing it by expressing vexation. The goldsmith Thomas Heming was not so shy when he wrote 'a very huffing letter . . . about his money' to one of his greatest patrons, Sir Watkin Williams-Wynn, when he discovered that Mr Creswell was making his new dinner service rather than himself.[21]

Fig. 104. Cup and cover, supplied to the Duke of Bolton by Parker and Wakelin; *c.* 1760. Silver (London); height 45 cm, 100 troy oz

Fig. 105. Customer index from the Gentlemen's Ledger, showing name and title of client, page of account in the ledger, with notes on transfer from and to other ledgers, and status. Victoria & Albert Museum, London

Fig. 106. Tureen, originally a pair later described as 'fine cellery', by Parker and Wakelin, for Robert Darcy, 4th Lord Holdernesse; *c.* 1760. Silver (London); height 30.5 cm, width 46 cm. Victoria & Albert Museum, London

Fig. 107. *Robert Darcy, 4th Earl of Holdernesse*, by George Knapton (1698–1778); 1752. Oil on canvas; 119.5 × 141 cm. Leeds City Art Galleries (Temple Newsam House)

Fig. 108. *George William, 6th Earl of Coventry*, by Allan Ramsay (1713–84); 1762. Oil on canvas; 126 × 100 cm. Croome Court, Worcestershire

Fig. 109. *Croome Court and Park*, by Richard Wilson (1713/4–82); 1758. Oil on canvas; 128 × 165 cm. Croome Court, Worcestershire

STRATEGIES OF PURCHASE

What emerges from the pages of Parker and Wakelin's ledgers is not a monolithic body of consumers, belonging only to a wealthy elite, who commissioned high quality silverware, but a diverse group of customers who employed very different strategies of purchase and payment, which were not necessarily consistent over time. Patterns of purchase were linked to life cycle, and the 'snapshot' of an inventory can be misleading. The customer ledgers offer a longer view, as individual accounts can be tracked backwards and forwards through time. The index at the front of the customer accounts lists ambassadors such as Fulke Greville alongside the newly rich such as Joseph Gulston. Life changes are noted such as 'Now D[uke] of Cumberland' as 'Dead' or personal fortunes influenced what people bought and when (fig. 105). Lord Molyneux (1748–95), for example, bought a whole range of goods over a long period of time, and honoured his bills once a year.[22] The important rites of passage of aristocratic life are marked by his purchase of silver: on succession to his father's estates, in 1756, at Croxteth Hall in Lancashire; on his marriage to Lady Isabella Stanhope in 1768; and on his creation as Earl of Sefton in 1771. His account with the Panton Street firm flourished with orders for new plate, such as the dinner service he bought in January 1769, which included five dozen plates, 'eight gadroon sauceboats' and 'four dozen ribbed comports' all engraved with the Molyneux and Stanhope arms, weighing just over 3,200 troy oz and costing £1,350.[23] With an annual income of £6,000 this represented a very serious outlay. His conversion, if only outward, from Catholicism to the Church of England was rewarded with an Earldom and yet more fine silver.[24]

Robert D'Arcy, fourth Earl of Holdernesse (1718–78) had bought the latest French-style silver from Parker and Wakelin in the late 1750s, like the elaborate tureen and cover, one of a pair (fig. 106) modelled after Meissonier's *Livre des Legumes*. He must have bought them while Secretary of State (1751–61), the role in which he is depicted in his portrait by George Knapton (fig. 107). By the later 1760s, however, most of his orders were for mending and repair work: wickering kettle handles; 'mending neatly a small saucepan'; and 'boiling and burnishing' two 'fine cellery tureens', £2 10s., which were returned to Parker and Wakelin for maintenance in 1768. At the same time four candlesticks were similarly refurbished and 'part of the chaised work repaired'.

Different strategies of purchase cut across divisions of age, sex and social position. There were some customers who bought a great deal of silver from Parker and Wakelin, organized around a single large one-off order, or a series of purchases that might cover years, sometimes generations, of a family. Those customers who were young tended to be those reaching their majority, such as Lord Cowper, who informed his banker in Florence that he should be sent seven cases of silverware which had been kept in the bank during his minority.[25] Others who bought silver at a relatively early age before their twenties, can nearly all be identified as recent inheritors of wealth. For example, Thomas Egerton who inherited his father's estate at Heaton in Lancashire in 1766 at the age of seventeen went almost immediately to Parker and Wakelin to buy a dinner service,[26] as did Peniston Lamb two years later when he suceeded to Brocket Hall in Hertfordshire at the age of eighteen.[27] Customers who were over the age of fifty in the 1760s tended to be those long-term clients who had dealt with George Wickes. Thomas Fane, Earl of Westmorland, opened his account at the King's Arms in 1743 and bought large quantities of silver. Yet between 1766 and his death aged seventy-one in

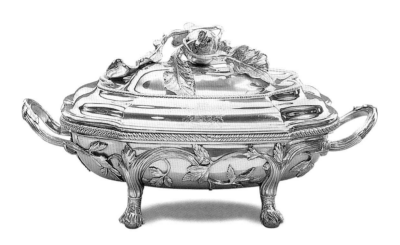

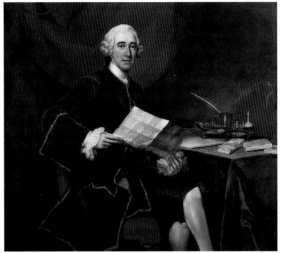

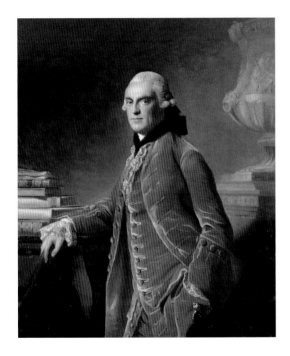

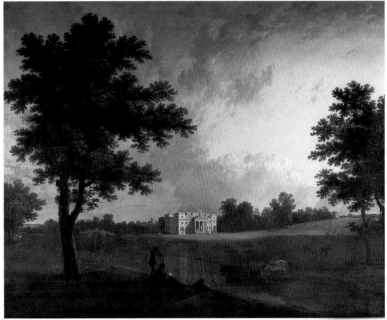

1771, his account is full of repair work and smallwares. His son John, styled Lord Burghersh, was aged thirty-nine in 1766 when he began making large purchases of jewellery and silver. Another regular customer was the third Earl of Egremont. In the archives at Petworth, bills from Wickes and Netherton, Parker and Wakelin, and Wakelin and Tayler appear amidst a host of other London luxury tradesmen: P. Marquin, hairdresser; Joseph Griffin, gunsmith; Peter le Quainte, hatter; Peter Wirgman, silver and gold bucklemaker; Edward Burch, engraver; and Gould and Howe, shoemakers.[28]

The majority of Parker and Wakelin's customers were in their thirties and forties, which coincides with the average age of inheritance. Succession to the family estates usually brought access to resources, either of money, property or items that could be traded in. An heir remained dependent upon the good-will of his father to provide an allowance, a residence and an adequate settlement to support himself, his wife and children until he inherited. It is understandable that on succession a customer would want, and could more

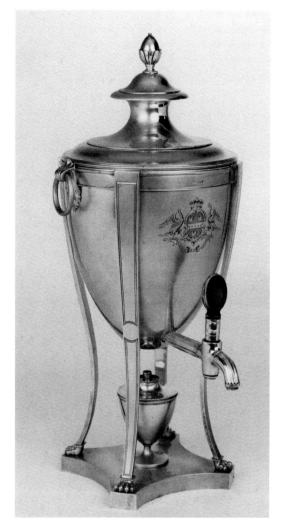

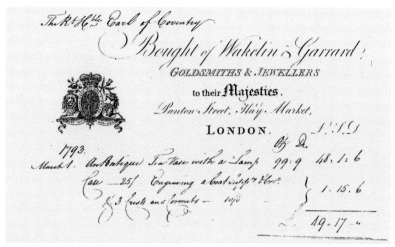

Fig. 110. 'Antique' or neo-classical tea vase, by Wakelin and Garrard sold to 6th Earl of Coventry; 1792. Silver (London); height 58 cm

Fig. 111. Bill from Wakelin and Garrard to 6th Earl of Coventry for the 'Antique Tea Vase'; March 1793. Croome Court, Worcestershire

Fig. 112. *A view of Sir Edward Hulse's Breamore*, by Sigrist; *c.* 1760. Oil on canvas. Breamore Estate, Hampshire

easily afford, to refurbish, make additions to or commission new plate to suit his own taste. In many of Parker and Wakelin's customers' accounts it is possible to recognize the year of inheritance by an order for the making or the refurbishment of a large quantity of silver. The association of the sixth Earl of Coventry (1722–1809) with the firm dated back to 1751, when he inherited his father's estate at Croome Court in Worcestershire (figs 108, 109) and had become involved in politics, as MP first for Bridport, and later Worcester.

As a gentleman of considerable means the earl devoted a high proportion of his wealth to his building, collecting and furnishing projects on his estate at Croome. His first tasks as the sixth Earl were to consult 'Capability' Brown in the landscaping of his gardens, and to employ the Panton Street business to refurbish his silver dinner service. Work included the 'new burnishing of terrines and covers', 'fluting and doing up as new 4 scalloped shells' and 'taking off and new mounting the handles and feet of 2 terrines and making 8 chaised pieces under the handles'.[29] This work, plus the 'taking out and regraving of Arms' came to £632 12s. 6d. Coventry settled his bill by trading in old silver. The process of refurbishment continued until February 1752, and it was not until 1753, a year after his marriage to the beautiful but impoverished Maria Gunning, that the earl bought new silver from Wickes and Netherton. The household bills reveal regular invoices from the Panton Street firm, from

whom he bought his larger silver: from Wickes and Netherton in the 1750s; Parker and Wakelin in the 1760s and 1770s; Wakelin and Tayler in the 1780s; and Wakelin and Garrard in the 1790s (fig. 110 and 111).

Yet the sixth Earl of Coventry, like Drury's customer George Smith, did not confine his patronage to just one firm. He had the money and inclination to buy from a range of silversmiths at the same time. Bills from some of the other larger London retailing goldsmiths, such as Abraham Portal, Thomas Gilpin and Joseph Brasbridge, have survived in the family accounts.[30]

Other customers, like the Hulse family, preferred to deal with one goldsmith at a time and showed great loyalty to individual businesses. Sir Edward Hulse (1715–1800) began refurbishing Breamore in Hampshire, the Elizabethan manor house that his father had bought in 1748 before he succeeded in 1759 (fig. 112).[31] Edward's father had been Physician in Ordinary to Queen Anne, George I and George II; his wife was the daughter of Sir Richard Levett, who had been both Lord Mayor of London and a governor of the Bank of England. In 1741 the second baronet followed in his father's footsteps by marrying city money, in the person of Hannah Vanderplank, the daughter of a London merchant of Dutch extraction. He set about establishing his family in Hampshire, becoming Sheriff in 1765. Their portraits by Francis Cotes still hang in the house (figs 113, 114)

It is probably no coincidence that Sir Edward appears to have begun keeping track of his expenses from the date of his wedding, in a cash book that begins on 23 February 1741 with £5 13s. for 'Expenses at my Marriage'. It is followed by a long list of presents to his wife, including an onyx tweezer case, as well as £31 18s. to Mr Godde the 'Jewler', £5 13s. to 'Payne the China man',[32] £63 to 'Willson the Draper' and £27 9s. to 'Mr Cooper for plate'.[33] It is also at this time that Sir Edward ordered a silver dinner service for £350 from 'Mrs Godfrey' who had premises in Norris Street, off the Haymarket.[34] Sir Edward appears to have been a man of habit, for he returned to her in 1746 to supplement his wife's dressing service with a 'Basin and ewer Silver Gilt' for £8 9s. 8d., and returned again in 1767 for some teaspoons. In 1767 he also changed silversmith, perhaps on Eliza Godfrey's death, and his account book records on 5 March '£13 9s. Mr Parker's Bill for Plate'.[35] Perhaps he had passed the Panton Street shop en route to Norris Street. From then on

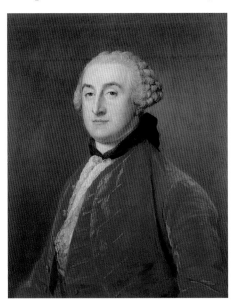 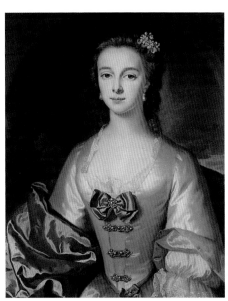

Fig. 113. *Sir Edward Hulse* (1715–1800), by Francis Cotes (1726–70); *c.* 1750. Oil on canvas; 56.5 × 39.4 cm. Breamore Estate, Hampshire

Fig. 114. *Hannah Vanderplank*, by Francis Cotes (1726–70); *c.* 1750. Oil on canvas; 56.5 × 39.4 cm. Breamore Estate, Hampshire

regular but spare entries appear for the business: in 1777 for 'Parker the Silver Smyths Bill', in 1786 for 'Taylor and Wakeling' and in 1788 'By Wakelings bill'. The material record reinforces this steady, regular and reliable patronage: waiters and compote dishes in 1771; a pair of soup tureens made the following year, bearing the Hulse–Vanderplank arms, made to update Eliza Godfrey's service acquired thirty years previously (fig. 115); serving plates in 1783 and waiters the following year from Wakelin and Tayler (fig. 116); vegetable dishes in 1798 (fig. 117) and more in 1801 from Wakelin and Garrard.[36] The Hulse family's patronage continued to the end of the nineteenth century, lasting more than a hundred and forty years.

Similar patterns were adopted by others, such as Lord Monson (1727–74), whose Lincolnshire household bills show that the family moved from one major London goldsmith to another; from Paul Crespin in the 1750s to the Hemings, father and son, in the 1760s and 1770s, not moving on to Wakelin and Tayler until the 1780s and 1790s. His brother, the Hon. George Monson

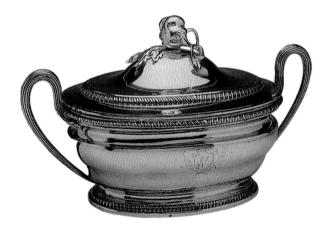

Fig. 115. One of a pair of soup tureens and covers, by Parker and Wakelin; 1772. Silver (London); length 40.7 cm. Private collection

Fig. 116. One of three waiters, by Wakelin and Tayler; 1784. Silver (London); length 17.8 cm. Private collection

Fig. 117. One of a set of four vegetable dishes and covers, by Wakelin and Garrard; 1798. Silver (London); diameter 19 cm. Private collection

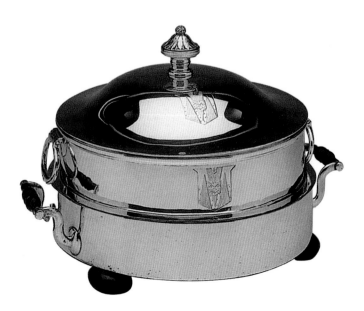

(1730–76) went to Parker and Wakelin while he was Groom of the Bedchamber to George III, as the Prince of Wales (1756–60) and as King (1760–63). The importance of such long-term and 'loyal' customers, with good connections, is made clear by Joseph Brasbridge, who thought it worthy to note in his autobiography that 'Sir Charles Ross took a very active interest in [his] welfare, which was continued by his widow . . . as long as I remained in business . . . and the whole of his family were like wise constant customers for more than fifty years'.[37]

While Sir John Hussey Delaval (1728–1808) (*see* fig. 159) went to Parker and Wakelin for his silver he patronized James Cox for his jewellery. Cox was in business as a jeweller from 1749, at the Golden Urn in Racquet Court off Fleet Street, and his customers included the Princess of Orange and Viscount Galway.[38] Letters from the entrepreneurial Cox to Delaval in 1769 reveal the mutual obligations and privileges which existed between the two parties. Delaval had commissioned a rose diamond necklace from Cox, similar to the one he had made for the Empress of Russia which had cost £2,200. Cox informed Delaval that 'in regard to the jewels tho' they exceed in Weight what I expected being set very close with great nicety and care, yet (as I think it my Duty to do) I have charg'd no more than the Workman's charge to me for setting, and the Diamonds what they cost'.[39] Cox gave Delaval such advantageous terms because he had:

> taken the liberty to shew them to the Duke and Dutchess of Cumberland who express'd great satisfaction and were pleased to say that they wished I had had the setting of her Royal Highness's Jewels, I am now doing a very rich pair of diamond Bracelets with ten Rows of large Pearls each. I have delivered a fine Row of Pearls for a Necklace and am making a rich gold snuff box to contain the Duke's picture surrounded with brilliants all of which I owe to Your kind Reccommendation which I hope ever to merit the continuance of.

This strategy of exploiting a customer's patronage in making a costly and elaborate piece and using it as a form of advertisement was not just employed by London goldsmiths and jewellers. Both Wedgwood and Boulton aimed expensive, new and fashionable wares at the top end of the market, to the 'Great People', to establish 'their character' first, and then later opened up the market by reducing their price, so making the ware attractive to 'the middling People'.[40] Boulton's silverwares were aimed at 'the few rich people', with the aim of establishing his 'celebrity'.[41] It was often more important for the retailer to have his goods on display in these households, were they could be seen by others, than be paid for them promptly or make a handsome profit.

Many eighteenth-century luxury retailers commented on the patience required to handle these customers, but all were keen to cultivate their patronage. Arthur Webb, the jeweller, called on many of his customers in person, noting their names in his day book: 'To call on Lady Burgoyne Cumberland Street on Wednesday week May 16', 'To wait on Lady Kinnaird fryday week May 24'.[42] Brasbridge delivered Mr Wykeham's set of silver cover dishes to Leeds Castle himself, securing as a result a second large order.[43] Lady Mary Coke's goldsmith, Thomas Heming, also visited her at home. These attentions were all part of the skill of a shopkeeping goldsmith, whose work was not confined to persuasion from behind the counter.

According to Parker and Wakelin's accounts, the purchase of large quantities of wrought silver in a single order was not a common occurrence. Only twenty-two of Parker and Wakelin's customers bought above £300 worth of silver at any one time between 1766 and 1770. Small, regular, purchases formed a backbone to the business, and John Rundell's maxim that 'if little things are well attended to most People would be sure to Come again and be better Customers'[44] seems to be proved by several of Parker and Wakelin's customers. Until 1770 Charles Bourchier had bought only paste buckles and bottle tickets, but in that year he placed a large order of plate which cost him over £330. As Wedgwood noted 'tis good to have an opening, and to be known, the former may increase and the latter cannot hurt us'.[45] The lubrication of such relationships was crucial to survival, which is why shopkeepers offered all kinds of services to their customers. It may also explain why businesses were happy to take on small repair and maintenance jobs, like the provision of silver spouts to china teapots and the wickering of coffee-pot handles, which brought in ready money and maintained contact with the customers. Parker and Wakelin's ledgers are full of these small services: the payment of customers' plate tax; lacquering a brass tea pail for the Earl of Guilford; lining the foot of a cup with lead for Captain Howe; supplying tin hearing trumpets to Richard Bull, visiting the Herald's Office to examine arms for John Trevanion; providing a mouth piece to a french horn for Joseph Gulston; and a bosun's call for Kenrick Clayton.

Sometimes the need to keep up a continuous relationship with customers could get out of hand. Arthur Webb ran errands for one of his customers, Edward Howard, who appears to have been an aspiring, amateur playwright. Webb 'waited on Mr Garrick myself with the Tragedy' as instructed, but had to report back to Howard that although he was received 'in a polite manner . . . it was too late for the present season as everything in the Dramatick way was already settled'.[46] Webb, in exasperation, confessed to an old friend that 'I am almost become his secretary and amanuensis to his dramatick performance'.[47] The relationship between a customer and retailer often involved more than just the simple exchange of currency for goods.

WOMEN AS PURCHASERS

There has been much written on women as consumers in the eighteenth century, yet only thirty-seven of the 321 clients in the 1766–70 Gentlemen's Ledger were female: two 'Countesses', seven 'Ladys', twenty-two 'Mrs' and six 'Miss'. Only the names of the Countesses Waldegrave and Holdernesse, and Miss Blake head accounts for large quantities of silverware such as plates, or large individual pieces such as tureens and épergnes. The Countess of Waldegrave (1736–1807) (fig. 118) had good reason to spend profusely: she had secretly married the Duke of Gloucester in 1766, and his name appears in a separate account alongside hers from 1769 in Parker and Wakelin's ledgers. In the same year their relations had been 'dissected and held up to ridicule with every circumstance of impertinence and scurrility' in a tête-à-tête portrait in the *Town and Country Magazine*, under the name of 'Doriment and Maria'.[48]

The Countess of Waldegrave was the only woman to have bought a twenty-four place setting dinner service, including an épergne and 'chaised table' for £83, two-dozen plates and numerous dishes and cutlery to match. This was followed by a substantial silver-gilt dressing service, comprising a looking glass, basin and ewer, boxes for jewels, combs, and pots for paste, pomatom and patches, weighing 431 troy oz and costing £172. The purchase of silver, which was initially charged to her husband's account, was later removed to

Fig. 118. *Maria Walpole, Lady Waldegrave in mourning dress*, by Thomas Gainsborough (1727–88); *c.* 1764. Oil on canvas; 127 × 101.6 cm. Los Angeles County Museum of Art

her own. The affair is reminiscent of Defoe's fictional heroine Roxana, who became the mistress of a prince. As the heroine narrates:

> As he lov'd like a Prince, so he rewarded like a Prince; First of all he sent me a Toilet [dressing service], with all the Appurtenances of Silver, even so much as the Frame of the Table; and then, for the House, he gave me a Table, or Side-board of Plate . . . with all things belonging to it, of massy Silver.[49]

It is noticeable that most of the ladies bought largely teawares, like the '12 Polish'd Teaspoons and Strainer' bought by Lady Robert Manners for £1 17s. 6d.[50] and the 'festoon Tea Vase' bought by Lady Onslow, in 1771, for £53 3s. 6d.[51] Thomas Bagge, who had bought his wife's engagement and wedding rings from Parker and Wakelin in June 1768, six days after their marriage he went on to buy his wife a matching tea service of silver which included a chased tea vase with festoons (£35 12s. 1d.), 2 chased tea canisters

(£19 0s. 9d.) in a shagreen tea chest with silver furniture (£7 3s.), a chased coffee pot (£9 11s. 11d.), a chased cream ewer (£3 4s. 3d.), '12 fluted handle tea spoons and 12 plain' (£5 12s. 3d.) and 'two pair of tongs' (£1 3s. 4d.). The prominence of chasing suggests an elaborate and decorative service.

By looking back to the first client ledger of the business, begun in 1735 by George Wickes and covering the first five years of business, it is clear that the number of named women in the accounts had in the past been much higher, sixty-four out of 305 clients, just over a fifth of the total. As the business prospered the names of female customers declined. If we look back at the plate tax returns only twenty-two of the 135 London returns for over 4,000 troy oz of plate were registered in the name of women, and four of those were dowagers, suggesting that even fewer women had control of large quantities of plate, at least in principle, if not in fact.

Although the number of women appearing in Parker and Wakelin's accounts is small and their purchases in their own names modest, their true consumer power and influence is hidden behind the names of their fathers, husbands, brothers, sons and lovers. A large part of Joseph Gulston's reckless expenditure, which in the end bankrupted him, was on expensive diamond jewellery, bought from Parker and Wakelin, for his equally spendthrift wife. He also purchased garnet earrings for his daughter. Lord Burghersh's account is credited with a crystal heart ring for a Miss Woolford. Sir Phillip Musgrave organized the mending of silver for his sister. Wealthy ladies advised their husbands, brothers and fathers on the purchase of the silverware; for example, Theresa Robinson (1744–75), who married John Parker (1734–88) in 1769, a year after he had inherited extensive family estates, including Saltram in Devon and a London house (fig. 119). It was Theresa and her elder sister Anne Robinson who took an active part in all the improvements to Saltram, including the commissioning of silverware. The Parkers began patronising Parker and Wakelin at the time of his inheritance, buying forty gadroon plates and two round, fluted, comports, all engraved with Parker's new crest, in June 1768.[52] In 1775 Thomas Robinson, second Baron Grantham, wrote to his brother that Mrs Parker had ordered a silver bread basket at Parker and Wakelin's in Panton Street, asking his banker, Draper, to pay the bill.[53]

LOCATION AND CONNECTIONS

When not on their country estates, most of Parker and Wakelin's customers had addresses in the fashionable West End: there were notable clusters in Grosvenor Square,[54] Berkeley Square[55] and Cavendish Square.[56] In Grosvenor Square there were fifty-one houses, sixteen of which were occupied by peers.[57] In 1750 its west side housed a dowager duchess, a duchess, three earls and a lord. Grosvenor Street and Brook Street could field between them two marquises, four earls, four dukes and five other titles. Number 26 Grosvenor Square was bought in 1743 for £3,750 with seventy-nine years of its lease to go, and was sold fourteen years later for £6,000. In March 1763 Earl Granville's house in Arlington Street was sold at auction for £15,000. We know from surviving correspondence that many clients of the business dropped in when passing by the shop, like Sir Roger Newdigate on his way back from Parliament. Thomas Robinson, Baron Grantham, wrote to his brother Frederick in January 1785 that he had walked home from Hanover Square and had 'called in at a Silversmith's in Panton Street', where there was a 'nice list of Plate' and ordered four candlesticks to be made and bought 'some useless articles' presumably fashionable ornamental fripperies.[58]

The physical proximity of Parker and Wakelin's customers was only one factor within a complex network of relationships. Many had been educated at Westminster, Winchester or Eton College and went on to the two most socially prestigious university colleges – Christ Church, Oxford, and Trinity College, Cambridge. After university the membership of various clubs and societies ensured that links formed at school and university were maintained in later life. Eighty-five of Parker and Wakelin's customers were members of the Society for the encouragement of Arts, Manufactures and Commerce which had been founded in 1754.[59] It was here, too, that George Wickes met potential customers and established himself as part of enlightened society.[60] Others were members of the Society of Antiquaries and the Society of the Dilettanti.[61] Over half their customers had a seat in the Commons or the Lords.

To this network of sociability should be added often complex connections of marriage. For example, a Miss Noel began patronising the Panton Street firm in 1754. Her brother, Sir Edward Noel, had married Judith Lamb in 1744. Judith's brother, Peniston Lamb (1748–1819), who became first Viscount Melbourne, married into the Milbanke family, marrying Elizabeth (1749–1818), sister of Sir Ralph Milbanke, in 1769. A painting of the Milbanke and Melbourne families by Stubbs (1770), helps give some impression of the close ties between them (fig. 120). Lady Melbourne sits to the left, her father Sir Ralph Milbanke stands beside her, Mr John Milbanke stands in the centre,

Fig. 119. *Theresa Parker* (1744–75), by Sir Joshua Reynolds (1723–92); *c.* 1764. Oil on canvas; 243 × 135 cm. The National Trust (Saltram)

Fig. 120. *The Milbanke and Melbourne Families*, by George Stubbs (1724–1806); *c.* 1769. Oil on canvas; 97.2 × 149.3 cm. The National Gallery, London

Fig. 121. Set of four entrée dishes, by Parker and Wakelin; 1768. Silver (London); width 25.8 cm, 80 troy oz 18 dwt

with Lord Melbourne to the right wearing a handsome dark-blue coat with gold buttons.[62] A survey of Parker and Wakelin's accounts reveals a steady progression of patronage as one member of the family after another placed orders with the firm: from Mary Noel in 1754, to Sir John Milbanke, brother of Elizabeth, in 1765, Sir Peniston Lamb in 1769 and Sir Ralph Milbanke in 1770. Lamb began accumulating a dinner service in January 1769 in preparation for his wedding in March that year. Four 'pincusion comport dishes . . . ribbed a little way down' cost him £33 12s. 4d, part of a much large order that included fluted tureens, plates, knives, forks and spoons, all engraved with the arms of Lamb impaling Milbanke (fig. 121).

While this network of association tended to promote the idea of an identifiable elite, other factors militate against such a simple reading. Many of these wealthy plate-buying customers did not come from ancient landed families but from the newly rich, like Richard Bull of Ongar. He had acquired his wealth through his activities as a merchant trading with Turkey, yet he was known to his contemporaries more as an antiquary and friend of Horace Walpole. He was painted with his wife by Arthur Devis in 1747, the year of his marriage. The interior in which they sit, whether real or devised, is meant to convey a sense of fashion and wealth, with the handsome gilt rocaille picture frame and the expensive oriental porcelain on the mantelpiece. Twenty years after this portrait was painted, Bull was ordering silver from Parker and Wakelin, including a large nurled inkstand and two hearing trumpets.

Several other of Parker and Wakelin's clients were self-made men. Nicolson Calvert (c. 1725–93) was the son and heir of Felix Calvert, a brewer of Portland Place, who in 1755 inherited Hunsdon House in Hertfordshire, on the death without heirs of his older brother. A prosperous merchant, Calvert married the daughter and joint-heiress of a wealthy Irish landowner. Robert Cotton Trefusis was a wealthy Cornish magnate whose plans included building a quay at Flushing, 'even if it cost him £5000'.[63] In 1770 Trefusis abandoned his project of refurbishing the Tudor family home and bought a house in London. At this point he began patronising Parker and Wakelin for large quantities of tableware, which he left in his will to his son.[64] Only in his jewellery does he appear rather flash, with his gold shoe and knee buckles that cost him £30, his gold pencil and toothpick, and brilliant-studded shirt buckles. Bull, Calvert, Trefusis and the rest of the wealthy but untitled customers, bought silver that was indistinguishable in style and cost from that of the nobility. The search for differences in taste according to source of wealth appears as misguided as attempts to connect patrons of the Rococo with a Tory opposition to neo-Palladian Whiggery.[65]

FAMILY, FRIENDS AND PROVINCIAL CONNECTIONS

Not all Parker and Wakelin's customers belonged to the wealthy, metropolitan and aristocratic elite. A distinct group were relatives, friends of the partners, and close business associates and fellow tradesmen. Defoe, as early as 1726, noted how the tradesmen of England had grown so wealthy that they were 'coming every day to the Herald's Office, to search for coats-of-arms of their ancestors, in order to paint them on their coaches, and engrave them upon their plate'.[66] Although reflecting a more general concern for the maintenance of the social hierarchy, there is no doubt, from the wills and inventories of tradesmen, that they were furnishing their homes in style, and with expense.

George Wickes's widow, Alder, appeared in their ledgers in 1771.[67] Mrs Watson, John Parker's mother-in-law, bought small silverwares,[68] as did

John's bachelor brother, Thomas.[69] Several members of the Meade family had accounts with the firm, relatives of Samuel Netherton's second wife Elizabeth Meade Smith (1730–1803), as well as Samuel himself.[70] Relatives of Mary Allen, Edward Wakelin's wife, had accounts, including her mother 'Mrs Allan',[71] her sister 'Miss Allen'[72] and Wakelin's son-in-law Samuel Wallace.[73] The Reverend Mr Charles Allen, who married Edward and Ann in Ely Chapel also appears.[74] William Paris Tayler's half brother, Stephen Vitou, bought a few small trinkets. Tayler was to become a partner in the business with John Wakelin in 1776.

Thomas Panton, whose father had in 1671 purchased and developed the plot of land where the King's Arms eventually stood, appears to have been a regular customer, buying a coffeepot, spoons, a plated candlestick, and sending in numerous items for mending. One of Panton's lively daughters, Mary (d.1778), married well, becoming the second wife of the third Duke of Ancaster, who was also to patronize Parker and Wakelin. Edward Pauncefort, who had bought the premises from Panton and sold it to George Wickes in 1735, purchased many small wares from the business.[75] Pauncefort's daughter Mary married James Hubbald of Greville Street.[76] Husband and wife both had accounts with Parker and Wakelin, which reveal that Mrs Hubbald was paying Parker and Wakelin £9 per quarter as rent for a workshop.[77] James and his wife appear with regularity in the accounts but bought only small 'necessities' and refinements, like teaspoons and corkstoppers. Their marriage was witnessed by John Trevanion, a customer in the Gentlemen's Ledger, who bought large quantities of small items such as thimbles, stock buckles and cornelian seals. He was probably acting as an agent for export.

John Neville, the goldsmith who had joined Ann Craig in business (after Wickes's departure and her husband's death) in 1740, appears in the firm's accounts from that date.[78] 'Mrs Neville', perhaps his wife, appears much later in the 1780s.[79] Other goldsmiths and their relatives make an appearance in the customer accounts: Francis Creuze,[80] who was supplying the firm with precious stones and pearls; Mr Firmin,[81] perhaps Samuel Firmin, the button-maker; and Miss Tuite, who is likely to have been the daughter of William Tuite the goldsmith and amateur engineer.[82] James Fenoulhet, who patronized the business in 1772, had numerous associations with the goldsmiths of London via his mother's family, the Willdeys, who had a toyshop by St Paul's Cathedral.[83] There are names of fellow luxury traders, such as John Blittenberg, the tailor, who had supplied John Parker's wedding clothes in 1766.[84] It is not clear whether the artist Francis Cotes knew John Parker before he painted his portrait, but after the commission in 1766 his own name, that of his wife[85] and brother, Samuel, appear in the Panton Street accounts.[86] Samuel sent his miniatures to Panton Street to be mounted as bracelets.

While none of these customers made any large or elaborate orders, their custom was a crucial element in the success of the business. They provided and maintained links outside London, brought in a small regular income and contributed to ties which bound London networks of custom and manufacture together. Family relations and their associated circles meant that the business had strong provincial links. George Wickes, the founder of the firm, was born in Bury St Edmunds, Suffolk, and a large number of customers in the first years of the business can be traced to that county, including ' West of Bury, Suffolk', and the 'Rev Mr Burch of Charington in the County of Suffolk'.

When in 1735 the mayor of Bristol, Leonell Lyde, sought a gift for Judge John Scrope it was perhaps not surprising that he should have approached

Wickes, whose wife had wealthy Bristol merchant connections, for the commission. Her maternal grandfather, Richard Aldworth, had been a member of the Society of Merchant Adventurers of Bristol and was elected Lord Mayor of Bristol in 1643. The magnificent ewer and basin, costing over £148, was described by its recipient as the 'most curious' ever seen, largely because of its extravagant cast cartouches and wild roccoco design. Sixteen years later the current mayor returned to the same firm for his gift of 50 guineas to be made into a three-branch candelabra, bearing the mark of Wakelin (*see* fig. 24).[87]

A surge of customers from Worcestershire appear in Wickes' accounts from 1750, at the same time Samuel Netherton became Wickes's partner, and the year later, when John Parker joined Wickes as an apprentice. Both Netherton and Parker were members of established county families, and may have drawn in Lord Coventry from Earls Croome; Edwin Lord Sandys (1726–97) from Ombersley, the Bromleys of Upton upon Severn and the Martins of Overbury, who were also bankers in Lombard Street. John Martin (1724–94) was not a partner in the family bank, like his brothers James and Joseph (1726–76), but 'appears to have chosen as a profession that of being his father's heir'. In 1761 he had married Judith Bromley, a neighbour and heiress to a Palladian villa, Ham Court, at Upton. All three brothers bought large amounts of silver from Parker and Wakelin: John after he suceeded his father in 1767, and Joseph when he became head partner in the bank in 1760, and after his appointment as Sheriff of London in 1770 (fig. 122).

Local links provided access to metropolitan power and patronage. The Reverend Dr Cotton came from Claines; William Dowdeswell (1721–75) of Pull Court, owned land in Longdon that bordered that of the Parkers. Dowdeswell became Chancellor of the Exchequer in July 1765, but this did not alter his pattern of patronage of small regular orders: for a carved bottle ticket in November 1765, but mostly for mending work like repolishing a bread basket, fastening the lining of a candlestick and furnishing a socket to a punch ladle, never costing more than £40 and usually just a few shillings. Other customers from Worcestershire included Sir John Sebright of Wolverley and Sir Edward Winnington (*c.* 1728–91) of Stanford Court. The Winningtons appear to have preferred very plain table silver, as the dinner plates they ordered from Parker and Wakelin in 1772 had flat rims with no gadrooned borders, described as 'plain Oblong dishes' and matched an earlier service of 1719.[88] Thomas Byrche Savage of Elmley Castle ordered a fine set of chapel plate for his local church from Parker and Wakelin in 1770 (*see* fig. 78), followed three years later by a similar set for St Peter's Church at Little Comberton, where Savage's family were patrons for the living.[89] These orders accounted for most of the church silver Parker and Wakelin sold.

There is another group of customers that occurs in the Gentlemen's Ledgers. They appear to be agents, buying not for themselves but to supply others. Their accounts are marked by initials in the margin of the order. In the 1750s they include Bannister and Hammond, Messrs Isadore Lynch and Company, and Boyds and Birkbeck. By the early 1780s they were joined by the Russia Company, Darells and Quick, Bray and Company, and Sandel and Company. One of the few names that can be identified in the 1760s and 1770s is that of Wood and Trevanion. John Trevanion (*c.* 1740–1810) is listed in the *Royal Kalendar* of 1775 as a London merchant trading at 3 Bishopsgate Yard. He was buying large quantities of steel snuffers, nutmeg graters, sauceboats and candlesticks, which were presumably speculatively shipped out in bulk.

STRATEGIES OF PAYMENT

The advantages of securing a sale had to be weighed against the serious disadvantages of the length and amount of credit customers often required. It has been argued that in the area of consumer goods the position of the nobility had shifted from constituting the whole market to occupying the top end of an increasingly large market, but at this upper end the elite kept their hold.[90] Campbell advised the tradesmen of London that 'the Quality' affected 'to be dilatory in their Payments, to distinguish the Word Honour from Mechanic Honesty'.[91] Over seventy years later Phillip Rundell, the Royal Goldsmith, was to comment on the same problem, in a different way: 'If we could collect our just debts then indeed we might be rich'.[92] He was convinced that customers 'would pay if properly rubbed up'. The shopkeepers who specialized in luxuries, locking up their capital in expensive materials as well as committing themselves to time-consuming and skilled workmanship had to bear the added weight of customers who expected credit. Using the bankruptcy records of fairly large businesses, historians have shown that tradesmen who dealt with the upper classes had to be prepared to give long-term retail credit.[93] Extending credit too far and having too little cash was one of the most common causes of business failure. Dru Drury attributed his own bankruptcy to 'a great deal of weight bespoke and little money to finish it with'. Drawing on Hogarth's painting *Marriage à la Mode*, Colman and Garrick produced the *Clandestine Marriage* in 1766. The City merchant Sterling, whose daughter is to marry the son of Sir John Melvil, exclaims on the difference between the manners of the Court and the country: 'Your

Fig. 122. *Joseph Martin*, by Thomas Hudson (1701–79). Oil on canvas; 66 × 53 cm. Holland-Martin Family

Fig. 123. *Daniel Perreau*, engraved for the *London Magazine*; 1 August 1775. National Portrait Gallery, London

M^R. D. PERREAU.

lords, and your dukes, and your people at the Court end of town stick at payments sometimes – debts unpaid, no credit lost with them – but no fear of us substantial fellows'.[94]

The method and time customers took to honour their bills is the key to another set of consumption strategies. Parker and Wakelin's customers settled their accounts in a variety of ways, in ready money, bills of exchange and in kind. Customers sent in their gold and silver lace or old silver, to be credited with its bullion value in part or full payment of their bills. Lord Viscount Galway settled a bill for £455 of dining silver with £11 cash and £444 worth of 'old plate', including salts, dishes and castors, traded in for their melt price of 5s. 8d. per troy oz. Anthony Keck settled one of his accounts with the gold mountings to a snuff box which raised £15 15s; while the Earl of Buckingham thought it worth trading in an old silver tongue scraper for 2s. 6d. as part payment of a large bill for £622 worth of plate. In Sheridan's *School for Scandal*, first perfomed in 1777, Sir Oliver asks Surface: 'Is there nothing you could dispose of? For instance now I have heard that your father left behind him a great quantity of massy old plate'. Surface replies, 'O Lud! thats gone long ago', and Sir Oliver exclaims 'Good lack! all the family race-cups and corporation bowls!'. The trading in of plate was a common means of paying debts, but it was a finite source for many desperate rakes.

Others customers paid in cash, in the form of ready money, bills of exchange, bonds, or by a combination of these methods. Buckingham paid the rest of his 1772 bill 'By a bill on Messrs Drummond at 6 weeks' for £35, although 2s. went unpaid, and was 'Look'd upon as Bad', that is, irretrievable.[95] Many of Parker and Wakelin's customers had accounts with the major London bankers: Coutts, Drummonds, Hoares and, of course, with the Bank of England. Reading their bank accounts reveals a whole network of financial obligations.

Purchase and payment could be completed within a few days, months or sometimes years after the invoice was sent. Over half of Parker and Wakelin's clients paid their bills within one to six months of receiving their accounts, while a quarter paid between six months and a year. As such these were valuable customers. Credit for up to two years accounted for a further thirty customers, while those who left their bills unpaid for over two years accounted for only five individual cases. Francis Burdett and the Martin brothers (who were bankers in Lombard Street, and owned an estate near Parker's in Worcestershire) nearly always paid their bills within days of their accounts being drawn up. Their business-friendly behaviour conforms to Lord Chesterfield's advice to his son: 'As far as you can possibly, pay ready money for everything you buy, and avoid bills. Where you must have bills . . . pay them regularly every month, and with your own hand'.[96]

The majority of Parker and Wakelin's customers, in common with many who bought expensive luxuries, expected, and secured, extended periods of credit ranging from a few days to several years. Boulton's London agent advised 'no terms but one – on any Ac[coun]t whatever, and that should be a 3 month Ac[coun]t, to be drawn for at 2 months from the delivery of the Ac[coun]t . . . it is attended with great risk in London to give longer credit'.[97] Yet Parker and Wakelin were obliged by custom to extend much lengthier periods of credit to their customers. Thomas Gooch waited four months to pay for his 'ornament to a Turks cap', while most settled their bills once a year. Some, like Bishop Fernes, must have stretched the patience of Parker and Wakelin to the limit. In January 1769 he had acquired from them a small tortoiseshell snuff box for £1 13s, but he did not pay for it until April 1773. Although most of their customers settled their bills, there were a few whose

accounts were a continual source of worry. Part of the Portuguese Ambassador's account for elaborate tablewares bought in 1770 had to be written off, to the sum of £95.[98] John Parker noted against the £500 unpaid account of Daniel Perreau, 'hanged for forgery', which he was, alongside his twin brother, in 1776 after a much publicized trial (fig. 123).[99] Parker and Wakelin were lucky to have escaped with only a £500 loss as Daniel, with the help of Caroline Rudd and his brother Robert, had been cashing forged bonds, one to the amount of £7,500 at Drummonds.

Most of Parker and Wakelin's customers seem to have paid their bills twice or even three times a year, between March and May, and November and December. When customers were out of London, during the months of August, September and October, shopkeepers' income dropped dramatically. Payment, in other words, was influenced by the Season, which 'linked the country house with the more elegant and diversified life of the urban drawing room, refining the one, and reinvigorating the other'.[100]

The largest source of income for the aristocracy came from the rents of their tenant farmers and annual rack rents, which were gathered once a year. Sir Edward Knatchbull (d.1789) of Mersham Le Hatch in Kent, one of Parker and Wakelin's customers, replied to Thomas Chippendale's request for payment in 1770 'I receive my rents once a year so I pay my tradesmens bills once a year w^ch is not reckoned very bad pay as the world goes.'[101] Yet this response did not deter Chippendale from taking further orders from Knatchbull. Two years later he ordered 'more furniture from Chippendale w^ch he has engaged to let me have in three months and I have engaged he shall have this Money the latter end of Octo. provided I have it at that time but as many days exceed so many more days he is to stay for his Money'.[102] This correspondence suggests a waiting game between the two. Knatchbull's account with Parker and Wakelin reveals that he did indeed settle his accounts in late October or early November each year. This did not, of course, mean that he paid up easily. In 1778 another letter written by Chippendale reveals further problems:

> I am sorry to hear you are so displeased with our bill for the goods sent to Hatch. I well remember that you told me last year you should pay me no more than £100 when the Goods were done but surely Sir, you nor no one else would seriously Imagine that those Elegant Goods would come to no more. What you think Exorbitant, I do assure you is moderate sum will bear the inspection of any man of the Business, who is judge to no one else.[103]

The Panton Street business had prestigious clients whose accounts were a continual source of anxiety. In 1744 Lord Mountford bought a 'pair of fine chais'd tareens', based on a design by William Kent, from Wickes costing just over £312 with case, part of a large bill for £1,471 13s. 6d.[104] Just over £1,000 was paid in old silver and the rest in cash. After his death in 1755 his son pursued a relentlessly reckless programme of expenditure, notching up an account with Parker and Wakelin that by 1772 involved Lady Mountford's marriage settlement.[105] It was not until 1776 that a balance was finally struck, when Parker and Wakelin organized the sale at auction of his plate. On the credit side of Mountford's account is the sum of £61 10s. 'Commission pd Christie for selling it @ 5pct deducted from the £1,230 7s. 6d. realised by the sale'. The proceeds, however, were insufficient to clear the debt and on 29 September 1776 the partners delivered an account for £567 4s. 8d. still outstanding. To this was added £17 1s. 7d, the interest at 5 percent per annum on the seven months and seven days which had elapsed since that date.[106]

There were other customers who proved difficult. In 1777 Wakelin and Tayler pursued the Duke of Hamilton's outstanding bills inherited from their predecessors via the courts, paying their lawyer Benjamin Sparke £8 to 'protest 2 bills of Hamiltons'. It was not until 1777 that Ansill and Gilbert, the firm's major subcontractors, were paid £500 for making up Hamilton's plate.[107] Here we can see the advantage of the subcontracting system for the retailer. If Parker and Wakelin had relied on their own employees for manufacture they would have been obliged to pay them their regular wage, but subcontractors had to wait until the client paid for their own bills to be paid.

The bills that survive from the goldsmiths Heming and Chawner to Lord Monson show that it was not just Parker and Wakelin who suffered such treatment from their aristocratic customers. Between 26 May 1777 and 23 February 1779, Monson ordered some £330 12s. 10d. of plate, including 'a large Beaded Vase Coffeepot', '2 large Elegant Chas'd Oval Tureens fluted and Covers' and '2 Elegant chas'd Toast holders in Antique Taste'. Heming appears to have kept adding items on to his ever extending bill. In May 1778 Monson paid part of the bill with £173 8s. 4d. worth of old silver at 5s. 6d. per troy oz. This included a cistern, two chamberpots and two tureens, weighing 571 troy oz 15 dwt, but he did not send a further £100 until March 1780, leaving £58 4s. 6d. outstanding. A repeat of the bill was sent in in May 1781, yet Monson did not finally settle the account until 31 May 1782. As Heming noted at the bottom of the third reminder 'as the above acct has been open between 4 and 5 years I shall esteem a favourable answer an obligation confer'd on Your Obedt Servt Geo: Heming'.[108] It is not surprising that the next orders from Heming were small, amounting to only £5 2s. 9d, mostly for mending, and were settled within a month of the bill being sent.[109] Yet at the same time as Monson was causing Heming trouble, he was ordering silver from Parker and Wakelin, and later Wakelin and Tayler, and paying his bills regularly each year.

Networks of indebtedness could be complex, were widespread and well known, providing perfect material for many a popular eighteenth-century drama. Samuel Foote's play *The Minor*, advertised in the *Gentlemen's Magazine* of 1760, would have appealed to the London businessmen in the audience as they would have recognized the problems of getting bills paid. This comedy in three acts centres on Sir William Wealthy and his son George. Sir George enters into a treaty with Transfer, the broker, who agrees to supply him with money charging 40 percent interest, and sends him a large quantity of Birmingham wares, Witney blankets and flint stones. Louder, a gamester, agrees to sell these, employing Shift the auctioneer in order to procure plate and furniture.[110] In fact as in fiction the more people that were involved in a debt, the less likely the tradesman was to secure its repayment.

Fortunately for Parker and Wakelin, their tight control over monies owed meant they were not forced into bankruptcy like so many of their contemporaries in the luxury trades. Dru Drury's business failed in 1778 when he 'lost more than £16,000' mainly due to customers' unpaid bills. Thomas Betts the London glasscutter, who died in 1765, was valued at £10,172, yet £1,297 was owed him in 'Book Debts' and a further £113 due in notes in hand. Fortunately these debts were offset by £3,000 in government securities and £1,736 in leasehold estates.[111] For many the weight of desperate or unrecoverable debts was enough tip them into failure. One of the reasons why Boulton closed his silver manufacture at Soho in 1778 was that he could not ride the long periods of credit his aristocratic customers expected. One of his customers, Richard

Perrot, was outraged when Boulton informed him that 'Two months is the utmost period of credit that we are able to allow any person whatever on silver wares, for when the period exceed this point we lose money by the interest on silver'.[112] Perrot argued that if he had been shopping in London he would have expected at least a year's credit, it was all part of the metropolitan way of doing business.

Shopkeepers and tradesmen had to judge whether a customer was credit worthy or not, for nearly all luxury traders were expected to wait for their money. Here lay the importance of information about customers. Knowledge about imminent births, marriages, deaths, accessions and bankruptcies could help a shopkeeper navigate the choppy waters of credit and debt. Parker and Wakelin were keen to note the developing social and personal relationships of their clients. Knowledge about forthcoming marriages, honours and christenings could herald possible business. John Parker noted in the index at the front of the Gentlemen's Ledger that 'Williams' was 'Mrs Vanderwall's son'; John Clarke was 'Mrs Tryon's friend'; and that Mrs Gillet has married Laprimaudaye. He recorded that Prince Henry had become Duke of Cumberland; that 'Honble Comr Hervey' had been made Lord Bristol; and that Mrs Young's husband had been knighted. Parker also noted that Davidson Richard Grieve lived up to his name, as he was a 'grievous fellow'.

In his day book, the goldsmith and engraver George Coyte made similar annotations against the names of his clients: 'Mrs Blake in Clarke Street, Berkeley Square is Mrs Wray's great friend as she says'.[113] Arthur Webb wrote to one of his oldest clients, the Reverend Wickham, that 'I have been informed by a friend from Bath that Miss Seymour was going to be married, if opportunity offers and you and your Lady think proper to mention me as the Jeweller would be an additional favour conferred on me'.[114]

If the shopkeeper did not know the customer, decisions about character and credit had to be made on the spot. Boswell's encounter with Jefferys the retailing goldsmith, at his shop in Cockspur Street (the same goldsmith who had made up Sir George Smith's dressing silver), reveals that credit worthiness was a matter of honour and reputation as much as the practical ability to pay:

> I . . . went to the shop of Mr Jefferys, sword-cutler to his Majesty, looked at a number of his swords, and at last picked out a very handsome one at five guineas, 'Mr Jefferys', said I, 'I have not money here to pay for it, Will you trust me?' 'Upon my word, Sir', said he, 'you must excuse me. It is a thing we never do to a stranger'. I bowed genteelly and said, 'Indeed, Sir, I believe it is not right'. However, I stood and looked at him, and he looked at me. 'Come, Sir' cried he, 'I will trust you'. 'Sir' said I, 'if you had not trusted me, I should not have bought it from you'. He asked my name and place of abode which I told him. I then chose a belt, put the sword on, told him I would call and pay it tomorrow, and walked off. I called this day and paid him. 'Mr Jefferys', said I, 'there is your money. You paid me a very great compliment. I am much obliged to you. But pray don't do such a thing again. It is dangerous'. 'Sir', said he 'we know our men. I would have trusted you with the value of a hundred pounds'.[115]

Decisions about a customer's credit worthiness had to accommodate the changing fortunes of the individual. Joseph Brasbridge related how he had been shocked by Mr Caswell who,

when a young man was a constant customer to me for small articles, such as forks and spoons; for his fortune being limited, he was too prudent to buy anything not absolutely necessary for the respectability of his table. Knowing his circumstances, I always gave him such long credit, that the pleasure of serving him was the sole advantage I derived from his custom.

Caswell then married the niece of the wealthy Mr Davison, who 'left Mr Caswell £80,000 at his death and to my great amazement, certainly not unmixed with indignation, I never saw my customer again; for when he no longer wanted credit, he found that other shops were more brilliant than mine'.[116]

8

Disseminating Design:
'a distinct language'

I shall often have occasion to speak of forms and proportion . . . it is necessary we should settle a distinct language that our definitions may be precise and not mistaken

Matthew Boulton to Richard Chippindhall, 1793[1]

The pages of the Panton Street accounts give us little indication of the role of design and designers in their business. There is one reference to the name of an architect, a cup and cover made 'after Kent' supplied in 1768, a copy presumably of the one supplied in gold by George Wickes to Colonel Pelham in 1736 after a design by William Kent.[2] The only mention of a pattern is for Fulke Greville's tureen, part of a large dinner service ordered by him in 1768. It was not of paper but a model; it was engraved with the customer's coat of arms for future reference. There are no payments for drawings, designs or prints in either the workmen's or the customer's accounts. The descriptions of orders are limited, we know that a 'fine' sauceboat was probably elaborately chased, and that a 'neat' cream jug was well finished, both have high charges for workmanship in relation to the cost of the metal. There is rarely more that can be gleaned from the ledgers. Yet we know from the surviving silver that the business supplied tureens after designs by the King's architect, William Chambers, and later by the sculptor John Flaxman. There are shapes and decorative motifs that derive from French and English designs that were circulating in London at the time. The process of making depended on the efficient transmission of design information between subcontractors, via two- and three-dimensional models. There was also a more general intellectual and economic concern with design training that gained momentum from the 1750s. Widely publicized debates about the nation's failure to compete with France centred on the production of luxury goods, not in terms of quantity but in quality, diversity and novelty.[3] The English were characterized by the French as dependable but unimaginative mechanics, while the English were critical yet envious of the style and quality of French luxuries.

In order to recreate the role of design in the Panton Street business it is necessary to draw liberally on the letters, diaries and journals of other businesses, not only from other London goldsmiths like Dru Drury and the Vulliamy brothers, but also from those who were dealing in bigger and wider markets in the eighteenth century, like the Birmingham entrepreneur Matthew Boulton and the potter 'to the universe', Josiah Wedgwood in Stoke on Trent.

What becomes clear from all these sources is the way those who sold silver placed the customer in the fore of design, accommodating their desires while

influencing their decisions. It was a subtle game to play. Retailers and makers satisfied customers' demands by copying existing work, gaining access to the latest prints, keeping up with fashion and turning verbal, written and visual intructions into three-dimensional reality. It was a hazardous business that might only too easily end in the return of the final product with the concomitant loss of time, materials and money, as well as future custom. One-off designs demanded new patterns, lengthly negotiation and highly skilled workmen, while the more regular stock gave a more dependable, less risky, return. As Josiah Wedgwood made clear in a letter to his partner Thomas Bentley, it was the manufacture and sale of 'uniques', commissioned by their wealthy and fashion-conscious customers that brought fame to the business, although their production involved more work and often little profit compared with their standard counterparts, which were sold ready-made and in quantity.[4] Yet the 'uniques' were perfect advertising vehicles; elements of their design could be translated into stock forms, they were a means of both satisfying and creating demand.

The transformation of ideas into objects relied upon a verbal, written or visual conversation between consumers, producers (designers and makers) and sellers. The creation of a commissioned object required a shared language of understanding whereby a customer's desires could be communicated to the supplier, then negotiated and translated into a working programme of manufacture. There are, therefore, three distinct stages through which the design of an object needed to pass. The first stage was the *conception* of the form and decoration, which depended on the exchange of information between customer and maker, often mediated via the designer and the retailer. The second stage was one of *negotiation*, whereby initial ideas and costings were rejected, modified or confirmed. The third stage involved the *transformation* of the design into the object to be purchased. Each stage involved the exchange of design information.

The language of description within the silver and jewellery trades appears, from the business accounts, bills and correspondence that survive, to have been shared, facilitating the movement of part-finished objects within networks of subcontractors.

CONCEPTION

Buyers and sellers relied upon each other to identify what was desirable, they had a symbiotic relationship. While customers solicited advice from their tailors, goldsmiths and cabinet-makers about what was and was not in fashion, makers and retailers also depended on certain customers for information on the latest designs, via the clothes, silver and furniture they ordered. This information came in a variety of forms: objects already in their possession from which patterns could be taken; printed sources which could be borrowed and copied; or ideas communicated via letters or sketches. The elite visited each other, admired and criticized their homes and contents, and copied desirable objects. Lady Mary Coke, for example, after her stay at Sudbrook in 1766, wrote to her host, Lord Strafford, asking if 'he wou'd be so good as to let me have a drawing of his grate in his new eating room, as I propose to have one just the same'.[5]

Wedgwood spent much of his time cultivating access to private collections, like that of the fourth Duke of Bedford, in order to find examples of the latest taste. Writing to Bentley in 1765, Wedgwood explained that he had: 'been three Days hard and close at work takeing pattns from a set of french China [Sèvres]' at Woburn, 'the most elegant things I ever saw, and am this evening to wait and be waited upon by designers, modelers etc.'.[6] On another occasion

he hoped that Bentley would 'have the opportunity soon of getting some figures from the Cabinets of ye Noble customers, which have not yet appeared in the shops'.[7] For Wedgwood and others, the problem was keeping track of who owned what as access had to be negotiated and was a privilege rather than a right. For this reason Wedgwood wanted to know if Lord Bessborough, the well-known collector of antiquities, had

> sold all his casts from Antique Gems, or the Gems themselves to the Duke of Marlborough? I am, and so are you, much interested to know this as we had leave from Ld B: to take casts from all his Casts, but if the D. of M. has bo[t] them we shall . . . [need] to solicit again . . . Gems are the fountain head of fine and beautifull composition, and we cannot you know employ ourselves too near the fountain head of taste.[8]

It was not only direct access to objects that the manufacturers of luxury goods were keen to secure. Wedgwood also received prints from his clients, such as Sir William Meredith, from whom he acknowledged in 1765 'Five pacquets . . . inclosing prints of different sorts which he is so obliging to employ his good taste in picking up for me at the printshops'. The design of three condiment vases supplied to Kedleston by the London goldsmith Louisa Courtauld derive from d'Hancarville's engravings of William Hamilton's antique vase collection. The Vulliamy brothers sometimes relied on prints provided by their customers for the decorative detail of their cast bronze mounts. The pair of tables held by 'monkeys . . . their paws covered with Hieroglyphics' made for the Marquess of Blandford were based on 'exact Copies from a Print in Count Caylus's Collection' provided by the customer.[9] Discerning customers *au fait* with the latest fashions via published prints would have immediately recognized the sources for Courtauld's vases and the Vulliamy bronzes, it was a crucial part of their value. The French prints of Meissonier and Germain that popularized the rocaille style so fashionable in the 1730s to 1750s, were designed to be followed in spirit freely, as inspiration, but the neo-classical prints of d'Hancarville and Caylus were copied more accurately by makers, there was a more literal translation between printed source and final object.

A third source of design information came via a customer's 'idea', which was readily connected with an existing form, either printed or three-dimensional. A good example of the realization of this type of design source is Matthew Boulton's most popular watch stand, based on the figure of the Emperor Titus, first produced in 1771. Boulton informed his client, Samuel Pechell, that 'we think your idea of the Emperor Titus is a very good one for the purpose',[10] yet he was not willing to discount the price of the finished object to Pechell in recognition of his contribution. It is clear from the wording of Boulton's letter that his customer had expected and asked for one.

NEGOTIATION

Objects, prints and ideas had to be translated into drawings for the communication process to continue, for the conversation to develop. Sometimes it was the customer who initiated the first drawings upon which subsequent negotiations took place. In 1761 Thomas Gray advised his friend and fellow antiquary, Thomas Warton, that in the absence of any wallpapers 'that deserve the name Gothic' he should commission some, by finding anyone 'that can draw the least in the world' to sketch 'in India ink a compartment or two of diaper

work, or a nich or tabernacle with its fretwork', and send it to a wallpaper shop for a 'stamp' to be made up.[11]

When Lord Grantham asked his daughter, Theresa Robinson (*see* fig. 119), to commission a silver inkstand for him, she must have enclosed a sketch of her idea, as her father wrote back that the design was faultless except for the foliage around the bottom, which should be done 'in a bold, distinct and masterly manner, else it may prove crowded, costly in fashioning, and difficult to keep clean'.[12] His comments show an acute awareness of aesthetic, economic and practical elements in design. A year later she drew the profile of a silver wine cistern for her brother's approval, but noted that 'It looks too squat but answers the purpose of a cistern to contain bottles better'.[13] These drawings would then have been sent to the goldsmith, beginning an exchange of textual and visual information.

The letters of John Cartwright of Nottingham, who commissioned three commemorative ceramic punch bowls from the Leeds pottery of Hartley, Green and Company, reveal much about the problems of interpreting a customer's wishes by the supplier.[14] In November 1783 he wrote to the partners, 'I have made the best sketch I can of a branch with hops and leaves', although he added 'the leaf however, in the middle of the sketch is about one-third too large'.[15] He 'likewise sketched a border'. On one side of the bowl he 'would have my arms and on the contrary side my crest', although Cartwright explained: 'My drawing is so very imperfect, it may possibly be proper to inform you that my crest is the head of a wolf'. Between these he wanted a representation of a hop-picking scene. He added 'I meant to have copied for you an elegant group of dancing peasants taken from a copper-plate of a picture by Claude Lorraine, but Mrs C. is from home with the key to the drawer where it is kept'. As these extracts reveal, a customer's skills might not be up to the production of easily decipherable drawings, and the supply of additional material might be slow in coming. These difficulties and the customer's own zeal made communication slow and the time between initial contact and delivery long, all adding to the production costs, which might not be recouped from the client. It is a classic illustration of the problem of supplying 'uniques'.

If customers did not feel equal to or did not want the task of providing a sketch, then they might use an architect, especially if the silver was part of an on-going architectural project. For example, in 1774 Thomas Scrope of Coleby wrote to William Chambers requesting a design for a silver épergne:

> I wish you would also put together for me (for I cannot Draw) an idea I have for an Epargne; the part to hold the lemons to be a cornucopia, the frame a tripod, the things for pickles, Paterae, light and elegant and truely Antique.[16]

Chambers also provided designs for silver for the Duke of Marlborough while he was working for him at Blenheim in the later 1760s. Robert Adam did the same for many of his clients including Sir Watkins Williams-Wynn at Wynnstay and St James's Square, for Sir Lawrence Dundas the Scottish merchant and contractor, and the Curzons at Kedleston. It was the customer who paid for these designs and not the goldsmith, but this did not secure any form of ownership over them. Once the design went into the workshop to be made it was often appropriated, copied, adapted and reproduced for other customers.

Sometimes it was the supplier who responded first with the drawings, which then required the customer's opinion and amendment. This might herald a lengthly interchange of information. Campbell wrote, in his advice book *The London Tradesman*

How absurd it would be [if a seal engraver or die-sinker] could not give a Sketch upon Paper of the design of the Work? [As] By this I should be able to judge if or not he apprehended my Meaning; and might be enabled from this View of my own Ideas, to correct the Error of my first Invention, which I could never do, unless the Artists could furnish me with this plan.[17]

Most of the luxury trades included in Campbell's book required drawing skills; the cabinetmaker, the gold and silver laceman, the goldsmith and the silkman. In 1773 Thomas Chippendale, the cabinetmaker, wrote to Sir Edward Knatchbull enclosing several designs including one for an Axminster carpet, reminding his customer that 'if you or Lady Knatchbull chuses any alterations in any Colours, by describing it properly, it may be done'.[18] It was designed 'to correspond with . . . [the] ceiling to go in the bow', which had been planned by Robert Adam. It is not clear in what form Sir Edward responded, but the carpet was eventually delivered to Knatchbul's refurbished house at Mersham-Le-Hatch in Kent in 1774. Chippendale also sent 'her Ladyship patterns for the needlework which will be very large; and consequently will take some time in working'.[19]

The design conversation might be marked by a series of drawings, each representing a step toward production. The first drawings might take the form of cursory outlines to convey very loose and general ideas, sometimes no more than 'doodles'. Robert Adam refers to them as 'rough' or 'slight sketches'. A more formal design followed, often in ink, sometimes annotated, often with measurements and alternative decorative details. These were developed into sepia drawings, or 'coloured sketches', to give the customer a more attractive idea of what the pieces might look like, sometimes ensemble with other forms.

Once agreed upon, measured working drawings were made up, showing profile and plan, accompanied by the details of the cost of manufacture. These were occasionally translated into three-dimensional models in clay or wood as a means of more accurately calculating the cost of the commission. For example, the goldsmith Paul Crespin, writing to Mr Achard in 1752, notes that he has received a order from 'Madamme la Duchesse' to make six sconces in silver 'Come le modelle que long mat envoié pour des short six'.[20] In 1815 Thomas Fletcher, on his visit to Soho, noted that Boulton constantly employed '2 or 3 draftsmen. and as many modellers to build up in wood or wax everything they make to see its proportion and try the effect before they begin it in silver'.[21]

As a result of consultation over the first working drawings or models, the final designs would be drawn up and sent to the workshop. The survival of a large number of Robert Adam's designs for silver mean that we can match these stages in design with examples of his work. For example, we have the sketch, pen and ink, and the finished drawing of the design of a set of candlesticks by Adam for the Duke of Roxburgh, dated and signed August 1775 (figs 124, 125).[22] We can see how the drawings were translated into silver, as a set of four candlesticks made to the design and marked by Thomas Heming for 1776 survive (fig. 126).[23] The bucrania at the lower knop have been replaced by swags and bows, and Heming has added an acanthus border to the foot, as well as enriching the water leaves on the lower dome with veined chasing.

We can track some of these stages in communication via the detailed letters and accounts relating to the Swiss watchmaking brothers the Vulliamys, who began to supply silver in the 1780s from their London workshop. There is one particularly well documented case, the commission of a cup by Mr Turner,

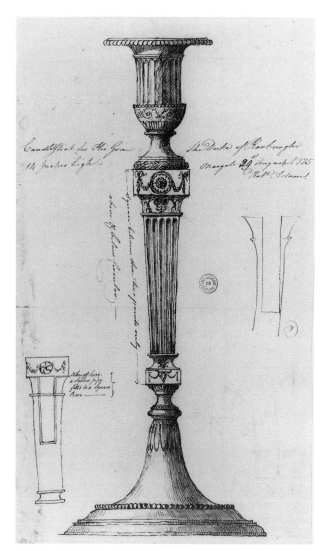

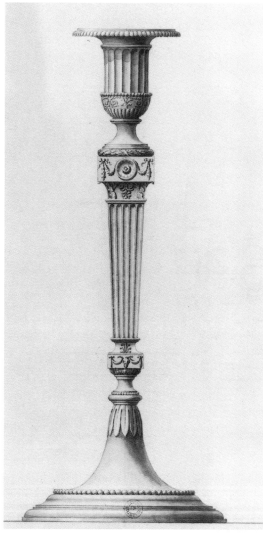

Fig. 124. *Candlestick for His Grace the Duke of Roxburgh . . . 29 August 1775*, by Robert Adam. Pen and ink; height 10 cm. Sir John Soane's Museum, London

Fig. 125. Coloured drawing from Adam's studio of Roxburgh's candlestick. Height 10 cm. Sir John Soane's Museum, London

that illustrates these various stages in design communication. We have only the Vulliamy side of the correspondence but it is detailed and can be related to the step-by-step production in surviving account ledgers. The first letter to survive relating to this commission is from Benjamin Vulliamy, requesting that Turner comment on a selection of designs that he had sent. Vulliamy asked that if he did not find them satisfactory he would 'be obliged if Turner sent him 'a slight sketch of the stile your friends would like and I will make you a fresh set'.[24] Turner must have responded as a month later Vulliamy sent him 'four different designs for Cups and vases taken from the Antique of one, the celebrated vase Brought from Rome by Lord Cawdor and now in possession of the Duke of Bedford'.[25] The actual silver cup does not survive, but we know that the design was based on the marble Lante Vase excavated from Hadrian's villa in Rome and now at Woburn (fig. 127).

These designs correspond with the second, pen and ink stage of drawings. Once one of the four drawings had been settled upon Vulliamy enclosed 'an outline upon a larger scale' as a means of calculating the cost of the final piece. This is the equivalent of the measured 'working drawing'. It seems that Vulliamy was not over confident of Turner's ability to interpret the design (to understand the visual language), as he added: 'I need scarcely mention to you

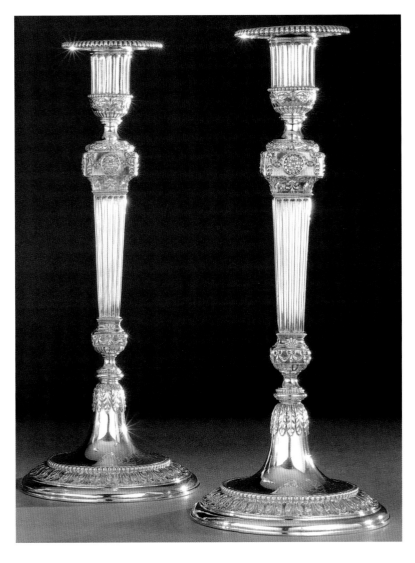

Fig. 126. Two of four candlesticks, designed by Robert Adam, supplied by Thomas Heming; 1776. Silver (London)

Fig. 127. The Lante Vase. Roman, excavated by 1639. Marble; height 1.75 m, diameter 1.66 m. The Duke of Bedford and the Trustees of the Bedford estate

that these things when executed look much larger than upon paper, these drawings being merely what may be termed Geometrical Elevations in which point of view these sort of things are never and indeed Scarcely can be seen in the pencil Drawing.' Vulliamy was careful to add that 'as it takes some time to make these sort of drawings and calculations, I thought it best not to make any more until I heard from you'. Fourteen days later Vulliamy responded to Turner's questions regarding the volume of the cups, the weight of silver to be used and the final details of the design. The letter concludes:

> The upper gadroon shall be attached to the Cover as you direct and we have drawn two handles of your choice . . . you should let us have a general sketch of the Arrangement of the Inscription whch may be best done on the drawings themselves, let us know if it is wished to have any engrav^d border round, if so sketch it likewise.

Sometimes a two-dimensional sketch did not convey sufficient information and a three-dimensional model had to be made. This most frequently happened during the calculation of costs, both of materials and workmanship. In 1807 Benjamin Vulliamy wrote to the Marquess of Blandford about the casting of two bronze lions, the expense of which,

it is not in my power to do at all without having a model of the same size to intimate from I would therefore propose to your Lordship if it meets with your approbation to let Smith Model a Lion in Clay for you to see the size of which your Lordship may judge while the model is in a rough state and therefore estimate the expense.[26]

For another customer, Lord Reay, he provided 'a clay sketch of the handle' for a pair of tureens and stands, and three further clay sketches of separate decorative details, of fruit, vegetables and shell fish.[27] It is abundantly clear from the Vulliamy copy-letter books that the preparation of drawings and models was expensive, and that if the order was not finally placed the business stood to lose a considerable amount of time and money. It was for precisely this reason that Benjamin Vulliamy wrote to another of their clients, Lord Breadalbane, for whom they had

made Drawings . . . [and] also a model of a Side Board to give Your Lordship a more perfect Idea of a magnificent service of Plate . . . in December last Your Lordship accompanied by Lord Reay call'd at our house and saw and examined the Model and fixed upon 3 dishes 1 Cistern and 2 side Dishes for which we were to make Large Drawings for your L^dship to see those drawing and an estimate were submitted and approved of when Your Lordship called again with Lord Reay in January . . . Yr Lordship will please to reconsider the Drawings make such alterations as you may think will improve their Design notwithstanding the great expense we have already been at in preparing Patterns and Material for that order.

These drawings may have looked like those Robert Adam made of the side boards of plate at Kedleston (*see* fig. 147) and Kenwood. They are bright watercolours that create a vivid image of how the silver would look within the dining room. They were made to seduce the customer, to clinch the commission.

Matthew Boulton's correspondence with his customers reveals that he frequently tried to short cut the exchange of designs and comments, to save both time and money. As he explained to Colonel Pechell, he had only sent 'slight sketches' of the Titus watch stand, as 'our finished drawings require more time than the multiplicity of our business will allow . . . nor are they necessary for one whose minds eye supplied the deficiences'.[28] This does not mean that Boulton failed to see the importance of drawings. When he was communicating direct with makers, in his role as middleman between customer and manufacturer, he stressed how crucial they were in the production process. In a letter to Nathaniel Marchant (1739–1816),[29] the celebrated gem engraver, he explained the necessity of models because 'the taste and judgement of different men vary as much as their faces and on that account as well as the difficulty in transferring to a second or third person [i.e. to the retailer, and then the actual maker] the precise ideas of the first without having an exact model to copy is a task too precarious. I wish nothing to depend on me except simply copying'.[30]

TRANSFORMATION

Once negotiation with the client had been brought to a satisfactory point on both sides, the form, ornament and price agreed upon, the process of communicating with the makers could begin, the transformation into the desired three-dimensional object. Clarity was essential if mistakes which cost time and money were to be avoided. This problem was magnified by the number of

hands an order had to pass through during its manufacture. The retailing gold-smith Dru Drury's complaints to his spoon supplier, Joseph Woolhouse, reveal the penalties of poor communication. Drury was vexed that Woolhouse had sent him a dozen spoons without 'the thread at the shoulder' which he had originally wanted, and which took him 'a good deal of time as well as trouble' to add.[31] Matthew Boulton's concern that he and his agent should 'settle a dis-tinct language that our definitions may be precise and not mistaken' reflects the desire to avoid such misunderstandings and thus expense. Their agreed language of size, shape and proportions was codified into a system which Boulton sent on a sheet of paper.

It is rare to find evidence relating to the stage between negotiation with the customer and the delivery of the finished order, revealing the process of manu-facture. We can, however, do this by turning once more to Turner's commis-sion for a cup from the Vulliamy's. The work book (1813) takes up the story of its manufacture and lists the names of the different specialists involved, what they did, and how much they were paid.

1813

Nov 5	Sh'p Acct paid carriage of a parcel	£0	3s.	9d.	
21	Brownley gluing up Beech to turn the Model	£0	6s.	3d.	
28	Lime tree Shaped for Pattn of handle	£0	17s.	6d.	
Jany 23	Cutting Pattern of the handles	£0	2s.	6d.	
14	Hope carving flute in wood model to fit the handles to	£0	2s.	6d.	
Jany 24	Carving the handles	£10	6s.	0d.	
Feby 10	Do. Patterns of G'roon Rings of body and foot	£1	12s.	0d.	
June 6	Barnett casting the Handles and gadroon Ring	£2	12s.	0d.	
July 20	casting the nob	£0	1s.	3d.	
June 30	Butler Cleaning	£0	2s.	6d.	
	Barker Chasing the Handle	£9	0s.	0d.	
	Jacob turning Wood Model 2½ days at 6s.	£0	15s.	0d.	
July 31	Butler cleaning after soldering	£0	0s.	8d.	
	Barker repairing the joints of the handle	£1	0s.	0d.	
Aug 4	Chasing silver nob	£0	10s.	0d.	
22	Cradock and Reed fashion of the Cup complete excepting Chasing Handles and Nob and filing the solid gadroon Ring	£15	15s.	0d.	
	54 oz Silver at 6s.	£16	4s.	0d.	
	Duty on 102 oz at 1s. 3d.	£6	7s.	6d.	
	Butler filing up handles etc. 8¼ days at 6s.	£2	9s.	6d.	
Sep 29	Seagrave Scratch brushing and burnishing	£0	14s.	6d.	
	Delivered to Mr John Brookes	£88	1s.	0d.	
	Bill dated 30 Aug 1815				

This bill can be interpreted: First, the paper pattern was translated into a multi-section wooden model, which was carved with the required decorative details and used as a casting pattern for the final silver object. Once the the pattern was cast and cleaned the separate pieces were assembled by the gold-smiths Cradock and Reed, presumably at their workshops in Leather Lane, Holborn. The cup was then returned to the Vulliamy's for finishing, which included filing and polishing. It took ten months from the confirmation of the design to delivery. After completion the workshop might keep a set of 'record drawings' that could be shown to other customers. A base-metal copy was usually made and kept in stock. These 'patterns' became the property of the

manufacturing goldsmith and are frequently included in the inventories of workshops and were sold on as part of a business.

Although Parker and Wakelin's accounts give little indication of this process of translation from two- to three-dimensions it is clear from the occasional reference that they must have followed a similar procedure. It will be remembered that John Romer paid Parker and Wakelin £400 for the 'patterns fixtures and the lease of the house' that he took over from Wakelin in 1760. The provision of these patterns is only alluded to in their account books, and not explained in detail. It was usual for these costs to be carried by Parker and Wakelin and this is made clear in the subcontractors' accounts. For example, in the workman Thomas Nash's account for February 1768 appears 'a Pierc'd Sugar Pott and Glass £2 14s', with an extra 14s. added for 'Making the Pattern'.[33] Similarly, Emick Romer charged Parker and Wakelin 12s. in June 1769 for 'Making the Pattern of the Frame . . . wth 5 Engrav'd crewitts'.[34]

The widespread circulation of patterns in the trade suggests that they were not the property of the client. It was more usual for particular patterns to circulate.[35] For example, Ansill and Gilbert supplied a 'set of vases (like Townshends)' for Lord Waldegrave in March 1768.[36] On one of the few occasions when there is an indication that a client *was* charged for a pattern, it is in the context of a dispute. The sixth Earl of Coventry's account with Wickes and Netherton of 1758 records: 'To cash p^d the modeller and cabinet for making ye patterns of epargne £23 12s.', but on the right hand, creditor side is written 'bill abated by compulsion'.[37] Coventry seems to have refused to pay for the pattern, presumably as the finished piece did not live up to his expectation and the firm was attempting to recoup some of the rather heavy expenses of production. This order may relate to the failed working out of a design for a 'large épergne' made for Lord Coventry by Robert Adam, who was working at Croome Court at the time.[38]

Despite the rigour of these design conversations customers were not always happy. It is clear from Boulton's letter to Sir Harbord Harbord, of 1776, that the silver cheese toaster he had commissioned was not what he had expected. Boulton writes, not without a touch of sarcasm:

> We wish we had been so fortunate as to have received the benifit [sic] of your observations when the drawing of the Cheese toaster was shewn to you, as thereby we should have avoided a very considerable loss . . . the top ornament, it may be changed, Castors may be added, the Place for the Water may be altered . . . If it w^d be acceptable to you when the whole am^t of our profit, we should be glad to make 'em or if you had rather never speak of it or think of it more, we will put it into the melting pot and annihilate the Idea of it.[39]

The problem with Harbord's order was not an isolated incident. In the same year Sir Robert Rich returned a gilt épergne to Soho even though James Wyatt's design had been faithfully executed. Sir Robert wanted the oval frame lengthened by four inches, this necessitated making a new one. He also wanted lighter festoons and the central bowl raised by two inches; he disputed the extra charge for making that these alterations required. Wyatt was brought in to arbitrate and found in favour of Rich. Although Boulton was able to recoup part of the high cost of making the models, by using them for other pieces of silver, he lost money making Rich's épergne. These incidents must have contributed to Boulton's decision to run down his silver manufacturing at Soho leading to its eventual closure.[40]

While the process of transforming designs into objects appears to have been common amongst London goldsmiths, there are distinctive styles in which it was made in the second half of the eighteenth century. Parker and Wakelin's silver follows three major 'patterns': that which reproduces existing silverware, both recent and not so recent; that which is distinctively French in origin; and a few pieces that can be associated with senior figures in design, most notably the architect William Chambers.

SOMETHING OLD AND MADE TO MATCH

Emphasis on drawn designs, models and the often lengthly process of negotiation by correspondence tends to give a false impression of much of the work expected from a goldsmith's shop, which relied on the copying of existing work. When the second Earl of Buckinghamshire (1729–93) was appointed ambassador and minister plenipotentiary to the Russian Court in 1762, he chose to expand his existing dinner service by commissioning plates and dishes from Thomas Heming, copying those supplied to him in 1748 and 1755 by William Cripps.[41] Joseph Brasbridge recalled how a Mr Pemberton came into his shop 'with a pair of very handsome candlesticks which had been presented to him', that he wanted Brasbridge 'to match exactly with another pair'.[42]

Parker and Wakelin's accounts reveal that many orders concerned the duplication of existing silver within the customer's possession. In 1767 Lord Howe commissioned two tureens and covers 'the other to my Lady'. John Palmer placed an extensive order for tableware in 1769, which included a pair of sauce boats and a scalloped waiter 'to match'. Lord Holland, in the same year, bought a dozen gadroon plates 'to match', and William Lewis a pair of pillar candlesticks 'to match his large ones'. When Sir Edward Hulse purchased 'a pair of figure Candlesticks (figures old)' in 1770, it is not clear whether existing figure columns were utilised or an old pattern copied.[43] Joseph Gulston bought a pair of pillar candlesticks 'like mine'. Usually the process of copying relied on borrowing the original. Sir Andrew Mitchell ordered another 'Terreen of the same shape, Size and Design as the one sent you' as part of his ambassadorial silver.[44] In 1801 Wakelin and Garrard had to apologize to Sir Roger Newdigate (1719–1806) for losing the candlestick he had sent to be reproduced. They assured him that the new one, which we will make upon your sending us the fellow candlestick, shall be of exactly the same standard and we will do everything in our power to indemnify you'.[45]

Evidence for this type of reproduction is represented in surviving silverware. In 1768 the first Earl Harcourt had Parker and Wakelin match a tureen that was already 28-years-old (fig. 128).[46] With its foliate scroll feet the 1740 silver was distinctly rocaille, yet the addition to the service he commissioned from Parker and Wakelin in 1769 was French neo-classical. They would have sat side by side on the dining table. Sir Gilbert Heathcote updated his dinner service in 1770 by adding a fashionable French-style stands to his 1743 tureens (fig. 129). The service was extended again, by Robert Garrard in 1809, with the addition of two more tureens made in exactly the same style as his 1743 ones. The Heathcotes, like the Harcourts, appear to have been unconcerned that the design of the service was now out of date, revealing a distinctive form of taste that makers and retailers were quite aware of: it was not antiquarian but simply 'old fashioned'.

There was clearly a demand for new silverware made after the style of old, as examples from Parker and Wakelin's ledgers show. The first Marquess of

Fig. 128. Tureen and cover, by John
Edwards, 1740, silver (London).
Liner by Wakelin and Tayler, 1777,
silver (London). Copy from Parker
and Wakelin, 1768, silver (London).
New liner Wakelin and Tayler,
1777. Length of stands 39.7 cm

Fig. 129. One of a pair of soup
tureens, by John Luff, 1743. Stands
by Parker and Wakelin, 1770, for
Sir Gilbert Heathcote 3rd Bt. Silver
(London); length of stands 59 cm,
length of tureens 39.5 cm, weight
for pair 517 troy oz. Grimsthorpe,
Lincolnshire

Fig. 130. Oval basin, by Dirich
Utermarke (with Dutch control
mark for foreign work from 1909);
1630. Silver-gilt (Hamburg); length
65.5 cm, width 54 cm. Nagel
Auctions, Stuttgart

Fig. 131. A copy of Dirich
Utermarke's Oval basin (fig. 130)
by Parker and Wakelin; 1772.
Silver-gilt (London). Victoria &
Albert Museum, London

Bute (1744–1814), bought candlesticks supplied by Daniel Smith and Robert
Sharp, in 1795, that followed a form previously employed by Charles Kandler
in the 1720s and 1730s.[47] The firm also supplied lobed circular salts in the
1770s , that been fashionable in the 1680s and 1690s.[48]

An even 'older' source for reproduction was provided by the third Duke of
Chandos in 1772. He commissioned a copy of an elaborately embossed oval
platter of c. 1630 already in his possession, marked by the Hamburg gold-
smith Dirich Utermarke (1565–1649) (figs 130, 131). The design for the origi-
nal is based on four sixteenth-century engravings by Adriaen Collaert, after
drawings by Martin de Vos. Four creatures are embossed: a lion and a panther
with wings, a bear and a monster, symbolizing the four past worldly kingdoms
as seen in the vision of the prophet Daniel (Daniel VII, 4–7), to be followed by
the fifth, the kingdom of Heaven.

1772

June 19	To a Large History Embossed Dish at 6s.		
	pr oz, 102 oz, £1 11s. 9d.	£59	19s.
	To Gilding Do at 5s. pr oz	£25	10s. 3d.
	To Mending, and Adding Pieces to an old		
	Emboss'd Dish	£2	10s.
	To Gilding Do 5s. per oz	£27	16s. 9d.
	To Graving 2 Crests Supporters and Coats on		
	the 2 Emboss'd Dishes 30s. a Case and 2 Bags	£3	4s.

The order appears in Parker and Wakelin's accounts, and reveals that the
original was repaired and emblazoned with the third Duke's coat of arms at
the same time:[49] Chandos settled part of his bill with £197 2s. 6d. from a
'Gold Cup and Cover, a salver and 2 spoons'. Ansill and Gilbert charged £20
for the 'Emboss'd Dish to Match', with no mention of any specialist chasers
being employed, although the very high fashioning charge of 11s. 6d. per
ounce indicates the unusual amount of work that would have been required
for the embossing and surface chasing.[50] Having suceeded his father the year
before the order, this commission may have been made to indicate a clear
dynastic statement of confidence. The dishes may have stood on the buffet, the
main focal point of the dining room, where its message could be consumed. It
is worth remembering here Sophie von la Roche's comments on 'old plate'
when she visited the shop of the London goldsmith Thomas Jefferys in 1786.
He took care, she notes, to display old as well as new silver, so providing the
'added pleasure of comparing the work of previous generations with up-to-
date modern creations, whereby the client's taste and artist's workmanship at
different periods may be construed and criticized'.[51]

For some it was simply cheaper and more desirable to buy 'old plate' at
auction. The first Earl of Bristol's accounts are full of visits to London sales.
At Brigadier Munden's sale, in 1726, he bought a set of agate-handled knives,
forks and spoons for £10 10s, and a copy of a Rubens's *Bachanal* for £5.[52] In
1762, when James Christie set up on his own, there were about sixty auction-
eers operating in London, selling anything from paintings to hay.[53] Horace
Walpole, like Lady Mary Coke, frequented the sale rooms of Christie's and
others as part of polite entertainment, as well as to pick up bargains. The often
fabulous language of the auctioneers seems to have been common knowledge
and entertainment. Sheridan, in the character of Puff, refers to their 'panegyri-
cal superlatives, each epithet rising above the other, like the bidders in their
own auctions'.[54]

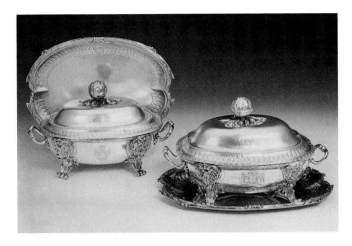

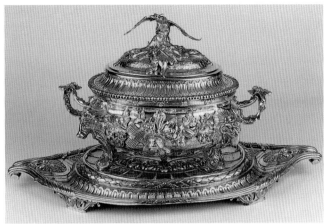

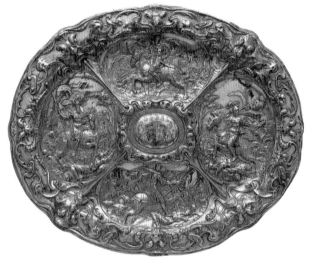

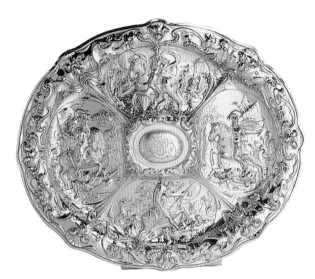

Lord Rosebery went to Christie's where he paid for just over the weight only for his silver, saving himself the expense of the workmanship.[55] In February 1773 Rosebery drew a bill on Drummonds 'To Pay Chrystie for Plate bought at Princess of Wales's sale being 1,530 troy oz at 5s. 7½d. per ounce amounting to £431 17s.'.[56] The annotated sale catalogue reveals that he bought lots 16 to 22 from the third day's sale, comprising two fish plates, ten gadroon and four octagon dishes, and three oval tureens and covers; and lots 39 to 41, comprising four scallop shells, a small saucepan and a soup ladle, a skillet, twelve skewers, a cheese toaster, an apple roaster and a service of eighteen oval dishes in five sizes.[57] The bidding must have been keen as the names of several London goldsmiths such as Bateman, Gilpin, Heming and Whipham appear in the margins of the same catalogue as successful bidders. In March Rosebery supplemented these purchases with three dozen new silver plates costing £100 from Parker and Wakelin. These were presumably made to match the plates he had bought from them in 1766.[58]

While Rosebery was busy bidding for dinner plate, Lady Delaval was concentrating on picking up some bargain jewellery from the same sale, including a heart sapphire ring set with seven brilliants for £5 7s. 6d; her husband acquired twelve enamel boxes for £2 5s. The price of Lady Deleval's ring can be compared with that of one made new for Joseph Gulston who had paid £22 for a 'brilliant ring set round with sapphires' from Parker and Wakelin.

While the attraction of buying 'old plate' at auction was obviously financial, there were also those who were deliberately seeking 'historical' examples. In 1769 Walpole wrote to Francis Montague: 'If you can get any old-fashioned plate I should like that the best, as far as fifty pounds.'[59] He was also eager to pick up 'some pictures of Caneletti . . . for the end of my great chamber; and more especially I am anxious for some Paris Plate or ancient cup and salver' from the Earl of Waldegrave's sale.[60] Although interest in the workmanship over the intrinsic value of old silver by antiquarians was still rare in the mid-eighteenth century, old silver was becoming part of a distinctive type of fashionable interior.

SOMETHING BORROWED AND IN THE FRENCH TASTE

Even a cursory look at surviving silver from the eighteenth century reveals a demand for French silver. Customers either acquired it in France, usually in Paris, or had copies made in England, usually in London. Despite a problematic political and economic relationship with France it became clear from the mid-seventeenth century that it was the leader in fashion, taste and style, and its leadership lasted into the nineteenth century.[61] Francophiles posted to Paris used their appointments as an opportunity to extend French-style plate already in their possession. As we have already seen, Harcourt's service was made to match work he already owned by Robert-Joseph Auguste, including a set of fine tureens.[62] The third Duke of Richmond (1735–1806), while Ambassador Extraordinary to the Court of Louis XV at Versailles in 1765, ordered a table service of Sèvres china direct from the manufactory, and purchased furniture for Goodwood, including chairs by Delanois, and commodes by Courturier, Latz and Dubois.[63] Lawrence Dundas smuggled rock crystal and ormolu lustres from Paris in the diplomatic train of the Prussian ambassador in 1767, and shipped tapestries home to England from the Gobelins factory in 1769.

John Byng, Viscount Torrington, abhorred this French fancy. The journals of his tours around England reveal how widespread this taste was. At Thoresby Park, home of the Duke of Kingston, he noted balefully that: 'The house seems like the one in St James's Square, fitted up with French furniture; all for shew, as if the Damned Mrs Cornelis had clubbed tastes, All which gaudy furniture and useless china will find its deserved price within these few days'.[64] George Wickes had supplied the family with a magnificent high-rococo dinner service fifty years earlier, one of the most 'French' designs supplied by an English goldsmith. The reference to Mrs Cornelys, a well-known courtesan, was not intended to be polite. At Chatsworth, home of the Devonshires, Torrington was taken round by the housekeeper and shown 'all the foolish glare, uncomfortable rooms, and frippery French furniture of this vile house'.[65] Twenty years later the fashion for things French had not abated. Richard Rush, the American envoy to Britain between 1818–1825, noted that in 'the house of an English minister of state, French literature, the French language, French topics were all about me; I add, French entrées, French wines'.[66]

There were many French silver designs available in England as prints, such as those based on Huquier's *Oeuvre de Juste Aurèle Meissonnier*, published in Paris in 1728 and circulating in London from the 1740s. Pierre Germain's *Elements d'Orfèvrerie*, published in 1748, was another popular source. The popularity of these designs encouraged English publications like a *Book of Eighteen Leaves* by Parker and Wakelin's engraver Robert Clee (1757), which copied designs from French sources. They were not intended to be slavishly duplicated but to act as inspiration. A pair of wine coolers of 1763

show how they were interpreted in silver (figs 132, 133).[67] They are clearly based on Germain's design, with their naturalistic cast vine handles, serpentine bodies and fluted rim; yet the waved base has been replaced with more formal gadrooning, the ribbon-tied ornament has been more freely adapted and floral swags have been added to the body. Many examples of such

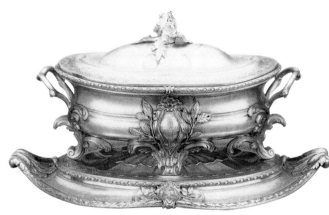

Fig. 132. Page from R. Clee's *Eighteen leaves*, 1757, drawn from Pierre Germain's *Elements d'Órfevrerie*, Paris; 1748. Yale Center for British Art, New Haven

Fig. 133. One of a pair of wine coolers, from a set of four, applied with the Royal Arms, by Parker and Wakelin; 1763. Silver (London); height 26.7 cm, scratch weight 115 troy oz 12 dwt

Fig. 134. One of a pair of oval soup tureens, Parker & Wakelin; 1762. Silver (London); stand 1773, marked with French control marks, length 56.5 cm, 245 troy oz 10 dwt

Fig. 135. Page from R. Clee's *Eighteen leaves*, 1757, drawn from Pierre Germain's *Elements d'Órfevnerie*, Paris; 1748. Yale Center for British Art, New Haven

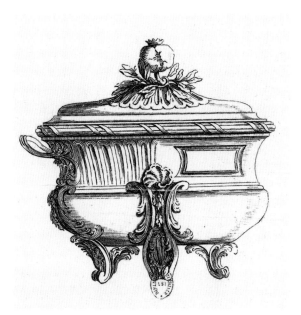

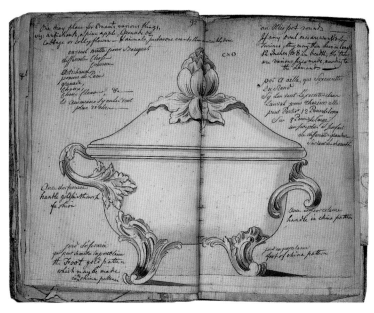

Fig. 136. Page from Pierre Germain's *Elements d'Órfevrerie divises en deux Parties de Cinquante Feuilles Chacune Composez par Pierre Germain Marchand Órfevre Joaillier a Paris*, Paris; 1748. Victoria & Albert Museum, London

Fig. 137. Page from 'Original Drawing Book 1', Leeds Pottery, showing a round 'olio pot', annotated in French and English based on a Germain design with alternative elements: 'goldsmithswork' (left) and 'china pattern' (right) *c.* 1778–91. Victoria & Albert Museum, London

loosely interpreted 'French style' silver survive, and can be traced back to Parker and Wakelin's ledgers. Perhaps the proximity of Clee and his close relationship with the firm encouraged such a noticeably Francophile taste. A soup tureen of 1762 (fig. 134),[68] combines the overall form and ovolo rim of another of Germain's designs (plate no. 8, upper) (fig. 135), along with the cast scroll feet and central armorial bearing cartouche of another Germain tureen design (plate No. 5, lower), both in Clee's book. Germain's *Elements D'Órfevererie*, published in 1748 was also the source of inspiration for ceramic tureens (fig. 136), such as those made by the Leeds Pottery, who provided a body shape, handles, feet and final in the 'goldsmiths work fashion' (fig. 137).

A distinctively French-style tureen-form identifiable with Parker and Wakelin was popular throughout the 1760s and 1770s, using the same cast components of swept scroll feet, reeded-foliate handles and serpentine fluted borders chased with shells. The delicately-cast vegetable finials draw on Meissonier's *Livre des Légumes*. There are examples of 1765 at Anglesey Abbey (fig. 138) and of 1772 in Baltimore. The turnip finial appears earlier on other Parker and Wakelin silver, including those on a set of four soup tureens commissioned *c.* 1760 by the Earl of Holdernesse (*see* chapter 7, fig. 106).

Yet French-style silverware did not just derive from prints, there was plenty of French silver already in England. Of all the French goldsmiths working in Paris in the second-half of the eighteenth century, the English seem to have favoured particularly the work of Roberte-Joseph Auguste (1723–1805), who enjoyed an international reputation, furnishing various European courts including those of England, Portugal, Sweden, Denmark and Russia. Diplomatic bags appear to have bulged as Francophiles attemped to evade customs and bring back fashionable booty. The customs system was complex; many appeared unclear as to what was contraband and what was not. Following the seizure of numerous dresses from Lady Holdernesse, in July 1764, there are an increasing number of references in letters to a new strictness.

Five years later Horace Walpole[69] wrote of his exasperation at the attitude of the customs officials when they destroyed a silver dinner service he was attempting to import into England from Paris:

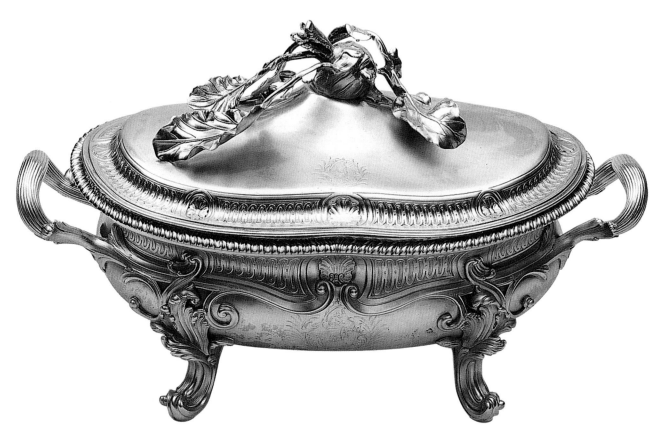

Fig. 138. Oval soup tureen, by Parker and Wakelin; 1765. Silver (London); height 38.5 cm. National Trust (Angelsey Abbey)

Fig. 139. Centrepiece, by Claude Ballin II; 1747. Silver-gilt (Paris); height 44.5 cm. Grimsthorpe, Lincolnshire

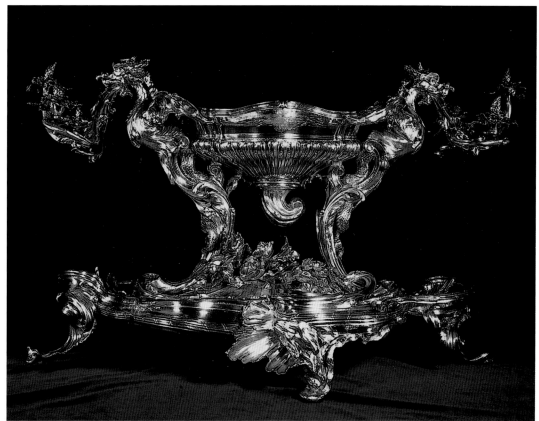

Plate, of all earthly vanities is the most impossible. It is counterband in its metallic capacity, but totally so in its personal: and the officers of the Custom House not being philosophers enough to separate the substance from the superficies, brutally hammer both to pieces and return you only the intrinsic.[70]

Walpole would have paid the duty, though high (seventy-five percent was the lowest duty charged on produce and manufactures from France)[71] for the preservation of his dinner service, but the customs officials assumed otherwise and battered it so it could be freely imported as bullion without charge.[72] It was duties such as these that Adam Smith blamed for ending 'almost all fair commerce between the two nations'. As a result of his experiences with customs, Walpole advised his friend, Lord Montagu, that if he wanted to bring any continental plate into England, be content with anything one can bring in one's pocket'. One wonders how Sir Gilbert Heathcote acquired his large French silver-gilt centre piece by the Parisian goldsmith, Claude Ballin II, of 1747.[73] The *décharge* mark for export suggest that this piece was specifically made for Sir Gilbert in Paris and imported – a real and exceptional mark of conspicuous consumption (fig. 139).

An analysis of what these Francophile English customers bought reveals not an undiscriminating love of all things French but the appropriation of distinctive types and designs of goods, which were used to create an anglicized *goût-française*.[74] The distinctiveness of this 'franglais' style in both objects and manners is evident from the reactions of a Frenchman to his English hosts. La Rochefoucauld commented that 'The English way of living is totally different from ours. It seems even, in every particular detail that a Frenchman in England has before his eyes, that he must concentrate, reciprocally, on avoiding doing everything he is used to doing'.

The purchasing pattern of the fourth Duke of Bedford helps recreate this distinctive type of taste, and how it was exploited by English goldsmiths. Bedford was one of a group of English aristocrats well known for their Francophilia, and as Ambassador to Paris in 1762 he had an ideal opportunity to indulge his taste.[75] The Duke was appointed to negotiate the peace between England and France which was to end the Seven Years War. Household bills from this period suggest that the Duke must have furnished his residence at the Hotel de Breteuil in Fontainebleau almost entirely *à la française*.[76] On completing his ambassadorial mission the Duke returned home in June 1763, but not empty handed. Apart from all the furniture from *ébenistes* Pottemain and Genty, the clocks from Verneaux and hangings by Belache, Louis XV presented the Duchess with a complete service of Sèvres porcelain, the same one that Wedgwood was invited to copy two years later.[77] Their purchase of French goods continued once back in England, including a pair of silver candlesticks marked by the Parisian goldsmith Robert-Joseph Auguste in 1766. They appear to be the earliest dated Auguste candlesticks of this design surviving within an English collection (fig. 140).[78]

The design of these candlesticks made a significant impact on the English market as they were reproduced in small quantities by London goldsmiths from 1766. The circular fluted bases with laurel leaf border, flaired fluted stems with cast leafy swags, and foliate branches with horizontal straps formed a distinctive design that was to be reproduced well into the nineteenth century. Furthermore, it is possible to attribute a specific trade name to them, that of 'fine festoon' (relating to the leafy swags) which became popular with a distinctive group of Parker and Wakelin's customers (fig. 141). It seems likely that Parker and Wakelin gained access to this design of silver via their customers.

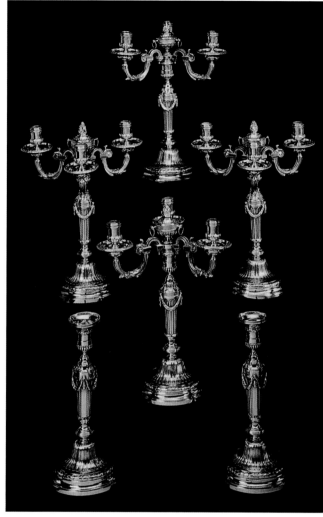

Two particular candidates spring to mind: the fourth Duke of Bedford and the first Earl Harcourt. Both were wealthy Francophile aristocrats, both became ambassadors to Paris and both had an expensive taste in French decorative art. Both, too, already possessed French silver, and specifically this particular type of Auguste candlestick. Harcourt possessed a set of four three-light candelabra and a pair of table candlesticks by Auguste, dated 1767.

Another Francophile candidate for the source of Parker and Wakelin's Auguste-style candlesticks is the fourth Duke of Marlborough, who was the first to buy a 'festoon candlestick' from Parker and Wakelin, in 1768. Dissemination was rapid, and their pattern of purchase reveals a group of customers who kept coming back for more. They included the Earl of Holdernesse, who had already bought a French-style tureen from Parker and Wakelin in the early 1760s, Sir Gilbert Heathcote, Sir William Bagot, Mrs Bourchier, Lord Boston and Lord Molineaux. In 1769 three orders were placed with Parker and Wakelin for this design of candlestick, by Mr Jenkinson, Earl Harcourt and John Martin. Ansill and Gilbert delivered Jenkinson's '2 pr fine festoon (french) candlesticks' weighing 123 troy oz 17dwt in January 1769. They charged Parker and Wakelin the high price of £12 12s. for their fashioning, revealing the amount of extra decorative work required compared with the more standard range of candlesticks they supplied. Harcourt's '4 pr fine fes-

Fig. 140. One of a pair of candelabra, by Robert-Joseph Auguste; 1767. Silver (Paris); height 36.2 cm. The Duke of Bedford and the Trustees of the Bedford estate

Fig. 141. Set of four candelabra and pair of candlesticks, by Parker and Wakelin; 1767. Silver (London); height 37 cm

toon candlesticks', weighing 247 troy oz 8dwt, were accompanied by a 'pr Treple Branches' weighing an additional 78 troy oz 9dwt, for which Ansill and Gilbert charged a total of £35 4s. for making. They would have complemented the existing set of Auguste candlesticks of 1767 already in the Earl's possession. Parker and Wakelin continued supplying 'fine festoon' candlesticks into the 1770s and a pair of 1777 of the same design survive, bearing Wakelin and Tayler's mark.[79] The design remained in the Panton Street firm's repertoire into the late nineteenth century.[80,81]

Yet in a trade characterized by specialization, the involvement of several workshops in manufacture, and ease of reproduction, it was difficult to keep a popular design in the hands of a single firm. By 1770 John Carter, one of Parker and Wakelin's subcontractors, appears to have been supplying the same design of candlestick to customers who are not in the Parker and Wakelin ledgers. Thomas Heming's mark appears on the design from at least 1771, including a pair made for Sir Watkin Williams-Wynn.[82] Andrew Fogelberg supplied a set of four 'fine festoon' candlesticks bearing the Dutton crest in 1774.[83]

SOMETHING NEW: THE INFLUENCE OF THE ARCHITECT

It is very rare to find evidence of professional designers at work in the Panton Street Ledgers. It is not until the 1780s that an identifiable designer appears, the sculptor John Flaxman. In 1783 he designed a medallion and a figure for a silver tureen, commissioned by Wedgwood, from Wakelin and Tayler[84] and in 1797 Robert Garrard supplied a client with 'a Flaxman Coffee pot', the design for which appears in a nineteenth century Garrard pattern book. Yet we know that in the 1760s and 1770s Parker and Wakelin supplied silver based on designs by the architect William Chambers, although his name does not appear in Parker and Wakelin's accounts. This is because it was the customer and not the business who was responsible for his role in the design. Not all goldsmiths operated in this way. Boulton paid James Wyatt for Sir Richard Rich's épergne design in 1772.[85] A generic sketch showing elements survives; notably the foliate and scroll branches and festoon supports, which were incorporated into final piece. Wyatt was making purchases from Parker and Wakelin in 1772, buying, amongst other things, a 'fluted antique tea vase' with matching ewer and coffee pot.[86]

Architects' designs for silver are usually associated with large-scale plans for improvement, of which the silver is a small but integral part. When the fourth Duke of Marlborough commissioned a large dinner service from Parker and Wakelin, in November 1769, it was perhaps natural that he should request William Chambers, who was already working at Blenheim, to design his tureens and chapel silver.[87] Between 1769 and 1772 Chambers was paid for the presentation of designs relating to decorative art including those for a state bed, pier glasses, griffin candlesticks and console tables. The hangings for the state bed were supplied by Ince and Mayhew, who dedicated their *Universal System* (1759–63) to the duke, 'a patron ever willing to promote Industry and Ingenuity'. Chambers' designs for silver show that he was heavily influenced by French taste, especially in the use of naturalistic ornaments in the style of Meissonier's *Livre de Légumes*, and archaic-inspired decorative details such as ringed lion masks, arabesque friezes and the Greek key pattern.[88] Chambers had attended J-F. Blondel's École des Arts in 1749, spent four years in Rome and numbered among his friends some of the great French architects and designers, including Charles de Wailly, Marie-Joseph Peyre and Laurent Le Geay. Marlborough's '4 fine terrines 2 oval and 2

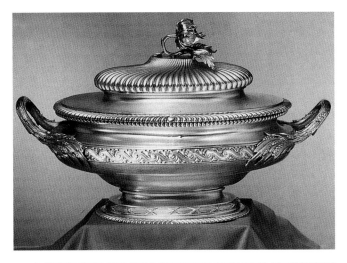

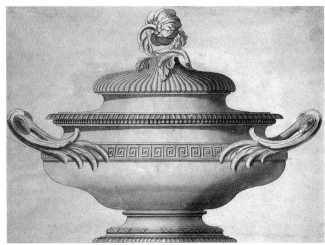

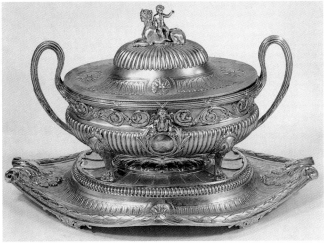

Fig. 142. One of a pair of soup tureens, by Parker and
Wakelin; 1769. Silver (London); height 27.9 cm. Leeds City
Art Galleries (Temple Newsam House)

Fig. 143. Design for a soup tureen, by John Yenn, after Sir
William Chambers; c. 1768–9. Pen and watercolour; 27.2 × 38
cm. Victoria & Albert Museum, London

Fig. 144. One of a pair of soup tureens on stand, by Parker &
Wakelin; 1772. Silver (London); width 36.2 cm, 525 troy oz
the pair

Fig. 145. One of a pair of soup tureens, engraved with the
coat-of-arms, crest and coronet for George Wyndham, 3rd
Earl of Egremont (1751–1837), Parker & Wakelin; 1774.
Silver (London); length 33.6 cm, 301 troy oz for the pair

Fig. 146. One of a pair of soup tureens and stands, engraved
with the arms of 1st Viscount Beauchamp, Earl of Hertford
(1718–94), by Thomas Pitts; 1772. Silver; height 33 cm, 499
troy oz the pair

round', after Chambers' design, weighed a handsome 580 troy oz 16dwt and cost the duke £314 19s. 7d.[89] They were made by Parker and Wakelin's sub-contractors James and Sebastian Crespel and their account reveals '2 oval 2 round Terrines with Vitruvia Scrole', costing £160 for the silver and an impressive £116 4s. for the making.[90] Both of the oval tureens survive[91] (fig. 142) and it is clear that the spreading foot with gadrooned and tied reed bands, applied with a vitruvian scroll and bellflower border, and the handles cast in the form of bunches of wheat with domed cover of radiating flutes were based on a design by Chambers, drawn by John Yenn, and now in the Victoria and Albert Museum (fig. 143).[92] The drawings for them are pen-and-wash presentation drawings, probably made for the customer to comment upon. It is likely that a modeller transformed the designs into three dimensions before manufacture in silver.

The tureens were part of a large order for dinner plate which included '16 fine festoon sauceboats', received on 15 August 1768 costing the duke £272 8s. 7d, and '26 dish covers, 10 oval, 10 round, 4 pincushion', received on 1 August 1769 costing £442 15s. 8d.[93] Four of the original sauceboats and fourteen of the dish covers, six round and eight oval with matching bands of vitruvian scrolling, are still at Blenheim. Chambers also made drawings of a chalice and flagon,[94] supplied by Parker and Wakelin.[95] It is almost impossible to deduce how far Chambers became involved in the design process once the drawings had been agreed upon and passed on to Parker and Wakelin. Flaxman's lack of interest in the functional components of his designs, which are rarely detailed, suggests a distance from actual production. Chambers' drawings show a greater awareness of the technicalities of manufacture. Wedgwood worried that Chambers might notice how he had altered the design of his griffin candlesticks to make them in ceramic, which suggests that Chambers still had a proprietorial interest in them.[96]

Fig. 147. Design for the west end of the dining room, Kedleston Hall, Derbyshire, by Robert Adam; showing the complete arrangement of the sideboard and buffet; 1762. Pen and ink with watercolour and pencil. Kedleston Hall, The Scarsdale Collection

Fig. 148. Nathaniel Curzon's dinner service, designed by Robert Adam, made by William Cripps and retailed by Phillips Garden; 1758. Silver (London)

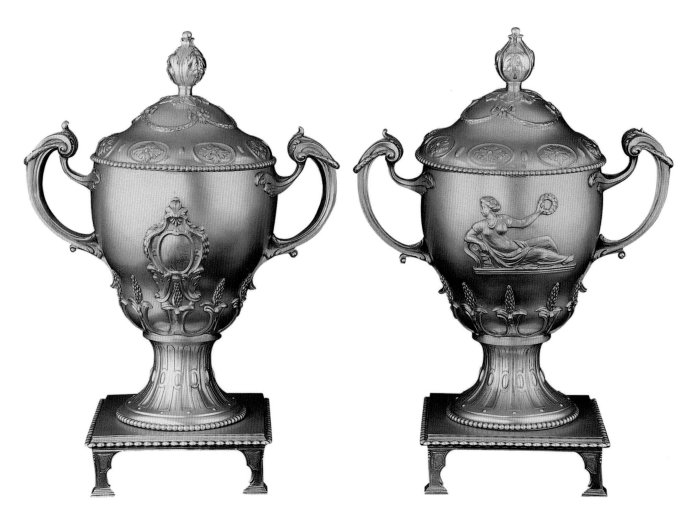

Fig. 149. Pair of vases, by Parker and Wakelin, based on designs by William Kent; 1767. Silver-gilt (London), height 40.6 cm, 224 troy oz. The presentation inscriptions read 'This stand, cup and cover were given by Dame Mary Curzon to Dorothy, wife of A. Curzon upon her marriage Feb 6th 1766' and 'This stand, cup and cover were given by will, to A. Curzon Esquire by Mrs Elizabeth Milnes, 40 years served to Lady Curzon'. Rare Art (London) Ltd.

Once Chambers' design for the tureens had passed round Parker and Wakelin's subcontractors, the pattern was used to update the firm's stock designs, and it began to filter through the London trade. The distinctive gadrooned cover appears on tureens bearing Parker and Wakelin's mark in 1772 (fig. 144)[97] and 1774 (fig. 145).[98] These two designs show how the same body shape and upswept finials could be customized and made to look quite different through the use of four cast feet or a single pedestal foot and the application of different finials and applied body ornament. The tureen made in 1772 was further 'frenchified' with the addition of a 'Germain style' stand. The gadrooned body and festoons reappear on tureens made for the Earl of Scarborough and was copied by Thomas Pitts for the Earl of Hertford in 1772 (fig. 146).[99]

While Chambers' distinctive taste for French-derived neo-classicism is evident in silver supplied by Parker and Wakelin, there is little evidence of Adam-style silver in the firm's repertoire. None of Adam's great patrons, including the Childs at Osterley, the Temples of Stowe or the Winns at Nostell Priory appear in Parker and Wakelin's accounts. Yet it is perhaps misleading to suggest that customers stuck rigidly to their architect's taste. Although the Weddells of Newby Hall in North Yorkshire were employing Adam to classicize their home, building the first purpose-built sculpture gallery to house their Grand Tour spoils, they were buying flagrantly rococo silver for their table, as the tureens bought from John Romer in 1769 testify. Sir Nathaniel Curzon

employed Adam at Kedleston and bought 'antique' plate (that is, neo-classical style), from Phillips Garden (fig. 147) made to Adam's design (fig. 148).[100]

While Lord Coventry was employing Adam at Croome he chose to buy only his more mundane plate from Parker and Wakelin, and patronized Thomas Heming for his antique-style silver. The wording of Heming's bills was always more florid than those of Parker and Wakelin: objects were described as 'Elegant' and 'Superbe', and were 'highly finished', 'in the richest manner'.[101] Whereas Heming's bills to his clients are full of silver described as in the 'antique taste', the word 'antique' appears in Parker and Wakelin's accounts only from 1769, and then only twice, for a 'fine antique cream ewer with chased oak leaf border' for George Onslow, and for a 'fine antique tea vase with drapery' for Thomas Grosvenor. The following year only three further orders were placed for 'antique' silver, including 'a fine antique coffee pot' and matching teapot for Charles Pelham, a 'fine antique tea vase wth water leaves', and another with 'festoons' for the second Earl of Bessborough (1704–93). It is likely that they were in Chambers' French taste, as Bessborough had begun employing him to design and build his villa at Roehampton in 1762.[102] Bessborough employed Thomas Jenkins to find and purchase antique statuary in Rome, and patronized Wedgwood, who proudly commented that Bessborough claimed he would 'exceed the Ancients' in the production of his vases. As patron of the antique he was lauded for 'his ancient style', while at Roehampton the visitor seemed 'to breathe and tread on Classic Grounds'.[103]

While some customers followed the advice of their architects, others had their own preferences that could be quite at odds with current fashions. In 1767 Nathanial Curzon's brother, Asheton, commissioned from Parker and Wakelin a pair of silver-gilt cups and covers that drew from an earlier form of 'classicism', that of William Kent (fig. 149).[104] The wheat-ear ornament at the base of body and the festoon emanating from the scroll handle derive from an alternative design for Colonel Pelham's gold cup, published in *Some Designs of Mr Inigo Jones and Mr Wm. Kent*, by John Vardy in 1744, and made up by George Wickes in 1745. Probably designed sometime prior to 1736, this 'old-fashioned' neo-Palladianism was combined with a rococo serpentine body and more neo-classical paterae and festoons to create a distinct and odd hybrid.

The design conversations that took place between retailers, their customers and makers could be complex. The balance of power between them shifted and changed from commission to commission, as well as during the evolution of an order. The working goldsmith William Theed declared that he suffered much inconvenience from the intrusion of his employers' 'opinions in matters of taste and design' when making up silver, and reckoned that 'he could always go one better if He had access to the Nobleman or Gentleman who gave them Commissions and were easily lead to adopt His opinions'.[105] Yet the retailing goldsmiths, like Rundell and Bridge and Parker and Wakelin before them, were akin to the Parisian *marchands-merciers*, who although they 'no longer actually made things but had them made for them . . . were the go-betweens, . . . who stirred up interests, hastening evolution of styles . . . Their actual work was carried on between purchase and manufacture, between supply and sale'.[106] They acted as connectors, and were therefore also disseminators of taste.

Conspicuous Consumption: Diplomacy, Dining and the Domestic Interior

> In setting out your sideboard – you cannot think that ladies and gen-
> tlemen have splendid and costly things without wishing them to be
> seen or set out to best advantage.
>
> Thomas Cosnett, *Footman's Directory*, 1815

Consumption has everything to do with context, the environment into which goods are introduced, manipulated, give and are given meaning. The intention of this chapter is to reconstruct the public and private contexts in which silver was used, displayed and seen. Silverwares were more than just commodities with only functional or exchange value.[1] Far from being marginal accessories, they were integral to the shaping of personal, local and even national identities. A deeper appreciation of how they were manipulated and read, consciously and unconsciously, helps us understand the dynamics of social interaction and ideas about taste, status and constructions of value. For example, when Sylas Neville was invited to a dinner at Holkham Hall in Norfolk, on one of the Coke family's 'public days', it was neither the number of guests (twenty-eight), nor the amount of food (two courses of twenty-eight dishes), that caught his greatest attention but 'the magnificent service of plate', which he noted with admiration engaged 'the attention of every visitor'.[2] Yet Neville was not so uncritical, or so lacking in fashion consciousness to note that 'Some of the pieces are of little use and do not look well upon the table'. Neville accepted the table as an arena of power, but saw that it was constantly subject to the forces of fashion, it balanced between tradition and novelty.

The task of recovering the meaning of these objects is complicated. The place and value they are given is not static but changes over time, according to their audience and their relationship with other goods. Silverwares are part of a complex and changeable network of interrelations between people and things.[3] Interpretation depends upon one's viewpoint. On the rare occasions when consumers in the past did record their choices and intentions it is often difficult to establish their own position and motives; they were usually related to exceptional events and circumstances thought worthy of note.

Reconstructing everyday and private use is bedevilled by familiarity, which inspired little comment, and the low value put upon household accounts, our main source of information, which were often dispatched as so much rubbish when the bills had been paid. When Lord Warrington's agent was trying to sort out the affairs of the late Lord Malpas, in the 1790s, he could find no 'regular and complete statement of these accounts', and discovered that 'the servants at Christleton were burning [them] . . . as they wanted them in the kitchen'.[4] Fortunately the purchase and use of silverware was right at the heart of a

growing culture of politeness and refinement, and these, as John Brewer has noted, 'had little value unless they were shared; they had to be put on display to be shown to others'[5] and as a result generated a rich written record. As Adam Smith observed, 'the chief enjoyment of riches consists in the parade of riches', and silverwares formed one of the most conspicuous and universally understood physical manifestations of these riches.[6] It was this sentiment that Matthew Boulton appealed to in his attempt to persuade Colonel Burgoyne to pay more for his set of silver girandoles than he had originally been quoted for. Boulton explained 'there has been no pains spared to render them handsome which indeed they ought to be as they are fully exposed to the view of everyone who enters the room you design 'em for'.[7] It is in the reactions to, and recording of, these displays that a wealth of evidence can be found. To understand these references it is necessary to reconstruct the meanings given to silver and the methods employed for its display. This requires a different type of evidence from the account books used so far: letters, diaries and newspaper reports. Here the qualitative must take precedence over the quantative.

This chapter is directed towards a specific type of silver, that used for dining. Dining silver accounted for around seventy-five percent of an average customer's expenditure on silver, and therefore assumed a large role in household affairs. It also accounted for two-thirds to three-quarters of a whole year's business for Parker and Wakelin. The Marquess of Cornwallis' plate was inventoried by Wakelin and Garrard on his death in 1805.[8] Out of a total of £1,919 7s. 6d. worth of silver, calculated by its weight value only, £1,593 comprised dining wares, including eight dozen table plates (£488 10s. 6d.), 23 oval gadroon dishes (£277 15s.) and two dozen soup plates (£133 2s.).[9] This can be compared with the cost of one of the newly built and most fashionable houses in Westminster, in Grosvenor Square, which in 1755 were estimated 'at the Value of three, four and five thousand Pounds a House'.[10]

The preoccupation of retailers and their customers with tableware almost could be said to have become part of the national character. The Parisian *marchand-mercier* Daguerre noted that tableware was all that the English were interested in, and lamented that he had not brought more samples of dinner plates with him when he set up his showroom in London, in 1788.[11] Dining silver was the focus for the most public and the most often used form of display, representing wealth in its weight, and taste in its form. The purchase of dining silver emerges as a creative act, and the sites for its use are 'active contexts rather than passive backdrops for consumption'.[12] Britain's wealth and taste were indicated via the weight and decorative effect of its silver: in the shop windows, in the homes of the wealthy and on the tables of the ambassadors sent abroad to represent the nation's interest.

REPRESENTING THE NATION

If social politics can be defined as 'the management of people and social situations for political ends', then the dinner party provided a prime opportunity for just such exercise of power.[13] 'Meals of all sorts, but especially dinners provided ideal for political gossip, discussion and debate'.[14] An invitation to dine with Lady Rockingham, whose husband led the Whigs from 1762, and who opposed war with the American colonists, was known to be as political as it was social. It is not surprising that the dinner services provided for them were important indicators of status, power and wealth. It was for this reason that key officers of state had been allocated prerequisite plate since the seventeenth century.

There was an official sliding scale of 'worth' laid out by the Jewel Office, recognisable by the weight of plate given. The four heads of Household departments were allowed 1,000 troy oz each, the Speaker of the House of Commons was entitled to 4,000 troy oz, but ambassadors were at the top of this hierarchy and were allowed 5,893 troy oz of white plate and 1,066 troy oz of gilt plate. From the 1680s they, like other public servants, were sometimes discharged from their duty to return the plate, and as a result public plate became private plate after the satisfactory completion of service. While the amount and value by weight was officially set, the fashion of it depended on the tastes and purse of the office holder.[15] From the 1720s the escalating cost of fashioning claimed by ambassadors caused disputes with the Jewel Office, culminating in Lord Chesterfield's bill for over £3,800 for the plate he took with him to the Hague in 1727. We can see from the few pieces that survive, like the pair of wine coolers subcontracted to Paul Crespin, that the workmanship was costly, involving elaborate casting and intricate chasing, and was charged (with the silver) at 13s. per troy oz. That year the Master of the Jewel House set a limit of 8s. 6d. per troy oz (with silver) for fashioning.

According to custom it was the prerogative of the Royal Goldsmith to handle the orders for ambassadorial plate which, by their weight, represented handsome business. However, during the 1760s his role was being challenged as ambassadors went increasingly to the goldsmith of their preference rather than the one appointed by the king. Tradition faced competition as fashion challenged custom. In 1768, on his appointment as ambassador to Paris, Lord Harcourt went to Parker and Wakelin rather than Heming, the Royal Goldsmith, to buy his prerequisite silver. An impression of its weight and style can be seen in a photograph of the dining room at Stanton Harcourt, in Oxfordshire, where the family had moved in the mid-eighteenth century (fig. 150). Part of the silver service is displayed on the buffet to the left (and has since been sold).

The order included 174 plates; seven dozen table knives, forks and spoons; thirty dishes (eight oval, eighteen round and four comport); two large oval and two round tureens; two fine ice-pails; and six monteiths as well as a dessert service. The 'baggat' plates have reeded edges tied with ribbon, and shell-motif terminals at the hexagonal cusps, they are not just stock plates with simple gadroon borders (*see* chapter 4, figs 42–46). The services were packed into seventy-seven baize bags and sent to the Jewel Office in four plate chests, matted and corded in four wainscot chests which were padlocked.

Harcourt's patronage of Parker and Wakelin did not go unnoticed by Thomas Heming, the Royal goldsmith. In a lengthly letter to the ambassador he complained that 'it was never understood that . . . it shou'd be in the breast of that Nobleman or Gentleman' to employ his own supplier without the acquiescance of the King's Goldsmith'. By employing Parker and Wakelin, and not himself, Heming argued that he had become 'merely a convenient Cypher, of no other use but to Raise money for the advantage of other shops'.[16] Heming, warming to his subject continued 'indeed it must be very unpleasing to be appointed to an Office, and to see another publishing to the world that they do the Business and Reap the Profits of it – when everyone knows it was my Province to make it, and I have since Learnt that the King was much surpriz'd I was not employ'd'. Heming pointed out that, as the provider of the bullion costing £2,400 he had paid £200 in fees, plus £140 interest on borrowing 'for 12 months, which upon average is about the time that I lay out of my money', and an insurance which he could 'not get done under £140'. 'I should be glad' he asks 'to know what benefit all this negociation was to me.'

Not only was the level of competition over such a lucrative order evident, but also the importance of it as a form of advertising. As we know that Parker and Wakelin had also supplied Sir Andrew Mitchell's ambassadorial service (fig. 151 and 152), which he took to Berlin in 1766, it is clear that Heming's letter to Harcourt was probably the tip of a much larger iceberg of frustration.[17]

An ambassadorial dinner service was as important to those who were invited to use the service as to those who supplied it. The astonishment of the American envoy, Richard Rush, at the amount of plate on English tables must also have applied to earlier periods. Dining at Lord Castlereagh's in 1818 he described how 'a profusion of light fell upon the cloth, and as everything else was of silver, the dishes covered, and wines hidden in ranges of silver coolers, the whole had an aspect of pure white'.[18] The amount, range and style of plate sent messages of wealth, confidence and taste that were all part of the diplomatic language.

ASSEMBLING THE DINNER SERVICE

While the acquisition of ambassadorial plate provided the office holder with the opportunity to obtain an entire dinner service at one go, the usual pattern if consumption was to assemble one over a long period of time. Between 1766 and 1770 only twenty two of Parker and Wakelin's clients bought a large, if not complete, service of plate, the most expensive being Lord Harcourt's diplomatic service, costing £3,632, and the most modest Gilbert Heathcote's

Fig. 150. The dining room at Stanton Harcourt, Oxfordshire, with dining silver, part of Lord Harcourt's ambassadorial service to the left on the buffet

Fig. 151. *Sir Andrew Mitchell* (1708–71), after Allan Ramsay (1731–84); 1766. Oil on canvas, 77.5 × 63.5 cm. National Portrait Gallery, London

Fig. 152. Gentlemen's Ledger opened at Sir Andrew Mitchell's account with Parker and Wakelin; 1766. Victoria & Albert Museum, London

at £323. It was more usual to 'creep into' a dinner service, like Horatio Mann, who explained to Walpole that he had £600 to £700 worth of plate 'including knives, forks, spoons, salvers, salts, ladles; in short all the small things . . . so that I have plates and dishes to buy, but I may go one so that by degrees I may creep into a service before I am aware of it . . . every inch of lace I might put on coats I will tun into plates and sauceboats'.[19] By 1766 he was adding an épergne with four saucers and branches from Parker and Wakelin, the finishing touch to a service that had begun its formation twenty years earlier.

The assemblage and maintenance of a dinner service, with all its constituent parts, appears to have exercised the ingenuity of ladies and gentlemen from the highest nobility to the most modest members of the lower gentry, if their comments in diaries and letters reflect their concerns. When Thomas Parker, third Lord Grantham, dined at Lord Macclesfield's in 1779, he wrote with satisfaction in a letter to a friend, 'Good dinner, profusion of old plate'.[20] Quality was determined by cost, and perhaps more importantly by the range of utensils and vessels included in the service. The eighteenth century saw a growth in specialist dining equipment, whose correct use was dictated by fashion and etiquette, as detailed in the many advice books, such as Trusler's *Honours of the Table* (1788). Those who were less well off tried very hard to maintain the minimum required format for the table. The diary of the antiquarian, the Reverend William Cole (1714–82), gives some idea of how those with smaller incomes acquired, accumulated and maintained their stock of dining silver. Cole observed that 'Some of my Father's old solid Silver Knives and Forks I lost at College, and the others almost worn out: as they have been in daily use with me these thirty years, and as long perhaps with my Father: and my old Desert Knives quite worn to the stumps'. His battered stock of flatware risked jeopardising his social standing when visitors came to dinner, so he asked a neighbour to buy him, on his next trip to London,

> a Case of bright-green Ivory-handled Knives and Forks, and a Case of the same Sort of Desert Knives and Forks: or else good solid substantial Silver-handle ones . . . I have been at a Loss for sufficient when I have larger Company than ordinary: having only one compleat Dozen of green Ivory–mounted in Silver; which I bought at Cambridge about 8 years ago, and cost me £3 16s.[21]

Fashions in dining were continually changing. Service *à la française*, where all the dishes for each course were laid on the table at the same time, remained popular until the 1850s, although the second-half of the eighteenth century saw a movement towards increasing informality at table. In 1756 Martha Bradley noted how the strict formality of waiting to be served by the hand of the 'Mistress ensured that half the guests did not dine well', while 'Now everyone helps himself as he likes, and where he likes', which was done by 'sending his Plate to the Person that sits near what he likes'.[22] Although the English imitated the French in their table layouts, and were keen to pick up the latest tips, it did not prevent them from criticising their standards of hygiene, a common trope and a means of putting the French in their place.

While in Paris in 1765, William Cole observed one thing

> worthy of Imitation, [which was] the Practice of setting a large Silver Tumbler or Goblet of about half a Pint by the Master and Mistress's Plate, and others of Glass or Plate for the Rest of the Company; which cleanly method entirely avoids the disagreeable Circumstance of drinking after other People: but however well contrived this

Practice might be, that of having coarse ordinary table linen, and hardly clean, with dirty spoons and Knives was not so laudable.[23]

Part of the skill of maintaining an up-to-date table was to make sure you had the newest items, and were *au fait* with new fashions of presentation and service. The nineteenth-century gastronome, Brillat-Savarin, looking back to the previous century, noted that accompanying the increase in more intimate home entertaining was the appearance of endless new pieces of equipment: 'A wide variety of vessels, utensils and other accessories has been invented, so that foreigners coming to Paris find many objects on the table, the names of which they do not know and the purpose of which they often dare not ask'.[24]

While silverwares have always witnessed some of the earliest innovations in dining equipment, in the second-half of the eighteenth century the size and weight of these new articles became smaller and lighter, and their number multiplied at a faster rate than ever before. Often made of thin rolled sheet, some so thin that they were exempt from the hall-marking regulations, they included cruet, soy and egg frames, argyles, bottle tickets, butter and ice spades and asparagus tongs.[25] These objects may have been small, but households seem to have purchased a great number of them, often in sets. Cornwallis' inventory, quoted earlier, included 50 bottle tickets. By the end of the century more specialist equipment appeared on the table, including grape shears and egg spoons.

Other types of innovative tableware appear in Parker and Wakelin's ledgers, like Sawbrook Freeman's 'oyster machine' at £13 12s.[26] George Selwyn (1719–91) delighted in newly invented silver; he bought from Parker and Wakelin a 'cucumber slicer', an 'artichoke cup' and butter spades in the late 1760s.[27] As fashions came in there was sometimes a period when customers adapted what they had, before they bought new. Around the 1760s, for example, it became customary to place the bowl of the spoon upward, rather than downward, which necessitated the turning back of the handles so that the bowl lay flat on the table. Several of Parker and Wakelin's customers sent their spoons in to be 'turned back': for example, John Croft paid 3s. in 1766 for his gravy spoon and soup ladle to be turned, which also required the re-engraving of his crest on the handle so that it would face upwards on the table. Ralph Milbanke, however, bought them new in 1766, purchasing '6 large turnback spoons' in July 1766 for £2 1s. 10d, plus 13s. for their making.

Innovation in tableware meant that the position of silver itself was being challenged as new luxury wares like china and porcelain offered fashionable alternatives, and Sheffield plate had novelty value. Household inventories reveal an ever increasing list of china wares that were entering the home. Silver tableware was matched with home-produced ceramics from Wedgwood and Chelsea, and imported porcelain from China and Dresden. Sir Gilbert Heathcote, of Normanton Park in Rutlandshire (c. 1723–85), for example, owned a 'Dinner Service of Blue and White Nankeen China', a 'Small Service of Dresden ditto', a set of Dresden tea china and eighteen dishes of Chelsea China with two dozen plates to match, as well as his silver dinner service of some 1,500 troy oz.[28] In 1769 Lord Rosebery was buying 'plated hand candlesticks Tootenaugh mettall', and although only costing £3 3s., had them engraved with his crest and coronet just like his silver. Sir John Hussey Delaval (1728–1808) began buying Sheffield plate rather than silver towards the end of the century, which seems to have reflected a growing trend. By 1781 he had a Sheffield plate tea urn, coffee urn, bread basket, sauceboats, argyles, two branch candlesticks, writing stands, salvers and oil and vinegar

stands, which warranted their own inventory.[29] The nobility could be as proud of their Sheffield plate as of their silver. Mary Noel proudly informed her niece, in 1792, that 'we are going to have Company at Dinner to-day . . . my plated branches and my eighteen Silver spoons are all come to make a shew, so we shall be very grand'.[30]

Perhaps the British were more than usually obsessed by the etiquette of the dining table, compared with their continental neighbours. Foreign commentators were struck by its formality, the importance placed upon the occasion and the length of time it took. While the Frenchman La Rouchfoucauld admired the relaxed atmosphere of English domestic life, especially the leisured breakfast, he was perplexed and horrified by the contrast of dinner. Describing a typical day at Euston Hall, where he was the guest of the Duke of Grafton (*see* chapter 1, fig. 12), he wrote how,

> At 4 o'clock precisely one must be in the drawing room, and there the formalities are more than we are accustomed to in France. This sudden change in manners is astonishing . . . One observes an uncomfortable politeness; strangers go in first to dinner and sit near the lady of the house, they are served in order of seniority with the most rigid etiquette; so much so that, for the first few days, I was inclined to believe they were doing it for a joke. Dinner is the most boring of all things English; it always lasts for four or five hours.

Four o'clock was the customary time for dinner, as countless other diarists and letter writers confirm. At Wimpole Hall, home of the second Earl of Hardwicke, Caroline Yorke noted: 'From 4 till past 6 at dinner. Then coffee afterwards, looking at prints, talking', while 'Exact at ten the sideboard is laid with a few light things upon it'. Strict timekeeping and the observation of hierarchy were part of the system of status enforcement at dinner. The number of tureens and sauceboats indicated wealth, and plates and bowls bore the engraved crests and cyphers of the hosts. The size, range of equipment and ornamentation of the dinner service conveyed messages of power, of dynasty and of politeness.

By combining surviving silverware with household inventories it is possible to reconstruct the scale, range and style of some of these family dinner services. The Hervey family were not great patrons of Parker and Wakelin, although George Hervey, second Earl (1721–75), did order plate from Wickes and Netherton in 1750. Much was acquired while he was ambassador to Turin (1755–58) and Madrid (1758–61). His brother, Augustus John Hervey, third Earl of Bristol (1724–79) spent most of his career at sea and had little time for the family seat at Ickworth, which he inherited. Yet an inventory of the Hervey family plate, in 1811 at Ickworth, helps us to reconstruct the composition of it. The dinner service is listed first: ten dozen gadrooned table plates, three dozen matching soup plates, twenty oval dishes of five different sizes, two irregular shaped dishes; four pincushion dishes, eight octagon shaped dishes of two sizes, two oblong double dishes, 'four rich first course casseroles' which, the inventory maker noted, 'were made to keep warm with hot water', four first-course chafing dishes, four salad dishes, two oval mazarines, two oval and two round tureens and covers , twelve sauceboats of three different designs, eighteen gadrooned and four plain salts, two cruet frames, one soy frame and six castors.[31] Together with the pair of ice pails, two bread baskets, ten waiters, bottle stands, a wine cistern, twelve candlesticks with branches, plus six more described as 'rich' and twenty-six more plain, and all the cutlery, the complete service weighed just over 12,750 troy ozs valued at £3,507, its melt value. Once

the cloth had been removed a set of gilt dessert silver could be used, accommodating up to forty-eight settings, with eight gadroon pincushion dishes and four more round, four salad dishes, four fruit baskets, four oval chased basins and four sugar dishes with ladles, weighing a total of 1,161 troy oz.

The Hervey plate appears to have been at the upper end of the scale of family dining. Sir Gilbert Heathcote's silver represents a more average holding on its inventory at his death in 1785. Sir Gilbert was the grandson of a city merchant who became one of the founders of the Bank of England, and Lord Mayor of London. He used part of his great wealth to buy a country seat at Normanton. He left £700,000 on his death in 1733. It was the third baronet who was responsible for acquiring most of the silver listed in 1785, which had been bought between 1768 and 1770. The dining service comprised four-dozen table plates and twenty five variously shaped round dishes and a plain round fish plate.

The twenty five serving dishes would have served one of the two main courses that made up service *á la française*, as illustrated (figs 153, 154). Everything was put on the table at the same time and guests chose for themselves what they wanted. The first course was heavier than the second, with a dessert course to finish. The larger plates would, for example, have been used

Fig. 153. Table Layout, from *The Modern Method of Regulating and Forming a Table*; 1760. Brotherton Library, Leeds

Fig. 154. Table-setting for a dinner in May, from M. Bradley, *The British Housewife*, vol. 1, c. 1760. Brotherton Library, Leeds

Fig. 155. *Sir Gilbert Heathcote 3rd Baronet*, by Richard Cosway (1742–1821), painted to celebrate his marriage; *c.* 1770. Watercolour on ivory, in an ormolu frame; length 4 cm. Grimsthorpe, Lincolnshire

Fig. 156. *Elizabeth Hudson, second wife of Sir Gilbert Heathcote 3rd Baronet*, by Richard Cosway (1742–1821), painted to celebrate her marriage; *c.* 1770. Watercolour on ivory, in an ormolu frame, length 4 cm. Grimsthorpe, Lincolnshire

to serve a first course that might comprise a mixture of boiled turkey, beef olives and fricassee of veal and ham. The smaller plates might serve vegetables such as kidney beans, bottled peas, coleslaw, salad and servings of oysters and lambs ears. Heathcote also possessed two chased tureens, made by John Luff in 1743, which he updated with new stands provided by Parker and Wakelin in 1770[32] (*see* chapter 8, fig. 129). These would have been used to serve soups, such as hare, mock turtle and clear soup. There were also two pairs of plain and two pairs of chased candlesticks, four sauce boats and six chased salts and ladles. A chased épergne with eight branches, for four baskets and four saucers, was used on the dessert table, loaded with candied fruit and sweet meats.[33] Sir Gilbert had a keen eye for changing fashions in silver. He had bought a gadroon tea vase in 1768, but only two years later he purchased an up-to-the-minute festoon-pattern one, with vitruvian scroll foot, reflecting the taste for neo-classical designs. This coincided with his marriage to his second wife, in 1770, which necessitated the re-engraving of his dinner service with the new Heathcote/Hudson armorials (figs 155, 156).

What emerges from these and other lists of household dining plate is that there was a core of essential items to every service; wealth and status was expressed through additions to this. The minimum kit comprised table and soup plates, the usual order being for three dozen (as a clean plate was required for each course); four tureens, usually two oval and two round, often of two different sizes; serving dishes of various shapes and sizes; sauceboats or tureens; salts; candlesticks; a breadbasket or two; and, if possible, a wine cistern and later on an épergne. The épergne was the ultimate in refinement for the dessert table. John Macdonald, a footman who published his memoirs in 1790, prided himself in producing a dinner in Bombay with fifty dishes, concluding with 'two silver *epargnes* full of sweetmeats' as a means of indicating the importance and style of his master, a triumph of English etiquettte abroad.[34] The essentials could be supplemented with additional equipment like chafing and salad dishes, mazarines, an ice pail, escallop dishes and an ever increasing range of accessories.[35]

If one did not have enough plate to entertain in style it could be hired, from the goldsmith or from friends. When the Duke and Duchess of Bedford held a ball in their Bloomsbury house in 1757, they borrowed silver from the Duke of Marlborough, Lord Bolingbroke, Lord Gower, Lady Ossory and Lady

Betty Waldegrave. A list of gratuities paid to each of the chairmen 'for bringing and carrying the plate' is in the family archives.[36] The hire of equipment for special occasions was common across all the luxury trades. The London cabinetmakers Ince and Mayhew, for example, hired out tables to Lord Monson, in 1785, for a large party.[37] Others capitalized on their dining services in a more economically astute manner. According the the gossiping Horace Walpole, the Duke of Newcastle put his 'service of gold plate . . . in pawn, unless when fetched about on extraordinary dinners and occasions'.[38]

It is clear that there was a minimum requirement of silver for the table, if position in society was to be upheld. The Duchess of Grafton failed to retain enough plate and furnishings to maintain status after her divorce from the duke in 1765. He offered her £150 a year and her jewels, but refused to pay £1,000 to furnish a home for her, and denied her a share of the silver. The duke only broke the boundaries of polite behaviour when it was reported that he not only 'led his mistress into public', but also placed 'her at the head of his table', interpreted by the press as a public insult, as well as a private indulgence.[39]

The consumption of silver was an ongoing process and had to accommodate not only changing fashions in form, function and decoration, but personal events such as marriage, births and accession to the family estates, which required, if not new plate, the re-fashioning or at the least the re-engraving of old. The third Earl of Darnley's (1719–87) account with Parker and Wakelin is marked by the purchase of a 'child's spoon' in 1771, which may have been for his first son, born in 1767.[40] This was part of a much larger order of 3,214 troy oz of new plate, paid for with 1,792 troy oz of old silver.[41] Sir Charles Saunder's account ends with his death in 1775, and the order of fifty-eight mourning rings. His heir's account begins with the 'takeing out engraving of large quantity of plate', as the arms were changed on the family dining silver. The family dinner service was itself as much a record of dynastic change and development as an indicator of fashionable taste.

SILVER AT HOME

It was a convention that household inventories always listed the silver, along with the china, glass and linen, as a separate category, divorced from the rooms in which it was kept and used. It is misleading to see it in such isolation. There is plenty of evidence to show that the purchase of silver was seen as integral to the decoration of a room rather than as an accessory. The diarist Reverend John Thomlinson, observed that the aunt of a clergyman's family near Durham spent '£50 to furnish her drawing room, i.e. £20 for silver tea kettle, lamp and table'.[42] If the silverware comprised the grandest single decorative contribution to the room in this quite modest setting then it helps us re-evaluate its importance within the domestic environment of the less than wealthy.

At the other end of the scale are the designs of Robert Adam for coordinated and matching interiors, like those at Kenwood and Kedleston, which incorporate designs for silver within the overall plan of an interior (see chapter 8, fig. 147). Under Adam's aegis at Mersham-Le-Hatch in Kent, Sir Edward Wyndham calculated that by 1773 he had spent £20,526, of which £16,525 had gone on the building work; £949 to Robert Adam; £1,902 to Thomas Chippendale; plus an extra £592 for carpets, silks, bedding and china.[43] Significantly, silver was given a separate category within the costing, amounting to £360 including 'an elegant antique drapery vase' for £49 and 'an elegant festoon epergne' with seven baskets for £83. Both would have

been part of the neo-classical decor that Adam had designed which, unlike the stucco, was easily portable.

The even more detailed accounts at Croome Court in Worcestershire, relating to Lord Coventry's remodelling, allow us to put the cost of individual silver items in the context of other luxury goods. For example, in 1760 he paid Vile and Cobb £42 for 'six handsome Carved Mahogany Armed Chairs on castors, stuffed and quilted and covered with Morocco Leather.[44] Eight years later he paid exactly the same for 'a Compleat sett of fine blue nankeen china', and a year later £40 6s. 3d. for a modest set of '4 pincushion comport dishes' from Parker and Wakelin.[45]

THE INVENTION OF THE DINING ROOM

The survival of houses, their interiors and inventories means that it is possible to reconstruct some of these sites for the display of silver, either inherited, commissioned or up-dated The term 'dining room' did not come into general use until after the mid-eighteenth century.[46] Only dinners were taken in this room, as breakfast and supper happened wherever was convenient. Dining, or 'eating rooms' as they were more often called, could be the grandest space within an English house. While most fashions in eating and drinking, and interior architecture followed the French, the centrality of the dining room was peculiarly English. As Robert Adam explained, in France 'eating rooms seldom or never constitute a piece in their great apartments, but lie out of the suite, and in fitting them up little attention is paid to beauty'.[47] Unlike the French, who only met in an antechamber for dinner, and relied on 'the display of the table for show and magnificence, not to the decoration of the apartment', the English took more care and pride of their dining rooms, where they spent a greater amount of time. Whereas the French deserted the table, 'as soon as the entertainment is over' and ' immediately retire to the rooms of company', the English, explained Adam, were 'Accustomed by habit, or induced by the nature of our climate' to linger over the pleasures of the bottle. As a result: 'The eating rooms are considered as the apartments of conversation, in which we are to pass a great part of our time.'

Although many house refurbishments reveal that it was the dining room that was often the first to be tackled, and in the grandest manner, as at Osterley, in many cases the old had to live with the new. Despite the influence of the growing band of architects such as Adam and of interior designers (then called upholsterers), many dinner services took their place in houses which were neither decorated in the latest nor, like the Hervey dinner plate, in a single style. Not all households were under the thumb of Maria Edgeworth's Mr Soho, the 'first architectural upholsterer of the age', whose tyranny over Lady Clonbrony resulted in 'new hangings, new draperies, new cornices, new candelabras, new everything!'[48]

In contrast to this satirical lavishness, there was also an eye for economy. William Cole was all for having their dining room 'an ash or olive colour as being the cheaper and more durable. But my Lady objected that, though more expensive, the fashionable French white would be cheaper in the end'.[49] The new dining room had been designed by the architect Henry Flitcroft's Clerk for Kenton House in 1778, although few other alterations were made to the building, and Caroline Yorke deplored the fact that most of the house was 'furnished in old style'.

Sir Griffith Boynton (1745–78), who suceeded his father in 1761, brought his new wife the following year to the family residence at Burton Agnes in

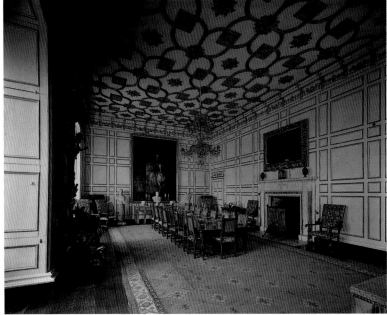

Yorkshire. It had been in the possession of the Boynton's since the Norman Conquest, and at the time of the purchases from Parker and Wakelin in the 1760s it was a Tudor and Jacobean house, with richly carved oak panelling and screen and elaborate stone chimneypieces (fig. 157).[50]

Fig. 157. The dining room at Burton Agnes Hall, Yorkshire

Fig. 158. The dining room at Warwick Castle, added in the 1760s, to the designs of Lightholer an early example of Jacobean Revival

While Boynton chose not to modernize the interiors, he was buying the most fashionable tableware that Parker and Wakelin supplied, including fine festoon salts and several dozen octagon-threaded shell knives and forks.[51] At Petworth, the third Lord Egremont (1751–1837) and his guests dined on 'modern' silver at the end of a sixty foot room, against a 'wainscot of which was Gibbon's carving in wood'.[52] Others, like Fulke Greville (1717–1809), spent a great deal of money on up-dating their homes, often preserving the exterior but lavishing attention on the interior. At Warwick Castle Greville spent over £5,000 between June 1764 and July 1766 in refurbishing his family seat, in which Walpole noted 'a large dining room new built',[53] to the design of Timothy Lightholer (fig. 158). An early example of Jacobean revival, the dining room ceiling was decorated with interlocking pointed quatrefoils adjoining slightly earlier panelling.[54] Into this went a brand new set of French-plated candlesticks and waiters that Parker and Wakelin supplied in 1766.

We know from an inventory of 1786 that Sir Gilbert Heathcote's dining room, at North End in London, was fitted out with three mahogany dining tables, ten chairs, an 'old arm chair', two dumb waiters, a walnut card table, a four-leaf screen, a pot cupboard, a sconce glass in a gilt frame, two gilt girandoles and a carpet.[55] His more fashionable dining room was in his London house at Grosvenor Square, where the dining room was furnished with three blue moiré window curtains, two oval glasses, two twelve-leg tables, a pembroke table, a card table, a claw table and three dining tables. There was also a marble sideboard, on which silver for the service of wine might have been presented; a frame; a sliding screen; twelve mahogany chairs plus an old Wilton carpet. The back dining room, which was presumably used on less formal occasions, sported three old crimson curtains, two dining tables and carved chairs, two pier glasses and two old marble tables. There were two girandoles, a pole screen and a Scots carpet.[56] Of all the new devel-

Fig. 159. *Sir John Hussey Delaval,*
artist unknown; *c.* 1770. Oil on
canvas. Seaton Delaval, Northumbria

opments in Westminster, Grosvenor Square was the most admired and 'a Great many Noblemen and Gentlemen of the first Quality and nicest taste' lived there.[57]

From these and other descriptions it becomes clear that although there were certain set fixtures for the dining room – notably a sideboard, for the service of wine – there was flexibility in the number of tables and chairs, and a variety of decorative options, headed by the choice of curtains and carpet.

To assume any simple notion of stylistic preference is misleading. It was possible to follow several different styles at once. Sir John Hussey Delaval (fig. 159) owned three country estates plus a house in London. At Doddington he preserved the Elizabethan exterior but remodelled the interior; at Seaton he commissioned a classical-style addition complementary to Vanbrugh's architecture of the main building; at Ford he chose the Gothic to harmonize with the antiquity of the castle. Robert Adam was employed at 23 Hanover Square to refurbish the drawing rooms. John Cornforth's criticism of those who seek a smooth development of styles, applies to silver as much as to architecture, and Delaval's decisions show how 'the importance of family sentiment and increasing pleasure in history' could override fashion.[58]

Silver, unlike furniture and portraits, was often moved between town and country, and must have helped disseminate metropolitan fashions in dining amongst the rural elite. We know from Delaval's meticulous accounts that the family silver was transported from one house to another. An inventory of plate sent from Seaton to London, in December 1750, included eighty-five items of silverware, from a large can, a bread basket and five cups with gilt edges that belonged to his mother, to a case with eleven dishes, four-dozen plates and a shaving basin.[59] The rest of the silver appears to have been 'put in the Irron Chest' at Seaton, awaiting the family's return.[60] Another inventory was made in 1765 indicating the carriage of silver to Doddington.[61]

The influence of the Season, which began in March and ended in July, dictated a steady rhythm of movement between town and country residences. There is little evidence to reflect any precedence between the two, although Richard Rush, writing in 1817, described how the great families 'have houses in London, in which they stay while Parliament sits, and occasionally visit at other seasons; but their homes are in the country. Their turreted mansions are there, with all that denotes perpetuity – heirlooms, family memorials, tombs'.[62] Only the very wealthy, like Lord Lonsdale, whose income was, Joseph Farington believed, between £80,000 and £100,000 in 1808, could afford to have a service of silver at each of his four houses: at Lowther, Whitehaven, Cottesmere and in London, which itself was a sign of status.[63] When Matthew Boulton provided a dinner service for Elizabeth Montagu in 1777 he 'thought it right you prepare two cases for lodging it in, when not in use wch are divided into proper compartments and by means of them you can easily transport from one place to another'.[64]

OUT OF THE LIMELIGHT: PLATE BELOW STAIRS

So far we have looked at the silver from the perspective of the owner, and its more public presence, on show in the house, on the table, upstairs. Yet as we have seen it was far from static: it not only moved from house to house but it moved within the house, linking the worlds of above and below stairs, the master and mistress of the house and their servants. From Matthew Boulton's remarks to Elizabeth Montagu it seems that most plate was kept below stairs, as he advises that:

> Such plate as your Turrenes should never go into the Kitchen except
> the linings of 'em, otherwise they will soon lose their beauty, and
> even though they don't go into the Kitchen, yet all silver exposed to
> the London air will grow Black and Tarnished unless kept up in
> paper and Bags.[65]

Particularly fine silver was kept in special cases. Thomas Twining's comment
on the immaculate upkeep of Lord Rochford's gateway, reveals the way silver
was treated: 'One would think the noble family had kept them, like their
plate, in chagrin cases lines with green bays, and had them cleaned and
brushed every week'.[66]

Most larger households could afford to keep a servant who was responsible
for the plate, usually the butler, whose duty it was to inventory the plate and
keep it in good order. It was the duty of the butler to place 'the silver
and plated articles on the table' for dinner, and to see 'that everything is in its
place, and rectifies what is wrong'.[67] Lady Breadalbane told her butler that he
'should never allow anyone but himself to place the best branch candlestick
on the table'.[68] In Susanna Whatman's housekeeping book, begun in 1776,
she notes that the butler is to have 'Care of the key of the plate', and at bed-
time 'he locked up the plate'. At Erdigg the footman slept with his bed in front
of the only door to the safe, where the silver was kept on baize-lined shelves.[69]

In the introduction to the published version of this manual Hardyment has
noted that 'the need to be specific about details reflected innovations in
domestic life-styles with which untrained servants would be unfamiliar'. In the
last three decades of the eighteenth century there had been, as the author of the
Domestic Encyclopedia (1802) pointed out, a rapid succession of advice books,
'often more distinguished by their alluring title pages than by their intrinsic
merit'. Their proliferation must have been in response to a perceived need.

Lord Holdernesse kept nine household servants. His cook was paid £73
10s. a year, the upper butler, who would have looked after the plate £40, the
same amount as his wife's maid.[70] These costs can be compared with the fam-
ily's expenditure on silver. Holdernesse paid Parker and Wakelin £30 11s. for
a pair of double-branched silver candlesticks in the same year that he paid his
housekeeper £36 for a year's work. William Fortescue kept six upper servants,
headed by the butler who received £35 to £40 a year, and nine under servants,
including two housemaids who were paid £6 to £8 a year. The servants ate off
pewter; each servant had his or her own numbered knife and fork, and they
were charged for any that disappeared or were broken.[71]

Lord Hervey's expenditure on silver at Ickworth can put in the context of his
estimation of the costs of running the establishment, which he calculated to be
£1,700 per year. The largest single outgoing was £600 for housekeeping and
cellars, for twenty-two in the family. He paid £390 5s. on 'wages and Liveries
with Servants Tax', while it is interesting to note that he allowed £25 a year for
'keeping up and Repairing Furniture'.[72] Sir Edward Knatchbull's housekeeper
was 'expected to go round the house at least twice a week to see that the House
maids take care of the furniture'. No sugar was allowed the servants 'except in
sickness'.[73] Thomas Johnes of Cardiganshire, who kept a more modest house,
described his needs in a letter to a friend in Edinburgh in 1808:

> I am in want of a servant, a working servant, not a butler or fine
> gentleman – for those are creatures I abhor. My household consists
> of two footmen, for I wish to spend my own money myself, and not
> squander it on idlers. One of them will attend my dressing which

requires only to hand my Cloathes, shoes etc. well cleaned, and to shave my head once a week. He will have also the chief charge of the plate which the quantity is very great, and the malt Liquor.[74]

While the butler oversaw the silver it was the housemaid's job to clean it. However late the family's dinner might be, the silver had to be washed, polished and put away in the strong room before the butler and footman could go to bed.[75] Goldsmiths' bills frequently included materials needed for maintaining the silver: abrasive powders, cloths, skins and flat soft-bristled plate brushes. Thomas Mead bought six brushes and skins for cleaning his tureens,[76] and Lord Monson paid 5s. 6d. for '2 brushes and skins and 2 buffs'.[77] Parker and Wakelin delivered Edward Hatton's chalice and paten in a deal box with a brush and skin. Goldsmiths often supplied boxes of 'crocus martis' and hartshorn powders to their customers. Crocus was a red or yellow abrasive powder made of calcined metals which could be rubbed onto the silver and brushed off. In a similar way, grated hart's horn or antler could be used as a source of ammonia. Hartshorn could be purchased from chemists. Richard Siddall, the chemist next door to Parker and Wakelin, most likely supplied their requirements. Robert Clee, who engraved Siddall's trade card, included a bottle labelled 'Hartshorn' on the shelves to the left (see fig. 39). The goldsmith George Coyte, noted in a surviving day book a recipe for cleaning plate: 'Take burnt Hart horn boyl it in water a Hour and put in a bitt of rag boyl it with it rub your plate well with it; and after clean it with a bitt of clean cloth'. Mrs Beeton's advice to the housemaid, published over a hundred years later, follows the same method:

> Wash the plate well to remove all grease in a strong lather of common yellow soap and boiling water, wipe it quite dry; then mix as much hartshorn powder as will be required into a thick paste, with cold water or spirits of wine; smear this lightly over the plate with a piece of soft rag, and leave it for some time to dry. When perfectly dry, brush it off quite clean with a soft plate brush and polish the plate with a dry leather.[78]

Mrs Beeton also advised the keeping of 'plate rags for daily use', made by 'boiling soft rags (nothing is better for this purpose than the tops of old cotton stockings) in a mixture of new milk and hartshorn powder' which produced a 'most beautiful deep polish'. Matthew Boulton suggested that Elizabeth Montagu clean her new silver dinner service ' in the common way . . . take a clean soft white brush and wash . . . with soap, warm water or spirits of wine, and then wash all clean with warm water only and wipe all clean with dry soft linnen cloths'.[79] As parts of this service were matted, Boulton recommended that a softer abrasive be used, whiting rather than hartshorn, to maintain the contrasting effect. When there was more cleaning work than the staff could cope with help was bought in. The Earl of Holderness paid Parker and Wakelin £1 11s. 6d. for 'three days work for a man's cleaning the plate'.[80] Well kept silver required high maintenance.

An inventory of the household effects of William Clayton, made in 1783, gives some idea of where plate was kept and cared for. The contents of the butler's pantry lists silver, glass and china connected with drinking including ale glasses, decanters, tea urns and chocolate mugs, as well as two plate chests and mahogany knife boxes.[81] The butler's pantry at Seaton comprised two press beds, two feather beds, a quilt, four chairs, a table and bedlinen,[82] as the footman would have slept there for security. Inventories of the Waldegrave

goods at Dunster Castle also list the plate as being in the butler's pantry, along with the glass in a separate closet.[83] Judith Milbanke stressed that their newly built house at Seaham was to have 'a *large* Butlers pantry' at the back.[84] A set of salvers supplied by Edward Wakelin to the ninth Earl of Exeter are scratched on the base 'Pantry', alongside their weights.[85]

The family silver, however, could prove an irresistible temptation to the servants, and there are many accounts in newspapers and diaries of thefts. Walpole reported to Mary Barry that 'I am come to town suddenly and unexpectedly; my footman John had pawned a silver strainer and spoon, which not being found out till now, as it had been done here, he ran away in the night'.[86] In 1763 Lady Molesworth's house 'was set on fire by a servant' who had 'sent a box to a friend in Ireland, [which] he never had the courage to send for'. On the friend's death his goods were put up for sale and 'the box was opened and found full of plate with the Molesworth's arms on it'.[87] The theft of a large quantity of silver including 'a large Salver chas'd, value about Fifty Pounds . . . [and] an old-fashioned Cup and Cover, holds about three pints' from James Adair of Soho Square in 1766, was reported in the *Public Advertiser*. 'Jane McGinnis who was a servant in the house, and Edward McGuinnis, her Brother, with Mary his wife' were charged.[88]

LIFE AFTER DEATH

Many of Parker and Wakelin's customers left precise instructions about what was to happen to their silver and jewellery after their death. Jewels that had been worn by a wife during a husband's life were perhaps more obviously, although not necessarily legally, the natural possession of the widow. William, 1st Lord Radnor of Longford Castle for example, in his extensive twenty-two-page will made in 1776, left his wife Anne 'all her Rings and the watch which she usually wears' (fig. 160).[89] All his 'Jewels Pearl necklaces Watch Etwee and Trinkets' were also hers, but only until their eldest son atttained the age of twenty-one and married. William Fellowes, in 1797, left his wife 'all my jewels she now wears and any that hereafter may be purchased'.[90] He clearly considered them his property.

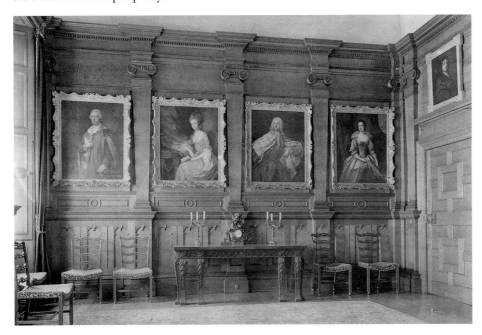

Fig. 160. The dining room at Longford Castle, with portraits of William, first Earl of Radnor and his wife Anne, by Thomas Gainsborough (left); and Jacob, first Viscount Folkestone and his wife, by Thomas Hudson (right)

Fig. 161. Inkstand, made by Ansill and Gilbert, retailed by Parker and Wakelin; 1771. Silver (London), engraved 'The gift of Horace Walpole, Esq afterwards Lord Orford, to William Pennicott, Rector of Long Ditton, Surrey, and bequeathed by the latter to John Tony, Wilts, 22 August, 1842', length 30 cm, 56 troy oz. The Gilbert Collection Trust, London

Fig. 162. Teapot, mark of Parker and Wakelin struck three times on the base; c. 1760. Silver (London); height 12.1cm, scratch weight '14.4' for 14 troy oz 4 dwt. This teapot belonged to Samuel Johnson, and was probably the one he referred to in his diary on 28 April 1771 when he took stock of his possessions, noting under 'Plate' that he had a teapot worth £7. The Hyde Collection, Harvard University

The allocation of silver was more problematic, as items were not so clearly the property of individuals within a household. Many wills include family silver amongst the chattels that were formally listed and handed on. Lord Holland, for example, left to his wife Georgiana Caroline all his 'household furniture pictures Silver plate China Postchaise Glass Statues Books Liquors' as well as his 'Cattle Horses Swine and and Sheep' associated with the estate in Kensington West.[91] Colonel Monson gave his 'dearly beloved wife . . . all the plate jewels and ready money in their house'.[92] Hugh Fortescue bequeathed to his wife Lucy 'all his coaches and chariots . . . such as she shall choose and all her dressing plate, rings and jewels and all my plate with the Aylmer and Fortescue arms upon it'.[93] It was more common for men to make these general references to goods, few of which are described in detail.

Many were keen that silver should survive them, not only as a potential source of retrievable cash but also, and increasingly, as an 'heirloom', tied as much to a place as a person, and integral to the idea of a family dynasty. All Lord Radnor's silver, which would have included the extensive dining service he bought from Parker and Wakelin after 1765, when he was raised to the peerage, went to his oldest son Jacob, Viscount Folkestone. However, the family portraits (which he had commissioned from Gainsborough and Reynolds in the 1760s fig. 160) were 'already considered as heirlooms' and he hoped that they would 'not be disposed of but go along with the said house (Longford Castle) and be enjoyed by such persons as shall from time to time be invited' there.

Silver was also designated in these wills as 'heirlooms, that is family property left in trust for perpetuity, the current owner having no right to dispose of it'.[94] These objects lost their primary exchange value, and sometimes even their use value, as their memory-value transcended both. Lady Spencer wrote to her spendthrift and debt-bound daughter Georgiana, Duchess of Devonshire, in 1782 'I beg you will never part with the jewells. I have often told you they are not your own and should be looked upon as things only entrusted to your care – do not pass over this article without answering'.[95] Sir Roger Newdigate made it clear that all his household goods, including the plate, should 'be left in the said house, [Arbury Hall] and be held and enjoyed herewith as Heir Looms'. In a similar vein Lord Buckingham made it clear in his will that all his 'household stuff', including select pieces of plate, should be kept at the family estate in Blickling, Norfolk, 'as Heir Looms', which should be inventoried. The plate included ' The Great Cistern The large branch Candlesticks and Ice Pails'. To his wife he left 'such Parts of his Plate as she shall chuse not exceeding 1,000 ounces absolutely', as well as 'all the furniture of every kind which should be in or belong to her own Room and her servants Room in his House in London' at the time of his 'Decease'.[96] Here we see the idea of the appropriate weight rather than type of plate being kept to maintain status. Coulson Fellowes left his wife Urania 600 oz of plate and all my jewels' and his son William 1000 oz of plate.[97]

Edward Knatchbull indicated both sentiment and a view to the future in his will. He gave to his two daughters, Elizabeth and Catherine, 'my late dearly beloved wife's silver coffee pot likewise a set of Dresden China which she won at a Raffle'. The family pictures however were to 'be secured as heirlooms and shall for ever be enjoyed or as far as the law will admit by the Person and Persons who for the time being shall be in possession of or entitled to my mansion so the same may not be disposed of '.[98] A pair of silver-gilt two-handled covered pots, supplied by George Wickes in 1741, were engraved with early nineteenth-century arms and the inscription 'Heir Loom bequeathed by the Honble. Stanhope Dormer 1811'.[99]

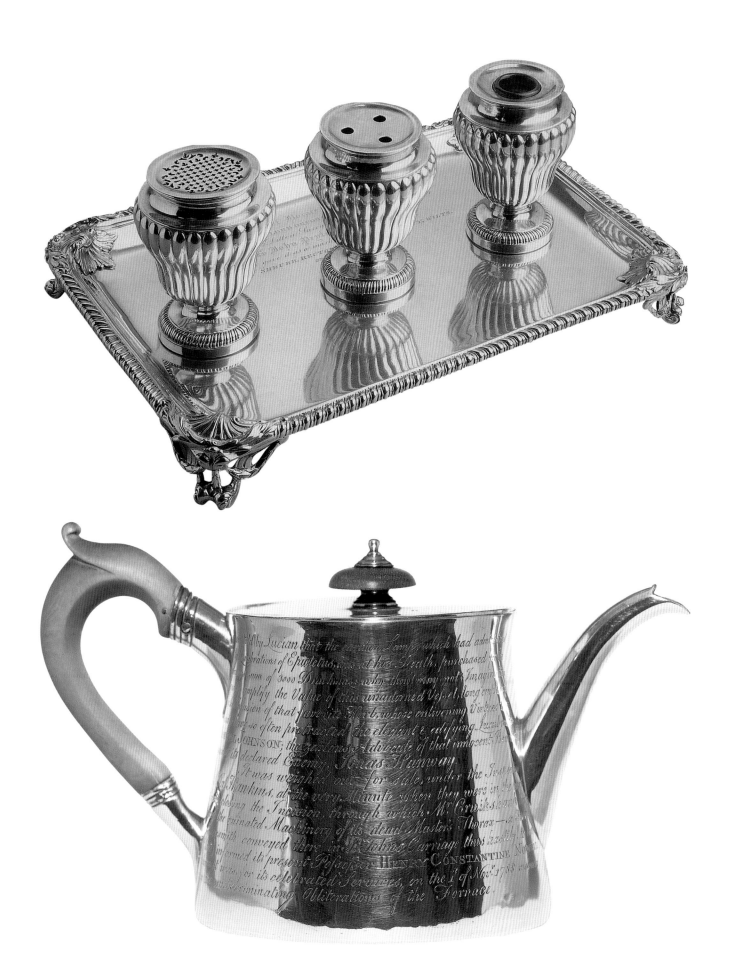

It is clear that some designated silver was meant to survive beyond changes in fashion. A gift of silver could become a powerful and effective means of prolonging the memory of an individual, and the life of the silver. A fine silver inkstand that Horace Walpole bought from Parker and Wakelin's retail shop in 1772 was a gift from the purchaser to the rector of Long Ditton. As the engraved inscription explains it was later 'bequeathed by the latter to John Peyto Shrubb, Esq who gave it as a mark of affection to his son' (fig. 161).[100] Its association with Walpole and the sentiment of the gift have ensured its survival to the present.

There is no more appropriate example of the relationship between personal identity and an object than the survival of Dr Johnson's silver teapot.[101] We can assume that this plain, oval, silver teapot entered Johnson's household as a practical yet fashionable object, no doubt at first the centre of attention at his private tea table, where the select few, such as Thrales, partook of witty and elegant conversation as well as tea.[102] The teapot bears the mark of Parker and Wakelin struck three times, and is probably the one Johnson referred to in his diary on 28 April 1771, when he took stock of his possessions. Under 'plate' he noted that he had a teapot worth £7 and a coffee pot worth £10.[103]

It was not until Johnson's death, in 1784, that it became a souvenir of its owner and a symbol of his beliefs (fig. 162). As it was about to be sold to a goldsmith for its melt value it was rescued and its body engraved with the story of its survival, binding its fate to the memory of its owner and ensuring its immortality.[104] The inscription, which is worth quoting in full, connects social and economic, intrinsic and aesthetic, private and public ideas of value. The first lines relate that 'We are told by Lucian, that the earthen lamp which had administered to the Lucubrations of Epictetus, was at his Death purchased for the enormous sum of 3,000 Drachmas'.[105] Through a classical analogy an everyday object was literally transformed, via the accident of ownership, into the unique and highly valued. The inscription continues:

> why then? may not Imagination equally amplify the Value of this unadorned Vessel, long employed for the Infusion of that favourite Herb, whose enlivening Virtues are said to have so often protracted the elegant and edifying Lucubrations of SAMUEL JOHNSON; the zealous Advocate of that innocent Beverage, against its declared Enemy Jonas Hanway. It was weighed out for sale under the Inspection of Sr Jno Hawkins, at the very Minute when they were in the next Room closing the Incision through which Mr Cruikshank had explored the ruinated Machinery of its dead Master's thorax, – so Bray (the Silversmith, conveyed there in Sr John's Carriage, thus hastily to buy the Plate), informed its present Possessor, HENRY CONSTANTINE NOWELL by whom it was for its celebrated Services, on 1st of Novr 1788, rescued from the undiscriminating Obliterations of the Furnace.

While Johnson's executor had been content to recoup only the teapot's melt value, to the collector it was worth far more than its weight in silver and it has since become a valued piece of Johnsoniana, and in the process acquired a plinth and a plaque.

V
FINAL YEARS AND FUTURE PROSPECTS

'The King's Arms' 1776–92

Looking up from the pages of the firm's business accounts, and to the wider affairs of the country, we can see changes in economy and politics that challenged the stability that had governed the late 1760s and early 1770s. In 1775 the War of American Independence began, breaking a period of peace which had begun with the end of the Seven Years War in 1763. Adam Smith's *Wealth of Nations* (1776), drew a picture of an emerging capitalist economy that underlined the difference with the past. For the partners in Panton Street there were choppy waters to navigate.

In 1770 Parker and Wakelin renewed their first ten-year partnership contract for a further ten years. It is not clear why they both decided to retire in 1776; Edward Wakelin was fifty-nine and John Parker was forty-three-years-old. The business was handed over to Edward Wakelin's son, John, who had been apprenticed to him in 1766, and to William Paris Tayler, who appears in the business accounts from 1769 as an employee. On 25 September 1776, Wakelin and Tayler's joint mark was registered at Goldsmiths' Hall. As Wickes and Netherton had assisted Wakelin with a loan to set up in partnership, so Wakelin in his turn helped his son and William Tayler with a loan of £1,400.[1]

Instead of retiring back to Staffordshire, Wakelin moved to Mitcham in Surrey. He, like Parker, maintained contact with the Panton Street business after 1776, keeping an account with Wakelin and Tayler until 29 September 1783. Wakelin, however, was not to enjoy either a lengthly or an easy retirement. The *Gentleman's Magazine* contains a brief obituary notice which reads: 'At Mitcham Surrey Mr Edw. Wakelin formerly a goldsmith in Panton Street. Died 7 Feb. 1784.'[2] He was sixty seven-years-old, and had only had eight years retirement from Panton Street. The following September, Samuel Netherton, as Wakelin's executor, paid John Wakelin a legacy of £20. Such a small sum belies his real generosity and commitment to the continuation of family involvement in this highly successful business. In his will, dated 24 September 1779, Wakelin had made his two friends and business associates, Samuel Netherton and John Parker, his executors.[3] His wife Ann and his youngest son Edward had pre-deceased him. He revoked the £100 annuity that he had organized for his unmarried sister-in-law, Mary Allen, who had been 'in narrow circumstances' but was then 'much amended by some Legacies', leaving her £10 'in perfect charity'. He went on to explain that:

> I have at this time several considerable sums of money owing me and the recovery [of] them (or at least some of them in a very uncertain state). I hope my son-in-law Samuel Wallace will not take it amiss that I do not make any additions to the fifteen hundred pounds to be payd him being the remaining part of my daughters fortune outstanding to the marriage articles.

His only surviving daughter, Elizabeth, would have been twenty-nine-years-old at the time, and no mention is made of any children. Everything else he left to his son John, and £1,153 was duly transferred from his father's account into his own.[4] The cost of his funeral, £31 15s. was entered into the business accounts on 24 April 1784. It is clear that Wakelin was a kindly man, he had been a member of the Almshouse and Pension Charity, providing housing for the poor of St Martins in the Fields.[5]

John Parker was to enjoy a longer and more prosperous retirement than his partner. In 1776 he and his wife left London and returned to their home county of Worcestershire. As the family home, the White House at Longdon had been rented out to tenant farmers since the death of John's father in 1751, they took a house in Worcester. During John Parker's absence in London an elegant Georgian city had grown out of the medieval half-timbers of the old Worcester, with a new canal constructed in 1771; a new bridge, completed at St Martin's the following year; and a flourishing porcelain manufactury and large glove works erected (fig. 163).[6] John Byng confirmed the local antiquary Dr Nash's opinion of the city noting that 'the great concourse of polite strangers from every quarter showed the superior excellence of the town and neighbourhood'.[7] He also admired the well-built and newly paved streets, particularly the Foregate, where the Parker's house was situated, 'the ornament of Worcester, being of good length and width . . . with genteel houses'.[8] Yet even well into the nineteenth century the Foregate led to fields (fig. 164).[9]

Parker's sisters, Mary, Eleanor and Elizabeth had all married local men. Mary, the eldest, became the wife of John Smith, a Worcester gentleman, in 1751, only to die five years later aged only thirty. Eleanor lived in the village of Kempsey, and had married Samuel West of Earls Croome, who became High Sheriff of Worcester in 1773. Elizabeth wed Moses Johnson, a mer-

Fig. 163. *Perspective view of the City and Cathedral of Worcester*, engraved for the *Modern Universal British Traveller*; 1789. Worcestershire Record Office

Fig. 164. *Plan of the City and Suburbs of Worcester*, from Valentine Green, *History and Antiquities of the City and Suburbs of Worcester*, vol. 2; 1795. Worcestershire Record Office

chant, and lived in the St Martin's district of the city. Only his sister Ann did not marry, and she joined John and Mary Parker in their house in the Foregate. All four sisters died childless. His bachelor elder brother, Thomas, worked as an attorney from premises in Silver Street. His cousin, business associate and godfather to his son, Samuel Netherton, rented out premises near the race course[10] and lived in the St Nicholas district, not far from the Foregate.[11]

A surviving personal account begun on Parker's arrival in Worcester, on 29 September 1776, helps shed further light on his retirement.[12] At first he seems to have spent a great deal of time back in London: he attended the fashionable assembly at Vauxhall, and bought a harpsichord from Samuel Cotes in 1777, purchasing a 'celestina stop' for it the following year.[13] *Berrow's Worcester Journal* regularly advertised 'elegant and expeditious travelling' by coach to London, leaving at 5 pm every day except Saturday from the Star and Garter in Foregate Street, arriving at Charing Cross the next day at 3 o'clock in the afternoon.[14] Soon, however, local affairs began to take precedence. Parker bought tickets for the race balls, and was always meticulous in accounting for the money he regularly lost at cards, £4 1s. 11d. in 1784. He paid subscriptions to the local coffee room at the Bell, and took *Say's Weekly Journal*. We know that the Parkers dined in some style, as sets of their elegant silver cutlery still survive, engraved with the family cypher of a stag's head.[15] From the 1780s the Parkers went on regular trips to spa and seaside resorts, including Lymington, Southampton, Bath, Cheltenham, Buxton and Bristol, interspersed with visits to Camberwell to see Mary Parker's mother, who had remarried in 1775. Her new husband, Nicholas Nixon, was a wealthy London brandy and hop merchant. John and Mary Parker's yearly expenses crept up from £1,035 in 1793 to £1,594 the following year. These are large sums when compared with the annual profits of the former partnership.

Despite his retirement, John Parker kept in regular contact with the Panton Street business through the rents he levied and the taxes and insurances he paid in connection with his London properties. He was receiving rent for four premises in Panton Street and Oxendon Street, totalling £170 a year, and £138 a year from his mother's house in Stoke Newington.[16] It is clear that he remained proud of his business. In his personal accounts there is reference to £3 3s. for a 'Fram'd Drawing of my Doub: House in London (never executed)'.[17] Parker had also invested wisely, receiving £50 per year from an annuity, £54 per year interest on a loan and £262 per year on a couple of dividends.

In 1778 John's unmarried sister, Ann, died. Eighteen years later Parker recorded that his sister Elizabeth passed away on 'Saturday 13 May 1786 about eight in the morning aged fifty-five years'.[18] He paid Richard Redding £9 'for the oak coffin with additional lid, with a groove for the same, and pitted all over to make it water-tight, lined with a fine flannel and covered with superfine black cloth'.[19] The executor's account is in Wakelin and Tayler's ledgers.[20] In 1790 Mary Nixon died; her will reveals the differing fortunes of the testatrix and her sister Ann, and the legacy that a failed business could leave.[21] While Mary had lived a prosperous life with both husbands, Ann had been drawn into the debts and subsequent bankruptcy of her husband Joseph Johnson, a London laceman.[22] At her death Johnson owed his sister-in-law £756 and arrears on an annuity of £20 per annum. Mary Nixon was wise to ensure that the 'trinkets, rings, household goods, plate, china, books, picture and furniture' that she equally divided between her daughters, should 'not be

in any manner subject to the Receipt, Debts, Controul or Engagement of their, or either of their said Husbands, but shall be for the Sole and separate uses only of my Said Daughters'.[23]

On 5 June 1794 John's bachelor brother Thomas died. In a will drawn up the month before he made his brother sole executor, leaving him the estate and house at Longdon and his house in Silver Street.[24] To his only surviving sister, Eleanor, he bequeathed an annuity of £100, yet it was to his friend 'Miss Mary Taylor of Sidbury' that he gave his 'best Silver Coffee pot and Lamp as a small token of the great esteem I have many years retained for her'. The church plate he had commissioned from Wakelin and Tayler for Longdon church in 1791 remains as a memorial to him (fig. 165).[25]

Despite the seemingly ruthless efficiency of John Parker's accounts, in which he noted 'Mary Parker died 6 March 1795 aged 61', it is clear that he was deeply moved by his wife's death. Amidst the expenses of the funeral including '2 mutes' and 'an Achievement over the door', is £1 1s. paid to the vicar for 'leave to erect a monument at Longdon', for which he paid 'Stephens' £69. William Humphries Stephens (b.1737) was a noted Worcester statuary, and his tablets with their various coloured marbles and well-carved details have been described as 'models of eighteenth century good taste'.[26] The monument, still standing in Longdon Church, is surmounted by the Parker arms and bears an extensive text that commemorates two generations of the family (fig. 166). A watercolour of Longdon church by Thomas Netherton Parker's daughter, Mary, then Lady Leighton, gives an impression

Fig. 165. Church plate comprising a communion cup, two patens and a flagon, in their original wainscot box, commissioned by Thomas Parker for Longdon Church from Wakelin and Tayler; 1791. Silver (London); height of flagon 30 cm

Fig. 166. The Parker Memorial, Longdon Church

Fig. 167. *Longdon Church*, by Lady Leighton; *c.* 1840. Watercolour; 14 × 22 cm. Private collection

of the tranquility of the spot where the Parkers lie (fig. 167).[27] Mary Parker left £1,250 bank stock to her husband and £900 to her son.[28] John commissioned, with charactersistic efficiency, six mourning rings from 'Wakelin and Company' at 24s. each.

John Parker, to whom we owe the meticulous accounts of the business and his notes on the family, died just over a year later, aged sixty-two. It seems odd that a man so cautious and careful in his affairs should not have drawn up a will, yet there were few left of his family alive. He did, however, leave a memorandum about bequests at his death dated 24 December 1795, leaving them to his son's discretion to pay.[29] He left £10 each to his relations, £21 to John Wakelin, £5 5s. to each of his three servants, and indicated that Mr and Mrs Netherton should have mourning rings. His son added at the foot of the page, 'John Parker died 22 May 1796 at ten o'clock at night'. It is due to Thomas Netherton Parker's preoccupation with his ancestry, and his geneological investigations in pursuit of the family arms, that we owe the survival of extensive family papers which enable us to catch more than a glimpse of a successful London goldsmith and his provincial background. It was with great pride that he noted 'I have a gold signet ring engraved with the arms which I now bear, which was bequeathed in the will of my Great great Grandfather Thomas Parker who died AD 1676'.[30]

JOHN WAKELIN AND WILLIAM PARIS TAYLER

On Parker and Wakelin's retirement in 1776, John Wakelin took William Paris Tayler as his partner (fig. 168). Tayler had joined the business in 1769, three years before the birth of John Parker's son, Thomas Netherton, in 1772. John Parker's account in the Workmen's Ledger records '£15 allowed for Board of Mr Tayler' as early as September 1769,[31] and Tayler's signature appears on a bill from Parker and Wakelin to Lord Coventry dated 20 June 1770.[32] Tayler was the son of William Tayler, a citizen and leatherseller of London, and had been apprenticed to the goldsmith John Eaton on 6 February 1765 and turned over the same day to his father.[33] There was obviously a close bond between John Parker and William Tayler, as occasional details in the ledgers indicate. In 1777 Parker bought consols [shares in government stock] for him; this may have been in recognition of his freedom of the

Fig. 168. Bill head of John Wakelin and William Tayler, signed by their shop boy James Lister; 1782. The British Museum

Goldsmiths' Company, granted 1 April that year. Parker's personal account also itemizes £7 7s. paid to 'Blackburn for my picture for Tayler' in 1783,[34] and in 1789 'two presents for Mr Tayler while in London' of £20.[35] It is likely, that before the birth of Parker's own son, Thomas Netherton, Tayler had been adopted into the Parker household as a means of ensuring continuity in the business.

In 1778 the business was back in touch with Matthew Boulton of Birmingham. Wakelin and Tayler's orders from Boulton include silver ice pails, branches[36] and three sugar basins which were chosen from a trade catalogue. There seems to have been some confusion regarding the latter, as Boulton wrote to Wakelin informing him that catalogue number 975834 was in fact a slop basin, and 'if you mean them for sugar . . . they should have covers as is commonly the case'. To make the cover would have been expensive so he suggested his silver wire and glass sugar basins at 63s. each.[37]

John Wakelin moved into the house that John Parker and his wife had occupied in Panton Street, above the King's Arms. He paid Parker rent for his home and the business paid Parker for the rent of the shop below. He also bought 'sundry furniture and fixtures' from Parker.[38] He was joined in his home by Humphry Samuel, James Lister and John Payan who paid for their board and rent, presumably as shop boys. John Payan may have been the son, or younger brother, of one of the firm's subcontractors, the jeweller Daniel Payan. From the evidence of the business accounts the partnership of Wakelin and Tayler prospered, their annual profits came to £600 in 1777, £760 in 1778 and £600 in 1779.

By 1779 the business needed to expand again, as the growing numbers of customers in the ledgers suggest. This was done by turning the corner premises into another workshop (figs 169, 170). This was situated at the junction of Panton Street and Oxendon Street, and had been in the business since at least 1760, when Wickes's name appears in the Rate Returns, and then in the hands of Wakelin until his retirement in 1776. Extensive changes were required to turn it into a manufacturing site, as the collector of the Poor Rate noted that 'much money has been lay'd out in alterations and digging vaults'.[39] In 1779 this became Wakelin and Tayler's new workshop, for which John Parker owned the lease, levied an annual rent of £70 and insured for £500 'on acct of the improvements'.[40] The end of year accounts for 1779 show that the Crespels were paying £79 rent and taxes for this 'new' workshop and £38 for the 'old' workshop, that is for the premises next-door-but one to the King's Arms.[41] In 1781 Wakelin and Tayler paid for further improvements costing £120.[42] Four years later the Crespels insured the premises for a total of £1000, £700 of which was for the utensils and stock in the workshop.[43] Annuities bought on both Sebastian and James Crespels' lives, together with the loan of £1,321 7s. 3d. 'by their Joint Bond bearing 5% pr Annum with collateral security of all their tools, Fixtures and Implements in Trade of All denominations' suggest that the Crespels were now virtually owned by Wakelin and Tayler.[44] A watercolour sketch (fig. 171) of the early nineteenth century shows this corner site.

In 1780 and 1781 John Wakelin appears to have been preparing for his marriage to Catherine Tyler, whom he wed in January 1782. His account includes the payment of bricklayers, glazier, plumber, carpenter and upholsterer, as well the installation of a water closet (a modern luxury), and for painting and paper hanging.[45] Catherine cannot have lived long, as he had a son, William, by Ann Wakelin in October 1784.[46] In the same year more radical refurbishments were required when a party wall collapsed, destroying a 'great quantity

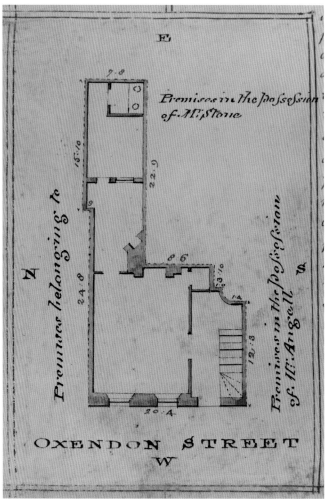

Fig. 169. Plans of the premises on the corner of Oxendon Street and Panton Street; late eighteenth century. Shropshire Records and Research

Fig. 170. Plan of the premises on Oxendon Street, Shropshire; late eighteenth century. Shropshire Records and Research

Fig. 171. View of the corner of Oxendon Street and Panton Street; early nineteenth century. Watercolour. John Johnson Collection, Bodleian Library, Oxford

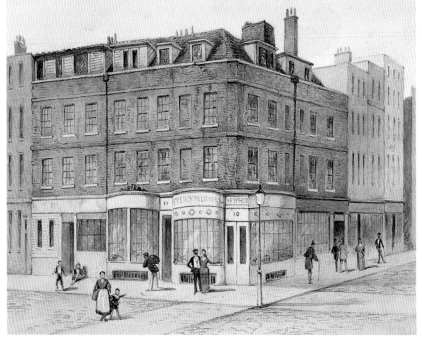

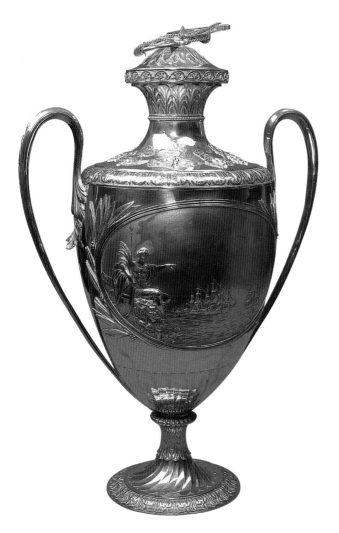

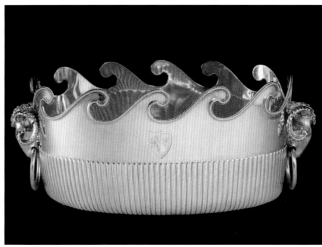

of plate, glass, furnishings and goods', belonging to the next door neighbour, an upholsterer called John Weatherell.[47]

Despite these crises, the business continued to prosper. They supplied some elegant examples of neo-classical silver in the 1770s, 1780s and 1790s: a cup and cover presented by the Royal Exchange Assurance Company to Richard Pearson in 1779 (fig. 172); a soup tureen and cover of 1780 (fig. 173); a verrière of 1790 (fig. 174), with beaded vitruvian scroll rim and ram mask handles; and the Richmond race cup, also for 1790. The day book which survives for this period describes the order for 'a Race Cup (Richmond) low cover with Leaves between bead and Vitrivia cover Leaves on Body plain shield the rest like Drawing in Shop Book mark'd (R)'.[48] Its matted waterleaf base and large areas of plain polished silver, reveal how far neo-classicism had progressed since Adam's design for the Richmond cup drawn in 1768, and made-up in silver by Parker and Wakelin's subcontractors, Smith and Sharp.

Customers who appear in the Gentlemen's Ledger in the 1780s include Charles Towneley, the collector of classical statuary; the Duke of Hamilton, who was busy purchasing ancient Greek vases; Nathanial Dance and James Wyatt, the architects; and the imperious Countess Schwellenberg, who was Keeper of the Royal Robes, a position shared with Fanny Burney. Sir Joshua Reynolds, who had bought an inkstand to present to the Royal Academy (fig.

Fig. 172. Cup, by Wakelin and Tayler, presented by the Royal Exchange Assurance Company to Sir Richard Pearson, in 1780–1, embossed with a scene of the battle of Flamborough Head (1779). Silver (London); height 56 cm, 155 troy oz. Royal Naval Museum, Portsmouth

Fig. 173. Soup tureen and cover, by Wakelin and Tayler; 1780. Silver (London), length 40.5 cm, 105 troy oz

Fig. 174. Verrière, by Wakelin and Tayler; 1790. Silver (London); length 34.2 cm, scratch weight 49 troy oz 17 dwt

Fig. 175. Inkstand, by Parker and Wakelin, presented by Sir Joshua Reynolds to the Royal Academy on his appointment as first President; 1769. Silver (London); width 36.8cm. The Royal Academy, London

Fig. 176. Pair of presentation cups in the original red leather box, by Wakelin and Garrard. Engraved 'A PREMIUM from the SOCIETY for the encouragement of ARTS MANUFACTURES and COMMERCE to Lewis Majendi, Esq. Of Hedingham Castle, Essex for the Culture of BEANS and WHEAT in 1794'; 1795. Silver-gilt (London); height 17.5 cm, 27 troy oz 10 dwt

Fig. 177. Bill from Wakelin and Garrard to Lord Willoughby de Broke; 1807. Height 25 cm. Shakespeare Birthplace Trust

175) in the 1770s, returned as an account customer in 1784. In 1795 the Reverend Lewis Majendi celebrated his premium from the Society for the encouragement of Arts Manufactures and Commerce for the culture of beans and wheat, in 1794, with a pair of silver-gilt presentation cups, which survive in their original red-leather box lined in green velvet (fig. 176).[49] Their vase-shaped bodies, chased water-leaf decoration and bright-cut flower and ribbon cartouches are in the latest classical taste.

It must have been a bitter blow when Tayler died on 29 July 1792, 'at 3 in the morning aged 49'.[50] His obituary in the *Gentleman's Magazine* confirms this, notifying readers that 'Mr Wm Tayler goldsmith of Panton Street', died 'At Stockwell Surrey after a lingering illness'.[51] The day before he died Tayler drew up a codicil to his will, leaving 100 guineas to Samuel Ford 'my surgeon', and his house and furniture at Stockwell to Elizabeth, his doctor's wife. John Parker's patronage was acknowledged by Tayler in his will, which referred to his benefactor as his 'most esteemed friend and patron' and made Parker his sole executor.[52] Tayler left Parker, his wife and son £500 each. He left £1000 to his 'unfortunate' sister Ann Wheatly, 'to be invested in any of the Goverment funds', and instructed that the dividends should be paid to her half yearly. On her decease £100 was to be paid to her son, whom Tayler had apprenticed to a baker in Waltham Abbey.[53] His only other family seem to have been a half brother, Thomas Forrest, to whom he gave £500[54] (and a further £500 to his son Thomas Lister Forrest) and a half sister Mary, married to Stephen Vitou[55] of Blackmore, Essex, bequeathing her and her daughter, Mary Barrett, £100 each. Tayler left his partner John Wakelin, and his children Elizabeth and John £100 each. Hugh Brodie, silversmith of Rupert Street, and Honorius Crespel of Panton Street, witnessed his signatures on the will and its last minute codicils. Honorius was the son of Sebastian Crespel, a partner in Wakelin and Tayler's chief subcontracting firm, showing how personal and business affairs continued to be closely intertwined. Out of Mr Scott's appraisement of William Tayler's goods, John Parker acquired some linen, perhaps from a mixture of sentiment and economy which so characterized his other dealings.[56] It is likely that Scott was from the same firm of basket-makers who wickered the handles of Wakelin and Tayler's coffee pots.

John Wakelin, now bereft of a partner, looked to Robert Garrard, who had married Sarah Crespel in 1789. So, as before, the partnership remained within the 'extended' family (fig. 177). The business was styled as 'Wakelin and Garrard'[57] on their bill head, but often appears as 'Wakelyns' in customers' letters and diaries.[58] John Parker's son, Thomas Netherton Parker, was twenty-years- old at the time of Tayler's death, but his education at Eton and then Oriel College Oxford had prepared him for the life of a gentleman, not a businessman. John Parker's personal accounts include, in 1790, £70 'for furnishing and fitting up' his son's 'Rooms at Oriel' with a regular quarterly allowance of £55. In 1795 Thomas Netherton Parker gave the College a customary gift of silver, one dozen table forks in acknowledgement of his MA (fig. 178).[59] After a European tour[60] he received a commission of captain in the Worcestershire Cavalry, and in 1796 married the young heiress Sarah Browne of Sweeney Hall in Shropshire (figs 179, 180). Thomas Netherton devoted his time to the affairs of his country estates, publishing works on vicarial tithes, cottage economy and the problems of warming horticultural buildings.[61] His carefree easy-flowing writing in the family papers makes a distinct contrast to the neat and controlled hand of his father. Whereas John kept immaculate accounts, it is clear that Thomas Netherton Parker was not so careful. Although not actively involved with the Panton Street business he

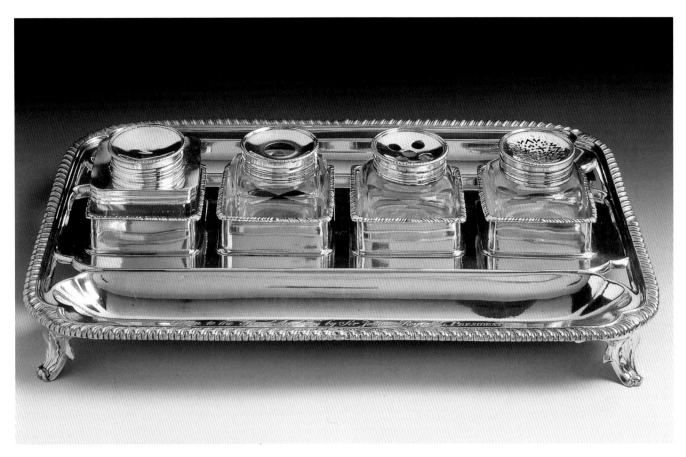

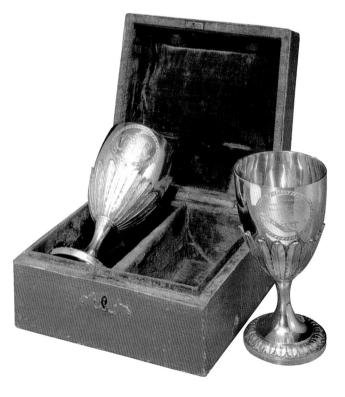

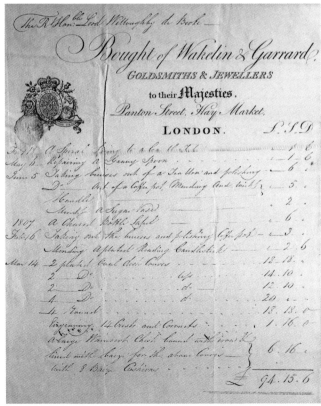

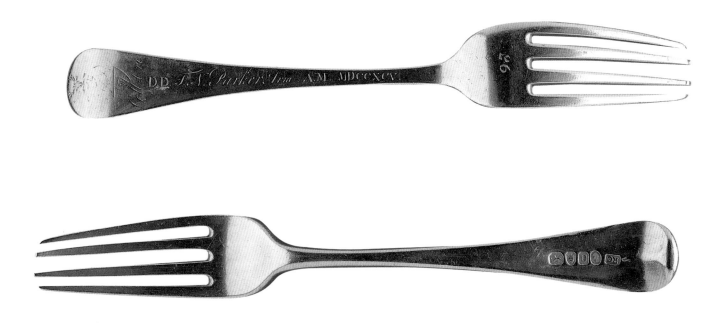

was still collecting rents for the property that his father had shrewdly acquired in London. But in 1807 'having so far overdrawn his credit with Mr Garrard', the current owner of the business, he had to remit £1,000 from a £3,000 bond debt owed by Garrard in consideration of his overspending.[62]

A surviving Workmen's ledger, which begins in 1792, reveals that Wakelin and Garrard were using an even larger network of specialist subcontractors than their predecessors.[63] Thomegay provided gold chains, Watson supplied diamonds which Clinton and Coles set. Miss Leaf strung pearls for necklaces, and was paid for six months' work with a silver teapot valued at £6 6s. Thomas Sevestre created mottoes in hair for mourning rings, and Hugh Brodie who had witnessed Tayler's will, supplied most of the firm's watches. C. Binger mounted swords and made gold boxes. Flight and Kelly made up tea caddies and knife boxes. The specialist silver suppliers included Northcote, who made spoons and forks, and William Stanfield, who provided castors and cruets. Hancock and Company continued to supply candlesticks. John Tylor sold them tea urns; Pitts and Preedy tureens and Daniel Pontifex teapots. Barnes and Company seem to have done most of Wakelin and Garrard's engraving, and the extensive account for DeCaix suggests he was their chaser, in 1796 he was paid for chasing '130 pieces of silver in masks'.

In the nineteenth century the firm had to face new challenges. The system of subcontracting which had been developing throughout the eighteenth century, so clearly revealed in the workmen's ledgers, now faced competition from the beginnings of mass production from Midland metalworking companies that satisfied the ever-growing demand for fashionable novelties. Robert Garrard's (1758–1818) early years in sole command from 1802, on the death of John Wakelin, were marked by dramatic changes in response to this competition. One of his first moves was to expand the retail premises, absorbing the corner site facing the Haymarket. A surviving stock book covering the period 1797 to 1805 reveals how Robert Garrard increased the stock from a value of £8,702 in 1802, to £10,141 the following year, reaching £13,531 in 1805. This was achieved by enlarging the range of goods, and increasing the quantity and quality of jewellery sold, as well as diversifying into a class of luxury goods such as travel bags. The next fifty years, which included their appointment as Crown Jewellers in 1843 marks a new phase in the history of the firm.

Fig. 178. Two of twelve forks presented by Thomas Netherton Parker to Oriel College, Oxford, marked by Richard Cooke; 1795. Silver (London). Oriel College, Oxford

Fig. 179. *Thomas Netherton Parker*, by Sir Martin Archer Shee (1769–1850). Oil on canvas; 66 × 53 cm. Private collection

Fig. 180. *Sarah Parker* by Sir Martin Archer Shee (1769–1850). Oil on canvas; 66 × 53 cm. Private collection

Appendix 1

LIST OF PARKER AND WAKELIN'S SUPPLIERS TAKEN FROM WORKMEN'S LEDGER NO. 2 (*c.* 1776–74) (VAM8)
* indicates account in previous and missing Workmen's ledgers

Goldsmiths and Allied Tradesmen

Refiners

BINNS, William	silver	1769–73
COX, Robert Albion	silver	1769–73
SPINDLER and PALMER	silver	1767–69*

Suppliers of Skills/Processes

CALER, Thomas	gilding	1769–71
CHAPELL, Robert and Son	gilding	1770–72*
CROCKETT, John	gilding	1770–73
CLEE, Robert	engraving	1770–73*
LANGFORD, John and SEBILLE and afterwards	piercing	1769–70
LANGFORD, John	piercing	1770–72
NASH, Thomas	piercing	1768–73

Suppliers of General Silverwares

ALDRIDGE, Edward and WOODNORTH, William	canisters, baskets, dish crosses, salts	1766–71*
ALDRIDGE, Edward	canisters, baskets, cruets	1771–72
ANSILL, James and GILBERT, Stephen	plates, tureens	1766–72*
BUTTY, Francis and DUMEE, Nicholas	tea urns, sauceboats	1768–72
CRESPEL, Sebastian and James	plates, tureens	1769–76
HERNE, Lewis, and BUTTY, Francis	tea urns, sauceboats	1766–68*
JONES, Thomas	tureens, sauceboats	1767–72
NORMAN, Phillip	sauceboats and flatware	1768–71
ROMER, Emick	sugar baskets etc.	1770–72
SMITH, Daniel and SHARP, Robert	tureens, sauceboats	1766–73
WHIPHAM I, Thomas and WRIGHT, Charles	cups, inkstands, tankards, vases	1767–69*
WRIGHT, Charles	inkstands, trowels, canisters, boats	1769

Suppliers of Specialist Silverware

ARNELL, John (with Edmund VINCENT to 1767)	candlesticks	1767–72
BOULTON, Matthew	candlesticks	1771

COKER, Ebenezer	candlesticks, waiters	1766–72*
CARTER, John	candlesticks, waiters	1767–73
HAMMOND, Thomas and Co. (becomes John CARTER in 1767)	candlesticks	1766*
CRIPPS, William	waiters	1766
CHANEL, Francis	cruets, frames	1767–68*
DANIELL, John [Jabez] and Son	cruets	1773
METHAM, Robert	cruets and baskets	1769–71
NASH, Thomas	cruets, castors, salts	1768–73
PIERCEY, Robert	cruets, frames, castors, bottle tickets, salts	1766–72
GARDNER, Richard	coffeepots, sauceboats	1770–71
WHYTE, David	cups and covers only	1770–72
VINCENT, William and LAWFORD, John	épergnes, baskets	1767–68*
LAWFORD, John	épergnes, baskets	1768–70
PITTS, Thomas	épergnes, tureens	1766–72*
LESTOURGEON, William and Son [Aaron]	canisters, funnels	1767–71*
LESTOURGEON, Aaron	canisters, funnels	1771–72
HENNELL, Robert and David	salts	1766–71*
BRIND, Walter	panakins and papboats	1768–74*
COWPER, Benjamin	spurs	1771
CALLARD, Isaac	forks and spoons	1766–70*
CHAWNER, William and Thomas	spoons, tea and salt	1766–71*
CHAWNER, Thomas	spoons, tea and salt	1772
PORTAL, William	knife and fork hafts	1766–72*
RAINAUD, Philip	forks and spoons	1772–73
SQUIRE, Thomas	blades and tines	1766–76*
TOOKEY, James	spoons, tea and salt	1766–68*
WOOD, Christopher and FILKIN, Thomas	forks and spoons	1770–72

Suppliers of Sheffield Plate

HANCOCK, Messrs and Sons	candlesticks	1768–72
HOYLAND, John and Co.	candlesticks	1772
TUDOR, SHERBURN and LEADER	punch ladles, snuffer pans	1767–68
WINTER, Robert Elam	candlesticks, dish crosses	1767–72
(becomes) WINTER, PARSONS and HALL	candlesticks, dish crosses	1772

Suppliers of French Plate

LEGRIX, John	French plate	1767–75

Suppliers of Boxes, Cases, etc.

COLLINS, Michael	chests	1771–73
DARVIS, Edward	tea chest furniture	1773
SMITH, Edward	plate chests	1769–73
WESTRY, John	chests, furniture, e.g. locks, handles, etc.	1766–73*

Jewellers and Allied Tradesmen

CHARPENTIER, Gideon Ernest	general bills	1771
FORREST, Thomas	general bills	1770–73
HOLMES, Edward	general bills	1767–74
PAYAN, Daniel	general bills	1770–73
SHUCKNELL, Michael	general bills	1767–73
PADMORE, George	buttons, buckles	1766–72*
RIVIERE, Isaac	buttons, thimbles	1768–73
TOUSSAINT and MORRISSET, James	enamelled goods	1768–72
HAYENS, Henry	filigree	1770–73*
BARBOT, John	gold work	1767–75
DERUSAT, John	gold work	1768–72*
EVANS, James Morley	gold chains	1767–72
RUSSEL, Elias	gold work	1767–73*
PEPPER, John	pocket books	1769–74
CREUZE, Francis and John	precious stones, pearls	1766–74
WOOD, John	precious stones, pearls	1771–75
PRICE, Edmund	rings and pocket books	1766–73
FREWIN, Richard	seal engraver	1769–72
RUSH, Samuel	seal engraver	1767–71*
COWPER, Benjamin	spurs	1771–3*
BINLEY, Richard, (and afterward BINLEY, Margaret)	stringing	1767–68
HOWELL, Thomas	stringing	1768–72
LUCAS, Joseph	watches	1767–73*

Appendix 2

ABERGAVENEY, Hon. Lord
ADAIR, Esq. William, Pall Mall
AISLABIE, Esq. William (c.1699–1781)
ALDERSON, Esq. John
AMYAND, Esq. Claudius (1714–74)
ARMSTRONG, Miss
ARMSTRONG, Hon. Gen. (Ledger 7)
ASHBURNHAM, Rt. Hon. Earl of
BAGGE, Esq. Thomas Lynn
BAGOT, Sir William (1728–98)
BEAVER, Esq. Thomas
BENNETT, Mrs
BENNETT, Esq. Richard Henry Alexander
BESSBOROUGH, Rt. Hon. Earl of (1704–93)
BEST, Esq. James (Ledger 7)
BETHELL, Captain Christopher
BILLIER, Esq
BLAKE, Miss
BOLINGBROKE, Rt. Hon. Lord Viscount
BOONE, Esq. Charles
BOSTON, Rt. Hon. Lord, Dead (1706–1775)
BOYD, Esq. John (1718–1800)
BOYLE, Hon. Bellingham
BOYNE, Esq. Charles
BOYNTON, Sir Griffith (1745–78)
BOURCHIER, Gov. Charles
BOURCHIER, Mrs
BOUVERIE, Hon. Miss
BOUVERIE, Hon. Mrs (Ledger 7)
BRAND, Esq. Thomas (1717–70)
BROMLEY, Esq. Robert
BROWNE, Esq. Samuel, Lynn (1732–1803)
BRUCE, Rt. Hon. Lord
BUCKINGHAM, Rt. Hon. Earl of
BUDGEN Esq. Thomas, Dead (d.1772)
BUDGEN, John Smith
BULL, Esq. Richard (1721–1805)
BURDETT, Esq. Francis
BURDETT, Sir Robert (Ledger 7)
BURGHERSH, Rt. Hon. Lord
BURGOYNE, Hon. Gen. (1739–85)
CAILLEUD, Hon. Gen. (1724–81)
CALVERT, Esq. Nicolson (1724–93)
CALVERT, Esq. Peter, Red Lion Square
CAMPBELL, Rt. Hon. Lord Frederick (1729–1816)
CANTERBURY, His Grace the Lord Bishop of (1713–83)

CAREY, Hon. Gen.
CARLISLE, Rt. Hon. Earl of (Ledger 7)
CARNARVON, The Most Noble Marquess of (1706–71)
CARR, Esq. Ralph
CARVALHO, His Excellency Mr (1699–1782)
CAVENDISH, Rt. Hon. Lord Frederick (Ledger 7)
CHAMPNEYS, Sir Thomas, Bart.
CHANDOS, Duke of (1731–89)
CHAPMAN, Sir John
CHESTERFIELD, Lady (1693–1778)
CHESTERFIELD, Rt. Hon. Lord, Dead (1694–1773)
CLARKE, Hon. Coll
CLARKE, Esq. John, Mrs Tryon's friend
CLAYTON, Lady Dowager, Dead
CLAYTON, Sir Kenrick, Dead
CLAYTON, Esq. Robert
CLIVE, Esq. George
CLUTTON, Esq. Owen (d.1796)
COCKS, Esq. Joseph
COLMORE, Mrs
COMPTON, Esq. Henry
COPLEY, Esq. Joseph Moyle
CORNWALLIS, Rt. Hon. Earl of (1738–1805)
COTSFORD, Esq.
COTTON, Rev. Dr
COVENTRY, Rt. Hon. Earl of (1722–1809)
COX, Esq. Richard
CRAYLE, Esq. (Ledger 7)
CROFT, John
CUMBERLAND, His Royal Highness Duke of (1745–90)
CURZON, Esq. Asheton, (1730–1820)
DALLING, Hon. Coll (Ledger 7)
DAY, Esq. John, Mr Norton's friend
DARNLEY, Rt. Hon. Earl of (1719–1807)
DAYROLLES, Esq. Soloman (1739–86)
DELAMER, Lady
DELAMER, Rt. Hon. Lord, Dead
DELAVALL, Sir John Hussey (1728–1808)
DEMELLO, His Excellency, Mr
DERING, Sir Edward (1732–98)
DOILEY, Rev. Mr Matthew (Ledger 7)
DOWDESWELL, Esq. William (1721–75)
DRAPER, Hon. Gen. (1721–87)
DUMMER, Esq. Thomas
EDWARDS, Esq. Gerard Ann
EGERTON, Sir Thomas (1749–1814)

EGLETON, Lady
EGLETON, Sir Charles, Dead
ELLIS, Rt. Hon, Wellbore (1713–1802)
ERNLE, Sir Michael
EXETER, Rt. Hon. Lord Bishop of
EXETER, Rt. Hon. Earl (1725–93)
FAIRFIELD, Esq. Richard
FARNABY, Captain
FARNHAM, Rt. Hon. Earlof (d.1771)
FAUQUIER, Esq. Francis, Argyll Street (1704–68)
FELLOWS, Esq. William
FENOULET, Esq. James
FERNES, Rt. Hon. Lord Bishop of
FITTER, Esq. James
FORTESCUE, Esq. James
FORTESCUE, Rt. Hon. William Henry (1722–1806)
FOX, Hon. Stephen now Lord HOLLAND (1745–74)
FREEMAN, Esq. Sambrook (1727–1800)
GAINSBOROUGH, Rt. Hon. Earl of (1743–95)
GALWAY, Rt. Hon. Lord Viscount
GILLET, Mrs, now Laprimaudez
GLENN, Hon. Gov.
GLOUCESTER, His Royal Highness Duke of (1743–1805)
GOOCH, Sir Thomas, Bart. (d.1788)
GRAFTON, His Grace Duke of (1735–1811)
GRANT, Rev. Mr, of Ilford
GRANT, Mrs (Ledger 7)
GRANTHAM Rt. Hon. Lord (1738–86)
GREENE, Esq. Edward Burnaby (d.1788)
GRESHAM, Sir John
GREVILLE, Esq. His Excellency Fulke (1717–1809)
GRIEVE, Davidson Richard 'a Grievous fellow'
GRIFFIN, Sir John (1719–97)
GROSVENOR, Esq. Thomas (1734–95)
GUILFORD, Earl of (1704–90)
GULSTON, Esq. Joseph (1744–84)
GWILLYM, Esq. Richard Vernon Atherton (d.1783)
HAGATT, Esq.
HALIFAX, Rt. Hon. Earl of (1716–71)
HAMILTON, Rt. Hon. Lord Archibald
HARCOURT, Hon. Coll. (Ledger 7)
HARCOURT, Rt. Hon. Earl of (1736–1809)
HARDY, Sir Charles (1716–80)
HARE, Rev. Dr
HARE, Hon. Captain, Dead
HARMAN, Rev. Dean
HARRINGTON, Rt. Hon. Earl of (1719–84)
HATTON, Hon. Edward, Dead
HATTON, Mrs, Portman Square
HEATHCOTTE, Esq. John
HEATHCOTTE, Sir Gilbert
HENRY, His Royal Highness Prince (1723–85)
HERVEY, Hon. Comm. now Lord Bristol (1724–79)
HERVEY, Francis
HILDYARD, Robert D'Arcy (1743–1814)
HOBART, Esq. Hon. George
HOLDERNESSE, Rt. Hon. Earl of (1718–78)
HOLDERNESSE, Countess
HOLLAND, Rt. Hon. Lord (1705–74)
HORT, His Excellency Sir John
HOUBLON, Sir Edward

HOW, Esq. John
HOW, Hon. Captain
HOW, Mrs (Ledger 7)
HOWE, Rt. Hon. Lord Viscount (1729–1814)
HUBBALD, Esq. James
HUBBALD, Mrs
HULSE, Sir Edward (1715–1803)
IBBETSON, Esq. John
INGE, Mrs (Ledger 7)
JENNINGS, Esq. George (1721–90)
JEPHSON, Esq. Alexander (d.1768)
JOHNSTONE, Hon. Coll.
JONES, Esq. John, George Street
JONES, Miss
KECK, Esq. Anthony (1708–67)
KEENE, Whitbread, Hill Street (1731–1822)
KENNION, Esq. John
KENT, Esq. Charles
KILBY, Mrs
KILBY, Christopher, Esq.
KILDARE, Marquess of, now Duke of
LEINSTER (1722–73)
KILMOREY, Rt. Hon. Lord Viscount (1710–91)
KNATCHBULL, Sir Edward (d.1819)
KYNNERSLEY, Clement, Esq.
LAMB, Sir Penniston, now Lord
MELBOURNE (1745–1828)
LAWRENCE, Dr
LEE, Captain
LEGH, Mr
LEGH, Mrs
LEINSTER, Duke of, Dead (1722–73)
LETHIEULLIER, Esq. Christopher (1712–78)
LEWIS Esq. William
LONG, Esq. Richard (Ledger 7)
LYNES, Mr
MACCLESFIELD, Rt. Hon. Earl of (1723–95)
MACEY, Mrs, Dean Street
MALING, Esq. Christopher Thompson
MANN, Sir Horatio (1744–1814)
MANNERS, Rt. Hon. Lady Robert
MANNERS, Rt. Hon. Lord James
MARCH, Rt. Hon. Earl of (1724–1810)
MARCH, Sir Charles, Pall Mall
MARLBOROUGH, His Grace Duke of (1738–1817)
MARSH, Esq.
MARTIN, Esq. James
MARTIN, Esq. John (1724–94)
MARTIN, Esq. Joseph, Dead (1726–76)
MARTIN, Mrs
MEADE, Esq. Thomas
MEADE, Mrs (1730–1803)
MIDDLETON, Esq. Richard (1726–95)
MILBANKE, Sir Ralph (1721–98)
MILL, Sir Richard
MILTON, Rt. Hon. Lord
MITCHELL, His Excellency Sir Andrew, Dead (1708–71)
MOLYNEUX, Rt. Hon. Lord Viscount (1748–95)
MONFORT, Rt. Hon. Lord
MONSON, Hon. Coll. Thomas (1727–74)
MONSON, Rt. Hon. Lord

MONTAGU, Edward, Hill Street, Dead
MONTAGU, Mrs, Hill Street (1720–1800)
MORDAUNT, Hon. Coll. (1697–1780)
MORDAUNT, Esq. John (1697–1780)
MORRICE, Esq. Humphry
MOSTYN, Captain (Ledger 7)
MUGLEWORTH, Esq. Henry
MUSGRAVE, Esq. Joseph (Ledger 7)
MUSGRAVE, Sir Philip
NAPIER, Hon. Gen., Dead
NEVIL, Rev. Mr (Ledger 7)
NEWDIGATE,. Sir Roger (1719–1806)
NORTH, Rt. Hon. Lord (Ledger 7)
NUNEHAM, Rt. Hon. Lord Viscount
ONSLOW, Esq. George (1731–92)
ONSLOW, Rt. Hon. Lady
OSBERN, Miss
OSBERN, Hon. Admiral, Dead
PAGE, Sir Gregory
PALMER, Sir John (1735–1817)
PANTON, Esq. Thomas
PARKER, Esq. John, Sackville Street
PECHELL, Hon. Coll.
PELHAM, Esq. Charles
PENRUDDOCKE, Esq. Charles (1743–88)
PENTON, Mrs
PENTON, Rev. Mr
PERROTT, Esq. John
PITT, Esq. Thomas (1737–93)
PITT, Hon. Gen.
PRATT, Esq. John, Brewer Street, Soho
PRATVIEL, Esq. Edward
RADNOR, Rt. Hon. Earl of (1724–76)
RICE, Rt. Hon. George (1724–79)
RICHARDSON, Esq. Piercy Street
RIGBY, Rt. Hon. Richard (1722–88)
ROCHFORD, Rt. Hon. Earl of (1717–81)
ROSEBERY, Rt. Hon. Earl of (1729–1814)
RYVES, Esq. Thomas
St. QUINTIN, Esq. William (d.1791)
SANDYS, Rt. Hon. Lord Edwin (1726–1797)
SARGENT, Esq.
SAUNDERS, Esq. James (Ledger 7)
SAUNDERS, Esq. Thomas
SAUNDERS, Rt. Hon., Sir Charles (1713–75)
SAVAGE, Esq. Thomas Byrche
SAWBRIDGE, Esq. John (1732–95)
SAWYER, Esq. Herbert (Ledger 7)
SAYER, Esq. James, Palace Yard
SCARBOROUGH, Rt. Hon. Earl of (Ledger 7)
SCIAEVIALVYA, Esq. Joseph
SEBRIGHT, Sir John (1725–94)
SEDLEY, Sir Charles
SELWYN, Esq. George Augustus (1719–91)
SHAW, Sir John

SHARP, Esq., Dead, Golden Square
SHELBURNE, Rt. Hon. Earl of (1737–1805)
SHEPHERD, Esq. Edward
SOUTHWELL, Esq. Edward
STEPHENS, Esq. Philip (1723–1809)
STRATFORD, Rt. Hon. Edward (1740–1801)
STRICKLAND, Sir George
STRODE, Esq. Samuel, Dead
SYMONS Esq. Richard
TALBOT, Hon. John Chetwynd (1749–93)
TAYLOR, Esq., Portland Street
TEMPLE, Sir Richard
THOMOND, Rt. Hon. Earl of (1723–74)
THOMPSON, Mrs
THOROTON, Esq. Thomas (1723–94)
THURSBEY, Esq. Harvey
TOMLINSON, Miss
TOWNSHEND, Rt. Hon. Charles
TRACY, Esq. Dodwell, Dead
TRACY, Mrs
TREFUSSIS, Esq. Robert
TREVANION, Esq. John
TREVANION and WOOD, Messrs
TRYON, Esq. Charles, Dead
TRYON, Mrs, now Clarke
TRYON, Rev. Mr
UPTON, Esq. Clotworthy
WALBANCKE, Mr Edward
WALDEGRAVE, Countess (1736–1807)
WALDEGRAVE, Rt. Hon. Earl of (1718–84)
WALKER, Esq. Thomas, Soho Square
WALLIS, Esq. James (Ledger 7)
WALLIS, Esq. Samuel, Norfolk Street
WALTER, Esq. John Roll (1714–79)
WALTHAM, Rt. Hon. Lady
WALTHAM, Rt. Hon. Lord
WATSON, Mrs, Camberwell
WEBB, Hon. Gen.
WESTMORLAND, Rt. Hon. Earl of, Dead
(1700–71)
WEYMOUTH, Rt. Hon. Lord Viscount
WHEATE, Lady
WICKENS, Rev. Mr
WINCHESTER, Rt. Hon. Lord Bishop of
WINDHAM, Mrs
WILLIAMS, Esq. Mrs Vanderwall's son
WILLIAMS, Esq. John, Mrs Browne's friend
WINNINGTON, Sir Edward (1727–91)
WODEHOUSE, Esq. John
WOOD, Esq. Thomas
WOODLEY, Esq. William
WYNN, Esq. Thomas (1736–1807)
YORK, Sir William
YOUNG, Mrs, Albemarle Street
YOUNG, Sir William

Notes

CHAPTER 1

1. Picard 2001, p. 296.
2. Huntington Library, California, Montagu Papers, MO 1175 A and B, Elizabeth Montagu to Henry Homes, Lord Kames, 13 April 1767. Mrs Montagu's comments were incorporated into Lord Kames' *Elements of Criticism*, 1780.
3. Skinner 1981 (1776), p. 225.
4. Skinner 1981 (1776), p. 134.
5. Skinner 1981 (1776), p. 135.
6. Latham 1993, p. 196, 21 May 1661.
7. *See* Hare 1978. The earliest English ordinance relating specifically to goldsmiths dates from 1238, which not only set the standards of fineness for gold and silver but commanded the Mayor and Aldermen of London to select six goldsmith wardens, to superintend the craft.
8. 'Our Traitorous Money makers', in Brewer and Styles 1980, pp. 172–242. The distribution of silver and gold in the 18th century was governed by a gold standard which worked to encourage the export of silver.
9. James Stewart, *An Enquiry into the Principles of Political Economy*, 1767, quoted in Williams 1997, p. 177.
10. Mayhew 1999, p. 111.
11. Quinn 1995, p. 76.
12. Goldthwaite 1989, p. 34.
13. Braudel 1982, p. 538. Colbert was associated with mercantilism, which has been equated with a prehistory of industrial and economic development dominated by princely courts, luxury goods, restrictive guild practices and a misguided obsession with trade balances and bullion flows, but *see further* Sonenscher 1998, pp. 232–3.
14. Braudel 1982, p. 540.
15. *A Relation of the Island of England about the year 1500*, trans. C. Sneyd, Camden Society, xxxvii, 1847, pp. 42–3.
16. Rush 1987, p. 34.
17. Parker and Wakelin's Gentlemen's Ledger records that Phillip Stephens paid £43 18s. for just such a silver tea urn.
18. Brown 1995, p. 97.
19. Skinner 1981 (1776), p. 235.
20. Quoted in Glanville 1987, pp. 106–7, from Ketton-Cremer, *Norfolk Assembly*, 1957.
21. Kenyon 1995, p. 132. 28 December 1809, Nellie Weeton writes to her friend Bessy Winkley, describing her first evening at her new employers, the Pedder's; Home, Dove Nest.
22. Taylor 1963, p. 214.
23. Forbes 1998, p. 319.
24. *See* V. Brett, 'The Compleat Appraiser, an eighteenth-century manual and 'the valuing of plate', *Silver Society Journal*, 2003, p. 7, on the new Duty on Plate which encouraged 'the Public to sell . . . but it is plain, this cannot be the price for long; because refiners have not, on account of this Act, made the least Alteration in the Value of Silver to those who buy it to work up'.
25. Prideaux 1896, pp. 265–7.
26. Croome Archives, F60D/7, Bills for Silver and Jewellery, Parker and Wakelin, Panton Street, 30 June 1769.
27. Croome Archives, F60D/4, Bills China and Glass, Charles Vere at the Indian King, Salisbury Court, Fleet Street, 22 February 1768.
28. Young 1999, p. 166.
29. Mallett 1969, p. 100.
30. *See* Mrs Papendieks' comments to Queen Charlotte, 1762, quoted in Young 1999, p. 178.
31. Young 1999, p. 182.
32. McCracken 1990, p. 39.
33. Eatwell 2000, p. 63.
34. Brunner 1967, p. 23.
35. Reitlinger 1963, vol. II, p. 8.
36. Crane 1883, *Art and the Formation of Taste*, p. 29, quoting Lucy Crane, Walter Crane's sister.
37. Culme 2000, p. 34.
38. Culme 1999, p. 7.
39. Culme 1999, pp. 1–8.
40. Culme 1987, vol. I, p. xxxvi.
41. Now in the collection of the Museum of Fine Arts, Boston; *see* Alcorn 2000, cat. no. 115, pp. 188–90.
42. Clifford 1998, p. 99.
43. Brewer 1993, p. 341.
44. Defoe 1987 (1727), p. 188.
45. Defoe 1987 (1727), pp. 15 and 187.
46. Brasbridge 1824, p. 82.
47. For brief histories of Garrard, *see* Broadley 1912; Lever 1974, pp. 94–8 and Lever 1975, pp. 140–62; Clifford 1987, for seventeenth and eighteenth centuries; Barr 1980, for the nineteenth and twentieth centuries; Culme 1987, pp. 172–5 and Culme and Gere 1993. In 1911 the business moved from Panton Street to 24 Albemarle Street and 17 Grafton Street. The business was absorbed into the Goldsmiths and Silversmiths Company Ltd in 1952, when they moved from Albemarle Street to 112 Regent Street. Until their amalgamation with Aspreys in 1998 they were a subsidiary of Mappin and Webb Ltd; 2002 celebrates their relaunch and return to Albemarle Street.
48. For full listing with dates *see* bibliography. There are as many ledgers again down to the end of the 19th century.
49. SRO 2868/93 partnership agreement, 1760.
50. Defoe 1987 (1727), p. 311.
51. Postlethwayte 1766, vol. 2, under 'Ledger'.
52. Harris 1986, vol. 1, p. 232.
53. Harris 1986, vol. 1, p. 183.
54. Lonsdale 1989, p. 121, Mary Barber (*c.* 1690–1757).
55. John Gay, *Polly: an Opera; Being the Second Part of the Beggar's Opera*, Act I, Scene I. 1728.
56. Kent Record Office, Darnley Papers, U565/F11.
57. Fairclough 1995, p. 376. By 1781 he had spent over £4,500 on silver.
58. 'Current Art Notes', *The Connoisseur*, vol. XL, December 1914, no. CLX, p. 239.
59. Huntington Library, California, Montagu Papers, MO1175 A and B, Elizabeth Montagu to Henry Home, Lord Kames, 13 April 1767.
60. Rush 1987, p. 137.
61. Malcolm 1808, vol. II, p. 237.
62. Coke 1889, vol. II, p. 21, 9 June 1767.
63. Coke 1889, vol. II, p. 37, 27 June 1767. This plate Lady Mary left to her nephew, the Duke of Buccleuch's second son, Lord Montague. In 1888 it was in the hands of Lord Montague's grandson, Lord Howe.
64. 'Current Art Notes', *The Connoisseur*, vol. XL, (December 1914), no. CLX, p. 239.

CHAPTER 2

1. Barr 1980, pp. 197–205.
2. Packer 1997, p. 78. Folkingham's Orphan's Court Inventory, 1729, CLRO Orph. Inv. 3330a and b, lists Wickes as creditor; Folkingham's shop at the Golden Ball was very close to Threadneedle Street.
3. Sir Robert Walpole became a customer of Wickes in 1737, *see* VAM1, p. 137.
4. Craig died in 1736, his widow, Ann, took

John Neville as her partner, who subsequently went bankrupt 10 June, 1746 B4/11, 156, and again in 1753, *see* PRO B1/22, 52, 1/23.262 and 4/12.302; and Grimwade 1990, p. 760.

5. SRO 2868/39 copy settlement 23 April 1737, releasing the property from Amy Alexby, widow, to George Wickes.

6. SRO 2868/29; Summerson 1962, p. 43.

7. Cruikshank 1985, pp. 22–3.

8. *Survey of London*, vol. xx, Trafalgar Square and Neighbourhood (Parish of St Martin's, part III, 1940, pp. 101–2.

9. *See* first page of the first surviving ledger, entered 24 June 1735, total cost £364 10s. 2d. including payments to carpenter, painter, joiner, carver, glass grinder, sign painter, bricklayer, plumber and glazier

10. Skinner 1981 (1776), part I, p. 221.

11. Barr 1980, p. 26.

12. Shop bill in possession of Garrards. *See* VAM1, p. 77, 24 March 1735 for first orders from the Prince of Wales.

13. Although Netherton retired he did not give up his interest in trade, he appears as one of the subscribers to *The American Negotiator: Or the Various Currencies of the British Colonies in America*, 1761, along with the goldsmiths Edward Aldridge, William Chawner, James Tookey and Charles Wright.

14. Campbell 1969 (1747), p. 29.

15. Hoppit 1987, p. 35.

16. Grimwade 1974, p. 9.

17. Staffordshire Burial Index, with thanks to Tony Bowers from the Birmingham and Midland Society for Genealogy and Heraldry for finding this entry. There is an entry for an Edward Wakelin, 31 July 1663, for the same place, who may have been a relative. It is possible that Edward's family were connected with the Wakelins, who were glassmakers who had moved from Abbots Bromley to Bristol in the late 1400s. CLRO Indenture signed 3 June 1730, 'Edward Wakelin Son of Edward Wakelin late of Uttoxeter in the County of Stafford Baker Decd', premium £21.

18. Murdoch 1995, p. 251.

19. Mildmay 1977, p. 43; Lincoln Record Office, Monson Papers.

20. By the 18th century the Goldsmiths' Company ordained that 'no apprentice is to be taken for a shorter term than seven years unless he is apprenticed to his own father or has received instruction in the craft before', and that the apprentice be of a 'competent age ... of 11,12,13, 14 years or more', Reddaway and Walker 1975, p. 228.

21. According to Grimwade 1990, p. 580, Simon Le Sage, quoting from Heal, worked from his father's premises from 1739, till he left business in 1761. Augustus (or Augustin), presumed younger brother of Simon, recorded by Heal as a goldsmith and clockmaker, Great Suffolk Street 1755–84, St James's Haymarket 1790.

22. Hartop 1996, p. 128.

23. VAM4.

24. VAM4.

25. IGI, marriage allegation, Ely Chapel, 7 May 1748, the Rev Charles Allen officiating, which gives Edward Wakelin's year of birth as 1718.

26. Bumpus 1907, pp. 111–12. The Chapel of St Etheldreda in Ely Place, Holborn, was once the magnificent town house of the Bishops of Ely, built at the close of the thirteenth century.

27. VAM1, p. 20, 7 July 1735, Mrs Allen paid cash for a tea pot £4 14s., and ten flowered rings.

28. Register of Baptisms, Westminster, St Martin's in the Fields.

29. Register of Baptisms, St Martin's in the Fields. Edward must have pre-deceased his father, as he is not mentioned in his will, drawn up in 1779.

30. VAM4.

31. VAM4, pp. 1 and 11. Includes references to sister Betsy, brother William for schooling, John Allen, and a bill from an undertaker, 24 May 1747.

32. Christie's London, 11 November 1993, lot 224.

33. Christie's London, 11 November 1993, lot 225.

34. Christie's London 18–19 October 1983, lots 281 and 282, Edward Wakelin, 1747.

35. Grimwade 1990, p. 691.

36. Goldsmiths' Company Archive, Apprentice Book 1740–63, no. 7, p. 106–7; September 1748, son of James Ansill of the Parish of Stow in the County of Stafford Husbandman. Free 1 January 1764.

37. Goldsmiths' Company Archive, Apprentice Book 1740–63, no. 7, p. 136, 2 May 1750, son of Nathaniel Bray late of the Parish of St Mary Lothbury Diamond Cutter, 20 September 1753 (possibly a relation of John Bray, Churchwarden, Longdon Church), turned over to William Priest Goldsmith. Premium £30. Free 7 February 1759.

38. Goldsmiths' Company Archive, Apprentice Book 1740–63, no. 7, p. 176, 8 May 1752, son of John Gilbert late of Hixton in the County of Stafford yeoman. Free 1 February 1764.

39. Goldsmiths' Company Archive, Apprentice Book 1740–63, no.7, p. 183, 5 October 1752, son of John Arnell of Paddington in the County of Middlesex, weaver apprentice to John Quantock. Turned over to Edward Wakelin 6 December 1758.

40. Ashmolean Museum, Douce Collection. A. Kirk was aged fourteen and I. Kirk aged eighteen when they invented and executed the engraving. A shop bill of 'John Kirk, Engraver' *c.*1789 informs us that he worked at premises on the north side of St Paul's Churchyard and engraved 'Stone, Steel, and Silver Scals, also Dies for Tickets ... masks, Leaves, Shells and any other ornaments for Jewellers Work. Workmen's marks and all other Stamps whatever', *see* Heal 1927, p. 25, pl.xiii.

41. VAM4, pp. 1 and 11.

42. Sotheby's New York, 23 April 1993, lot 479, includes four candlesticks by Soloman, 1756, and three more to match, bearing the marks of Parker and Wakelin, 1763.

43. VAM4, pp. 19 and 28.

44. *Parliamentary Report* 1773, p. 71.

45. Campbell 1969 (1747), p. 34.

46. Barr 1980, p. 120. Their origin derives from one of the clients, a Mrs Horton, an actress who took minor parts at Covent Garden and played with Garrick at Drury Lane in 1751, who regularly settled her bills in kind, including silver pit tickets.

47. Colin Freebrey, 'The Work of Emick Romer (1724–99) Norwegian Silversmith in London', unpublished MA thesis, University of Oslo, 1976. According to the IGI, he married Millecent Bennett of Clifton, Gloucestershire.

48. Grimwade 1990, p. 766, from Judith Banister, 'In the Cause of Liberty', *Country Life*, 12 November 1981. *See* PRO IR1/19 f105 for Edward Norton Storr, and IR1/21 f101 for Thomas Storr. Robert Barker suggests that Stephen Romer, apprenticed to Edward Brignall, of St Dunstan jeweller, April 1763 (IR1/23 f165) and John Romer apprenticed to Frederick Hershall of St Martin's Silver Chaser January 1765 (IR1/24 f93) could be his sons.

49. VAM4, pp. 22, 30 and 77.

50. Glanville and Goldsborough 1990, p. 17.

51. VAM4.

52. The loan appears as regular payments made to Netherton in Wakelin's personal account in the Workmen's Ledger, VAM8, pp. 64 and 167, e.g. 'pd Mr Netherton's a Yrs Interest on £100. due'.

53. Westminster City Libraries, Collector's Books: Paving Rate E1720, 13 October 1768 and Poor Rate F6018, 1768. Successive leases survive for this property, SRO 2868/45 lease 20 March 1695; 2868/48 20 February 1805; 2868/50 30 December 1817, and the last when the property was sold outside the firm 2686/59 23 December 1856.

54. SRO 2868/45.

55. SRO 2868/48 'Counterpart Lease for 14 years from Midsummer 1805 corner house in Oxendon street on the East side and North side of Panton street'.

56. SRO 2868/310, built according to Thomas Netherton Parker, at the time Thomas Parker married his second wife Catherine Monox at Longdon, 16 June 1589.

57. HWRO BA5658 class f899:499. *See* further, 'The remains of a formal garden at Longdon Hall', *Hereford and Worcester Gardens Trust Newsletter* Summer 1996, pp. 6–7. My thanks to Mrs Pat Unwin for drawing my attention to this article.

58. SRO 2868/260 copy attested will of Thomas Parker of Longdon, 28 December 1744.

59. PRO:PCC PROB11/788–185.

60. Chesterfield 1984, p. 273, 25 December 1753.

61. Campbell indicates that goldsmiths' premiums ranged between £20 and £50,

which was comparable to mathematical and optical instrument makers, upholders and distillers; cheaper than brewers, coachmakers and mercers who required £50 to £200, and more expensive than armourers, cutlers and gold beaters who gave between £5 and £20.

62. Grassby 1997 p. 46. *See* Edmund Bolton, *The Cities Great Concern, In this Case or Question of Honour and Arms Whether Apprenticeship Extinguish Gentry? Discoursed with a Clear Refutation of the Pernicous Error that it Doth*, 1674.

63. These sons of gentlemen who entered the goldsmiths' trade were, however, outnumbered by those who came from trading backgrounds: Phillips Garden was the son of a London draper, Thomas Heming's father had been a mercer from Ludlow, and David Hennell came from a family of Buckinghamshire framework knitters. Both Thomas Gilpin and Thomas Whipham were the sons of Bedfordshire innkeepers.

64. Wedgwood 1903, vol. I, p. 51, Josiah Wedgwood to John Wedgwood, 2 August 1765, writing about keeping a man in London.

65. SRO 2868/258, bequeathed to him in the will of John Rogers of Haresfield, whose sister had married Thomas Parker of Longdon in 1684.

66. The premises valued at £500.

67. British Museum, Department of Prints and Drawings, Banks and Heal Collection.

68. Ponsford 1978, p. 32.

69. Moritz 1965, p. 24.

70. Brasbridge 1824, p. 51.

71. SRO 2868/93.

72. Portal 1993, p. 25.

73. Compare with other partnership contracts; for example, those in PRO Chancery Masters Exhibits, C.104.141, draft partnership agreement between Alexander Cook and John Nemes, merchants, 1746; C.107.149 Mrs Cornelys and John Fermor 1761 for concerts, balls and assemblies. C.112.181 part 2 between Samuel Ward gold and silver refiner and Thomas Price button maker, both of Birmingham 1776; C.107.104 articles of co-partnership Davies, Owen Swanton and Evans 1773 and David Jones, Owen and Hope, hatmakers 1785.

74. Rhys 1946, p. 239, *The London Merchant: or, the History of George Barnwell*, 1731.

CHAPTER 3

1. Schwarz 1993, p. 127.
2. Schwarz 1993, p. 128.
3. Raven 1992, p. 163.
4. Schwarz 1993, p. 7.
5. Sabor and Doody 1988, p. 454.
6. Defoe 1987 (1724), p. 300.
7. Thomas Bowles' engraving of Cheapside in about 1750 helps give some impression of the size and impact of these signs.
8. Summerson 1962, p. 124.
9. Smollet 1972, p. 87.

10. Rouquet 1755.
11. Stokes 1931(1), p. 50, 24 October 1765.
12. Quoted in Whitley 1928, p. 19.
13. Lewis 1941, p. 23.
14. Defoe 1726, p. 67.
15. Malcolm 1808, p. 404.
16. John Carpenter, a pewterer, occupied the corner premises fronting the Haymarket, but according to the additions to the *Handbook to the Royal Hospital Chelsea*, he died in 1738; his widow, presumably Elizabeth Carpenter, continued the business, *see* Cotterell and Heal 1926, p. 225.
17. These details are clearly visible in Tallis' depiction of the Haymarket published in his *London Street Views*, 1838.
18. Referred to as 'Yeats House' in the firms ledgers; WCA E1720 Paving Rate Book 1768 records payments by Alexander Yates.
19. For example, VAM11, p. 95, 27 June 1782, Mrs Hickford's account, and Broadley 1912, p. 237v.
20. Altick 1978, p. 46.
21. Porter 1996, p. 31.
22. Smith 1986, p. 85.
23. Ackroyd 2000, p. 278.
24. SRO 2868/93, endorsed 29 September 1770.
25. *See* McCusker 1978.
26. The only ledger that survives for the business which would give an impression of the size and range of this stock relates to a much later period (1797), when Edward Wakelin's son, John, and Robert Garrard, were in partnershipVAM26, 'The Joint Stock of John Wakelin and Robt Garrard taken the 10th Oct 1797', which included 'Patterns, Tools and Fixtures at Workshop £400; – Do – now Crespels £400, Shop clock and great Table £20'.
27. VAM7, p. 129.
28. VAM7, 6 April 1769.
29. Christie's, 22 November 1978, lot 387.
30. *DNB*, vol. VIII, 1973, p. 780.
31. V and A Museum, National Art Library, sale catalogue.
32. The only other orders are from Dean Harman, who ordered '2 fluted tureens and covers' in October 1767, '2 gadroon tureens and covers' in March 1768, and in May 1768 a tureen and cover.
33. Cunningham 1849, p. xix: 'The London Season was formerly regulated by the Law Terms, fashionable persons frequenting the metropolis at the four periods of the year, Hilary, Easter, Trinity and Michaelmas … The Long Vacation (when London is most empty) extends from August 10th to October 24th'.
34. PRO C.108/104 Letter Book no.16.
35. PRO C.108/104 Letter Book no.16.
36. *See Kilkenny Castle*, Duchas, Heritage Service, n.d., Walter Butler of Garryricken (1703–83) and his wife Eleanor Morres (1711–94) inherited the Butler titles and lands in 1766, and decided to move into the very dilapidated Castle. His son John had married the heiress Anne Wandesford, of Castlecomer, and Walter and John spent much of his inheritance on the Castle.

37. Natural History Museum, Entomology Library, Drury Papers SB f D6, Letter Book 1725–1803, p. 353, letter to Nathaniel Jefferies, 23 August 1775.
38. Badcock 1971 (1677), p. 69. There were only three other important assay offices in England operating between 1766 and 1770: Chester, Newcastle and Exeter. The London office accounted for 97% of all silver assayed in England. Provincial goldsmiths could send their plate to London, and their plate is included in the London Assay figures.
39. 1777–78: 6,390 troy oz (532 pounds); 1781–28: 1,174 troy oz (98 pounds), *see* Quickenden 1986, p. 418.
40. Glanville 1987, p. 106.
41. *Memoirs of the Late Philip Rundell Esq.*, London 1827, p. 12.

CHAPTER 4

1. Harris 1998, p. 451.
2. Campbell 1969 (1747), p. 142.
3. Rouquet 1755.
4. Harris 1992, p. 170.
5. Torsten and Berg 2001, p. 41.
6. Berry 1994, p. 169.
7. Barrell 1992, p. 89.
8. Veblen 1964, p. 235.
9. Wilson 1902, p. 3.
10. For furniture *see* Kirkham 1969, pp. 501–13 and Kirkham 1974, pp. 89–91; for scientific instruments *see* Morrison-Low 1995, pp. 13–19; for sculpture *see* Baker 1995, pp. 90–107.
11. Snodin 1990, p. 33.
12. *Annual Register* 1768, p. 138, total cost £7,562 of which the coachmaker was paid £1,673, the carver, £2,500, the gilder £933, the painter £315, the laceman £737, the chaser £665, the harness maker £385, the bit maker £99, the milliner £31, the sadler £10, the woollen draper £4 and the cover maker £3.
13. Uglow 2002, p. 146.
14. Harcourt n.d., p. 161.
15. Fox 1987, p. 357.
16. Defoe 1987 (1726), p. 1.
17. University of Cambridge, Cholmondeley (Houghton) Mss, Ch(H), Papers 42/44 endorsed 'Working Goldsmiths', thanks to Robert Barker for drawing my attention to these papers.
18. Phillips 1804, p. 43.
19. Styles 1993, p. 547.
20. Wendeborn 1791, vol. I, p. 162.
21. Hazlitt, 1902, 'on Coffee-house Politicians', p. 274.
22. Schwarz 1993, p. 33, quoting Hall 1962, p. 119.
23. VAM7.
24. Sotheby's London, 10 June 1993, lots 77–79 and 82.
25. VAM8.
26. VAM7.
27. Christie's London, 31 March 1998, lots 83 to 86, and four pie dishes, 1772; Christie's London, 21 November 1973, lot 103.
28. An abbreviated version of this appears in Clifford 1995, pp. 5–12.

29. Although no less skilled, separate box-making apprenticeships were registered. The flat silver warps and moves under heat, making soldering difficult.
30. VAM7.
31. Sun Insurance 11936, vol. 261, p. 351, policy no.390401 taken out 24 October 1777, for £200, including £100 plate in trade.
32. VAM 86.HH.40.
33. VAM 86.HH.40.
34. Brasbridge 1824, p. 134.
35. Brasbridge 1824, p. 136, Brasbridge was upset because Makepeace had refused to let him have them at trade discount 'although a friend of his father'.
36. I am much obliged to Robert Barker for interpreting the evidence around this issue, and his clear discussion of it.
37. Smith 2000, pp. 353–61.
38. Archenholtze 1803, p. 102.
39. PRO, Chancery Masters Exhibit, C.108.284, letter book, 21 September 1772.
40. Roche 2000, p. 44.
41. PRO, C.108/285, handwritten list 'An Inventory of the Household Furniture Wearing Apparel, Books, Plate, Pictures, Drawings, Prints and other Effects of the late Mr Webb of Great Portland Street', and printed auction catalogue, for Mr Gerard 14 May 1792.
42. PRO C.210.3 (541), 1734 patent for 'new invented engine for making stone water pipes'; C.73.4 (585), 1743 patent for 'draining low lands and mines, and supplying towns and cities with water'; C.210.4 (671) 1752.

CHAPTER 5

1. Goldsmiths' Company Archive, Apprentice Book, no.7, 1740–63, p. 329, 9 June 1762. VAM9, Samuel Netherton's account, 21 September 1776, records 'cash pr Mrs Mapel Flowerdew £4 4s. 6d.
2. Flowerdew and Yelverton are recorded as paying Parker £15 a year for their board from 1766, their signatures appear in the Workmen's Ledger confirming Ansill and Gilbert's annual balance in 1767, VAM8, p. 12, 17 October 1767.
3. I am grateful to Tessa Murdoch for drawing my attention to one of Parker and Wakelin's trade cards in the British Museum, on the reverse is a receipt dated February 1765 and signed by Flowerdew on behalf of the partnership.
4. Goldsmiths' Company Archive, Apprentice Book, no.7, 1740–63, p. 317, 18 November 1761, son of an undertaker.
5. Goldsmiths' Company Archive, Apprentice Book, no.8, 1763–79, p. 329, 5 March 1766. According to Austin 1890, p. 107, 'apprentices may be assigned or turned over to another master, being a freeman, but he need not be of the same company, bound to serve the second master for the whole residue of his term'.

6. Goldsmiths' Company Archive, Apprentice Book, no. 8, 1763–79, p. 80, 5 March 1766.
7. Christie's, London, 18 December 1997, lot 137.
8. From the appearance of his name and address in the 1773 *Parliamentary Report* into the working of the Assay offices.
9. Taylor 1968, p. 219, Corporation of the City of London.
10. Sotheby's, London, 19 November 1987, lot 96. The 1745 centrepiece made for a dinner service commissioned by the elder sister of Conolly's wife, who had married the Duke of Leinster.
11. Ansill married 3 years after he had completed the apprenticeship, taking as his wife Ann Hackshaw on 26 February 1759 at St James's Westminster. By 1769 Ann was dead, as Ansill had married Elizabeth Admiraud on 5 June that year.
12. Goldsmiths' Company Archives, Apprentice Book 8, 1763–79, no.8, p. 22. Ansill took: "Henry Bridges, son of Henry Bridges of the Parish of St George the Martyr, coachman, 4 April 1764; p. 321, Randolph Jones of the Parish of Church Stretton in the county of Salop, glazier apprenticed to Thomas Carter, goldsmith, 13 January 1763, turned over 7 January 1767; p. 130, Charles Hulme, son of John Hulme of Uttoxeter in the county of Staffordshire, tobacconist, 13 April 1768; p. 138, Robert Ralph, son of John Ralph late of Greenwich, cheese-monger, deceased, apprenticed to William Skeen of St Ann's Lane goldsmith, 3 August 1768, turned over 13 June 1770; p. 221, Thomas Orton, son of George Orton late of Haugham Green near Horsham in the County of Sussex, clerk, deceased, 'there being paid to my said master the sum of £16 of the Charity of the Stewards of the feasts of the Sons of the Clergy turned over by consent 3 February 1779 to John Wakelin'; p. 139, John Henry Meyer, son of Gerhard Meyer of Philpot Lane chemist, apprenticed to John Symonds of Poppins Alley, Fleet Street, goldsmith, 3 August 1768, turned over 4 November 1772, p. 263 John Devereux, son of Robert Devereux of Church Lane in the Parish of St Giles in the Fields, victualler, 11 January 1775, turned over 3 February 1779 to John Wakelin. Stephen Gilbert p. 34, took Jonathan Hurt, son of Thomas Hurt of Aldersgate Street, filemaker, 1 August 1764; p. 78, Richard Weaver, son of James Weaver of Colebrooke in the county of Buckinghamshire, husbandman, 5 February 1766, free 8 January 1777, Hemming's Row, St Martin's Lane; p. 200, Charles Mogridge, son of Anthony late of Imbleton in the County of Worcester, clerk, deceased, 'paid the said Master £20 of the Charity of the Corporation of the Sons of the Clergy'; p. 301, Ralph Pearman, son of George Pearman late of Holborn, chinaman, deceased.

13. Goldsmiths' Company Archive, Apprentice Book no. 9, 1779–1802 p. 4, Joseph Taconet, son of Calista Remy Taconet late King Street, Golden Square, 6 November 1779
14. Whilst in partnership Gilbert took four more apprentices, Goldsmiths' Company Archive, Apprentice Book no.9, 1779–1802; p. 98, Richard Spender, son of Richard Spender of Lanes Court, Cold Bathfields, chaser, 2 June 1784; p. 152, William Faulkner, son of William Faulkner of Brompton Row, labourer, 7 February 1787; p. 179, John Williams, son of Thomas Williams of the Parish of St Anne, Soho, coal merchant, 7 May 1788; p. 290, John Greening, son of William Greening of Southwark, dyer, 1 January 1794. On Andrew Fogelberg, *see* Susann Silfverstolpe, 'Swedish or English? Another look at the work of Andrew Fogelberg', *Silver Society Journal*, Winter 1994, pp. 290–5. A Mrs Fogelberg appears in the accounts of Scotts the basketmakers in August 1774, and Mr Fogelberg in January 1776; for wickering work, *see* London Metropolitan Archive, SCT/11, Day Book 1775–78.
15. VAM8, p. 112.
16. Listed in *Parliamentary Report*, 1773, p. 88.
17. Grimwade 1990, p. 745, Sebastian Crespel had been apprenticed to the specialist dinner-plate maker George Methuen in 1745, apt training for the partnership that was to supply Parker and Wakelin with so much tableware.
18. Christie's, London, 30 April 1996, lot 68, the service was extended in 1772 including work by another of Parker and Wakelin's subcontractors, Francis Butty and Nicholas Dumée, and based on a design first supplied to the 4th Baron Craven in 1742 by John Hugh Le Sage, *see* Christie's, New York, 10 January 1991, lot 60.
19. Sotheby's, London, 5 June 1997, lots 90–92.
20. Skinner 1981 (1776), p. 207.
21. Campbell 1969 (1747), p. 146.
22. Campbell 1969 (1747), p. 146.
23. Quoted in *The Silver Society Newsletter*, no.48, November 2002, p. 6.
24. Mortimer 1763, p. 62; the others were Allcroft and Co., Foster Lane; Floyer and Price, Love Lane, Aldermanbury; Mawbery and Cox, Little Britain; Peter Planck, Foster Lane; Plumbe and Browne, Foster Lane; Slade and Co., London House of Aldersgate Street; White and Davis, Silver Street, Wood Street, Cheapside.
25. Grimwade 1990, pp. 476 and 742. Son of Edward Cox of Brewham in the County of Somerset, Gentleman, apprenticed to Humphry Payne 1745, turned over to John Payne in 1750, free 1752. First mark entered as a large worker, 1752, Fetter Lane; second mark 1758; third mark 1759. William Cox III,

his brother, apprenticed to him 1753, founded the most important London refinery of the time which became Cox and Merle in 1781.

26. Bodleian Library, Oxford, John Johnson Collection, Album L for Lotteries.

27. Woodcroft 1854, p. 894, 8 March 1768.

28. *Parliamentary Report* 1773, p. 70.

29. Yogev 1978, p. 53.

30. Grimwade 1990, p. 421.

31. VAM8, p. 15.

32. *The Watchmaker, Jeweller and Silversmith*, 2 January 1899, 'After the Whipham and Wright partnership ended Charles Wright continued to operate from Ave Maria Lane until about 1783 when the business and the lease of the premises were assigned to Henry Chawner. Later Chawner took in John Emes as a partner whose widow brought in Edward Barnard who had been Henry Chawner's foreman. Then in 1829 the firm became Edward Barnard and Sons Ltd'.

33. Working from 61 Fleet Street, *London Directory* 1770, still there in 1777, *see* the *New Complete Guide*, Heal 1935, repr. 1972, p. 267.

34. Stancliffe n.d., p. 14.

35. I would like to thank Thomas Whipham for making his research on the Whiphams available to me, *see* unpublished manuscript, 'Two Eighteenth Century Goldsmiths Thomas Whipham (senior) 1714–1785 and Thomas Whipham (junior) 1747–1815', August 2000.

36. Thomas Whipham senior appears to have flourished, becoming Prime Warden of the Goldsmiths' Company in 1771 and, as the goldsmith Joseph Brasbridge noted in his autobiography, Whipham acquired a 'country house' to which he retired, a sure indication of success, Brasbridge 1824, p. 140. According to Thomas Whipham, *see* above, he bought a house in St Peter's Street, St Alban's, where he died in 1785. His son together with Charles Wright and John Wright were appointed his executors.

37. Grimwade 1990, pp. 544–6.

38. Culme 1998, p. 70 PRO B/4/16, p. 221 26 June 1762

39. VAM8, p. 54.

40. Grimwade 1990, p. 456.

41. Grimwade 1990, p. 456.

42. Information kindly supplied by Matthew Winterbottom, Research Assistant to The Queen's Works of Art, quoting order in LC5/110f.35⁶.

43. Snodin 1977, pp. 37–42.

44. Grimwade 1990, p. 564, son of Thomas Jones, late Citizen and Goldsmith, apprenticed to John Threadway, 1748, and turned over same day to John Wray, citizen and tinplate worker. Free 1755, appears as a plate worker in Bells Buildings, Salisbury Court in *Parliamentary Report*, 1773.

45. Referrred to in Clayton 1985, p. 118.

46. Grimwade 1990, p. 624. Son of White Piercy late of Witney, Oxford, blanket maker, deceased, apprenticed to Samuel Wood, 1750, free 1757, livery 1763, plateworker, Foster Lane, in 1773. Second mark (first recorded) 1775, 21 Foster Lane, died *c.*1795–1801.

47. I am grateful to Roger Smith for supplying the evidence connected with Chanel.

48. Sun Insurance 11936/152, no.206177, 23 January 1764.

49. PRO PCC PROB 11/935 f.6.

50. An insurance policy of 1746 refers to Nash as being in Orange Street, and therefore a near neighbour of Parker and Wakelin.

51. Grimwade 1990, pp. 605 and 760. No record of apprenticeship or freedom, first mark 1759, Bull and Mouth Street; second mark as a smallworker, 1759, Noble Street, moved to Fletcher's Court, Noble Street, 31 October 1761; third mark, 1767, Dalston; 1768, moved to Noble Street; fifth mark, 1770. Appears as a bucklemaker, Dalston near Hackney, in *Parliamentary Report*, 1773, bankrupt 1782.

52. Grimwade 1990, p. 756. Son of James Lawford of Dartford, Kent, carpenter, apprenticed to Isaac Duke 1751. *See* Grimwade, 1990, p. 770, their mark previously attributed to Vere and Lutwyche.

53. Grimwade 1990, p. 646, Emmich Römer, son of Michel Michelsen Römer, goldsmith, of Oslo (1682–1739), born August 1724. Lived in Bragernaes and apprenticed in 1749. Recorded in 1751 as living in Strömso, back in Norway, 1795. *Parliamentary Report*, 1773, lists him as plateworker, 123 High Holborn.

54. Christie's, London, 23 February 1983, lot 155.

55. Young 1983, pp. 285–89.

56. May be related to Aaron Lestourgeon, who married Mary Anne Levy in 1722 at St James's Clerkenwell, who had a son christened Aaron in 1726. A William and Mary Martha Lestourgeon recorded as christening a child, William, at Christ Church, London in 1748, and it could be their son William who married a Sarah Turner in December 1775 at St James's Westminster.

57. Beet 2002, pp. 68–9.

58. IGI, William and Mary Martha Lestourgeon of Salisbury Court, baptized Aaron, 1742, at St Bride's, Fleet.

59. David Whyte supplied only cups and covers to Parker and Wakelin between 1770 and 1772, but his bills were for only small orders, £8 6s. 6d. in 1770/71. Walter Brind supplied pap boats between 1768 and 1774, he was paid every six months for sums from 12s. to a maximum of £5 9s. 6d.

60. Perhaps the same 'Mr Tookey in Silver Street, Strand' who in 1750 was one of the executors of Jeremiah King's widow.

61. IGI, Philip Rainaud married Ann Garrat, 28 February 1746, Westminster St George's, Mayfair.

62. For example, VAM7, 'new agat handle', 'fine threaded steel blade to mother of pearl knive'.

63. Stamped silver handles used between 14 and 15 troy oz of silver per dozen, but a dozen cast weighed 28 to 29 troy ozs.

64. Goldsmiths' Company 1999, p. 32.

65. Apprenticed to his brother Abraham in 1749. Although William completed his apprenticeship, and registered as a smallworker in 1761, within a few years he had set up as an ironmonger. In partnership with James King II from 1768.

66. Smith 1828, repr. 1986, p. 232, Smith describing the economy and eccentricity of Nollekens' home. *See* illustration B278 in Goldsmiths' Company 1999, p. 32.

67. V and A, 334.A.16, described as 'silversmiths' in the *London Directory*, 1768, and in *Baldwin's New Complete Guide*, 1770. William joined George Heming at the King's Arms in New Bond Street.

68. Wees 1997, cat. no.358, pp. 479–80.

69. I am grateful to Philippa Glanville for drawing my attention to Fossey's advertisement in the Heal Collection, British Museum, Department of Prints and Drawings.

70. Made free from the Longbow Stringmakers' Company in 1773. *See* Luke Shrager, 'Recent research into the missing registers', *Silver Society Journal*, Autumn 1998, p. 65.

71. Woods went on to acquire the workshop of Judith Callard, the widow of Paul, after marrying her daughter Marguerite. So what might appear as rival businesses in Parker and Wakelin's accounts turn out to be connected enterprises.

72. Grimwade 1990, p. 683.

73. Grimwade 1990, p. 769.

74. For example, Dru Drury, St Alban's, Wood Street, PRO.C.210.11 patent for 'entirely new method of making silver and other metallic hafts . . . by this means a Dozen of hafts which required a week for a Workman to compleat them in may be finished in a quarter of the time and the price so far reduced by the great labour saved as to be afforded in some cases for a Quarter of the price they used to be sold for', 1771. George Hall, 18 July 1810, of Strand, goldsmith, 'method of stamping spoons forks and other articles of gold, silver or other metals as are usually are or may be stamped or struck by means of . . . punches, or dies of any description', no.3361.

75. Brown 2001, p. 115.

76. Ibid.

77. Natural History Museum, Entomology Library, SB f D6, Dru Drury's Copy Letter Book, p. 133, August 1768.

78. From 1770 Drury moved from specializing in knives and forks to manufacturing and retailing a range of silverwares, after joining Nathaniel Jefferies at his Villiers Street shop in the Strand which his son took over and was illustrated by Scharf in 1824.

79. Goldsmiths' Company Archive, Apprentice Book no.7, 1740–63, p. 183, 5

October 1752, 'Son of John Arnell of Paddington in the County of Middlesex, weaver apprentice to John Quantock'. Turned over to Edward Wakelin 6 December 1758.

80. Grimwade 1990, p. 735.
81. Grimwade 1990, p. 467, son of William Coker of Berkhamsted, Hertford, cheesemonger, apprenticed to Joseph Smith 1728, free 1740, first mark 1738, address in Clerkenwell Green, mark in partnership with Thomas Hammond 1759–60, thereafter same address and 13 Wood Street from 1770. Described by his clerk and assistant as a large-plate manufacturer to 1773 Committee. Bankrupt 1781, died 1783.
82. See Wees 1997, p. 466. Whyte and Holmes, 1762, Christie's, South Kensington, 26 April 1989, lot.338; Richard Rugg, 1762–63, Sterling and Francine Clark Art Institute, cat. no.341; Ebenezer Coker, 1763, Christie's, New York, 29 April 1987, lot 486.
83. Wees 1997, p. 255, referring to cat. no.171, a soup ladle, and Pickford's note that Coker was apprenticed to Joseph Smith I, who trained a large number of spoonmakers.
84. From July to early September 1770 he was paid £30 for making-up 292 troy oz of plate, and between September and December 1770, £17 for 237 troy oz.
85. His appearance might be connected with the death of a Mrs Carter, announced in the Public Advertiser, 17 January 1766, no.739, 'Orders of Executors of late Mrs Carter, Silversmith and Jeweller, deceased upwards of 40 years in business in Russell-Street, Covent Garden. All her stock in trade of plate, Jewels, Watches consisting of fine diamond and other Rings, Gold and other Watches, Silver Tea Kettles, Coffee Pots, Cups and Covers, Tankards, Punch bowls ... Paste stone silver, knee stay stock and shoe buckles, Ear-rings, seals in Gold and Silver'.
86. Birmingham Central Library, Boulton Papers, Letter Book E, p. 277.
87. Ibid. p. 314, 14 December 1771.
88. Binfield and Hey 1997, p. 189.
89. Bedfordshire Record Office L31/114/3, Diary of Thomas Philip, third Lord Grantham, 1799, quoted in Gard 1989, p. 73.
90. Lewis 1982, vol. 10, p. 127, from Mann, 23 August 1774.
91. Bambery 1985, pp. 110–15. On their insurance policy, taken out under the names of Henry Tudor, John Sherburn and Thomas Leader in April 1766, they called themselves silversmiths: 'Sun Insurance policy, 232779, 15 April 1766, insurance on house only tenure of Henry Tudor: household goods his property £100, wearing apparel £40. House in tenure of John Sherburn £300, household goods therein £100, wearing apparel £50, horse mill, house, workshop, stables and offices £400, utensils

and stock £300. Warehouse workshop called Inner Row £300, utensils and stock £1,000. Total £2,800'.
92. V and A, Prints and Drawings, A Catalogue of Table, Bracket and Chamber Candlesticks, manufactured in Silver or Plated Metal, c.1780.
93. Sheffield City Archives, BR.286.
94. Sheffield City Archives, BR.247 letter book, 1776–93.
95. Turner 1987, pp. 213–4.
96. Heal 1988, p. 77, listed at the 'Chandelier next door to the Golden Leg', opposite Langley Street, Long Acre, c.1760.
97. Rosebery Archives, Cash Book 5, vol. 30, p. 5, 26 May 1769, bought of Chamberland and Hopkins.
98. See A. Bonnin, Tutenag and Paktong, (London, 1924), p. 18–51; see also, more recently, Brian Gilmour and Eldon Worral, 'Paktong, The trade in Chinese nickel brass to Europe, British Museum Occasional Paper 109, 1993; and Keith Pinn, 'Paktong', The Silver Society Journal, vol. 12, Autumn 2000, pp. 38–40.
99. Sheridan 1949, p. 290.
100. Forbes 1999, p. 228.
101. Heal 1988, p. 78.
102. Raby Castle, North Yorkshire, 4/747/EE. Two-handled racing cup and cover, silver-gilt, Thomas Pitts, 1762, inscribed 'Richmond 1762' and 'Matthew Dodsworth, Simon Scroope, Stewards'. He is likely to have supplied the 1763 Richmond Race trophy as well, which bears the mark of Parker and Wakelin, the cup supported by the cast figure of a boy and a goat; this appears in another cup made the year before, marked by Parker and Wakelin, and now at Jesus College, Oxford. The 1761 trophy is marked by another of Parker and Wakelin's suppliers, Lewis Herne and Francis Butty.
103. Grimwade 1990, p. 763.
104. Payments made to Pitts from Parker and Wakelin for his labour: October 1767, £174 for 197 troy oz; September 1768, £67 for 29 troy oz plate. From September 1768 to September 1769 he was paid £300 for working 4,328 troy oz; in August 1770, £491 for 2,370 troy oz; and in May 1771, £599 for 2739 troy oz.
105. London Guildhall Archives, Trade Cards.
106. Grimwade 1990, p. 543. David Hennell retired from business at the request of the Goldsmiths' Company to become Deputy Warden in 1773. He died 1785.
107. Hennell 1955, pp. 260; Hennell 1973, pp. 79–86; Hennell 1986.
108. VAM8, p. 87.
109. VAM8, p. 103.
110. Grimwade 1990, p. 575.
111. It was not until the 1790s that Wakelin and Tayler sought a supply of glass liners from alternative sources, from the glassmakers Blakeway and Hodson, and

from Simes. Blakeway and Hodson's trade card reveals that they operated from their 'Cut and Plain Glass Manufactory' at 71 Strand, until the partnership was dissolved in 1798. John Simes appears from the ledgers of Whitefriars to have been working from at least 1774, and from premises in High Holborn. Information kindly supplied by the late Robert Charleston.
112. Lincoln Record Office, Monson Papers, MON 12,311/19.
113. In 1770 he was paid £17, in 1771 £7, in 1772 £4 and in 1773 £8.
114. London Metropolitan Archive, Records of GW Scott and Sons, B/SCT/11 1775–7, 19 December 1776 'Mr Parker and Mr Wakelin, 3 handles to a cover stewin dish 1s. 6d, to a coffee pot 6d.'. They also provided a variety of plate, scullery and dog baskets, brooms and brushes, and theatrical stage props for Drury Lane theatre.
115. Banister 1967, pp. 21–24. and Banister 1961, p. 67.
116. Campbell 1969 (1747), p. 144, description of the process of gilding 'performed with an Amalgam of Gold and Quicksilver; the Gold is heated in thin Plates in a Crucible, and when just enclining to flow, three or four Times the Weight of Quicksilver is poured upon it, which is immediately quenched in Water, and both together becomes a soft Substance, yielding to the Touch like Butter. When they intend to gild, they rub the Subject to be gilded over with Aqua Fortis, and then with their Finger cover it over with the Amalgama; when it is all covered over and smooth, they hold it over a Charcoal Fire, by which Means the Gold remains upon the Plate; then they clean and polish it, which gives it the Colour they want'.
117. Son of Lawrence and Dorothy Clee, christened 11 July 1711, St Anne's, Soho.
118. I am grateful to June Corbett, the Churchwarden, for allowing me access to the Elmley Castle church plate which is kept off site.
119. Rococo 1984, C14.
120. PRO PROB 11/987, dated 15 May 1773, proved 25 May 1773.
121. I am grateful to Robert Barker for this and the following information about Robert Clee, which was presented in an unpublished paper to the Silver Society, 1995.
122. For an example of Chatelain's work see, 'Veüe de la Maison Royale de Richmond', illustrated in Rococo 1984, c6 adapted from Watteau's Embarkation for Cythera.
123. Rococo 1984, G46.
124. Sotheby's, New York, 21 October 1997, lot 265.
125. Smith 1828, p. 121.
126. VAM14, p. 204, 14 February 1784, 'piece of fine silver squared', '3 pieces of fine gold drawn and squared', 'making and drawing a piece of fine copper and marking'.

127. VAM14, p. 176.
128. VAM15, p. 183, 12 January 1783, '4 pieces for bed posts', 'repairing ornaments to bedsted with addition of silver'.

CHAPTER 6

1. Williams 1935.
2. VAM26 'The Joint Stock of John Wakelin and Robt Garrard taken the 10th Oct 1797', starts with 'Brilliant Earrings, Loose Diamonds, Pearls, Watches, Watch Chains', before moving on to silver and Sheffield-plated articles, pp. 1–30.
3. Mortimer 1763, p. 45.
4. PRO: C.108.284-5, part 1, 25 May 1771.
5. Campbell 1747, pp. 143–4.
6. PRO: C.108.284, part 1, sale catalogue, 1792.
7. Harth 1970, p. 152.
8. Halsband 1961, p. 265, 1761.
9. PRO: C.108/284.
10. Finn 2000, p. 135.
11. Chesterfield 1984, p. 88, 10 January 1749.
12. Ibid., p. 199, 12 November 1750.
13. Ibid., p. 108, 6 July 1749.
14. Ibid., p. 294, 4 December 1765.
15. Ibid., p. 106, 27 May 1749.
16. Rt. Hon. Charles Wolfran Cornwall, c.1785–86. National Gallery, Melbourne, Victoria.
17. I am grateful to Robert Barker for drawing my attention to *A General Description of all Trades*, London 1747, p. 123, 'And the Working Goldsmith's Feast, kept once a Year at Goldsmiths-hall, is chiefly supported by the Jewellers; at which Time they have also a Sermon preached at St Lawrence's church, near Guild-hall'.
18. Mortimer 1763, pp. 45–7.
19. National Library of Wales, Wynnstay box, 115/1–9, see Fairclough 1995, p. 378.
20. *New Complete Guide*, 1777
21. PRO: PCC PROB11/1222/452. Tayler left Thomas Forrest £500 in his will, and a further £500 to his son, Thomas Lister Forrest.
22. Heal 1972, p. 218. VAM11, f.76. John Wakelin's account includes money received for board of a John Payan, perhaps a son of Daniel.
23. Evans 1933, p. 35, married Ann Wright, his son William Peter Charpentier was apprenticed to Abraham Portal in 1778, he died in 1797.
24. Cambridge University Library, 84/1, p. 51.
25. VAM7
26. Grimwade 1990, pp. 649 and 766, no record of apprenticeship or freedom, nor entry of mark. Heal records him as a goldsmith in Suffolk Street, 1755–73, and he appears in the *Parliamentary Report*, 1773, as a goldworker.
27. Truman 1983–84, pp. 35–6, the snuff box is in the collection of the Goldsmiths' Company.
28. VAM7, 19 October 1770.
29. Woodforde 1979, p. 3, 16 November 1759.

30. Stokes 1931(1), p. xviii.
31. Corbeiller 1966, p. 16.
32. Galerie Nationale de Prague, photograph Tate Gallery, London.
33. A later policy, of 1786, gives his address as 18 Duke's Court, St Martin's Lane.
34. Beet 2002, pp. 72–3.
35. Ibid., p. 73.
36. Ibid., p. 55.
37. My thanks to Charles Truman for drawing my attention to this and sharing his research.
38. London Guildhall Archives, Trade Cards. William Brown, a jeweller and goldsmith at the Golden Ball, Foster Lane, advertised on his hand bill a 'great choice of fine long walking canes unmounted or mounted with gold heads or gilt. Variety of gold heads for walking canes by the Maker in the Newest fashion finely engraved or chased, by the best Hands in London'.
39. Beet 2002, p. 55.
40. Sun Insurance 11936 vol. 170 p. 558, 19 November 1766, 'John Frame (gent) a tenant in house', £200.
41. There was a network of Derussats living in St Anne's, Westminster, in the eighteenth century, *see* IGI.
42. With thanks to Brian Beet for drawing this to my attention.
43. Beet 2002, p. 60.
44. By machine 50 ft of the same chain could be produced in an hour, see Wright 1866, p. 451.
45. Grimwade, 1990, p. 504, no record of apprenticeship or freedom, only mark entered as smallworker in partnership with John Russel, 1761; address, Golden Head, Greek Street, Soho; Second mark alone, 1763, same address. Appears in the *Parliamentary Report*, 1773, as a goldworker where he is mentioned as having been prosecuted in 1770 for making gold watch chains 'worse than standard'.
46. Smollett 1984, p. 81.
47. Woodforde 1978, p. 227.
48. Nettel 1965, p. 61.
49. Bodleian Library, Lovelace Byron Papers, I/1, from Thomas Noel, second Viscount Wentworth, to his sister Judith, 12 November 1771.
50. Aitken 1946, p. 121, William Cowper to Revd. William Unwin, 23 May 1781, 'My neckcloths being all worn out, I intend to wear stocks, but not unless they are more fashionable than the former, In that case, I shall be obliged to you if you will buy me a handsome stock-buckle for very little money; for twenty or twenty-five shillings perhaps a second-hand affair may be purchased that will mke a figure in Olney'.
51. Sheridan 1909, p. 281.
52. Grimwade 1990, p. 611, no record of apprenticeship or freedom. Only mark entered as a smallworker, 1764, address, Thrift Street, Soho; appears as a bucklemaker, Frith Street, Soho in *Parliamentary Report* 1773. He was probably dead by 29 August 1774, when Eliza Padmore

entered a mark as a bucklemaker, 19 Frith Street.
53. Sun Insurance 11936, vol. 206, p. 1, 709, policy no. 298155. Isaac Riviere married Frances Forlitt in 1762 at St Clement Danes, Westminster.
54. His brother Samuel Newton Rivière (1753–1812), was apprenticed to his father, Daniel, and set up at 23 and 68 New Bond Street, with branches in Cheltenham and Bath. With thanks to Jean Tuschima for this information.
55. Purefoy Letters, p. 306, no.452, E.P. to Thomas Robotham, 13 July 1740.
56. Moore-Colyer 1992, p. 945.
57. Christies, London, 3 July 1997, p. 190.
58. Goldsmith 1952, p. 81. Miss Neville's fortune 'chiefly consists in jewels', but they are a 'parcel of old-fashioned rose and table-cut things'. Towards the end of the 17th century the Venetian lapidary, Vincezo Peruzzi, discovered the brilliant form of diamond cutting, the shape and position of the 56 facets in Peruzzi's cut caused the light which entered the stone to be reflected back through the same facets which received it. Thus far great brilliance was obtained.
59. Drummonds Bank Archive, Client Ledgers, 1766 A–H, f.62.
60. Rouquet 1755, p. 90.
61. Pointon 1998, p. 206, quoting from W.C. Oulton *The Memoirs of Her Late Majesty Queen Charlotte*, London, 1819.
62. Phillips 2000, p. 61.
63. Ribeiro 1998, p. 57.
64. Johnson 1925, pp. 202–3, 14–17 January 1756.
65. Lady Elizabeth Keppel, 1761, Woburn Abbey, the Marquess of Tavistock and the Trustees of the Bedford Estates.
66. Birmingham Central Library, MBP, Letter box D2, 362, 19 November 1770.
67. Chesterfield 1984, p. 108, 6 July 1749.
68. Natural History Museum, Entomology Library, Drury Archive, SB fD6. Letter Book 1761–83, p. 348v, 14 April 1775.
69. Guildhall Archives, Sun Insurance 11936, vol. 204, p. 40.
70. Pointon 1997, p. 382.
71. Coke 1889, vol. II, p. 244, 21 May 1767.
72. Pointon 1999, p. 131. Yet there were cases when the division between these two types of mourning ring were not so clear. For example, Boswell recorded that when Samuel Johnson's wife died he preserved her wedding ring. After Johnson's death, his servant, who had offered it to his family, who were uninterested, 'had it enamelled as a mourning ring for his master'. *See* Chapman, p. 168.
73. Phillips 1996, p. 116.
74. Lewis 1982, p. 69, from Hillier, Saturday 1 June 1765. John Kentish (c. 1725–96), jeweller.
75. Andrews 1938, vol. 4, p. 60, September 1794.
76. Parker 1987, p. 90, June 1753.
77. Bewick 1975, p. 69.
78. Parker 1987, p. 90, June 1753.
79. London Guildhall Archives, Trade Cards,

William Addis to Alexander Gordon, 2 March 1771.

80. Samuel Rogers, 'All works of any Device respecting agates, oriental, egyptian and any other pebble stones in the Lapidary way, such as rims for watches, cane heads, eggs, bezels for snuff bozes, tooth-pick and tweezer cases or any other hollowed and plain work curiously per-fomred by Samuel Rogers at the Turning Machine in Charles Street, over against the Vine Tavern'. London Guildhall Archives, Tradecards, illustrates the machine.

81. IGI, St Anne, Soho, 11 August 1759, information from Brian Beet.

82. Clifford 1999(2).

83. See further, Beet 2002, p. 54.

84. Natural History Museum, Entomology Library, Drury papers, SB fD6, Letter Book, f.356v, October 1775, letter to Ignazio Dies, Rome.

85. Morisset listed as a Huguenot in Evans 1933, p. 52.

86. Appears with Gabriel Wirgman, as jew-ellers in Denmark Street in Dru Drury's list of creditors, 1778, see Culme 1998, p. 75

87. Blair 1972.

88. Edgecumbe 2001.

89. Rosebery Archives, Cash Book 1764–68, p. 88, November 1766.

90. Margaret Binley, christened in 1746 at St Vedast, Foster Lane, daughter of Richard and Margaret Binley.

91. Grimwade 1990, p. 441, Margaret Binley registered at Goldsmiths' Hall as a small-worker in 1764, and Richard Binley regis-tered as a smallworker in 1760.

92. In 1769 £77, in 1770 £91, in 1771 £173 and in 1772 £98.

93. Bodleian Library, John Johnson Collec-tion, Lottery box.

CHAPTER 7

1. MBP, Letter Book D, p. 29, 1 October 1770.

2. Wedgwood 1903, vol. III, p. 177, 7 March 1774.

3. Ibid., pp. 363–4, 21 June 1777, 'Few Ladies, you know, dare venture at any-thing out of the comon stile 'till authoris'd by their betters'.

4. Wedgwood 1903, vol. II, p. 150, 1767.

5. Wills 1983, pp. 50–53.

6. Harth 1970, p. 171.

7. More recent literature on the middle classes includes Earle 1989; Barry and Brooks 1994; Nenadic 1995, pp. 122–56; Hunt 1996 and Richards 1999 have a chapter on the middle-class con-sumer.

8. Weatherill 1988, pp. 26–7 and 77.

9. 1756, 29 Geo.II c.14. 'An Act for grant-ing to his Majesty several Rates and Duties payable by all Persons and Bodies Politick or Corporate, having certain Quantities of Silver Plate'. Church silver and stock in trade was exempt. PRO

TR/7 'Those sent circular letters 13 May 1776 who have not regularly paid the duty, and such persons suspected of hav-ing plate who have made no entry', included those 'persons paying duty for four-wheeled carriages, but not for plate' suggesting a close relationship in the mind of the collectors between plate and carriage ownership. Repealed in 1777 by Lord North, 17 Geo.III c.53.

10. In 1527 the Tower Pound was abolished and replaced by the Troy Pound, in which 12 ounces made 1 pound, and 20 hundred weight made 1 ounce. In 1878 the Troy Pound was abolished except for weighing precious metals and stones, and its place taken by the older Avoirdupois Pound for ordinary com-mercial use, where 16 ounces make 1 pound and 16 drams make 1 ounce. See Dove, 1984, p. 39. When wrought plate or silver and gold was exported, new and unused, duty could be reclaimed by means of a drawback clause. This sec-tion of the Act was repealed in 52 Geo III, c. 59, allowing 'the exportation of manufactured plate for the private use of persons residing or going to reside abroad, the same drawback'.

11. Walpole to Conway, 4 March 1756. Troy weight had been introduced in 1527, and was not to be abolished until 1878, when its place was taken by the older avoirdupois for ordinary commer-cial use. Taylor 1963, p. 283.

12. Christie's, London, 14 July 1965, lot 144, height 18¼ inches.

13. Schwarz 1993, p. 51.

14. Picard 2001, p. 3.

15. For example, Buckinghamshire Record Office, Clayton Archive, D/CE Box K.

16. PRO, T47/6, 'List of Persons who have not regularly paid the Duty on their Plate'.

17. Yet there were many more titles to go round the luxury retailers of London. The London Directory, 1772, which published a full list of the titled aristoc-racy of the day reveals that there were 23 dukes, 82 earls, 10 viscounts and 60 baronets.

18. Hussey 1931, p. 729.

19. PRO Chancery Masters' Exhibit, C.108/285, Ledger G, 1735–57.

20. SB fD6, Letter book, p. 351, June 1775.

21. Fairclough 1995, p. 385.

22. VAM7, p. 181.

23. His account was settled in January 1770.

24. Thanks to Julia Carder, Curator, Croxteth Hall and Country Park who provided information on the family and the sale of the family plate by Christie's. 17 September 1973.

25. Wedgwood 1903, p. 5 September 1786.

26. VAM7, p. 81.

27. VAM7, pp. 22–3.

28. West Sussex Record Office, Petworth House Archives, PHA/8045, bills paid by George, third Earl of Egremont him-self to London tradesmen (1772)

29. VAM5, p. 59.

30. Croome Estate Archives.

31. Arthur Oswald, 'Breamore House, Hampshire III', Country Life, June 27, 1957, vol. CXXI, no. 3, 154. pp. 1, 320–3.

32. See Heal 1988, p. 50. Benjamin Payne at the Three Cannisters, corner of Chancery Lane, Temple Barr, 1753.

33. Breamore Archives, Ac189, Edward Hulse's Cash Book, 1741/2–57. I am grateful to Sir Edward Hulse for allow-ing me to consult his family archives.

34. Grimwade 1990, p. 524. Eliza Godfrey married second to Abraham Buteaux, who she survived to carry on business as his widow until marriage the following year to Benjamin Godfrey. Her mark entered 1741, presumably on her hus-band's death.

35. Breamore Archives, Ac192, Mr Edward Hulse's volume of household accounts, 5 March 1766 to 29 January 1789.

36. Garrard 1991, pp. 60–61, cat. nos. 19–22.

37. Brasbridge 1824, p. 124.

38. Scarisbrick 1994, p. 245; and Smith 2000.

39. Northumberland Record Office, Delaval Papers, 2DE31/10, 1769.

40. Wedgwood 1903, p. 91, 23 August 1772 'The Great People have had their Vases in their Palaces long enough for them to be seen and admir'd by the Middling Class of People, which Class we know are vastly, I had almost said infinetly, superior in number, to the Great'.

41. Quickenden 1995, p. 25.

42. PRO C108/284 Day and Work Book, 1789–91, 1787.

43. Brasbridge 1824, p. 247.

44. Unpublished account of the firm of Rundell, Bridge and Rundell, London Jewellers, 1843–46, by George Fox, photocopy of the original in Baker Library, Harvard University, Victoria and Albert Museum 276.E.3.

45. Wedgwood 1903, p. 384, 24 December 1770.

46. PRO C.108/284 Letter Book, September 1771.

47. Ibid., May 1772.

48. Canon Brian Carne, 'Frederick, 1732–87, the second Viscount Boling-broke, third Viscount St John', Report of the Friends of Lydiard Tregoze, no.21, 1988, p. 29.

49. Jack 1981, p. 70.

50. VAM7, p. 46, 9 October 1765.

51. Ibid., p. 11, 29 April 1771.

52. Ibid., p. 32, 24 June 1768.

53. Bedfordshire and Luton Archives and Record Service, Wrest Park (Lucas) Manuscripts, L/30/14/109/53, 7 July 1775.

54. Abergavenny, Aislabie, Boston, Coven-try, Fortescue, Halifax and Manners.

55. Bolingbroke, Bouverie, Clayton, Darnley, Rochford and Shelburne.

56. Caerwynn, Delamere, Fox, Grosvenor, Harcourt and Macclesfield.

57. Picard 2001, p. 48.

58. Bedfordshire and Luton Archives and Record Service, Wrest Park (Lucas) Manuscripts, L30/15/54/248, 15 Janu-ary 1785.

59. Hudson and Luckhurst 1954.
60. RSA Archives, Members Index.
61. Thirty-two of Parker and Wakelin's customers were members of the Society of Antiquaries. The Society of the Dilettanti founded between 1732 and 1734, as 'a small private society of gentlemen which . . . has exercised an active influence in matters connected with public taste and the fine arts in this country', *see* Joan Evans, *A History of the Society of the Dilettanti*, Oxford 1956.
62. Sitwell 1936, p. 59, fig. 63, Coll. Lady Desborough, Panshanger, now National Gallery.
63. G.C. Boase, *Collectanea Cornubiensis*, Truro 1890, pp. 1, 19–20.
64. PRO Chancery Master's Exhibit, C.108.273, will of Robert Cotton Trefusis, 1778, with inventory of household goods, totalling £2,217 16s. 8d., *see* also Cornwall Record Office, Trefusis Papers, 2310.
65. Colley 1984, p. 11.
66. Defoe 1987, p. 216.
67. VAM7, p. 65, 30 April 1771, she died three years later 4 June 1774.
68. Ibid., p. 210.
69. Ibid., p. 109 (1771).
70. Married 1772. *See* Barr 1980, pp. 185–7. James Meade VAM7, p. 105 (1771), VAM5, p. 60 (1760); Thomas Meade VAM7, p. 116 (1771); Dowager Meade VAM11, p. 9 (1778); Mrs Meade (VAM11, p. 108 (1778) and p. 127 (1783); Samuel Netherton VAM8, p. 267 (1776), VAM9, p. 180 (1772) VAM10, p. 138 (1779).
71. VAM1, p. 20 (1735); VAM4, p. 141 (1753).
72. VAM11, p. 48 (1777).
73. VAM11, p. 215 (1781); VAM13, p. 127 (1785).
74. VAM8, p. 34, (1775).
75. SRO 2868/39, 23 April 1737, marriage settlement between Edward Pauncefort and Mary Dodd. VAM4, f172 (1753).
76. SRO 2868/40, 26 May 1767, recital of settlement of 1737.
77. VAM7, p. 25 for James Hubbald and p. 75 for Mrs Hubbald.
78. VAM1, p. 168, 17 May 1740, their joint mark registered 15 October 1740, Neville alone from 1745, and bankrupt 1746 and 1753.
79. VAM11, p. 2 (1781).
80. VAM8, p. 7 (1775).
81. VAM8, p. 18 (1773).
82. VAM11, p. 40 (1778), William Tuite married Catherine Reddan in 1761, Tuite bankrupt 1770.
83. Clifford 1999 (2), p. 175. Baptized 1740 at St John, Hackney, sometime Clerk to the Board of Control for Indian Affairs, died 1796. Married Harriet Kl.oprogge 1768, died 1770; married Susanna Charlotte Richardson 1771, at St George, Hanover Square. I am grateful to Patric Dickinson, Richmond Herald, for his advice on the Fenoulhet family, and later from Brian Beet.
84. VAM11, p. 58 (1777) and p. 237 (1780).
85. VAM8, p. 64 (1773), VAM9, p. 23 (1776), VAM10, p. 258 (1781).
86. VAM10, p. 4 (1777), *see* Heal 1988, p. 126, 'Nathaniel Cotes at the Blackamoors Head, in Panton Street, second door from the Haymarket 1769–1788'.
87. Bristol City Corporation. The base is engraved with the arms of the three donors: sheriffs Henry Dampier and Isaac Baugh and, possibly, the mayor, David Peloquin, a Huguenot, a wealthy merchant and a Whig member of the Corporation.
88. Wees 1997, cat. no.67, pp. 138–9.
89. Engraved 'The gift of Thomas Byrche Savage Esq, to the Parish Church of Elmley Castle, 1770'; chalice (height 8.25 inches, 14oz), paten (diameter 6 inches, 7oz 7dwt) and flagon (height 10.75 inches, 33oz 15dwt). My thanks to Mrs June Corbett, Churchwarden, Elmley Castle Church for allowing me to *see* these.
90. John Brewer 1987, pp. 197–8, arguing for the rising presence of the middling sort, 'these men of moveable property, members of the professions, tradesmen and shopkeepers'.
91. Campbell 1747, p. 23.
92. 'Memoirs of the late Phillip Rundell', 1827, p. 16.
93. Federer (unpublished papers) 1980, 1987 and 1989.
94. Rhys 1946, p. 300.
95. Bolitho and Peel 1988, pp. 209–11. Of the 186 account customers who were 'Members of the Nobility and other persons of Title, as they appear in the ledgers of Drummonds Bank in the year 1795', 27 were also on Parker and Wakelin's books. With thanks to J.W. McDougall, Archivist of the Royal Bank of Scotland.
96. Chesterfield 1984, p. 86.
97. MBP 300.56, 24 September 1793, R. Chippindall to Matthew Boulton.
98. His Excellency Melo Sebastiano José de Carvalho, Conde O'oeiras, Marquis de Pombal (1699–1782). His dinner service included '4 fine sauceboats', '2 bagot comports', '2 waiters' and '23 gadroon bottle tickets'. Wedgwood 1903, vol. 1, p. 118, 18 February 1767, noted that his 'modeler hath been fully employ'd for two months past, in modeling various articles for his Excellency Mr Mello the Portugueze Embassador . . . I have been several times afraid the Embassador wod be sent home without his Crockeryware . . . they will most of them be unsuitable for your market, such as Glaciers for brandy and spiritous Liquors, do. for wine, do. for Cream, with a long &c if such useless Gimcracks'.
99. Langford 1990, p. 492. *See* further, Sarah Bakewell, *The Smart The True Story of Margaret Caroline Rudd and the Unfortunate Perreau Brothers*, London 2002.
100. H.J. Habbakuk, 'England's Nobility' in Goodwin 1953, pp. 1–21.
101. Kent Record Office, Knatchbull Papers, U951. Hatch building and furnishing accounts 1762–84, A18, 23 January 1770.
102. Ibid., A19, 6 January 1772.
103. Ibid., A18, 6 August 1778.
104. Sotheby's, 10 November 1994, lot 174.
105. *See* Barr 1980, p. 104.
106. *See* VAM11, p. 65, account for 'Christie and Ansell', 5 November 1777.
107. VAM11, p. 207.
108. Lincolnshire Record Office, Monson Papers, MON 11/30.
109. Ibid., MON 11/31.
110. *Gentlemen's Magazine*, July 1760, p. 325.
111. Werner 1999, p. 16
112. MBP, Letter Book F, 23 November 1774.
113. National Art Library, 86.HH.40.
114. PRO, C.108.284 Letter Book, To Revd. Mr Wickham, Shipton Mallet, December 1771.
115. *Boswell's London Journal 1762–1763*, Reprint Society, London, 1952, pp. 66–7, 1 December 1762.
116. Brasbridge 1824, p. 45.

CHAPTER 8

1. MBP 300.57, 4 October 1793, discussing buckle supply.
2. Published in 1744 by John Vardy in *Some Designs of Mr Inigo Jones and Mr William Kent, see* further, Barr 1980, pp. 95–104.
3. In 1749 John Gwynn published his *Essay on Design*, which called for a public academy for training in the arts. Malachy Postlethwayt in his *Universal Directory of Trade and Commerce*, 1766, repeated this call for the training of 'ingenious workmen . . . to improve the perfection and delicacy of our Old Manufactures, and to discover such New Trades and Manufactures, as will enable us, at least, to keep pace in wealth and power with our rival nations, if we cannot go beyond them'.
4. Wedgwood 1903, vol. 1, p. 23.
5. Coke 1889, p. 36, 30 August 1766.
6. Wedgwood 1903, vol. 1, p. 54.
7. Ibid., p. 303.
8. Ibid., p. 294.
9. PRO Chancery Masters Exhibit, C.104.58, part II, Ledger 1806–08, p. 47, 30 September 1806. The Comte de Caylus (1692–1765), one of the influential arbiters of taste in Paris, who formed and published his collection of antiquities.
10. MBP, Letter Book E, Boulton to Pecehell, 11 December 1771.
11. Denvir 1988, p. 230, from Toynbee and Whibley, vol. 2, 1935.
12. BL, Add.MSS 48 218, Letters, 3 February 1774.
13. BL, Add.MSS 48 218, Letters, 3 March 1773.
14. Victoria and Albert Museum, Department of Prints and Drawings, Hartley

Green and Co., Original Drawing Book No.1, 1778–92.

15. See McGill 1999, pp. 33–4.

16. Young, in Harris and Snodin 1996, p. 155, referring to BL Add MS 401136.20 (29 June 1774) and RIBA Letter CHA 2/59 (20 July 1774).

17. Campbell (1747) 1969, p. 141.

18. Kent Record Office, Knatchbull Papers, U951. Hatch building and furnishing accounts 1762–1784, A18/23, 23 June 1778.

19. Ibid., A18/21, 7 May 1778.

20. Jones 1940, p. 5, quoting from five letters preserved at Welbeck Abbey, written to John Achard, tutor to the second Duke of Portland.

21. Reference via Ann Eatwell, Victoria and Albert Musuem, from Bruce Laverty, Curator of Architecture, The Athenaeum of Philadelphia, from Thomas Fletcher, Letterbook, 1815.

22. Sotheby's New York, 21 October 1997, lot 224, Soane Museum.

23. Ibid.

24. PRO C.104.57 part 1, Vulliamy Papers, Letter Book III, 1814, p. 127, see further, Clifford 1998, pp. 96–101.

25. This vase is likely to have been the Lante vase discovered at the Villa Adriana at Tivoli, which by 1639 was in the possession of the Lante family in Rome.

26. PRO C.104.57 part 1, Vulliamy Papers, Letter Book I, 1807–10.

27. November 1808. It was common practice to provide customers with models when dealing with interior architecture. Lincolnshire Record Office, 2 ANC/25/1 and 25/5. Gilbert Heathcote paid £2 2s. 'for a model for Roof ' sent to Normanton in 1764, and 13s. 6d. to James Arrow for the 'making of a module of a Cornice and a packing case for do', which involved four-and-half-days work.

28. MBP, Letter Book E, 11 December 1771.

29. Seidman 1985, pp. 59–63. Letter dated 1791; and 'Catalogue Raisonné', Journal of the Walpole Society, 1987. He was 'seal engraver to His Majesty, chief engraver of stamps and assistant engraver to His Majesty's Mint', his most powerful patron was the glyptophile George, fourth Duke of Marlborough.

30. MBP, Letter Book, February 1791.

31. Natural History Museum, Entomology Library, Drury Papers, SB fD6, Letter Book 1761–83, p. 204v. See Clifford 1998, pp. 100–2.

32. MBP, 244, Letter Box 116–120, February 1791.

33. VAM8, p. 103.

34. Ibid.

35. Unlike the dies made for stamped buttons. Matthew Boulton in a letter to Asheton Curzon written in 1776, explained that 'a pair of dyes [are] being made for you for which you will be charg[d] one guinea (being our custom in such cases so to do) these Dyes will ever remain for your purpose only in making

these buttons'. Isaac Rivière made many button patterns for Parker and Wakelin, their Workmen's ledgers record in 1770 a 'nurled coat for a pattern', a 'nurled waistcoat pattern', his standard charge being 5d.

36. VAM8, p. 63.

37. VAM7, p. 69. See Barr 1980, p. 82.

38. Advising on the decoration and interior of the house and church. Soane Museum, Adam vol. V, f.78 'Portions of a large Epergne'.

39. MBP, Letter Book G, 15 February 1776.

40. Quickenden 1986, p. 417.

41. Sotheby's, London, 13 June 1983, lot 51, 12 dinner plates 23.5 cm wide, William Cripps 1748; 12 dinner plates 23.5 cm wide, Sebastian and James Crespel 1762; 2 serving dishes, 31.5 cm wide, William Cripps 1762; 2 serving dishes, 36.5 cm wide, William Cripps 1755; serving dish, 41.8 cm wide, William Cripps 1762; 2 serving dishes, 48.6cm wide, Thomas Heming 1762.

42. Brasbridge 1824, p. 135.

43. VAM8, p. 76.

44. VAM7, 15 November 1766, £40 4s. 10d., weighing 102 troy oz 2dwt.

45. Warwick Record Office, Newdigate Papers, B3047B, August 1801. The following year they sent a silver instead of steel snuffer, and apologized on behalf of their agent Mr McClauclin. B3047A, 6 February 1802.

46. Sotheby's, June 1993, lots 112 and 113. The silver was refurbished in 1777 by Wakelin and Tayler.

47. Christie's, London, 10 July 1996, lot 101.

48. Sotheby's, London, 28 February 1991, lot 171.

49. VAM7, p. 153.

50. VAM8, p. 217.

51. Williams 1959, p. 19.

52. Expenses of John Hervey, first Earl of Bristol, p. 152, 9 April 1726.

53. Learmount 1985, p. 48.

54. The Critic; or, A Tragedy Rehearsed, London 1779, p. 155.

55. Rosebery's cash books also reveal that he was buying second-hand furniture. Rosebery Archives, Dalmeny, Section 5, vol. 30, p. 10, 14 September 1769, bought furniture for his Grosvenor Street house from Lord Arrandale at £3 13s. 10s., and p. 73, bought more furniture at Mrs Hamilton's sale for £18 18s.

56. Rosebery Archives, Dalmeny, Cash Book 1773–84, Section 5, vol. 31, p. 6. 15 Febraury 1773, I would like to thank Lady Rosebery for her help and advice in consulting the family archives.

57. I would like to thank Harry Williams-Bulkeley for allowing me to consult the 'Catalogue of the superb Jewels, Trinkets, Plate, Gold and Silver Medals, China etc. of a Person of Great Rank, Dec., 1–3 February 1773'.

58. See Sotheby's, London, 23 May 1991, lot 228 and Sotheby's, Gleneagles, 26 August 1991, lot 191. With thanks to David and Sally Cowles for this information.

59. To Francis Montague, 27 August 1769, p. 286.

60. Letters, 28 August 1763, auction advertised in the London Chronicle, 23 to 25 August 1763.

61. Sotheby's, 10 June 1993, lot103.

62. Christie's, London, 20 May 1987, the four tureens made by William Pitts modelled on pieces by Robert-Joseph Auguste of about 1770. In the same way the Duke of Dorset took out French-style silver to Paris in 1784; the ambassadorial service supplied by Jefferys and Jones.

63. 12 November 1765, quoted in Goodwood, n.d., p. 20

64. Andrews 1936, vol. 2, p. 8, 1790.

65. Ibid., p. 37, 1789.

66. Rush 1987, p. 34.

67. Sotheby's, New York, 21 October 1997, lot 265. These coolers are two of a set of four, the other two being in an English private collection.

68. Christie's, New York, 15 April 1997.

69. He was a customer of the business from 1743, buying dessert forks, soup ladles and salt spoons, see VAM2, p. 162.

70. Lewis 1982, vol. X, p. 289. Addressed to Lord Montague in Paris, 7 September 1769. See James Smyth, Practice of Customs, 1821, pp. 56 and 183.

71. John 1995, p. 98. Adam Smith summed up the position of Anglo-French trade in 1776, 'Seventy-five per cent may be considered as the lowest duty to which the greater part of the goods of the growth, produce or manufacture of France were liable . . . those duties [are] equivalent to a prohibition . . .[and] have put an end to almost all fair commerce between the two nations'.

72. This was still going on in the 19th century. Ruskin, in his essay Ad Valorem, written in 1860, mentions how 'the wrought silver vases of Spain were dashed to fragments by our custom-house officers, because bullion might be exported free of duty, but not brains'. Reproduced in John Ruskin, 'Unto This Last' Four Essays on the First Principles of Political Economy, London 1862.

73. Phillips and Williams-Bulkeley 2000, p. 148.

74. John 1995, p. 98.

75. Ingram 1988, pp. 382–6.

76. Bedford Estate Office.

77. Bellaigue 1988, p. 418.

78. A set of four three-light candelabra and a pair of table-candlesticks to the same design were part of a large collection of Auguste silver in the possession of the Earl of Harcourt, another Francophile, but they bear the Paris date letter for 1767.

79. For example, four candlesticks, Parker and Wakelin, 1774, Christie's, New York, 30 October 1991, lot 265; 4 matching candelabra with a pair of matching branches, Parker and Wakelin, 1776, Christie's, 27 November 1974, lot 94; pair of two-light candelabra, Wakelin and Tayler, 1777, Christie's,

New York, 21 April 1998, lot 216.

80. J.H. Bourdon Smith, *Spring Catalogue*, 1987, no.30, p. 59, described as a 'pair of seven light candelabra in Adam taste'.

81. Sotheby's, London, 10 November 1994, lot 148.

82. Presented to Oriel College, Oxford by Wynn, who had matriculated in 1766, the candlesticks are engraved with the inscription 'D.D. Dn^s W W Wynne AD 1772', *see* E.A. Jones *Catalogue of Plate from Oriel College, Oxford*, 1940, pl.6; pair two-light candelabra, Thomas Heming, branches by John Romer, 1771, Christie's, 25 October 1989, lot 174.

83. Christie's, London, 17 March 1987, lot 390.

84. VAM9, Gentlemen's Ledger 1777–87, p. 1. One of Flaxman's account books containing a record of his transactions with Rundells from 1817 and 1825 show that he was paid sums ranging from five guineas in 1819, for a group of unidentified 'Sketches of Candelabra, Cups and A Border', to five or at most seven guineas for a single drawing.

85. Quickenden 1986, pp. 417–21.

86. VAM13, p. 604, October 1772.

87. For the attribution of these designs *see* Young 1986, pp. 31–35; and Young 1987, pp. 396–400; Young 1995, pp. 335–41; and Young 1996, pp. 149–53.

88. Other designs for silver by William Chambers, which we know were made up, survive, including an oval tureen with husk-swags pendant from ribbon-tied paterae and lion mask drop-ring handles, the cover with rayed lobes, bearing the mark of Parker and Wakelin's subcontractors Daniel Smith and Robert Sharp for 1771–72 (figs. 44 and 45). Their accounts with the business which survive from September 1766 to September 1774 make no reference to the tureen. A third design for silver by Chambers was executed in 1767–68 which bears the mark of John Swift but lacks contemporary armorials, and again in 1770–71 by the Crespels for the tenth Earl of Pembroke, for whom Chambers worked both at Pembroke House, from 1769–70, and at Wilton, from 1772–74. The latter version adapted the original design by replacing the oak leaf handles with acanthus foliage. The gadrooned cover is reminiscent of a design attributed to Germain but relates more closely to a tureen by Roettiers of *c*.1735–36 at Berkeley Castle. There is no record in the Crespels account with Parker and Wakelin for the tureens.

89. VAM7, p. 56.

90. VAM8, p. 112.

91. One is still in possession of the Duke of Marlborough at Blenheim, the other was acquired by Temple Newsam House, Leeds, in 1986, *see* Lomax 1992, pp. 96–9, cat. no. 89.

92. The design still being made in the late 19th century, *see* M.P. Levene, 'Fine antique silver' catalogue, September

1975, p. 3, no.T162, Garrard and Company, London 1892 engraved with the crest of the Duke of Marlborough, made to match the 1768 set.

93. Six of the sauceboats separated from the service have reappeared, Sotheby's, London, 24 October 1988, lot 147.

94. Young, p. 153, possibly an essay by C. J. Richardson in the manner of Chambers.

95. VAM7, p. 202, 20 July 1769, 'To a Chased Flaggon, Chalice and Bread Plate 71oz £43 3s. 10d, To Grav'g 3 Glorys (2 'em large) 15s, a red Morocco Case Lin'd wth plush £2 32s. 7s., To Cash pd for carriage to Blenheim and Box 4s'.

96. Young, in Snodin and Harris 1996, pp. 149–62.

97. Christie's, 25 June 1969, lot 58.

98. Christie's, 21 March 1979, lot 37.

99. Christie's, 25 October 1989, lot 167.

100. Christie's, 30 April 1996, lots 107–113.

101. Fairclough 1995, p. 379.

102. West Sussex Record Office, contract between Bessborough, Chambers and Wilton, 1762, for the sum of £6,100.

103. West Sussex Record Office, F46A 'To the Earl of Bessborough' and 'On the Earl of Bessborough's Villa at Roehampton', ms poems, n.d.

104. Koopman Ltd and Rare Art (London) Ltd, Catalogue, March 2001, pp. 6–7. I am grateful to Lucy Harris for contacting me about these, via Stephen Astley at the Soane Museum. *See* 'The Influence of William Kent', in Barr 1980, pp. 94–104.

105. Culme 1999, p. 23.

106. Roche 2000, p. 44.

CHAPTER 9

1. Kopytoff 1986, pp. 66–7.

2. Cozens-Hardy 1950.

3. Bianchi 1998, p. 10.

4. Cheshire Record Office, Cholmondley Collection, DCH/L/49.

5. Brewer 1997, p107.

6. Smith 1964, vol. 2, p. 159, from Marcia Pointon 1998, p. 201.

7. MBP, Letter Book E, f.303, 10 December 1771.

8. PRO 30/11/278. 'Inventory and Valuation of Plate of the late Most Noble The Marquess Cornwallis Decd', *c*.1805, with 'NB The knives forks spoons and ladles being valued in one lot Messr Wakelin must state the sum to be paid by Lady C. for them which she retains'.

9. Including eight dozen table plates, two dozen soup, two large and two small soup tureens, eight oval sauce tureens, two round breadbaskets and eight octagon dishes and covers

10. Stow 1754–55, vol. II, p. 668.

11. Bellaigue 1988, p. 420.

12. Glennie and Thrift 1996, p. 14.

13. Chalus 2000, p. 669.

14. Ibid., p. 689.

15. Although by 1727 a maximum of 8s. 6d. per oz for fashion had been enforced.

16. Harcourt n.d., p. 158, ms ref. 2182.H.e.11.

17. British Library, 58334, f.22, letter, 10 July 1766. VAM7, 17 July 1766, which included four dozen plates and twenty dishes, costing Mitchell £1,320, plus cash for carriage and waterage of parcel of plate and pewter.

18. Rush 1987, p. 32.

19. Lewis 1982 vol. 18, 17 July 1744, p. 472.

20. Bedfordshire and Luton Archives and Record Service: Wrest Park (Lucas) manuscripts L30/14/333/183, 2 March 1779.

21. Stokes 1931, p. 79, 8 days later Sanderson, a neighbouring cleric from Newton Longueville, wrote to Cole that he 'could not meet with any second-Hand Silver Knives and Forks, but had bought me green Ivory with Silver Ferrils'.

22. Emmerson 1991, p. 7.

23. Stokes (2) 1931, p. 270.

24. Brillat-Savarin (1825) 1970, pp. 264–5.

25. Prideaux 1896, pp. 265–7.

26. VAM7, 15 August 1767.

27. VAM7, 27 February 1767. He also bought a 'gilt chalice and salver in a red leather case', one of the few orders for ecclesiatical silver. He had been rusticated from Oxford in 1744 for employing a chalice at a wine party.

28. PRO Chancery Master's Exhibit C.109.261, 31 March 1786, 'Inventory of China and Linnen in the House in Grosvenor Square and North End'.

29. Northumberland Record Office, Delaval Papers 2DE21/10/36.

30. Elwin 1967, p. 418, 5 March 1792.

31. Suffolk Record Office, Hervey Family Papers, 941/75/1, Inventory of silver plate 1811, with additions 1823, 1827, 1829 in the Marquess of Bristol's hand. 941/75/2 is a copy of 75/1 with loose papers on plate at the Putney Heath house, and on the gilt plate, in the hand of the first Marquess of Bristol.

32. Liners were added in 1808 by Paul Storr, and Robert Garrard made two more to match in 1809, *see* Christie's, 29 June 1955, lot 124, illustrated.

33. The épergne sold by Christie's, London, 29 June 1955, lot 125, marked by Thomas Powell (probably Pitts), 1762, with arms of Heathcote impaling Yorke.

34. Macdonald (1790) 1985, p. 114.

35. Lomax 1991, pp. 118–33.

36. Thomson 1940, p. 282, a similar bill for a ball two years later shows that the arrangements made then were more expensive.

37. Lincoln Record Office, Monson Papers, 10/1A/10.

38. Lewis 1982, vol. 6, p. 485, 7 June 1748.

39. Stone 1993, p. 149, drawing on the extensive private correspondence between Henry Duke of Grafton and his wife Anne, in Suffolk Record Office.

40. Kent Record Office, Darnley Papers, U565/F11, 26 July 1771, 'pd John Patterson for a child's horse and coach £5 1s'.

41. Kent Record Office, Darnley Papers, U565/F11, 15 July 1771.

42. Hodgson 1910, pp. 64–167; quoted in Weatherill 1988, p. 159.

43. Kent Record Office, Hatch building and furnishng accounts, 1762–84, A/18/70.

44. Croome Estate Archives F60D/5, bills for furniture and furnishings, 28 June 1760. *See* further, Coleridge 2000, pp. 8–19.

45. Croome Estate Archives F60D/4, bills for china and glass from Charles Vere of Fleet Street, 22 February 1768.

46. Durant 1988, p. 34, notes that Johnson included the word in his 1755 dictionary.

47. Thornton 1993, p. 147.

48. Edgworth (1812), 1994, p. 68.

49. 'Wimpole Hall', *National Trust Handbook*, 1984, p. 57

50. 'Burton Agnes, Yorkshire', *Country Life*, vol. XIV, no.344, 8 August 1903, pp. 209–16.

51. VAM7, 5 May 1766.

52. Gore 1963, p. 242. Stoke, 18 August 1828.

53. *Walpole Society*, XVI, 1927–28, p. 63.

54. Binney 1982, pp. 2,023–26.

55. PRO Chancery Master's Exhibit C.109.261. 'An Inventory of the Household Furniture of the Late Sir Gilbert Heathcote Bart at His House at North End', as taken by Messrs Haig and Chippendale, 10 March 1786.

56. PRO Chancery Master's Exhibit, C.109.261, 'An Inventory of the Household Furniture belonging to the late Sir Gilbert Heathcote Bart, at his House in Grosvenor Square', taken by Messrs Haig and Chippendale, 15 March 1786.

57. Stow 1754–55, vol. II, p. 668.

58. Cornforth 1994, p. 45.

59. Northumberland Record Office, 2DE 31/10/60. 'The Inventory of Plate Sent from Seaton Delaval to London December 28 1750'.

60. Northumberland Record Office, 2DE 31/10/60. 'The Inventory of Plate Put in the Iron Chest at Seaton Delaval December 28 1750'.

61. Northumberland Record Office 2DE 21/10/36. 'Plate sent to London from Seaton Delaval Octr 30th 1781'.

62. Rush 1987, p. 184.

63. Quoted in Eatwell 2000, p. 60.

64. MBP 140, Letter book G, p. 830, 15 February 1777.

65. Ibid., p. 797, 6 January 1777.

66. Walker 1991, p. 383. To Richard Twining from the Strand, 1791. *See* also, p. 116, 1776, on Grantham church, 'one would think it was kept in a shagreen case, like an urn or a coffee-pot, and only uncovered on Sunday to *see* company'.

67. Beeton 1985 (1859–61), p. 962.

68. Hardyment 2000, p. 57.

69. Waterson 1980, p. 176.

70. From Holdernesse household accounts, photocopy V and A, Dept. Furniture and Interior Design Archive, 10 July 1770.

71. Devon Record Office, Fortescue papers, notes F1–3, from hand list.

72. Suffolk Record Office, Bury St Edmunds, 941/81/6.

73. Kent Record Office, Knatchbull papers U951/A46. Housekeeping Accounts 1787–91.

74. Moore-Colyer 1992, pp. 226–7; Adv.MS 24.2.12 f293, pp. 226–7, from Thomas Johnes of Hafod, Cardiganshire, to Robert Anderson in Edinburgh, Castle Hill, 10 January 1808.

75. Waterson 1980, p. 175.

76. VAM7, 26 September 1766.

77. VAM7, p. 12.

78. Beeton 1985 (1859–61), p. 995.

79. MBP 140, Letter book G, p. 830, 15 February 1777.

80. VAM7, p. 186.

81. Buckinghamshire Record Office, Clayton MSS, Box J, Saham, Norfolk 1783. 'An Inventory of the Effects on the premises of the late William Clayton Esq at Whitehall in Saham, Norfolk'.

82. Northumberland Record Office 2834/10. An Inventory of Ford Castle, 17 August 1768.

83. Somerset Record Office, Waldegrave Papers. DD/WO 54/11. Inventory, 23 November 1780, and DD/L /21/1. An inventory of plate, glass, etc. in the Butler's Pantry at Dunster Castle, 19 July 1783.

84. Elwin 1967, p. 387, 21 August 1791.

85. Sotheby's, London, 10 July 1990, lot 363, four silver salvers, Edward Wakelin, London 1755.

86. Lewis 1982, vol. 4 p. 367, 16 October 1791.

87. Lewis 1982, vol. 3 p. 10, May 1763.

88. Brett 2003, p. 3.

89. PRO: PCC Prob 11/10, 16–92, February 1776.

90. Huntingdon Record Office, Fellowes Collection, R35/4. Will of William Fellowes of Upper Grosvenor Street, 11 April 1797.

91. PRO: PCC Prob11/999–267, Lord Holland, July 1774, p. 1.

92. PRO: PCC Prob11/1031–225, 1777.

93. Exeter Record Office, Fortescue of Castle Hill, Papers, FH41, p. 27, will of Hugh Fortescue, 15 January 1714, died 1719.

94. *See* Pointon 1997, p. 36, her definition drawn from Anthony Trollope's novel *The Eustace Diamonds*.

95. Forman 1999, pp. 104–5.

96. Norfolk Record Office, NRS 10836. Abstract of the will of the Earl of Buckingham, 16 July 1793.

97. Huntingdon Record Office, Fellowes Collection, R7/2. Copy will of Coulson Fellowes of St James's Street, 30 December 1766, codicil 1768.

98. PRO: PCC Prob11/1186–599, 1788.

99. Sotheby's, New York, 23 November 1989, lot 369.

100. *See* Workmen's Ledger 1766–73, Ansill and Gilbert, 22 February 1772, 'a gadroon'd Inkstand wth 3 fluted boxes . . . shop', weight 57 oz 17 dwt, cost £8. 14s.

101. I would like to acknowledge the advice and help of Kai Kin Yung in researching this object, for which I am most grateful, and Marcia Wagner Lewinson for supplying a photograph.

102. Or the purchase appears in the missing Gentlemen's Ledger covering the period 1760–65.

103. As the pot bears the scratch weight '14:4' it appears that Johnson valued it at only 8s. above its sterling worth. As the pot bears no assay marks, and Johnson's name does not appear in the firm's ledgers, it is unclear whether Johnson bought it from their retail shop or acquired it as a gift.

104. Smith (1828) 1986, p. 86. Smith recollects that Nollekens was given permission 'to make a drawng of Dr Johnson's silver tea-pot', then in the possession of W. Hoper, which he did after having had a cup of tea from it. Johnson's watch and punch bowl were also preserved, and his ceramic teapot is at Pembroke College, Oxford.

105. According to Michael Vickers, 3,000 drachmas is approximately equal to £5,400 today, although 'most prices in ancient Greece were expressed in denominations of silver, a metal whose value with respect to gold has fallen since antiquity', Vickers and Gill 1996, p. 34; Smith (1828) 1986, pp. 86–7.

CHAPTER 10

1. VAM12, p. 53, 'a Promissory note' with interest at 5%, repaid 18 May 1780.

2. The *Gentleman's Magazine*, 10 February 1784, p. 152.

3. PRO:PCC PROB11/1114–114.

4. VAM12, p. 208.

5. City of Westminster Archives, WBA1103/1. 1772 releases for property.

6. Leatherbarrow 1968, p. 52. Built 1768–72.

7. Quoted from Gwillam 1977, vol. II, p. 52. Revd. Dr Nash was himself a customer of the Panton Street business, opening an account in April 1774, VAM8, p. 94.

8. Andrews and Beresford 1970, vol. 1, pp. 44–5, July 1 and 2 1781.

9. Gwillam 1977, p. 46.

10. HWRO (St Helen's) Ground plans of the houses etc. held by lease under the Corporation of Worcester, J. Aird 1777, p. 45, including a stone yard, the butts, a dwelling house, workshops, garden and pasture, and further gardens.

11. *The Worcester Directory* 1790, p. 42. SRO 2868/298. Buried at Longdon, 14 March 1778. Samuel Netherton also possessed premises leased from the Corporation of Worcester, *see* HWRO (St Helen's), BA5268 f.926.11 p. 45, ground plans of the houses etc. held by lease under the corporation of Worcester, measured and planned by J. Aird, begun 1777.

12. Barr 1988, pp. 94–5.

13. This could be the miniaturist Samuel

Cotes, brother of Francis who had painted the Parkers in 1766.

14. Worcester City Library, Local Studies Collection, microfilm of Berrow's *Worcester Journal*, this example, 10 October 1776, cost for single journey 28s. per person.

15. Private collection, set of 12 threaded knives and forks, engraved with Parker arms, mark 'IP', no date letter, and set of twelve scroll pistol handled knives and forks mark 'CO', no date letter.

16. For Wakelin and Tayler's workshop, John Wakelin's home, and premises occupied by George Bride, the engraver, and James Ward.

17. VAM8, p. 32.

18. SRO 1060/16.

19. SRO 1060/16.

20. VAM14, p. 62.

21. SRO 2868/79 and 80.

22. In partnership with Thomas Gibson, operating from Lawrence Lane, London.

23. SRO 2868/264. Will of Mary Nixon, 11 June 1788, codicil 16 December 1788.

24. PRP:PCC PROB11/1246-326.

25. The chalice, alms dish and two flagons are marked by Wakelin and Tayler 1790, the alms dish engraved around the upper rim: 'The Gift of THOMAS PARKER of Silver Street, WORCESTER Gentleman to the Parish Church of LONGDON on SAINT MICHAEL's Day XVI September MX … Revd Henry Salmon VICAR Robert Hopper John Bery CHURCH WARDENS'.

26. Gunnis 1951, p. 373.

27. SRO 2868/151, signed and dated 1860.

28. HWRO 458/6. Probate will of Mary Parker, 24 August 1795.

29. SRO 2868/265.

30. SRO 2868/284.

31. VAM8, p. 19.

32. Croome Estate, No.10, 'June 20 1770 in full for Messrs Parker and Co, Wm Tayler'.

33. Grimwade 1990, p. 678, Eaton resigned from the Livery on 29 May 1767.

34. VAM9, p. 24, Stewart and Cutten p. 100, John Blackburn (fl.1769–75) at the Royal Academy between 1769 and 1775, and Joseph Blackburn (fl.1752–78) first recorded in Bermuda in 1752, active in New England up to 1763, in London by 1764 and by 1773 in South Wales. With thanks to Paul Cox from the National Portrait Gallery for this information. A painting of the local Worcestershire antiquary, Dr Nash, painted by a 'Jos Blackburn' in 1770 at Eastnor, seems to confirm the latter as the most likely author, *see* Cox 1993, p. 5, footnote 4. A

Mr Blackburn is recorded as leasing a house in Silver Street from Worcester Corporation, *see* Aird 1777, p. 19. Blackburn also painted portraits of Edward Browne of Sweeney in 1774, and Edward Browne of Oswestry in 1783, *see* Burke and Savills 1980, p. 391.

35. SRO 1060/23.

36. Birmingham Central Library, Boulton Papers, Letter Book G, p. 867, 15 March 1777; Letter Book I, p. 512, 11 December 1779; p. 518, 22 December 1779 and p. 880 30 November 1781.

37. Ibid., Letter Book I, p. 886, 5 October 1781.

38. VAM11, p. 76, 22 March 1777, £72 9s. 6d.

39. Barr, 1980, p. 50.

40. London Guildhall Archives, Sun Insurance Policy. As the Westminster Fire Insurance policy reveals, Parker also owned the houses either side of this new workshop.

41. VAM40, p. 11.

42. VAM40, p. 36.

43. London Guildhall Archives, Sun Insurance 11936, vol. 338, p. 344, Sebastian and James Crespel, 2 September 1786, no.521518. Household goods in dwelling house £200, Sebastian's wearing apparel £30, James's wearing apparel £70, utensils and stock in trade £700.

44. Paul Storr leased manufacturing premises, in Francis Street, Grays Inn Lane, adjoining his new workshops in Harrison Street, to Robert, James and Sebastian Garrard from at least 18 November 1822, as their Sun Insurance Policy makes clear. *See* further, Sotheby's, London, 20 November 1987, lot 152.

45. VAM40, p. 205, Bates the Carpenter for 3 new mahogany sashes.

46. IGI, John Wakelin married Catherine Tyler, 28 January 1782, Westminster St Martin's; William Wakelin christened son of John and Ann Wakelin, 27 October 1784, Westminster, St Martin's.

47. SRO 2868/42. Weatherell had been 'prevented for many months from carrying on his trade and deprived of the use of a great part of his house and warehouse not only for his own family but in letting part out in lodgings which he has used to do', Parker asked for an arbitrator, and John Mayhew of Carnaby Market, a customer of the business, and partner to Matthew Ince, found in favour of Weatherell and Parker paid £255 damages.

48. VAM19, Day Book, 1771–91, 12 August 1790.

49. Sotheby's, New York, 28 October 1792, lot 296.

50. Noted on last codicil, HWRO 705:16 BA 458/6.

51. Grimwade 1990, p. 678; *Gentleman's Magazine*, p. 575; *European Magazine* p. 480.

52. PRO:PCC PROB11/1222/452.

53. The christian name of Ann's husband is left blank in the will, however, a lease relating to property in Woodford Parish, dated 1783, names Thomas Wheatly and his wife Ann as parties, Essex Record Office, D/P 167/18/4. Waltham Abbey was described in 1817 as being 'extremely full of inhabitants, owing to the various manufactures carried on there', *see* J. Hassell 1817–18, p. 183.

54. It is possible this was the same Thomas Forrest who appears in the Workmens' Ledger as supplying unspecified types of jewellery work, VAM8, p. 7.

55. Appears in the business accounts, VAM14, p. 46. The name is French, and may be related to Isaac Francis Vitu, goldsmith, son of Isaac Vitu of St Ann's, Westminster, mercer, apprenticed to David des Rheumeaux in 1715, *see* Evans vol. XIV, No.4, p. 59.

56. SRO 1060/23, John Parker's housekeeping book, begun 1776.

57. *See* PRO, 30/11/278, 'Inventory and Valuation of Plate of the late Most Noble the Marquess Cornwallis Decd', n.d. but c.1784, with note at the end 'The knives forks spoons and ladles being valued in one lot Messrs Wakelin must state the sum to be paid by Lady C. for those which she retains'. Bedfordshire County Record Office, Burgoyne Papers, 31/413, list of 'Family Plate parted with by Order of Chancery in 1795 and 1796 Ditto Gilt plate kept at Mr Wakelyns'.

58. Bedfordshire Record Office, Lucas Papers, 31/413 'List of Gilt plate kept at Mr Wakelyns', 1796.

59. *Members of Oriel College*, p. 240, bearing the mark of Richard Crossley, and engraved with the Parker crest. Admitted commoner 12 May 1789, 'fil Joh, de Civ Westm. arm', BA Oriel 7 February 1793, MA 29 October 1795, gave to the College in 1795 one dozen table forks'.

60. SRO 2868/166, Notebook, 'Tour in the Austrian Netherlands … May June and July 1794'.

61. SRO 2868/306, Notebook with draft family history 'Account of Parker family for Burke but never sent'.

62. SRO 1060/26. Account Book of Thomas Netherton Parker, April 1806 to October 1808.

63. VAM23 (1792–98).

Bibliography

PRIMARY SOURCES

Parker and Wakelin Case Study Archives

Archive of Art and Design (AAD), Victoria and Albert Museum (VAM), Garrard Ledgers.

AAD/1995/7 acquired by the Victoria and Albert Museum, Metalwork Department 1952, transferred to the National Art Library, Archive of Art and Design, 1987

Gentlemen's Ledgers, some indexed, containing client accounts (1735–1949).

Workmen's Ledgers (1747–62) and (1766–1816), day books (1777–1879).

Correspondence and papers relating to John Wakelin's debtors (1790–1814).

Daily account books (1797–1801), stock books (1797–1808). Garrard still possess the first two Gentlemen's Ledgers relating to the foundation of the firm (1753–48), photocopies of these with AAD (above), a microfilm is available at the Victoria and Albert Museum, National Art Library, of all ledgers up to 1818. This book concentrates primarily on Gentlemen's Ledger 1765–76 (VAM7) and Workmen's Ledger 1766–73 (VAM8) which overlap.

Shropshire Record Office

Leighton of Sweeney Collection:2868/93 partnership agreements 1760 and 1770, and leases to business property in London.

Parker Family

Shropshire Record Office

Leighton of Sweeney Collection: 1060/1–25 Accounts 1731–1804, 1060/143–146 and 172 inventories, 2868/25–63 London property, 2868/64–81 family. 2868/89–92 Stoke Newington estate, 2868/253–317 wills and miscellaneous. Hereford and Worcester Record Office

Parker papers: plans of Longdon BA5658/899:499 and wills and deeds BA458/5–6 Worcester Record Office.

Wakelin Family:

Public Record Office: PCC PROB11/1114–114 Edward Wakelin's will, 1779.

Comparative Business Archives

Business Papers

BOULTON papers: Birmingham Central Library, Letter Books.

BRAITHEWAITE, George – London goldsmith's accounts, Public Record Office C.105/5 part 1.

COYTE, George – London silversmith, VAM National Art Library and Department of Prints and Drawings, MSS 76.HH.40.

COX, James – London jeweller, automata maker and showman, Bodleian Library, Oxford, John Johnson Collection, Album L, for Lotteries.

DRURY, Dru– London goldsmith and entomologist, Natural History Museum, London, Entomology Library, SB f D6.

MORTON and Company – Sheffield silversmiths, Sheffield City Library, Bradbury Archive, 271.

NEVILLE, John – London goldsmith's papers, Public Record Office 1746 - B4/11.156 and 1753 B1/22.52.

SALOMAN – London diamond merchant's accounts 1760–1800, Public Record Office C.111.146–161.

SCOTT, G.W. and Sons – London basketmaker's accounts London Metropolitan Archive B/SCT/11 day book 1775–77.

VULLIAMY Brothers – Clockmakers and Silversmith's accounts Public Record Office C.104.57–58, silver accounts, 1793–1820.

WEBB, Peter and Arthur – London jeweller's accounts 1735–93, Public Record Office, C.108.284–5.

WEDGWOOD, Josiah – Keele University Archives, correspondence c.1760–80.

WHIPHAM, Thomas – London goldsmith's accounts, Devon Record Office 2814/B1–2c.1762–73.

Retail and Manufacturing Sites

London Guildhall Archives, Sun Insurance, 477/946271, (1819) taken out by J. and S. Garrard, for workshop, 1783.

Westminster City Archives, Collector's Books, Paving Rate E1720, (1768), Poor Rate F6018, (1768).

Training

Goldsmiths' Hall Archives, Apprentice Books No.7, 1740–63, no.8, 1763–70, no.9, 1770–1802, Court Book 1754–67.

Goldsmiths' Hall Archives, annotated 'Report from the Committee appointed to enquire into the Manner of Conducting the Several Assay Offices in London, York, Exeter, Bristol, Chester, Norwich and Newcastle upon Tyne', London, 1773.

Corporation of London Record Office, Edward Wakelin's apprenticeship indenture 1730, and John Parker's apprenticeship indenture 1751.

Government papers

1. Public Record Office

Plate Tax Registers: T47/5–7.

Plate Tax Lists, 1765–62 and 1776, and T47/6.

Defaulters 1757–68 and T36/8

Scottish Plate Tax 1756–62.

2. Public Record Office

Jewel Office Accounts

LC5/111 Jewel Office, Warrent Book, Series I, 1762–85.

LC5/113 Jewel Office, Warrent Book, Series II, 1727–93.

LC5/114 Jewel Office, Books of Letters and Inventories 1704–61.

LC9/45 Lord Chamberlain's Department, Delivery Book, Accounts and Receipts 1728–67 and 1767–82.

Sale Catalogues, National Art Library, Victoria and Albert Museum

BELLIS, Charles – jeweller, Christie's, 12–17 June 1782.

CLEE, Robert – engraver, Langford, 20–22 January 1774.

COX, James – jeweller, Christie's, 16 February 1792.

HARRACHE, Thomas – jeweller, Christie's, 3–4 May 1780.

SCALES – jeweller, Christie's, 27–82 April 1779.

Guide Books to London

DODSLEY, J. and DODSLEY, R., *London and its Environs described containing an account of whatever is most remarkable for Grandeur, Elegance, Curiosity or Use*, (London 1761).

HASSELL, J., *Picturesque rides and walks, with excursions by water, thirty miles round the British metropolis*, (London 1817–18).

Kent's Directory for the Year 1776, (London 1776).

London Directory for the Year 1768 Containing an Alphabetical List of the Names and Places of Abode of the Merchants of London, (London 1768).

MALCOLM, JAMES PELLER, *Anecdotes of the Manners and Customs of the London*, (London 1808).

MORTIMER, T. *The Universal Director or the Nobleman and Gentleman's True Guide* (London 1763).

PHILLIPS, RICHARD, *The Picture of London*, (London 1804).

The New Complete Guide To All Persons Who Have Any Trade or Concern with the City of London, (London 1765).

TRUSLER, JOHN, *The London Adviser and Guide: Containing Every Instruction and Information Useful and Necessary to Persons Living in London, and Coming to Reside There*, (London 1786).

WAKEFIELD, PRISCILLA, *Perambulations in London and its Environs*, (London 1809).

Tradesmens' Biographies

BEWICK, THOMAS, *A Memoir of Thomas Bewick Written by Himself*, (Newcastle 1761, repr. Oxford 1975).

BRASBRIDGE, J. *The Fruits of Experience*, (London 1824).

FOX, G., *Memoirs of the late Philip Rundell Esq. Goldsmith and Jeweller to His Majesty and the Royal Family Late of the Golden Salmon, Ludgate Hill, who by Industry and Perseverance accumulated the immense fortune of One Million and a Half*, (London 1827).

Tradesmens' Advice Books

ANON, *A General Description of Trades*, (London 1747).

CAMPBELL, R., *The London Tradesmen*, (London 1747, repr. 1969).

CHITTY, B., *A practical treatise on the law relative to apprentices and journeymen and to exercising trades*, (London 1812).

COLLYER, R., *The Parents and Guardians Directory*, (London 1761).

DEFOE, DANIEL, *The Complete English Tradesman*, (London 1726).

London and the State of the Trade

A Register of Premiums and Bounties given by the Society instituted at London for the Encouragement of Arts, Maufactures and Commerce London, (London 1778).

ANON, *Letters Concerning the Present State of England, London*, (London 1772).

DOSSIE, ROBERT, *Memoirs of Agriculture and other Economical Arts*, (London 1782).

GWYNN, JOHN, *London and Westminster Improved*, (London 1766).

POSTLETHWAYTE, MALACHY, *Universal Dictionary of Trade and Commerce*, (London 1766).

Report of the Committee Appointed to Enquire into the Manner of Conducting the Assay Office, (London 1773).

ROUQUET, ANDRÉ, *The Present State of the Arts in England*, (London 1755).

Customers: Family Papers

Ancaster: Lincolnshire Record Office.

Bessborough: West Susssex Record Office, F46A.

Bouverie: Northampton Record Office, inventories, bills and correspondence 1766–83.

Cholmondley Collection: Cheshire Record Office, DCH/L/49.

Clayton: Buckinghamshire Record Office, Box J. inventory 1768.

Coventry: Croome Estate Papers, Croome Court, Worcestershire. FD60 Bills for Silver and Jewellery

Darnley: Kent Record Office U565/F11.

Delaval: Northumberland Record Office, 2DF/28–31 Accounts 1760s to 1770s.

Drummonds Bank Archive, London.

Galway: Nottingham University Library, 12,308–701, bills, acounts, inventories.

Grafton: Suffolk Record Office, HA 513/4/73.

Grantham: Bedfordshire Record Office, L31

Heathcote: Breamore House, Hampshire.

Hervey: Suffolk Record Office, 941/75/1, inventory of silver plate 1811.

Hoares' Bank Archive, London.

Holland-Martin Papers, Hereford and Worcester Record Office, St Helen's, BA8397.

Hulse: Breamore Archives, Ac192 household account book 1766–89.

Knatchbull: Kent Record Office, U951 building and furnishing accounts, 1770.

Molyneux: Preston Record Office, DDM1/145–53, accounts.

Monson: Lincolnshire Record Office.

Newdigate: Warwick Record Office.

Rosebery: Private Archives, Section 5, accounts 1767–75.

Waldegrave: Somerset Record Office, DD/WO 54/11, inventories 1780 and DD/L /21/1.

Published Primary Sources

ABBOT, ROBERT, *The Housekeeper's Valuable Present*, (London *c.*1790).

ARCHENHOLZ, J.W.A., *A Picture of England*, (London 1789).

BEWICK, THOMAS, *A Memoir of Thomas Bewick Written by Himself*, (Newcastle 1762, repr. Oxford, 1975).

COSNETT, THOMAS, *The Footman's Directory*, (London 1810).

FORD, auctioneer, *A catalogue of all the genuine stock in trade of Mr John Neville, goldsmith and jeweller, late of Norris-Street, in the Hay-market, a bankrupt*, (London 1746).

HAYES, RICHARD, *The Gentleman's Complete Book-keeper*, (London 1741).

HENDERSON, W.A. *The Housekeeper's Instructor*, (London 1805).

NORTH, ROGER, *The gentleman accomptant: or, an essay to unfold the mystery of accompts, by way of debitor and creditor, commonly called merchants accompts*, (London 1721).

QUIN, M., *Rudiments of Bookkeeping*, (London 1779).

ROOSE, RICHARD, *An essay to make a compleat accomptant*, (London 1760).

RUSH, RICHARD, *A Residence at the Court of London*, (1833, repr. London 1987).

SMITH, MARY, *The Complete House-Keeper and Professed Cook*, (Newcastle 1772).

TRUSSLER, J., *The Honours of the Table*, (London 1788).

THOMSON, WARDAUGH, *The Accomptant's Oracle; or key to science being a Treatise of common arithmetic: with the Doctrine of vulgar and decimal fractions*, (Whitehaven 1771).

SECONDARY SOURCES

AITKEN, JAMES (ed.), *English Letters of the XVIII Century*, (London 1946).

ALLAN, D.G.C., 'Artists and the Society in the eighteenth century', in *The Virtuoso Tribe of Arts and Sciences. Studies in the Eighteenth-Century Work and Membership of the London Society of Arts*, (Athens, Georgia and London 1992), pp.91–119.

ALEXANDER, D., *Retailing in England during the Industrial Revolution*, (London 1935).

ALTICK, RICHARD, *The Shows of London*, (Cambridge MA, 1978).

ANDREWS, C. BRUYN (ed.), *The Torrington Diaries 1781–1794*, 4 vols, (London 1935).

APPADURAI, A., *The Social Life of Things. Commodities in Cultural Perspective*, (Cambridge 1986).

ARCHER-HOUBLON, ALICE, *The Houblon Family*, (London 1907).

AUSTIN, EVANS, *The Laws Relating to Apprentices*, (London 1890).

BADCOCK, T., *A New Touch-Stone for Gold and Silver Wares*, (1677, repr. Shannon 1970).

BAKER, MALCOLM, 'Roubiliac and Cheere in the 1730s and '40s: Collaboration and Sub-contracting in Eighteenth-century English Sculptor's Workshops', *Church Monuments*, vol.X. 1995, pp.90–107.

—— *Figured in Marble. The Making and Viewing of Eighteenth-Century Sculpture*, (London 2000).

BAMBERY, ANNEKE, 'Tudor and Leader: Sheffield Silversmiths' *The Antique Collector*, June 1985, pp.110–15.

—— *Old Sheffield Plate*, (Princes Risborough 1988).

BANISTER, JUDITH, 'A basketmaker's Accounts with Some Eighteenth Century Silversmiths', *Proceedings of the Society of Silver Collectors*, vol.I, 9, 1967, pp.21–4.

—— 'Rococo Silver in a Neo-classical setting. The Bristol Family Silver at Ickworth', *Country Life*, 4 September 1980.

—— 'A Postscript to the Barnard Ledgers', *Proceedings of the Society of Silver Collectors*, vol.III, 1/2, 1983, pp.28–40.

BARR, ELAINE, 'Gainsborough and the Silversmith', *Burlington Magazine*, vol.CXIX, June 1977, p.113.

—— 'John Parker – a portrait by Frances Cotes' *Burlington Magazine*, vol.CXXI, June 1979, pp.375–6.

—— *George Wickes 1698–1761 Royal Goldsmiths*, (London 1980).

—— 'John Parker, Gentleman and Goldsmith', *Apollo*, February 1988, pp.94–5.

BARRELL, JOHN, *The Birth of Pandora and the Division of Knowledge*, (London 1992).

BARRY J. and BROOKS B. (eds), *The Middling Sort of People: Culture, Society and Politics in England 1500–1800*, (London 1994).

BAUDRILLARD, JEAN, *A Critique of the Political Economy of the Sign*, (St Louis 1981).

BEARD, GEOFFREY, 'Decorators and Furniture makers at Croome Court', *Furniture History Society Journal*, vol.XXIX, 1993, pp.88–113.

BEET, BRIAN, 'Foreign snuffbox makers in eighteenth century London', *Silver Society Journal*, 2002, pp.49–78.

BELLAIGUE, GEOFFREY DE, 'Sèvres at Woburn Abbey', *Apollo*, June 1988) pp.413–17.

BENHAMOU, REED, 'Imitation in the Decorative Arts of the Eighteenth Century', *Journal of Design History*, vol.4, no.1. 1991, pp.1–14.

BERG, MAXINE and CLIFFORD, HELEN, 'Commerce and Commodity Graphic Display and Selling New Consumer Goods in Eighteenth Century England', in M. North and Ormrod, *Art Markets in Europe 1400–1800*, (Aldershot 1999), pp.187–200.

—— *Consumers and Luxury Consumer Culture in Europe 1650–1850*, (Manchester 1999).

BERMINGHAM, ANN, 'An Exquisite Practise: the Institution of Drawing as a Polite Art in Britain', in Brian Allen (ed.), *Towards a Modern Art World, Studies in British Art*, (New Haven and London 1995).

BERRY, C., *The Idea of Luxury. A Conceptual and Historical Investigation*, (Cambridge 1976).

BIANCHI, MARINA, *The Active Consumer Novelty and Surprise in Consumer Choice*, (London 1998).

BINDMAN, DAVID (ed), *John Flaxman, R.A.*, (London 1979).

BINNEY, MARCUS, 'Warwick Castle Revisited IV', *Country Life*, vol.CLXXII, no.4453, 23 December 1982, pp.2,023–26.

BLAIR, CLAUDE, *Three Presentation Swords*, (London 1972).

BLOOM, E.A. and BLOOM L.D., *The Piozzi Letters: Correspondence of Hester Lynch Piozzi 1784–1821*, (Newark and London 1989).

BOIME, ALBERT, *Art in an Age of Revolution 1750–1800*, (Chicago 1987).

BOLITHO, HECTOR and PEEL, DEREK, *The Drummonds of Charing Cross*, (London 1988).

BOSSENGA, G., 'Protecting Merchants: Guilds and Commercial Capitalism in Eighteenth-Century France, *French Historical Studies*, vol.XV, no.4, Autumn 1988, pp.693–703.

Boswell's London Journal 1762–1763, (London 1952).

BOUGHTON, PETER, *Catalogue of Silver in the Grosvenor Museum, Chester* (West Sussex 2000).

BRAUDEL, F., *The Wheels of Commerce, Civilization and Capitalism 15th – 18th Century*, (London 1982).

BRETT, GERARD, *Dinner is Served. A History of Dining in England 1400–1900*, (London 1968).

BRETT, SIMON (ed.), *The Faber Book of Diaries*, (London 1987).

BRETT, VANESSA, 'The Compleat Appraiser, an eighteenth century manual and the valuing of plate', *The Silver Society Journal*, 2003, pp.2–4.

BREWER, JOHN, *Party Ideology and Popular Politics at the Accession of George III*, (Cambridge 1976).

—— *Pleasures of the Imagination English Culture in the Eighteenth Century*, (London 1997).

BREWER, JOHN and STYLES, JOHN, (eds), *An Ungovernable People: The English and Their Law in the Seventeenth and Eighteenth Centuries*, (London 1980).

BREWER, JOHN AND PORTER, Roy, (eds), *Consumption and the World of Goods*, (London 1993).

BRILLAT-SAVARIN, JEAN-ANTHELME, *The Philosopher in the Kitchen*, (tr. Anne Drayton), (Paris, 1825, repr. London 1970).

BROADLEY, ALEXANDER MEYRICK, *The Story of the Haymarket Its Theatres, Taverns, Shops and Shows from the Coronation of King Charles II (1651) to that of King George V (1911)*, (London 1911).

—— *Garrard's 1721–1911 Crown Jewellers and Goldsmiths during Six Reigns and in Three Centuries*, (London 1912).

BROWN, PETER, *In Praise of Hot Liquors*, (York 1995).

—— (ed.), *British Cutlery: An Illustrated History of Design, Evolution and Use*, (York 2001).

BROWN, PETER and DAY, IVAN, *Pleasures of the Table. Ritual and Display in the European Dining Room 1600–1900*, (York 1977).

BROWN, PETER and SCHWARZ, MARLA, *Come Drink the Bowl Dry. Alcoholic Liquors and Their Place in 18th Century Society*, (York, 1996).

BUMPUS, T. FRANCIS, *Ancient London Churches*, (London 1907).

BURKE and SAVILLS, *Guide to Country Houses*, (London 1980).

BURNETT, JOHN, *A History of the Cost of Living*, (London 1969).

BURY, SHIRLEY, 'Flaxman as a designer of silverwork', in Bindman 1979, pp.43–52.

—— 'The lengthening shadow of Rundells part I: Rundells and their silversmiths', *Connoisseur*, CLXI, February 1966, pp.78–85.

CAMPBELL, COLIN, 'Consumption and the Rhetorics of Need and Want', *Journal of Design History*, vol.11, no.3, (1998), pp.235–46.

CANNON, JOHN, *Aristocratic Century. The Peerage of Eighteenth-Century England*, (Cambridge 1984).

CARRIER, JAMES G., *Gifts and Commodities. Exchange and Western Capitalism since 1700*, (London 1995).

CHAFFERS, W., *Hallmarks on Gold and Silver Plate*, (London 1863).

—— *Gilda Aurifabrorum. A History of English Goldsmiths and Plateworkers and their Marks Stamped on Plate*, (London 1883).

CHALUS, ELAINE, 'Elite women, social politics and the political world of late eighteenth-century England', *Historical Journal*, vol.43, 3 September 2000, pp.669–98.

CHAPMAN, R.W. (ed.), *Boswell – Life of Johnson*, (Oxford 1976).

CHERRY, JOHN, *Medieval Craftsmen Goldsmiths*, (London 1992).

CHESTERFIELD, LORD, *Letters to His Son and Others*, (London and Melbourne 1984).

CHURCH, ROY, 'Business History in Britain', *Journal of European Economic History*, 5, 1976.

CLAY, C., 'Marriage, Inheritance and the Rise of Large Estates in England 1660–1815' *Economic History Review*, 2nd ser.21 (1968).

CLAYTON, MICHAEL, *The Collector's Dictionary of the Silver and Gold of Great Britain and North America*, (London 1985).

CLIFFORD, HELEN, *Garrard: Royal Goldsmiths*, (London 1987).

—— 'The Organization of an Eighteenth Century Goldsmith's Business', *The International Silver and Jewellery Fair and Seminar*, (London 1990), pp.16–22.

—— 'Colonel Shorey, citizen and pewtererer of London', *The Journal of the Pewter Society*, vol.7, no.4, Autumn 1990.

—— 'King Christian VII's Visit to England in 1768', in Krog 1991, pp.11–29.

—— (1), 'The Award of Premiums and Bounties by the Society of Arts', *RSA Journal*, (August/September 1997), pp.78–80.

—— (2), 'Goldsmiths of invention: hidden connections and alternative occupations', *The Silver Society Journal* (Autumn 1997), p.574.

—— (3), 'Accounting for luxury: some sources and methods for the study of the eighteenth century London precious metal trades', *Business Archives Sources and History*, no.74, (November 1997), pp.1–12.

—— 'The Vulliamys and the Silversmiths 1790–1817', *The Silver Society Journal*, 10, 1998, pp.96–102.

—— (1), 'A Commerce with Things the Value of Precious Metalwork in Early Modern England', in M. Berg and H. Clifford, *Consumer Culture in Europe 1650–1850*, (Manchester 1999), pp.147–69.

—— (2), 'In defence of the toyshop: the intriguing case of George Willdey and the Huguenots', *Proceedings of the Huguenot Society*, xxvii (2) 1999, pp.171–88.

—— (3), 'Concepts of Invention, Identity and Imitation in the London and Provincial Metal-Working Trades, 1750–1800', *Journal of Design History*, vol.12, no.3, 1999, pp.241–56.

COCKERELL, T.D.A., 'Dru Drury, as Eighteenth Century Entomologist', *Scientific Monthly*, 1922, pp.67–82.

COKE, 1889

COLEMAN, D.C., *Myth, History and the Industrial Revolution*, (London and Rio Grande 1992).

COLERIDGE, ANTHONY, 'English furniture supplied for Croome Court. Robert Adam and the 6th Earl of Coventry', *Apollo*, February 2000, pp.8–19.

COLLEY, LINDA, 'The English Rococo. Historical Background', in *Rococo Art and Design in Hogarth's England*, (London 1984) pp.10–17.

COPLEY, STEPHEN, 'The Fine Arts in Eighteenth-century Polite Culture', in *Literature and the Social Order in Eighteenth-Century England*, (London 1984) pp.13–37.

—— 'Commerce, Conversation and Politeness in the Early Eighteenth Century Periodical', *British Journal for Eighteenth Century Studies*, vol.18, no.1, Spring 1995, pp.63–77.

CORNFORTH, JOHN, 'A Building Baronet II', *Country Life*, 10 February 1994.

—— 'On his own Legs', *Country Life*, 28 September 1995, pp.70–3.

COTTERELL, HOWARD H. and Heal, Ambrose, 'Pewterers' Trade Cards', *Connoisseur*, vol.lxxvi, December 1926, pp.221–6.

COX, D.C., '"This Foolish Business" Dr Nash and the Worcestershire Collections', *Worcestershire Historical Society Occasional Publications*, 7, 1993, p.5.

COX, NANCY, *The Complete Tradesman: a study of Retailing 1550–1820*, (Aldershot 2000)

COZENS-HARDY, B. (ed.), *The Diary of Sylas Neville 1767–1788*, (Oxford 1950).

CRASKE, MATTHEW, 'Plan and Control: design and the competitive spirit in early and mid-eighteenth century England', *Journal of Design History*, vol.12, no.3, Autumn 1999, pp.187–216.

CROSKEY, G. 'The early development of the plated trade' *The Silver Society Journal*, 2000, pp.27–37.

CROWN, PATRICIA, 'British Rococo as Social and Political Style', *Eighteenth-Century Studies*, 1986, pp. 269–82.

CRUIKSHANK, DANIEL, *A Guide to the Georgian Buildings of Britain and Ireland*, (London 1985).

CULME, JOHN, 'Attitudes to Old Plate 1750–1900', in John Culme, *The Directory of Gold and Silversmiths Jewellers and Allied Traders 1838–1914*, vol.I, (London 1987), pp.xvi–xxxvi.

—— 'A Journey to Russia Victorian Scholarship and the Kremlin Discoveries', *English Silver Treasures from the Krelim: A Loan Exhibition*, (London 1991).

—— 'The embarrassed goldsmith 1729–1831. Eighteenth-century failures', *Journal of the Silver Society*, 10, (1998), pp.66–76.

CULME, JOHN and GERE, CHARLOTTE, *Garrard Crown Jewellers for 150 Years 1843–1993*, (London 1993).

CUNNINGHAM, PETER, *Handbook for London Past and Present*, (London 1849).

CURTIN, MICHAEL, 'A Question of Manners: Status and Gender in Etiquette and Courtesy', *Journal of Modern History*, 57, (1985), pp.395–423.

DAVIS, JOHN, *Exchange*, (Buckingham 1992).

DAVISON, DENNIS, *The Penguin Book of Eighteenth-Century English Verse*, (London 1973).

DAY, IVAN, *Eat, Drink and Be Merry The British at Table 1600–2000*, (London 2000).

DEFOE, D. *A Tour Through the Whole Island of Great Britain 1724–6*, (London 1971).

—— *The Complete English Tradesman*, (1727, Far Thrupp 1987).

—— *The Fortunes and Misfortunes of the Famous Moll Flanders*, (London 1993).

DE MARCHI, NEIL and GOODWIN, C.D.W., *Economic Engagements with Art*, (North Carolina 1999).

DEYON, P. and GUIGNET, P., 'The Royal Manufactories and Economic and Technical Progress in France Before the Industrial Revolution', *Journal of European History*, vol.ix, no.3, (Winter 1980), pp.611–32.

DICKSON, P.G.M., *The Sun Insurance Office 1710–1960*, (London 1969).

DOBSON, C.R., *Masters and Journeymen: A Prehistory of Industrial Relations 1717–1800*, (London 1980).

DODSLEY, J. and DODSLEY, R. *London and its Environs described containing an account of whatever is most remarkable for Grandeur, Elegance, Curiosity or Use*, (London 1761).

DOSSIE, R. *Memoir of Agriculture*, (London 1782).

DOVE, ANTHONY B.L., 'Some New Light on Plate Duty and its Marks', *Antique Collecting*, (September 1984), pp.39–42.

DOWELL, STEPHEN, *History of Taxation and Taxes in England*, (London 1884).

DUERDIN, M., *Sheffield Silver 1773–1973*, (Sheffield 1973).

DURANT, DAVID N., *Living in the Past: An Insider's Social History of Historic Houses*, (London 1988).

EARLE, PETER, *The World of Defoe*, (Newton Abbott 1977).

—— *The Making of the English Middle Class Business, Society and Family Life in London 1660–1730*, (London 1991).

EATWELL, ANNE, 'Capital lying dead: attitudes to silver in the nineteenth century', *The Silver Society Journal*, 2000, pp.59–64.

EDGECUMBE, RICHARD, *The Art of the Chaser*, (Oxford 2001).

EDGWORTH, MARIA, *The Absentee*, (1812, London 1994).

EDWARDS, A.C. (ed.), *The Accounts of Benjamin Mildmay, Earl Fitzwalter*, London 1977.

EDWARDS, JOHN and NEWELL, EDMUND, 'The development of industrial cost and mangagement accounting before 18500', *Business History*, 33 (1991) pp.35–57.

EIMER, CHRISTOPHER, *The Pingo Family and Medal Making in 18th-Century Britain*, (London 1998).

ELLIS, MYRTLE, 'Adam Period Household Silver Silver design information in late 18th century domestic accounts', in *V and A Album*, (London 1988), pp.65–9.

ELWIN, MALCOLM, *The Noels and The Milbankes Their Letters for Twenty-Five Years 1767–1792*, (London 1967).

EMMERSON, ROBIN, *Table Settings*, (Princes Risborough 1991).

EVANS, JOAN, 'Huguenot Goldsmiths in England and Ireland', *Huguenot Society Proceedings*, 1933, vol.XIV, no.4.

FAIRCLOUGH, OLIVER, 'Sir Watkin Williams Wynn and Robert Adam: commissions for silver 1768–80', *Burlington Magazine*, vol.CXXXVII, no.1107, (June 1995), pp.376–86.

FALLON, JOHN P., 'The Goulds and the Cafes, Candlestick makers', *Proceedings of the Silver Society Collectors* (1974–76), pp.146–50.

FERGUSSON, FRANCES, 'Wyatt Silver', *Burlington Magazine*, vol.CXVII, no.861, (1974), pp.751–55.

FIELDING, SARAH, *The Adventures of David Simple*, (1744, repr. Oxford 1987).

FINN, MARGOT, '"Men's things": masculine possession in the consumer revolution', *Social History*, XXV-2 (2000), pp.133–55.

FLEISCHMAN, R.K. and TYSON, T.N. 'Cost accounting during the industrial revolution: the present state of historical knowledge', *Economic History Review*, XLVI (1993), pp.503–17.

FLEMING, JOHN and HONOUR, HUGH, *The Penguin Dictionary of Decorative Arts*, (London 1979).

FORBES, J.S., *A History of the London Assay Office*, (London 1998).

FORBERS, H.A. CROSBY, 'Chinese Export Silver for the British Market 1660 to 1780', *Transactions of the Oriental Ceramic Society*, vol.63, (1998–99), pp.1–18.

FORMAN, AMANDA, *Georgiana Duchess of Devonshire*, (London 1999).

FOSTER, SARAH, 'Going Shopping in Eighteenth-Century Dublin', *Things* 4, (Summer 1996), p.37–61.

FOX, CELINA, 'Images of Artists and Craftsmen in Georgian London', *Apollo*, (May 1987), pp.357–6.

FOX, ROBERT and TURNER, ANTHONY, *Luxury Trades and Consumerism in Ancien Régime Paris. Studies in the History of the Skilled Workforce*, (Aldershot 1998).

FRISBY, DAVID (ed.), *The Philosophy of Money Georg Simmel*, (London and New York 1978).

GILBOY, ELIZABETH, *Wages in Eighteenth-Century England*, (Cambridge MA 1934).

GIROUARD, M., 'The English Country House and the Country Town', in G. Jackson-Stops, et al (eds.), *The Fashioning and Functioning of the British Country House*, (Washington 1989).

GLANVILLE, PHILIPPA, *Silver in England*, (London and Sydney 1987).

—— 'The Silver of John, Fourth Duke of Bedford', *Apollo*, (June 1988), pp.415–20.

GLANVILLE, PHILLIPPA and GOLDSBOROUGH, JENNIFER FAULDS, *Women Silversmiths 1685–1845 Works from the Collection of the National Museum of Women in the Arts*, (London and Washington 1990).

GLENNIE, P. and THRIFT, N., 'Consumers, identities and consumption spaces in early modern England' *Environment and Planning*, A, 28 (1996), pp.25–45.

GOODDALL, FRANCIS, *Business Histories*, (London 1987).

GOODISON, NICHOLAS, *Ormolu. The Work of Matthew Boulton*, (London 1971).

GOODISON, NICHOLAS, *Ormolu*, (London 1974).

GOODWIN, A. (ed.), *The European Nobility in the Eighteenth Century*, (London 1953).

GOSS, C., *The London Directories 1677–1855*, (London 1932).

GOLDSMITH, OLIVER, *She Stoops to Conquer; or, the Mistakes of a Night*, (1777, London 1952).

Goldsmiths' Company, *The Art and Evolution of Cutlery*, (London 1999).

GORE, JOHN (ed.), *The Creevey Papers*, (London 1963).

GREENHOUSE, WENDY, 'Benjamin West and Edward III: A Neoclassical Painter and Medieval History', *Art History*, (1985), VIII, No.2, pp.178–91.

GRASSBY, RICHARD, *The Business Community of Seventeenth-Century England*, Cambridge 1997.

GREENBERG, J., 'The Legal Status of English Women in Early Eighteenth-Century Common Law and Equity', *Studies in Eighteeth Century Culture*, 4, (1975).

GRIMWADE, ARTHUR 'The Garrard Ledgers' *The Proceedings of the Society of Silver Collectors*, (1961), pp.10–14.

—— 'Crespin or Sprimont? An Unsolved Problem of Rococo Silver', *Apollo*, no.90, vol.XC, 1969, pp.126–9.

—— *Rococo Silver 1727–1765*, (London 1974).

—— *London Goldsmiths Their Marks and Lives*, (London 1990).

GUBBINS, MARTIN, 'Close plate', *The Silver Society Journal*, no.12, (Autumn 2002), pp.41–3.

GUEST, HARRIET, 'A Double Lustre: Feminity and Sociable Commerce 1730–1760', *Eighteenth Century Studies*, vol.23, no.4, (Summer 1990), pp.479–501.

GUNNIS, RUPERT, *Dictionary of British Sculptors 1660–1851*, (London, 1951).

GWILLAM, R., *Old Worcester People and Places*, 2 vols, (London 1977).

HALL, MAJOR H. BYNG, *The Bric-a-Brac Hunter or Chapters on Chinamania*, (London 1875).

HALSBAND, ROBERT, *The Life of Lady Mary Wortley Montague*, (Oxford 1961).

HALY, ANN (ed.), *William Verrell's Cookery Book*, (1759, repr. Southover 1988).

HANNAH, LESLIE, 'New Issues in British Business History', *Business History Review*, 57, (1983), pp.25–38.

HARCOURT, E.W., *The Harcourt Papers*, vol.VIII, (Oxford 1938).

HARE, SUSAN (ed.), *Touching Gold and Silver, 500 Years of Hallmarks*, (London 1978).

HARRIS, JOHN, 'Industrial Espionage in the Eighteenth Century', in Harris, John, *Essays in Industry and Technology in the Eighteenth Century: England and France*, (Hampshire 1992).

HARRIS, JOHN and SNODIN, MICHAEL, *Sir William Chambers Architect to George III*, (London 1996).

HARDY, JOHN, 'Neo-classical Taste at Blemheim', *Country Life*, vol.CLVII, (23 January 1975), pp.198–202.

HARTH, PHILLIP (ed.), *The Fable of the Bees Bernard de Mandeville*, (London 1970).

HARTOP, C., *The Huguenot Legacy. English Silver 1680–1760*, London 1996.

HARVEY, CHARLES; GREEN, EDMUND and CORFIELD, PENELOPE J., 'Continuity, Change and Specialization within metropolitan London: the economy of Westminster 1750–1820', *Economic History Review*, vol.LII, no.3, (August 1999), pp.469–93.

HASLAM, RICHARD, 'Hoare's Bank, Fleet Street', *Country Life*, (27 January 1994), pp.2,431–2,435.

HASSELL, J., *Picturesque rides and walks, with excursions by water, thirty miles round the British metropolis*, (London 1817).

HAWKINGS, DAVID T., 'Little used sources and new discoveries, silver plate and carriage tax', *Genealogists' Magazine*, (June 1999).

HAYES, JOHN, *Thomas Gainsborough*, (London 1980).

HAYWARD, HELENA, 'Some English Rococo Designs for Silversmiths', *Proceedings of the Society of Silver Colletors*, II, 3/4, (1973), pp.70–5.

HAYWARD, J.F., 'A Surtoute; designed by William Kent', *Connoisseur*, March 1959.

—— 'The Pelham Gold Cup', *Connoisseur* (July 1969). pp.23–26.

—— 'Silver Made from the Designs of William Kent', *Connoisseur*, (June 1970), pp.356–72.

HEAL, AMBROSE, *The Trade Cards of Engravers*, (London 1927).

—— *The London Goldsmiths 1200–1800*, (1935, repr. London 1972).

—— *Sign Boards of Old London Shops, A review of the Shop Signs employed by the London Tradesmen during the Seventeenth and Eighteenth Centuries. Compiled from the author's collection of contemporary trade-cads and billheads*, (1957, London 1988).

HEALEY, E., *Coutts and Co. 1692–1992: The Portrait of a Private Bank*, (London 1992).

HECKSHER, MORRISON H., 'Gideon Saint An Eighteenth-Century Carver and His Scrapbook', *Metropolitan Museum of Art Bulletin* (February 1969), pp.299–302.

HELFT, J. (ed.), *French Master Goldsmiths and Silversmiths from the Seventeenth to the Nineteenth Century*, (Paris 1966).

HENNELL, PERCY, 'The Hennells Identified', *Connoisseur*, (December 1955), p.260.

—— 'The Hennells: A Continuity in Craftsmanship', *Connoisseur*, (February 1973), pp.79–86.

—— *Hennell Silver Salt Cellars 1736–1876*, (London 1986).

HERBERT, W., *History of the Twelve Great Livery Companies*. vol.II, (London 1968).

HERVEY, S.H.A., *The Diary of John Hervey First Earl of Bristol with Extracts from his Book of Expenses 1688–1742*, (London 1894).

HIGGINS, DAVID and TWEEDALE, GEOFFREY, 'Asset or Liability? Trade Marks in the Sheffield Cutlery and Tool Trades', *Business History*, vol.37, no.3, (1995), pp.62–78.

HILL, ALAN G., *Letters of Dorothy Wordsworth*, (Oxford 1981).

HODGSON, J.C., 'The dairy of the Rev. John Thomlinson', *Surtees Society*, 118 (1910), pp.67–167.

HOPPIT, JULIAN, 'The use and abuse of credit in eighteenth-century England', in McKendrick and Outhwaite, (1986).

—— *Risk and Failure in English Business 1700–1800*, (Cambridge 1987).

HUDSON, D. and LUCKHURST, K.W., *The Royal Society of Arts 1754–1954*, (London 1954).

HUGHES, ANTHONY, '"The Cave and the Stithy": Artist's Studios and Intellectual Property in Early Modern Europe', *Oxford Art Journal*, 13:1, (1990), pp.23–40.

HUNT, MARGARET, *The Middling Sort. Commerce, Gender and the Family in England 1680–1780*, (Berkeley 1996).

HUSSEY, CHRISTOPHER, 'Longford Castle III', *Country Life*, (26 December 1931), pp.724–30.

ILCHESTER, Earl of (ed.), *Lord Hervey and His Friends 1726–38 Based on Letters from Holland House, Melbury and Ickworth*, (London 1950).

INGRAM, T.I., 'John Fourth Duke of Bedford, 1710–1771', *Apollo*, (June 1988), pp.382–6.

IRWIN, DAVID, 'Art versus Design: The Debate 1760 to 1860', *Journal of Design History*, vol.4, no.4 (1991), pp.219–32.

JACK, JANE, *Daniel Defoe Roxana The Fortunate Mistress, or a History of the Life and Vast Variety of Fortunes of Mademoiselle de Beleau, afterwards called the Countess of Wintselsheim in Germany Being known by the name of the Lady Roxana in the time of Charles II*, (Oxford 1981).

JACKSON, PETER, *Tallis's London Street Views 1838–1840*, (London 1969).

JACOB, WILLIAM, *An Historical Enquiry into the Production and Consumption of Precious Metals*, 2 vols, (London 1831).

JENSTAD, JANELLE AURIOL, 'The Gouldsmythes Storehowse; Early evidence for specialization', *The Silver Society Journal*, 1998, pp.40–3.

JOHNSON, R. BRINSLEY, *Mrs Delany at Court Among the Wits being a Record of a Great Lady of Genius in the Art of Living*, (London 1925).

JONES, E.A., *Catalogue of the Plate at Queens College*, (Oxford 1938).

JOSLIN, D.M., 'London private bankers 1720–85', *Economic History Review*, 2nd ser. vii (1954).

JUBB, MICHAEL, 'Income, Class and the Taxman: a Note on the Distribution of Wealth in Nineteenth-Century Britain', *Historical Research*, vol.60, no.141, (February 1987), pp.118–24.

JUPP, P.J., 'The roles of royal and aristocratic women in British politics *c*.1782–1832', in Mary O'Dowd and Sabine Wichert (eds.), *Chattle, Servant or Citizen: Women's Status in Church, State and Society*, (Belfast 1995).

KAPLAN, S.L., 'The Luxury Guilds in Paris in the Eighteenth Century', *Francia*, vol.IX, (1982), pp.257–98.

KAPLAN, S.L. and KAEPP, J. (eds), *Work in France, Representation, Meaning and Organization*, London 1986.

KELLETT, J.R., 'The breakdown of Guild and Corporation control over the handicraft and retail trades of London', *Economic History Review*, 2nd ser. x (1957–58).

KEMP, MARTIN, 'Scott and Delacroix, with Some Assistance from Hugo and Bonington', in Alan Bell (ed.), *Scott Bicentenary Essays*, (1973), pp.213–17.

KENT, D.A., 'Small Business and their Credit Transfer in Early Nineteenth Century Britain', *Business History*, (1994), vol.36, no.2, pp.47–64.

KENYON, OLGA, *800 Years of Womens' Letters*, (Far Thrupp 1995).

KIRBY, R.S., *The Wonderful and Scientific Museum; or Magazine of Remarkable Character*, vol.I, (1803), pp.174–9.

KIRKHAM, PAT, 'Samuel Norman: A Study of an Eighteenth Century Craftsman', *Burlington Magazine*, (August 1969), pp.501–13.

—— 'The Partnership of William Ince and John Mayhew 1759–1804', *Furniture History*, vol.X, (1974), pp.89–91.

KIRSHNER, JULIUS, (ed.), *Raymond de Roover Business, Banking and Economic Thought in Late Medieval and Early Modern Europe*, (Chicago 1974).

KOPYTOFF, IGOR, 'The cultural biography of things: commoditization as process', in Appadurai, (1986), pp.66–7.

KOWALESKI-WALLACE, BETH, 'Women, China and Consumer Culture in Eighteenth-Century England', *Eighteenth-Century Studies*, vol.29, no.2, (1995–6), pp.153–67.

—— *Consuming Subjects: Women, Shopping and Business in the Eighteenth Century*, (New York and Chichester 1997).

KROG, O.V. (ed.), *A King's Feast. The Goldsmiths' Art and Royal Banqueting in the 18th Century*, (Denmark 1991).

KWINT, M., BREWARD, C. and AYNSLEY, J. *Material Memories*, London 1999.

LAMBERT, SUSAN, (ed.), *Pattern and Design. Designs for the Decorative Arts 1480–1980*, (London 1983).

LA NEICE, SUSAN and CRADDOCK, PAUL, *Metal Plating and Patination Cultural, Technical and Historical Developments*, (London 1987).

LANGFORD, P., *A Polite and Commercial People England 1727–1783*, (Oxford 1990).

LANGLEY, G., *Life and Times of Gilbert Langley*, (London 1740).

LATHAM, *The Shorter Pepys*, (London 1993).

LEARMOUNT, BRIAN, *A History of the Auction*, (London 1985).

LE CORBEILLER, CLARE, 'James Cox: a biographical review' *Burlington Magazine* CXII (1970), pp.351–56.

Le Corbeiller, Clare, 'James Cox and his curious toys', *Metropolitan Museum of Art Bulletin* (June 1960), pp.318–24.

LEVER, CHRISTOPHER, 'Garrard and Co.', *The Connoisseur*, (June 1974), pp.94–8.

—— *Goldsmiths and Silversmiths of England*, (London 1975).

LEWIS, W. S., *Three Tours Through London in the Years 1748, 1776 and 1797*, (New Haven 1941).

—— (ed.), *Letters of Horace Walpole*, (New Haven and London 1982).

LIPKING, LAWRENCE, *The Ordering of the Arts in Eighteenth-Century England*, (Princeton 1970).

LLOYD, STEPHEN, (ed.), *Richard and Maria Cosway Regency Artists of Taste and Fashion*, (London 1995).

LOFTIE, MRS, *The Dining Room*, (London 1878).

LOMAX, JAMES, 'Silver for the English Dining Room 1700–1820', in Krog (1991), pp.118–33.

—— *British Silver at Temple Newsam and Lotherton Hall*, (Leeds 1992).

LONSDALE, ROGER, (ed.), *Eighteenth-Century Women Poets, An Oxford Anthology*, (Oxford 1989).

LUBBOCK, JULES, *The Tyranny of Taste. The Politics of Architecture and Design in Britain 1550–1960*, (New Haven and London 1995).

LUMMIS, TREVOR and MARSH, JAN, *The Woman's Domain. Women and the English Country House*, (London 1990).

LUNT, P.K. and LIVINGSTONE, *Mass Consumption and Personal Identity*, (Oxford 1992).

LUU, LIEN, 'Aliens and their impact on the goldsmiths' craft in London in the sixteenth century', in Mitchell (1993), pp.43–52.

MABILLE, GERARD, 'Germain, Durand, Auguste: the Art of the French Gold- and Silversmiths in Europe during the Age of the Enlightenment', in Krog (1991).

McBURNEY, WILLIAM H., (ed.), *The Lord Mayor, or the House of Guy Barnewell*, (London 1965).

McCRACKEN, GRANT, *Culture and Consumption New Appproaches to the Symbolic Character of Consumer Goods and Activities*, (Indiana 1990).

McCUSKER, J.J., *Money and Exchange in Europe and America 1600–1775*, (North Carolina 1978).

MACDONALD, JOHN, *Memoirs of an Eighteenth-Century Footman*, (1790, London 1985).

McKENDRICK, NEIL; BREWER, JOHN and PLUMB, J.H., *The Birth of a Consumer Society, The Commercialization of Eighteenth-Century England*, (London 1983).

McKENDRICK, N. and OUTHWAITE, R. *Business Life and Public Policy*, (1986).

McKILLOP, A.D., 'Samuel Richardson's advice to an apprentice', *Journal of English and German Phililogy*, XLII, (1943), pp.40–54.

MALLET, J.V.G., 'Wedgwood and the Rococo', *Apollo*, (May 1974).

MALMAS, P. and O'BRIEN, P.K., 'Taxation in Britain and France 1715–1810: a Comparison of Social and Economic Incidence of Taxes Collected for the Central Government', *Journal of Economic History*, vol.5, (1976).

MARCHAND, JEAN (ed.), *A Frenchman in England 1784*, (Cambridge 1933).

MARKHAM, SARAH, *John Loveday of Caversham 1711–1789. The Life and Tours of an Eighteenth-Century On Looker*, (Salisbury 1984).

MARRINER, SHEILA, 'Company Financial Statements as Source Material for Business Historians', *Business History*, vol.XXII, (January 1980), pp.203–35.

—— 'English Bankruptcy Records and Statistics Before 1850', *The Economic History Review*, 2nd series, vol.XXXIII, (1980), pp.351–66.

MARTIN, A.S., 'Makers, Buyers and Users: Consumption as a Material Culture Framework', *Winterthur Portfolio*, vol.28, no.2/3, p.157.

MASON, JULIAN, 'Accounting Records and Business History', *Business History*, vol.XXIV, (March 1982), pp.293–9.

MARKHAM, SARAH, *John Loveday of Caversham 1711–1789: The Life and Tours of an Eighteenth-Century Onlooker*, (Salisbury 1984).

MARTIN, ANN SMART, 'Makers, Buyers and Users: Consumerism as a Material Culture Framework', *Winterthur Portfolio*, vol.28, no2/3, (1993), pp.157–70.

MAYHEW, NICK, *Sterling: The History of a Currency*, (London 1999).

Memoirs of the Late Philip Rundell Esq. Goldsmith and Jeweller to His Majesty and the Royal Family, (London 1827).

METEYARD, ELIZA, *The Life of Josiah Wedgwood*, 2 vols, (1865).

MILWARD, J.S. and ARNOLD-CRAFT, H.P., *Portraits and Documents Eighteenth Century 1714–1783*, (London 1962).

MITCHELL, DAVID (ed.), *Goldsmiths, Silversmiths and Bankers, Innovation and the Transfer of Skill 1650–1750*, (Far Thrupp 1995).

MOLINEUX, G., *Memoir of the Molineux Family*, (1882).

MONCRIEFF, ELSPETH, 'Valadier workshop drawings: the discovery of a goldsmith's archive', *Apollo*, (May 1991), pp.315–19.

MOORE-COLYER, R.J. (ed.), *A Land of Pure Delight. Selections from the Letters of Thomas Johnes of Hafod Cardiganshire 1748–1816*, (Wales 1992).

MORE, THOMAS, *Utopia*, (1551, London 1997).

MORITZ, C.P., *Journey of a German in England in 1782*, trans Reginald Nettel (Oxford 1965).

MORRISON-LOW, A.D., 'The Role of the Subcontractor in the Manufacture of Precision Instruments in Provincial England during the Industrial Revolution', in Ian Blanchard (ed.), 'New Directions in Economic and Social History', papers presented at the 'New Researchers' sessions of the Economic History Society Conference, Edinburgh, (31 March to 2 April 1995), pp.13–20.

MOWL, TIMOTHY and EARNSHAW, BRIAN, *An Insular Rococo Architecture, Politics and Society in Ireland and England, 1710–1770*, (London 1999).

MUI, HOH-CHEUNG and MUI, LORNA, H., *Shops and Shopkeeping in Eighteenth-Century England*, (London 1986).

MULDREW, CRAIG, 'Credit and the courts: debt litigation in a seventeenth-century urban community', *Economic History Review*, XLVI (1993), pp.23–38.

——, *The Economy of Obligation. The Culture of Credit and Social Relations in Early Modern England*, (London 1998).

NENADIC, STANA, 'Middle-Rank Consumers and Domestic Culture in Edinburgh and Glasgow 1720–1840', *Past and Present*, 145, (1995), pp.122–56.

NEWMAN, JOHN, *Buildings of England. West Kent and the Weald*, (London 1991).

NEWMAN, HAROLD, 'Argylls: silver and ceramic', *Apollo*, (1969), vol.89, pp.80–105.

NICHOLSON, C., *Writing and the Rise of Finance: Capital Satires of the Early Eighteenth Century*, (Cambridge 1994).

NORTH, MICHAEL and ORMROD, DAVID, *Art Markets in Europe 1400–1800*, (Aldershot 1998).

O'CONNELL, SHEILA, *The Popular Print*, (London 1999).

OKIN, S.M., 'Patriarchy and Married Women's Property in England: Questions on Some Current Views', *Eighteenth Century Studies* 12:2 (Winter 1983).

OMAN, CHARLES, 'A Problem of Artistic Responsibility: the Firm of Rundell, Bridge and Rundell', *Apollo*, vol.LXXXIII, (1966), pp.174–82.

—— 'Plate and Prestige', *Apollo*, (January 1969).

OSWALD, ARTHUR, 'Breamore House, Hampshire III', *Country Life*, (27 June 1957), vol.CXXI, no.3154. pp.1,320–3.

PACKER, EMMA, 'Refining the Goldsmith', in Mitchell (1995).

PARKER, KENNETH (ed.), *Dorothy Osborne, Letters to Sir William Temple*, (London 1987).

PEARCE, J.A., 'Fashioned Sterling in Westminster's Fields. The Story of a Huguenot Family of Silversmiths named Crespel', *Huguenot Society Proceedings*, (August 1989).

PENZER, N.M., *Paul Storr*, (London 1954).

——, 'The Hervey Silver at Ickworth, *Apollo*, Part I (February 1957), pp.38–43, Part II, (March 1957).

PHILLIPS, CLARE, *Jewels and Jewellery*, (London 2000).

PHILLIPS, P.A.S., *Paul de Lamerie, Citizen and Goldsmiths of London: A Study of his Life and Work 1688–1751*, (London 1935).

PICARD, LISA, *Dr Johnson's London*, (London 2001).

PIGGOTT, STUART, *William Stukeley An Eighteenth-Century Antiquary*, (London 1985).

POINTON, MARCIA, *Strategies for Showing Women, Possession and Representation in English Visual Culture 1665–1800*, (Oxford 1997).

—— 'Intrigue, Jewellery and Economics: Court Culture and Display in England and France in the late 1780s', in North and Ormrod (eds), (1998), pp.201–19.

—— 'Materializing Mourning: Hair, Jewellery and the Body', in Kwint, Breward and Aynsley (eds), (1999), pp.39–57.

—— 'Dealer in Magic: James Cox's Jewelry Museum and the Economics of Luxurious Spectacle in Late Eighteenth-Century London', in De Marchi and Goodwin, (1999), pp.423–51.

PONSFORD, C.N., *Time in Exeter*, (Exeter 1978).

PORTAL, CHRISTOPHER, *The Reluctant Goldsmith Abraham Portal 1726–1809*, (Mendip 1993).

PORTER, DAVID, 'A Peculiar but Uninteresting Nation: China and the Discourse of Commerce in Eighteenth-Century England', *Eighteenth-Century Studies*, vol.33, no.2, (1999–2000).

PORTER, ROY, 'Material Pleasures in the Consumer Society', in Porter and Roberts (1996), pp. 19–35.

PRIDEAUX, WALTER S., *Memorials of the Goldsmiths' Company Being Gleanings from their Records Between the Years 1335 and 1815*, 2 vols, (London, 1896-7).

PUETZ, A., 'Design Instruction for Artisans in Eighteenth Century Britain', *Journal of Design History*, vol.12, no.3, (1999), pp.217–39.

QUINN, STEPHEN, 'Balances and goldsmith-bankers: the co-ordination and control of inter-banker debt clearing in seventeenth-centruy London', in Mitchell (1993), pp.53–76.

QUICKENDEN, KENNETH, 'Boulton and Fothergill Silver: Business Plans and Miscalculations', *Art History*, vol.3, no.3, (September 1980).

—— 'Boulton and Fothergill Silver an Epergne designed by James Wyatt', *Burlington Magazine*, vol.CXXVIII, no.999, (1986), pp.417–21.

—— (1), 'The Planning of Bolton and Fothergill's Silver Business', in Quickenden and Quickenden, (1995).

—— (2), 'Boulton and Fothergill's Silversmiths', *The Silver Society Journal*. 7, (Autumn 1995), pp.342–56.

QUICKENDEN, KENNETH and QUICKENDEN, N.A., *Silver and Jewellery: Production and Consumption since 1750*, Birmingham 1995.

RATH, T., 'Business Records in the Public Record Office in the Age of the Industrial Revolution', *Business History*, vol.XVII, (January 1975), pp.189–200.

RAVEN, JAMES, *Judging New Wealth: Popular Publishing and Responses to Commerce in England 1750–1800*, (Oxford 1992).

RAZZELL, P. (ed.), *The Journals of Two Travellers in Elizabethan and Early Stuart England: Thomas Platter and Horatio Busino*, (London 1995).

REDDAWAY, T.F. and WALKER, LORNA T.M., *The Early History of the Goldsmiths' Company 1327–1509*, (London 1975).

REITLINGER, GERALD, *The Economics of Taste: The Rise and Fall of Objets d'Art Prices Since 1750*, (vol. II), (London 1963).

REYNARD, PIERRE CLAUDE, 'Manufacturing strategies in the eighteenth century: subcontracting for growth among paper makers in the Auvergne', *Journal of Economic History*, vol.58, (March 1998), pp.155–82.

—— 'Manufacturing Quality in the pre-industrial age: finding value in diversity', *Economic History Review*, vol.VIII, no.3, (August 2000), pp.493–516.

RHYS, ERNEST (ed.), *Eighteenth-Century Plays*, (London 1946).

RIBEIRO, AILEEN, *Fashion in the French Revolution*, (London 1988).

—— *The Art of Dress Fashion and Eegance in England and France 1750 to 1820*, (New Haven and London 1998).

RICHARDS, SARAH, *Eighteenth-Century Ceramics Products for a Civilized Society*, (Manchester 1999).

ROCHE, DANIEL, *A History of Everyday Things. The Birth of Consumption in France, 1602–1800*, Cambridge 2000.

ROSS, E., 'Mandeville, Melon and Voltaire: The Origins of the Luxury Controversy', *Frame Transactions fo the IV International Congress on the Enlightenment*, vol.v, SVEC, (1976), pp.1,879–1,913.

ROWE, ROBERT, *Adam Silver 1765–1795*, (London 1965).

—— 'Neo-classical Silver in England', *Proceedings of the Society of Silver Collectors*, (May 1962).

ROUQUET, ANDRÉ, *The Present State of the Arts in England*, (London 1755).

SABOR, PETER and DOODY, MARGARET ANNE (eds), *Frances Burney; Cecilia, or Memoirs of a Heiress*, (1782, Oxford 1988).

SALE, A.J.H. and BRETT, VANESSA, 'John White: some recent research', *Silver Society Journal*, 1996, pp.34–45.

SARGENTSON, CAROLYN, *Merchants and Luxury Markets. The Marchands Merciers of Eighteenth-Century Paris*, (London 1996).

SAMUEL, EDGAR R., 'Sir Francis Child's Jewellery Busines', *Three Banks Review*, (March 1977), pp.3–15.

SHURE, DAVID, *Hester Bateman, Queen of Silversmiths*, (London 1959).

SCHWARZ, L.D., 'Income distribution and social structure in London in the late eighteenth century', *Economic History Review*, 2nd ser.xxxii (1979).

—— *London in the Age of Industrialization: Entrepreneurs, Labour Force and Living Conditions 1700–1850*, (Cambridge 1993).

SCOTT, KATIE, *The Rococo Interior. Decoration and Social Spaces in Early Eighteenth Century Paris*, (New Haven and London 1995).

SEIDMAN, GERTRUDE, 'An English gem-engraver's life: Nathaniel Marchant (1739–1816)', *Jewellery Studies*, (1985), pp.59–63.

SEKORA, JOHN, *Luxury: The Concept in Western Thought, Eden to Smollett*, (Baltimore 1977).

SEWELL, W.H., 'Visions of Labor: Illustrations of the Mechancial Arts before, in and after Diderot's Encyclopédie', in Kaplan and Koepp (1986), pp.258–86.

SINSTEDEN, THOMAS, 'Four selected assay records of the Dublin Goldsmiths' Company', *Silver Society Journal*, (Autumn 1999), pp.143–57.

SITWELL, Major General, H.D.W., *Conversation Pieces*, (London 1936).

—— 'The Jewel House and the Royal Goldsmiths', *Archaeological Journal*, vol.117, (1960), pp.131–55.

SKINNER, ANDREW, *Adam Smith The Wealth of Nations*, (London 1981).

SLAVEN, ANTHONY, 'The Uses of Business Records', *Business Archives*, 50, (1984), pp.45–60.

SMITH, BARBARA M.D., 'Patents for Invention The National and Local Picture', *Business History*, IV, no.1, (December 1961), pp.109–29.

SMITH, CHARLES SAUMAREZ, *Eighteenth-Century Decoration. Design and the Domestic Interior in England*, (London 1993).

SMITH, J.T., *Nollekens and His Times*, (London 1828, repr. London 1986).

SMITH, ROGER, 'The Devil Tavern Group. An eighteenth century horological trade association', *Antiquarian Horology*, (Spring 1999), pp.427–31.

—— 'James Cox (c.1723–1800): a revised biography', *Burlington Magazine*, (June 2000), pp.353–61.

SMOLLETT, TOBIAS, *The Adventures of Peregrine Pickle*, (London 1751, repr. Oxford 1969).

—— *The Expedition of Humphry Clinker*, (London 1777, Oxford 1966).

SNODIN, MICHAEL, 'Matthew Boulton's Sheffield Plate Catalogues', *Apollo*, July 1987, pp.25–32.

—— 'Charles and Edward Crace and Rococo Coach Painting', in M. Aldrich (ed.), *The Craces: Royal Decorators 1768–1899*, (London 1990), pp.33–41.

—— 'Putting Adam into Context', in Quickenden and Quickenden (1995), pp.13–20.

—— 'Adam silver reassessed', *Burlington Magazine*, (January 1997), pp. 17–25.

SNODIN, MICHAEL and BAKER, MALCOLM, 'William Beckford's Silver', *Burlington Magazine* (November and December 1980).

SNODIN, MICHAEL and STYLES, JOHN, *Design and the Decorative Arts in Britain 1500–1900*, (London 2001).

SONENSHCHER, MICHAEL, 'Journeymen and the Court in the French Trades 1781–1791', *Past and Present*, vol.CXIV, (February 1987), pp.77–109.

—— 'Fashion's Empire: trade and power in early 18th-century France', in Fox and Turner (1998), pp.231–56.

SOUTHWICK, LESLIE, 'William Badcock goldsmiths and hilt maker', *Silver Society Journal*, (1997), pp.584–99.

STAVES, SUSAN, *Married Women's Separate Property in England 1660–1833*, (Cambridge MA 1990).

STERNE, LAWRENCE, *Sentimental Journey*, (London 1986).

STEVENSON, L.C., *Praise and Paradox: Merchants and Craftsmen in Elizabethan Popular Literature*, (Cambridge 1984).

STILL, JUDITH, *Feminine Economies. Thinking against the Market in the Enlightenment and the Late Twentieth Century*, (Manchester and New York 1997).

STOKES, FRANCIS GRIFFITH (1), *The Blecheley Diary of the Rev. William Cole MA FSA 1765–67*, (London 1931).

STOKES, FRANCIS GRIFFITH (2), (ed.), *A Journal of my Journey to Paris in the Year 1765 by the Rev. William Cole MA FSA*, (London 1931).

STONE, LAWRENCE, *Broken Lives Separation and Divorce in England 1660–1857*, (Oxford 1993).

STONE, LAWRENCE and STONE, J.C.F., *An Open Elite? England 1540–1880*, (Oxford 1984).

STOW, JOHN, *A Survey of the Cities of London and Westminster*, vol.II, (series ed. John Strype), 6th ed., (London 1754–5).

STRANGE, EDWARD F., 'A London Silversmith of the Eighteenth Century', *Connoisseur*, vol.19, (1907), pp.99–102.

STURMER, DAVID, 'An Economy of Delight. Court Artisans of the Eighteenth Century', *Business History Review*, vol.LIII, no.4, (Winter 1979), pp.496–528.

STYLES, JOHN, 'Our Traitorous Money Makers', in Brewer and Styles (1980), pp.172–242.

—— 'Manufacturing, consumption and design in eighteenth-century England', in Brewer and Porter (1993).

—— 'The goldsmiths and the London luxury trades', in Mitchell (1995), pp.112–20.

SUMMERSON, JOHN, *Georgian London*, (London 1962).

TAYLOR, GERALD, *Silver*, (London 1956).

THOMSON, GLADYS SCOTT, *The Russells in Bloomsbury 1669–1771*, (London 1940).

—— *Letters of a Grandmother 1732–1735 Being the Correspondence of Sarah Duchess of Marlborough with her Granddaughter Diana Duchess of Bedford*, (London 1946).

THORNTON, PETER, *Authentic Décor: The Domestic Interior 1620–1920*, (London 1993).

THOROLD, PETER, *The London Rich, The Creation of a Great City from 1666 to the Present*, (London 1999).

TIERSTEN, LISA, 'Redefining Consumer Culture: recent literature on consumptio and bourgeoisie in Western Eureope', *Radical History Review*, 57, 1993, pp.116–59.

TIPPING, AVRAY, 'Clandon Park Pictures', *Country Life*, (15 October 1927), pp.571–3.

TORSTEN, M. and BERG, P., *Journals of Baron Angerstein*, London 2001.

TRISTRAM, PHILIPPA, *Living Space in Fact and Fiction*, 1989.

TRUMAN, CHARLES, 'Elias Russel's Gold Snuff Box', *Worshipful Company of Goldsmiths' Review*, (1983–4), pp.35–6.

—— *Sotheby's Concise Encyclopedia of Silver*, (London 1993).

TRUMBACH, RANDOLPH, *The Rise of the Egalitarian Family' Aristocratic Kinship and Domestic Relations in Eighteenth-Century England*, (New York 1978).

TUCKER, R.F., 'Real wages of artisans in London 1729–1935', *Journal of American Statistical Association*, XXXI (1936).

TURNER, ERIC, 'Silver plating in the 18th century', in La Neice and Craddock, (1987), pp.211–22.

UDY, DAVID, 'Neo-Classicism and the Evolution of Adam's designs in Silver', *The Antique Collector*, vol.XLIII, no.4, (August 1972), pp.192–7.

—— 'New Light on the Sources of English Neo-Classical Design', *Apollo*, March 1976, pp.202–7.

—— 'Piranesi's "Vasi", the English Silversmith and his Patrons', *Burlington Magazine*, 120, no.820, December 1978, pp.420–51.

UNWIN, G., HULME A. and TAYLOR, G., *Samuel Oldknow and the Arkwrights*, (Manchester 1924).

VEBLEN, THORSTEN, *The Instinct of Workmanship*, (1914, New York 1964).

VICHERT, GORDON, 'The Theory of Conspicuous Consumption in the Eighteenth Century', in Peter Huges and David Williams (eds.), *The Varied Pattern: Studies in the Eighteenth Cebntury*, (1971).

VICKERS, MICHAEL and GILL, DAVID, *Artful Crafts Ancient Greek Silverware and Pottery*, (Oxford 1996).

VOLTAIRE, FRANÇOIS-MARIE AROUET, *Letters on England*, (1734, London 1985).

WAKEFIELD, PRISCILLA, *Perambulations in London and its Environs*, (London 1809).

WAINWRIGHT, CLIVE, 'Some objects from William Beck-ford's Collection now in the Victoria and Albert Museum', *Burlington Magazine* (1971), CXIII, no.818, pp.254–64.

WALKER, R.B., 'Advertising in London Newspapers 1650–1750', *Business History*, XV/2, (July 1973), pp.112–80.

WALSH, CLAIRE, 'The design of London goldsmiths' shops in the early eighteenth century', in D. Mitchell (1995), pp.96–111.

—— 'Shop Design and the Display of Goods in the Eighteenth Century London', *Journal of Design History*, vol.8, no.3, (1995), pp.157–76.

WARK, R.R. (ed.), *Sir Joshua Reynolds' Discourses on Art*, (New Haven and London 1975).

WATERSON, MERLIN, *The Servants' Hall, A Domestic History of Erdigg*, (London 1980).

WEATHERILL, L., *Consumer Behaviour and Material Culture in Britain 1660–1760*, (London and New York 1997).

WEES, BETH CARVER, *English, Irish and Scottish Silver at the Sterling and Francine Clark Art Institute*, (New York 1997).

WENDEBORN, F.A., *A View of England Towards the Close of the Eighteenth Century*, (Dublin 1791).

WERNER, ALEX, 'Thomas Betts: an eighteenth century glass cutter', *Journal of Glass*, 1978, pp.12–21.

WESTON, ANN (ed.), *Garrard Royal Goldsmiths*, (London 1987).

WESTWOOD, H., 'The author WB identified', *Apollo*, (May 1960), pp.135–7.

WHITLEY, WILLIAM T., *Artists and their Friends in England 1700–1799*, (London and Boston 1928).

WHYMAN, SUSAN E., *Sociability and Power in Late Stuart England, The Cultural Worlds of the Verneys 1660–1720*, (Oxford 1999).

WILLIAMS, CLAIRE (trans.), *Sophie in London*, (London 1935).

WILLIAMS, JONATHAN (ed.), *Money A History*, (London 1998).

WILLS, GEOFFREY, 'Stafford Briscoe: a London Silversmith', *Burlington Magazine*, (1983), pp.50–3.

WILSON, HENRY, *Silverwork and Jewellery: a Textbook for Students and Workers in Metal*, (1902, London 1978).

WINTER, JOHN, 'The Valadier Drawings', in *Valadier: Three Generations of Goldsmiths*, (London, 1991).

WOOD, ANTHONY, 'The Diaries of Sir Roger Newdigate, 1751–1806', *Birmingham Archaeological Society, Transactions and Proceedings*, vol.78, (Oxford, 1962).

WOODCROFT, BENNET, *Index to Patents of Invention*, (London 1854).

WOODFORDE, JAMES, *The Diary of a Country Parson 1758–1802*, (Oxford 1978).

WORSLEY, GILES, 'Nuneham Park Revisted – I', *Country Life*, vol.CLXXVII, no.4999, (January 1985).

WRIGHT, BETH SEGAL, 'Scott's Historical Novels and French History Painting 1815–1855', *Art Bulletin*, (1981), XLIII, no.2, pp.268–87.

WRIGHT, C.E. and WRIGHT, R.C., *The Dairy of Humfrey Wanley*, (London 1966).

WRIGHT, J.S., 'The Jewellery and Gilt Toy Trades', in S. Timmins, *Birmhgham and the Midland Hardware District*, (London 1866), pp.451–62.

YAMEY, BASIL S., 'Scientific Book-keeping and the rise of capitalism', *Economic History Review*, 2nd ser.I, (1949).

—— *Art and Accounting*, (New Haven and London 1989).

YAMEY, BASIL S., EDEY, H.C. and THOMSON, H.W., *Accounting in England and Scotland 1543–1800*, (London and New Haven 1963).

YOGEV, GEDALIA, *Diamonds and Coral Anglo-Dutch Jews and Eighteenth-Century Trade*, (Leicester 1978).

YOUNG, HILARY, 'Thomas Heming and the Tatton Cup', *Burlington Magazine*, CVXXV, (1983), pp.285–9.

—— 'Silver William Chambers and John Yenn: designs for silver', *Burlington Magazine*, vol.128, (January 1986), pp.31–5.

—— 'Sir William Chambers and the Duke of Marlborough's Silver', *Apollo*, (June 1987), pp.396–400.

—— 'The silver designs of Sir William Chambers: a resumé and recent discoveries', *Silver Society Journal*, (Autumn 1995), pp.335–41.

—— 'An eighteenth-century London glass cutter's trade card', *Apollo*, (February 1998), pp.41–6.

—— *English Porcelain 1745–95. Its Makers, Design, Marketing and Consumption*, (London 1999).

YUNG, KAI KIN, *Samuel Johnson 1709–84*, (London 1984).

Unpublished Sources

FEDERER, ANDREW, 'Payment, Credit and the Organization of Work in Eighteenth Century Westminster', SSRC Conference on Manufacture in Town and Country before the Factory, Balliol College, Oxford, September 1980.

—— 'Commodities, Credit and Cash in the Luxury Trades of Eighteenth-Century Westminster', V and A/RCA Course, Victoria and Albert Museum, October 1987.

—— 'Westminster Tradesmen in the World of Goods c.1680–1800', Wright State University Center for 17th and 18th Century Studies Workshop, 2 January 1989.

JOHN, ELEANOR, '"The China Here is Lovely": The Acquisition of French Luxury Goods by the British in the Eighteenth Century', V and A/RCA, MA thesis, 1995.

WALKER, M.J., 'The extent of guild control of trades in England c.1660–1820: a study based on a sample of provincial towns and London companies, University of Cambridge, Ph.D. thesis, 1996.

Index

Page numbers in *italics* indicate illustrations

Illustration Acknowledgements

Ashmolean Museum, Oxford: 3, 21 , 47, 84, 100,

The Duke of Bedford and the Trustees of the Bedford Estate: 92, 127 (© Forschungsarchiv für römische Plastik Köln.), 140

Birmingham Central Library: 2

Bodleian Library, Oxford: 31 , 49, 48 (John Johnson Collection), 171 (John Johnson Collection)

Museum of Fine Arts, Boston: Theodora Wilbour Fund in memory of Charlotte Beebe Wilbour, photograph © Museum of Fine Arts, Boston: 5

J.H. Bourdon Smith, London: 58, 75, 77

Bradbury Collection, Sheffield City Archives: 67

Brasenose College, Oxford: 14, 16

Breamore Estate, Hampshire: 112, 113, 114

Brotherton Library, Leeds: 153, 154

British Museum: 6, 15, 17, 28, 30, 36, 38, 70, 71, 101, 168

The Duke of Buccleuch and Queensbury, Bowhill: 94

Christie's Images Ltd: 19, 20, 50, 52, 54, 56, 59, 60, 61, 62, 66, 72, 73, 74, 104, 110, 134, 139, 144, 145, 146, 148, 173

Cincinnati Art Museum: 95

Country Life Picture Library: 150, 157, 158, 159, 160

Croome Court, Worcestershire: 108, 109, 111

Elmley Castle Church, photograph Clive Haynes: 78

Getty Museum, Los Angeles: 1

The Gilbert Collection Trust, London: 161

Gale Glynn (Hugh Jessop): 10

Grimsthorpe, Lincolnshire: 129, 139, 155, 156

Guildhall Library, Corporation of London: 29

Holland-Martin Family: 122

Hunterian Art Gallery, University of Glasgow: 93

The Hyde Collection, Harvard University: 162 (photograph George Roos)

Jesus College, Oxford: frontispiece (photograph Ashmolean Museum, Oxford)

Kedleston Hall, The Scarsdale Collection: 147

Kenwood House, London: 87, 96 (Iveagh Bequest)

Leeds City Art Galleries (Temple Newsam House): 69, 107, 142

Los Angeles County Museum of Art (Gift of Mr and Mrs Alfred Hart): 118

The Lord Mayor and Corporation of Bristol: 24

Mallett & Son Ltd, London: 97

Martyn Gregory Gallery, London: 49

The National Gallery, London: 120

National Gallery of Victoria, Melbourne, Australia: 81

National Gallery, Prague: 83

National Portrait Gallery, London: 11, 12, 123, 151

The National Trust: 119 (Saltram), 138 (Anglesey Abbey)

Nagel Auctions, Stuttgart: 130

Oriel College, Oxford: 178

Private collection, photographs courtesy of Garrard: 115, 116, 117

Private collection, photographs Clive Haynes: 27, 32, 33, 165, 166, 167, 179, 180

Rare Art (London): 149

The Royal Academy, London: 175

The Royal Collection: 57

The Royal Naval Museum, Portsmouth: 172

Schloss Wilhelmshohe, Kassel: 90

Schredds of Portobello, London: 76

Shakespeare Birthplace Trust: 177

Shropshire Records and Research: 169, 170

Sir John Soane's Museum, London: 124, 125

Private Collection: 65

Sotheby's: 22, 44, 45, 53, 55, 121, 126, 128, 133, 141, 174, 176

Suffolk County Council, Libraries and Heritage: 13

Victoria & Albert Museum, London: 7, 8, 9, 23, 41, 42, 43, 46, 51, 79, 86, 88, 102, 105, 106, 131, 136, 137, 143, 152

Westminster City Archives: 25, 35, 39, 40

Worcestershire Record Office: 26, 163, 164

The Worshipful Company of Goldsmiths, London: 34, 82, 85, 63 (Bill Brown Collection), 64 (Bill Brown Collection)

Wynyard Wilkinson & Robert Barker: 4

Yale Center for British Art, New Haven: 80, 91, 132, 135

The Marquess of Zetland: 89